This is a remarkably complete book on one of the most important areas of modern computer graphics by four of the top people in the field. Its clear and detailed treatment of both theory and practice will make it an essential resource for my own work, and I would recommend it to anyone doing computer graphics or imaging.

—Peter Shirley, Professor, University of Utah

High Dynamic Range Imaging is a fantastic overview of the state of the art for some critical concepts in visual effects. It outlines the basic foundations of color theory that are the core of VFX image processing and also serves as a roadmap to the way we will be working in the future. This book should be required reading for any VFX artist doing high-end film work.

When working on a visual effects film, any images provided by the director of photography are both sacred and fragile. This book explains why and also helps guide the reader to a better understanding of how HDR imagery can eliminate a lot of common LDR problems in the VFX pipeline.

—Scott Stokdyk, Visual Effects Supervisor, Sony Pictures Imageworks

I was very impressed with this book. It is highly topical and relevant at this pivotal time in the technology of image recording and display. Even the average consumer is well aware of monstrous changes in the film industry: digital cameras supplanting film cameras and digital projectors muscling in on film projectors at cinemas. This book is an excellent touchstone of where the industry is and where it will be going in the coming years.

The book reads very well. It not only works as an excellent reference volume but it reads easily and teaches the subject thoroughly. There's no question that it's going on my bookshelf and I know many artists who will insist on having a copy too.

Finally, I appreciate that a book about images and perception does not skimp on plates. This is a very pretty book and communicates the problems with images very clearly.

—Doug Roble, Creative Director of Software, Digital Domain

Last week I saw the future: a 50-inch high dynamic range video display. The authors of this book predict that HDR displays may be as little as few years away, but having seen tomorrow, my demand for the technology is now . Fortunately, this book more than satisfies my craving for information on all aspects of high dynamic range imaging. It has brought the future to my reading chair and my software development efforts. It is all that I could (and did) ask for.

—Ian Ashdown, President, byHeart Consultants Limited

THE MORGAN KAUFMANN SERIES
IN COMPUTER GRAPHICS

HIGH DYNAMIC RANGE IMAGING

Senior Editor: Tim Cox
Editorial Coordinator: Rick Camp
Editorial Assistant: Jessie Evans
Publishing Services Manager: Simon Crump
Senior Project Manager: Angela Dooley
Cover Design: Chen Design Associates
Cover Image: Chris Cox and Sharon Henley
Text Design: Chen Design Associates
Composition: VTEX Typesetting Services
Copyeditor: Daril Bentley
Proofreader: Phyllis Coyne et al.
Indexer: Northwind Editorial
Interior printer: C & C Offset Printing Co Ltd.
Cover printer: C & C Offset Printing Co Ltd.
DVD-ROM replicator: C & C Offset Printing Co Ltd.

Morgan Kaufmann Publishers is an imprint of Elsevier.
500 Sansome Street, Suite 400, San Francisco, CA 94111

Library of Congress Cataloging-in-Publication Data
Application submitted

ISBN 13: 978-0-12-585263-0
ISBN 10: 0-12-585263-0

For information on all Morgan Kaufmann publications, visit our Web site at www.mkp.com or www.books.elsevier.com

Printed in China
07 08 09 5 4 3 2

THE MORGAN KAUFMANN SERIES
IN COMPUTER GRAPHICS

HIGH DYNAMIC RANGE IMAGING

ACQUISITION, DISPLAY, AND IMAGE-BASED LIGHTING

ERIK REINHARD
GREG WARD

SUMANTA PATTANAIK
PAUL DEBEVEC

AMSTERDAM • BOSTON • HEIDELBERG
LONDON • NEW YORK • OXFORD
PARIS • SAN DIEGO • SAN FRANCISCO
SINGAPORE • SYDNEY • TOKYO

Morgan Kaufmann is an imprint of Elsevier

MORGAN KAUFMANN PUBLISHER

Voor Franz and Ineke. Ik ben jullie geweldig dankbaar voor de steun en vrijheid die jullie me altijd gegeven hebben
—E.R.

To my daughters Alina and Tessala, and all those who see the world through new eyes
—G.W.

To my family
—S.P.

To Maya, who knows the genuine beauty of light
—P.D.

ERIK REINHARD is assistant professor at the University of Central Florida and founder and editor-in-chief (with Heinrich Bülthoff) of *ACM Transactions on Applied Perception*. He is interested in the interface between visual perception and computer graphics and also in high dynamic range image editing. His work in HDRI includes the SIGGRAPH 2005 Computer Animation Festival contribution *Image-based Material Editing*, as well as tone reproduction and color appearance algorithms. He holds a BSc and a TWAIO diploma in computer science from Delft University of Technology and a PhD in computer science from the University of Bristol, and was a post-doctoral researcher at the University of Utah.

GREG WARD is a pioneer in HDRI, having developed the first widely used HDR image file format in 1986 as part of the Radiance lighting simulation system. In 1998 he introduced the more advanced LogLuv TIFF encoding and more recently the backwards-compatible HDR extension to JPEG. He is also the author of the Mac OS X application Photosphere, which provides advanced HDR assembly and cataloging and is freely available from www.anyhere.com. Currently he is collaborating with Sunnybrook Technologies on their HDR display systems. Greg has worked as a part of the computer graphics research community for over 20 years, developing rendering algorithms, reflectance models and measurement systems, tone reproduction operators, image processing techniques, and photo printer calibration methods. His past employers include the Lawrence Berkeley National Laboratory, EPFL Switzerland, SGI, Shutterfly, and Exponent. He holds a bachelor's degree in physics from UC Berkeley and a master's degree in computer science from San Francisco State University. He is currently working as an independent consultant in Albany, California.

SUMANTA PATTANAIK is an associate processor of computer science at the University of Central Florida, Orlando (UCF). His main area of research is realistic rendering where he has been active for over 15 years and has contributed significantly through a number of research publications. His current focus is developing real-time rendering algorithms and modeling natural environments. He is currently serving as the computer graphics category editor of *ACM Computing Review*. Sumanta received his MS degree in chemistry from Utkal University, India in 1978 and PhD degree in computer science from Birla Institute of Technology and Science in Pilani (BITS-Pilani), India in 1993. Prior to joining UCF he was a research associate at the Program of Computer Graphics at Cornell University, a post-doctoral researcher at the SIAMES program of IRISA/INRIA France, and a senior staff scientist at the National Center of Software Technology, India.

PAUL DEBEVEC is a research assistant professor at the University of Southern California and the executive producer of graphics research at USC's Institute for Creative Technologies. Paul's PhD thesis (UC Berkeley, 1996) presented Façade, an image-based modeling and rendering system for creating photoreal architectural models from photographs. Using Façade, he led the creation of virtual cinematography of the Berkeley campus for his 1997 film *The Campanile Movie* whose techniques were used to create virtual backgrounds in the 1999 film *The Matrix*. Subsequently he pioneered techniques for illuminating computer-generated scenes with real-world lighting captured through high dynamic range photography, demonstrating new image-based lighting techniques in his films *Rendering with Natural Light* (1998), *Fiat Lux* (1999), and *The Parthenon* (2004). He has also led the design of HDR Shop, the first widely used high dynamic range image editing program. Most recently Paul has led the development of a series of Light Stage devices that allow objects, actors, and performances to be synthetically illuminated with novel lighting. This technique was used to create photoreal digital actors for the film *Spider Man* 2. Paul received the first ACM SIGGRAPH Significant New Researcher Award in 2001, was named one of the world's top "100 Young Innovators" by MIT's *Technology Review* in 2002, and was awarded a Lillian Gilbreth Lectureship from the National Academy of Engineering in 2005.

Contents

Foreword

High Dynamic Range Imaging is landmark in the history of imaging science. In the 1930s two professional musicians, Mannes and Godowsky, invented what became known as Kodachrome and the world of color photography was forever changed. We are now on the cusp of a change of similar magnitude and the catalyst is not color, nor even digital — it is HDR.

Over the last decade I was fortunate enough to learn about HDR imaging from the authors of this book and was graciously welcomed by them as a researcher new to the field. You could say they were kind enough to give me a backstage pass to one of the coolest shows in imaging science. I had already been fortunate to be in the center of the first row for the revolution in digital color imaging that started in the 1980s and is now pervasive. These authors gave me the even rarer privilege of witnessing the beginnings of a second revolution (and perhaps even playing a small role). As HDR becomes as common as color in the coming years the changes in digital photography will be as significant as the change from NTSC to HDTV in digital television. In fields such as medical and security imaging it could change our lives.

It might be too late for another backstage pass, but these authors and this book can catch you up on what has happened in the past decade (both backstage and at the wild after parties) and get you ready to be part of the next significant revolution in imaging. You truly might not believe your eyes. This book will hold a cherished spot on my shelves and those of my students for many years to come.

High Dynamic Range Imaging is invaluable to anyone interested in making or using images of the highest quality. Read it, live it, climb aboard, get ready for one heck of a show, and whatever you do, don't sit back and relax!

Mark D. Fairchild
Xerox Professor of Color Science
Director, Munsell Color Science Laboratory
Chester F. Carlson Center for Imaging Science
Rochester Institute of Technology

Preface

The thought of writing this book began with the realization that not a single book existed with the title *HDR? Duh!* While we rejected the idea of this title shortly after, both the idea for this book and its title matured and now you have the final result in your hands.

High dynamic range imaging is an emerging field, and for good reasons. You are either already convinced about that, or we hope to convince you with this book. At the same time, research in this area is an amazing amount of fun, and we hope that some of that shines through as well.

Together, the four authors are active in pretty much all areas of high dynamic range imaging, including capture devices, display devices, file formats, dynamic range reduction, and image-based lighting. This book recounts our experience with these topics. It exists in the hope that you find it useful in some sense.

The visual quality of high dynamic range images is vastly higher than conventional low-dynamic-range images. The difference is as big as the difference between black-and-white and color television. Once the technology matures, high dynamic range imaging will become the norm rather than the exception. It will not only affect people in specialized fields such as film and photography, computer graphics, and lighting design but will affect everybody who works with images.

High dynamic range imaging is already gaining widespread acceptance in the film industry, photography, and computer graphics. Other fields will follow soon. In all likelihood, general acceptance will happen as soon as high dynamic range display devices are available for the mass market. The prognosis is that this may be as little as only a few years away.

At the time of writing, there existed no single source of information that could be used both as the basis for a course on high dynamic range imaging and as a work of reference. With a burgeoning market for high dynamic range imaging, we offer

this book as a source of information for all aspects of high dynamic range imaging, including image capture, storage, manipulation, and display.

ACKNOWLEDGMENTS

This book would be unimaginable without the help of a vast number of colleagues, friends, and family. In random order, we gratefully acknowledge their help and support. Colleagues, friends, and family who have contributed to this book in one form or another: Peter Shirley, Erum Arif Khan, Ahmet Oguz Akyuz, Grzegorz Krawczyk, Karol Myszkowski, James Ferwerda, Jack Tumblin, Frédo Durand, Prasun Choudhury, Raanan Fattal, Dani Lischinski, Frédéric Drago, Kate Devlin, Michael Ashikhmin, Michael Stark, Mark Fairchild, Garrett Johnson, Karen Louden, Ed Chang, Kristi Potter, Franz and Ineke Reinhard, Bruce and Amy Gooch, Aaron and Karen Lefohn, Nan Schaller, Walt Bankes, Kirt Witte, William B. Thompson, Charles Hughes, Chris Stapleton, Greg Downing, Maryann Simmons, Helge Seetzen, Heinrich Bülthoff, Alan Chalmers, Rod Bogart, Florian Kainz, Drew Hess, Chris Cox, Dan Baum, Martin Newell, Neil McPhail, Richard MacKellar, Mehlika Inanici, Paul Nolan, Brian Wandell, Alex Lindsay, Greg Durrett, Lisa Yimm, Hector Yee, Sam Leffler, Marc Fontonyot, Sharon Henley, and Shree Nayar.

Extremely helpful were the comments of the reviewers who ploughed through early drafts of this book: Ian Ashdown, Matt Pharr, Charles Poynton, Brian Smits, Joe Geigel, Josh Anon, and Matthew Trentacoste, as well as the anonymous reviewers.

Several institutes, organizations, and companies have given us their kind support. The Albin Polasek Museum (*www.polasek.org*) allowed us to monopolize one of their beautiful galleries to take high dynamic range images. Several of these are shown throughout the book. The Color and Vision Research Laboratories at the Institute of Ophthalmology, UCL, have an extremely helpful publicly available online resource with color-related data sets (*cvrl.ioo.ucl.ac.uk*). SMaL Camera Technologies has given us a prototype HDR security camera that gave us useful insights (*www.smalcamera.com*). idRuna donated a copy of their Photogenics software — a high dynamic range image editing program (*www.idruna.com*).

Last but not least, we thank Tim Cox, Richard Camp, Jessie Evans, and Angela Dooley at Morgan Kaufmann for the outstanding job they have done producing this book.

Introduction

01

There are many applications that involve digital images. They are created with modern digital cameras and scanners, rendered with advanced computer graphics techniques, or produced with drawing programs. These days, most applications rely on graphical representations of some type.

During their lifetime, digital images undergo a number of transformations. First, they are created using one of the previously cited techniques. Then they are stored on a digital medium, possibly edited via an image-processing technique, and ultimately displayed on a computer monitor or printed as hardcopy.

Currently, there is a trend toward producing and using higher-resolution images. For example, at the time of writing there exist consumer-level digital cameras that routinely boast 5- to 6-megapixel sensors, with 8- to 11-megapixel sensors available. Digital scanning backs routinely offer resolutions that are substantially higher. There is no reason to believe that the drive for higher-resolution images will abate anytime soon. For illustrative purposes, the effect of various image resolutions on the visual quality of an image is shown in Figure 1.1.

Although the trend toward higher-resolution images is apparent, we are at the dawn of a major shift in thinking about digital images, which pertains to the range of values each pixel may represent. Currently, the vast majority of color images is represented with a byte per pixel for each of the red, green, and blue channels. With three bytes per pixel, more than 1.6 million different colors can be assigned to each pixel. This is known in many software packages as "millions of colors."

This may seem to be an impressively large number at first, but it should be noted that there are still only 256 values for each of the red, green, and blue components of each pixel. Having just 256 values per color channel is inadequate for

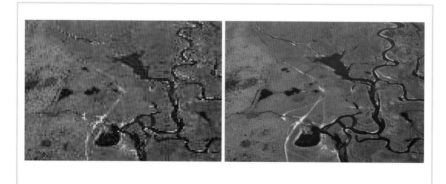

FIGURE 1.1 *Increasing the number of pixels in an image reduces aliasing artifacts. The image on the left has a resolution of 128 by 96 pixels, whereas the image on the right has a resolution of 1,024 by 700 pixels.*

representing many scenes. An example is shown in Figure 1.2, which includes an automatically exposed 8-bit image on the left. Although the subject matter may be unusual, the general configuration of an indoor scene with a window is quite common. This leads to both bright and dark areas in the same scene. As a result, in Figure 1.2 the lake shown in the background is overexposed.

The same figure shows on the right an example that was created, stored, and prepared for printing with techniques discussed in this book. In other words, it is a high-dynamic-range (HDR) image before the final display step was applied. Here, the exposure of both the indoor and outdoor areas has improved. Although this

FIGURE 1.2 *Optimally exposed conventional images (left) versus images created with techniques described in this book (right).*

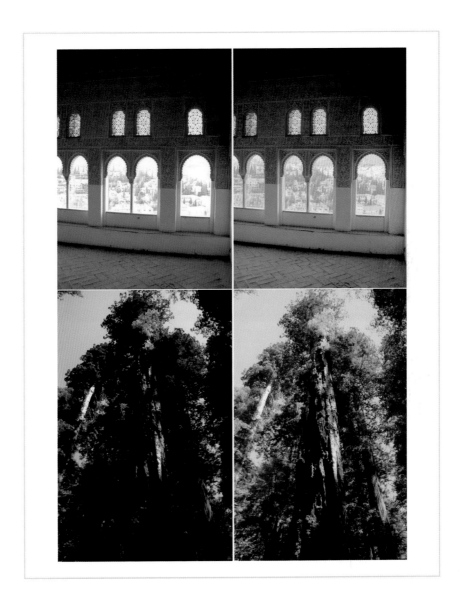

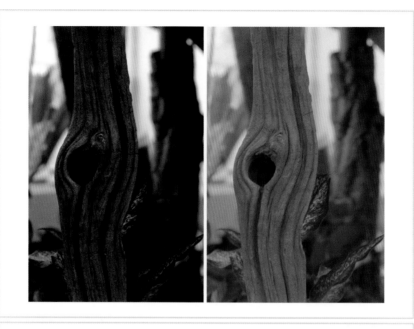

FIGURE 1.3 *A conventional image is shown on the left, and an HDR version is shown on the right. The right-hand image was prepared for display with techniques discussed in Section 7.2.7.*

image shows more detail in both the dark and bright areas, this is despite the fact that this image is shown on paper so that the range of values seen is not higher than in a conventional image. Thus, even in the absence of a display device capable of displaying them, there are advantages to using HDR images. The difference between the two images in Figure 1.2 would be significantly greater if the two were displayed on one of the display devices discussed in Chapter 5.

A second example is shown in Figure 1.3. The image on the left is a conventional image shot under fairly dark lighting conditions, with only natural daylight being available. The same scene was photographed in HDR, and then prepared for display

FIGURE 1.4 *The image on the left is represented with a bit depth of 4 bits. The image on the right is represented with 8 bits per color channel.*

with techniques discussed in this book. The result is significantly more flattering, while at the same time more details are visible.

The range of values afforded by a conventional image is about two orders of magnitude, stored as a byte for each of the red, green, and blue channels per pixel. It is not possible to directly print images with a much higher dynamic range. Thus, to simulate the effect of reducing an HDR image to within a displayable range, we reduce a conventional photograph in dynamic range to well below two orders of magnitude. As an example, Figure 1.4 shows a low-dynamic-range (LDR) image (8 bits per color channel per pixel), and the same image reduced to only 4 bits per

Condition	Illumination (in cd/m^2)
Starlight	10^{-3}
Moonlight	10^{-1}
Indoor lighting	10^2
Sunlight	10^5
Max. intensity of common CRT monitors	10^2

TABLE 1.1 *Ambient luminance levels for some common lighting environments (from Wandell's book* Foundations of Vision *[135]).*

color channel per pixel. Thus, fewer bits means a lower visual quality. Although for some scenes 8 bits per color channel is enough, there are countless situations in which 8 bits is not enough.

One of the reasons for this is that the real world produces a much greater range than the two orders of magnitude common in current digital imaging. For instance, the sun at noon may be 100 million times brighter than starlight [34,120]. Typical ambient luminance levels for commonly encountered scenes are outlined in Table 1.1.[1]

The human visual system is capable of adapting to lighting conditions that vary by nearly 10 orders of magnitude [34]. Within a scene, the human visual system functions over a range of about five orders of magnitude simultaneously.

This is in stark contrast to typical CRT (cathode-ray tube) displays, which are capable of reproducing about two orders of magnitude of intensity variation. Their limitation lies in the fact that phosphors cannot be excited beyond a given limit. For this reason, 8-bit digital-to-analog (D/A) converters are traditionally sufficient

. .
1 Luminance, defined in the following chapter, is a measure of how bright a scene appears.

for generating analog display signals. Higher bit depths are usually not employed, because the display would not be able to reproduce such images at levels that are practical for human viewing.[2]

A similar story holds for typical modern liquid crystal displays (LCD). Their operating range is limited by the strength of the backlight. Although LCD displays tend to be somewhat brighter than CRT displays, their brightness is not orders of magnitude greater.

In that current display devices are not capable of reproducing a range of luminances anywhere near the capability of the human visual system, images are typically encoded with a byte per color channel per pixel. This encoding normally happens when the image is captured. This situation is less than optimal because much of the information available in a scene is irretrievably lost at capture time.

A preferable approach is to capture the scene with a range of intensities and level of quantization representative of the scene, rather than matched to any display device. Alternatively, images should at a minimum contain a range of values matched to the limits of human vision. All relevant information may then be retained until the moment the image needs to be displayed on a display device that cannot reproduce this range of intensities. This includes current CRT, LCD, and plasma devices, as well as all printed media.

Images that store a depiction of the scene in a range of intensities commensurate with the scene are what we call HDR, or "radiance maps." On the other hand, we call images suitable for display with current display technology LDR.

This book is specifically about HDR images. These images are not inherently different from LDR images, but there are many implications regarding the creation, storage, use, and display of such images. There are also many opportunities for creative use of HDR images that would otherwise be beyond our reach.

Just as there are clear advantages to using high-image resolutions, there are major advantages in employing HDR data. HDR images and video are matched to the scenes they depict, rather than the display devices they are meant to be displayed on. As a result, the fidelity of HDR images is much higher than with conventional imagery. This benefits most image processing that may be applied during the lifetime of an image.

. .

2 It would be possible to reproduce a much larger set of values on CRT displays at levels too low for humans to perceive.

FIGURE 1.5 *Color manipulation achieved on an HDR capture (left) produced the image on the right. The left-hand HDR image was captured under normal daylight (overcast sky). The right-hand image shows a color transformation achieved with the algorithm detailed in Section 7.2.7.*

As an example, correcting the white balance of an LDR image may be difficult due to the presence of overexposed pixels, a problem that exists to a lesser extent with properly captured HDR images. This important issue, which involves an adjustment of the relative contribution of the red, green, and blue components, is discussed in Section 2.6. HDR imaging also allows creative color manipulation and better captures highly saturated colors, as shown in Figure 1.5. It is also less important to carefully light the scene with light coming from behind the photographer, as demonstrated in Figure 1.6. Other image postprocessing tasks that become easier with the use of HDR data include color, contrast, and brightness adjustments.

FIGURE 1.6 *Photographing an object against a bright light source such as the sky is easier with HDR imaging. The left-hand image shows a conventional photograph, whereas the right-hand image was created using HDR techniques.*

Such tasks may scale pixel values nonlinearly such that parts of the range of values require a higher precision than can be accommodated by traditional 8-bit pixel encodings. An HDR image representation would reduce precision errors to below humanly detectable levels.

In addition, if light in a scene can be accurately represented with an HDR image, such images may be effectively used in rendering applications. In particular, HDR images may be used as complex light sources that light conventionally modeled 3D geometry. The lighting effects thus obtained would be extremely difficult to model in any other way. This application is discussed in detail in Chapter 9.

Further, there is a trend toward better display devices. The first prototypes of HDR display devices have been around for at least two years at the time of writing [114, 115] (an early production model shown in Figure 1.7). Their availability will create a much larger market for HDR imaging in general. In that LDR images will look no better on HDR display devices than they do on conventional display devices, there will be an increasing demand for technology that can capture, store, and manipulate HDR data directly.

FIGURE 1.7 *The 37″ Brightside Technologies DR37-P HDR display device.*

It is entirely possible to prepare an HDR image for display on an LDR display device, as shown in Figure 1.2, but it is not possible to reconstruct a high-fidelity HDR image from quantized LDR data. It is therefore only common sense to create and store imagery in an HDR format, even if HDR display devices are ultimately not used to display it. Such considerations (should) play an important role, for instance, in the design of digital heritage and cultural archival systems.

When properly displayed on an HDR display device, HDR images and video simply look gorgeous! The difference between HDR display and conventional imaging is easily as big a step forward as the transition from black-and-white to color tele-

vision. For this reason alone, HDR imaging will become the norm rather than the exception, and it was certainly one of the reasons for writing this book.

However, the technology required to create, store, manipulate, and display HDR images is only just emerging. There is already a substantial body of research available on HDR imaging, which we collect and catalog in this book. The following major areas are addressed in this book.

Light and color: HDR imaging borrows ideas from several fields that study light and color. The following chapter reviews several concepts from radiometry, photometry, and color appearance and forms the background for the remainder of the book.

HDR image capture: HDR images may be created in two fundamentally different ways. The first method employs rendering algorithms and other computer graphics techniques. Chapter 9 outlines an application in which HDR imagery is used in a rendering context.

The second method employs conventional (LDR) photo cameras to capture HDR data. This may be achieved by photographing a static scene multiple times, varying the exposure time for each frame. This leads to a sequence of images that may be combined into a single HDR image. An example is shown in Figure 1.8, and this technique is explained in detail in Chapter 4.

This approach generally requires the subject matter to remain still between shots, and toward this end the camera should be placed on a tripod. This limits, however, the range of photographs that may be taken. Fortunately, several techniques exist that align images, remove ghosts, and reduce the effect of lens flare, thus expanding the range of HDR photographs that may be created. These techniques are discussed in Chapter 4.

In addition, photo, film, and video cameras will in due course become available that will be capable of directly capturing HDR data. As an example, the FilmStream Viper is a digital camera that captures HDR data directly. Although an impressive system, its main drawback is that it produces raw image data at such a phenomenal rate that hard drive storage tends to fill up rather quickly. This is perhaps less of a problem in the studio, where bulky storage facilities may be available, but the use of such a camera on location is restricted by the limited capacity of portable hard drives. It directly highlights the need for effi-

FIGURE 1.8 *Multiple exposures (shown on the right) may be combined into one HDR image (left).*

cient file formats for storing HDR video. Storage issues are discussed further in Chapter 3.

HDR security cameras, such as the SMaL camera, are also now available (Figure 1.9). The main argument for using HDR capturing techniques for security applications is that typical locations are entrances to buildings. Conventional video cameras are typically not capable of faithfully capturing the interior of a building at the same time the exterior is monitored through the window. An HDR camera would be able to simultaneously record indoor and outdoor activities.

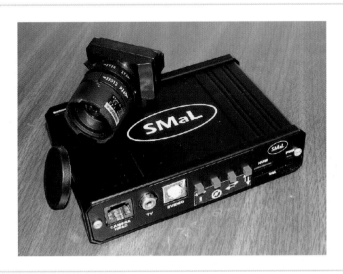

FIGURE 1.9 *SMaL prototype security camera. Image used by permission from Cypress Semi-condutor.*

Many consumer-level photo cameras are equipped with 10- or 12-bit A/D converters and make this extra resolution available through proprietary RAW[3] formats (see Chapter 3). However, 10 to 12 bits of linear data affords about the same precision as an 8-bit gamma-compressed format, and may therefore still be considered LDR.

HDR image representation: Once HDR data is acquired, it needs to be stored in some fashion. There are currently a few different HDR file formats emerging. The design considerations for HDR file formats include the size of the resulting files, the total range that may be represented (i.e., the ratio between the largest repre-

3 RAW image formats are manufacturer's and often model-specific file formats containing improcessed sensor output.

sentable number and the smallest), and the smallest step size between successive values. These trade-offs are discussed in Chapter 3, which also introduces standards for HDR image storage.

HDR display devices: Just as display devices have driven the use of 8-bit image processing for the last 20 years, the advent of HDR display devices will impact the general acceptance of HDR imaging technology.

Current proposals for HDR display devices typically employ a form of back-projection, either in a system that resembles a slide viewer or in technology that replaces the single backlight of an LCD display with a low-resolution but HDR projective system. The latter technology thus provides HDR display capabilities by means of a projector or LED array that lights the LCD display from behind with a spatially varying light pattern [114,115]. The display augments this projected image with a high-resolution but LDR LCD. These emerging display technologies are presented in Chapter 5.

Image-based lighting: In Chapter 9 we explore in detail one particular application of HDR imaging; namely, image-based lighting. Computer graphics is generally concerned with the creation of images by means of simulating how light bounces through a scene [42,116,144]. In many cases, geometric primitives such as points, triangles, polygons, and splines are used to model a scene. These are then annotated with material specifications, which describe how light interacts with these surfaces. In addition, light sources need to be specified to determine how the scene is lit. All of this information is then fed to a rendering algorithm that simulates light and produces an image. Well-known examples are represented in films such as the *Shrek* and *Toy Story* series.

A recent development in rendering realistic scenes takes images as primitives. Traditionally, images are used as textures to describe how a surface varies over space. As surface reflectance ranges between 1 and 99% of all incoming light, the ability of a diffuse surface to reflect light is inherently LDR. It is therefore perfectly acceptable to use LDR images to describe things such as wood grain on tables or the pattern of reflectance of a gravel path. On the other hand, surfaces that reflect light specularly may cause highlights that have nearly the same luminance as the light sources they reflect. In such cases, materials need to be represented with a much higher precision.

FIGURE 1.10 *HDR images may be used to light an artificial scene.*

In addition, images may be used as complex sources of light within otherwise conventional rendering algorithms [17], as shown in Figure 1.10. Here, we cannot get away with using LDR data because the range of light emitted by various parts of a scene is much greater than the two orders of magnitude available with conventional imaging. If we were to light an artificial scene with a representation of a real scene, we would have to resort to capturing this real scene in HDR. This example of HDR image usage is described in detail in Chapter 9.

Dynamic range reduction: Although HDR display technology will become generally available in the near future, it will take time before most users have made the transition. At the same time, printed media will never become HDR because this

would entail the invention of light-emitting paper. As a result, there will always
be a need to prepare HDR imagery for display on LDR devices.

It is generally recognized that linear scaling followed by quantization to 8 bits
per channel per pixel will produce a displayable image that looks nothing like
the original scene. It is therefore important to somehow preserve key qualities
of HDR images when preparing them for display. The process of reducing the
range of values in an HDR image such that the result becomes displayable in
some meaningful way is called dynamic range reduction. Specific algorithms
that achieve dynamic range reduction are referred to as tone-mapping, or tone-

FIGURE 1.11 *The monitor displays a tone-mapped HDR image depicting the background. Al-
though the monitor is significantly less bright than the scene itself, a good tone reproduction operator
would cause the scene and the displayed image to appear the same to a human observer.*

reproduction, operators. The display of a tone-mapped image should perceptually match the depicted scene (Figure 1.11).

In that dynamic range reduction requires preservation of certain scene characteristics, it is important to study how humans perceive scenes and images. Many tone-reproduction algorithms rely wholly or in part on some insights of human vision, not least of which is the fact that the human visual system solves a similar dynamic range reduction problem in a seemingly effortless manner. We survey current knowledge of the human visual system as it applies to HDR imaging, and in particular to dynamic range reduction, in Chapter 6.

Tone reproduction: Although there are many algorithms capable of mapping HDR images to an LDR display device, there are only a handful of fundamentally different classes of algorithms. Chapters 7 and 8 present an overview of all currently known algorithms, classify them into one of four classes, and discuss their advantages and disadvantages. Many sequences of images that show how parameter settings affect image appearance for each operator are included in these chapters.

Although the concept of HDR imaging is straightforward (i.e., representing scenes with values commensurate with real-world light levels), the implications to all aspects of imaging are profound. In this book, opportunities and challenges with respect to HDR image acquisition, storage, processing, and display are cataloged in the hope that this contributes to the general acceptance of this exciting emerging technology.

Light and Color

02

The emerging field of HDR imaging is directly linked to diverse existing disciplines such as radiometry, photometry, colorimetry, and color appearance — each dealing with specific aspects of light and its perception by humans. In this chapter we discuss all aspects of color that are relevant to HDR imaging. This chapter is intended to provide background information that will form the basis of later chapters.

2.1 RADIOMETRY

The term *scene* indicates either an artificial or real environment that may become the topic of an image. Such environments contain objects that reflect light. The ability of materials to reflect light is called "reflectance."

Radiometry is the science concerned with measuring light. This section first briefly summarizes some of the quantities that may be measured, as well as their units. Then, properties of light and how they relate to digital imaging are discussed.

Light is radiant energy, measured in joules. Because light propagates through media such as space, air, and water, we are interested in derived quantities that measure how light propagates. These include radiant energy measured over time, space, or angle. The definitions of these quantities and their units are outlined in Table 2.1 and should be interpreted as follows.

Quantity	Unit	Definition
Radiant energy (Q_e)	J (joule)	Q_e
Radiant power (P_e)	$J\,s^{-1} = W$ (watt)	$P_e = \dfrac{dQ_e}{dt}$
Radiant exitance (M_e)	$W\,m^{-2}$	$M_e = \dfrac{dP_e}{dA_e}$
Irradiance (E_e)	$W\,m^{-2}$	$E_e = \dfrac{dP_e}{dA_e}$
Radiant intensity (I_e)	$W\,sr^{-1}$	$I_e = \dfrac{dP_e}{d\omega}$
Radiance (L_e)	$W\,m^{-2}\,sr^{-1}$	$L_e = \dfrac{d^2P_e}{dA\cos\theta\,d\omega}$

TABLE 2.1 *Radiometric quantities. The cosine term in the definition of L_e is the angle between the surface normal and the angle of incidence, as shown in Figure 2.4. Other quantities are shown in Figures 2.1 through 2.3.*

Because light travels through space, the flow of radiant energy may be measured. It is indicated with radiant power or radiant flux and is measured in joules per second, or watts. It is thus a measure of energy per unit of time.

Radiant flux density is the radiant flux per unit area, known as *irradiance* if we are interested in flux arriving from all possible directions at a point on a surface (Figure 2.1) and as *radiant exitance* for flux leaving a point on a surface in all possible directions (Figure 2.2). Both irradiance and radiant exitance are measured in watts per square meter. These are therefore measures of energy per unit of time as well as per unit of area.

If we consider an infinitesimally small point light source, the light emitted into a particular direction is called radiant intensity measured in watts per steradian (Figure 2.3). A steradian is a measure of solid angle corresponding to area on the unit sphere. Radiant intensity thus measures energy per unit of time per unit of direction.

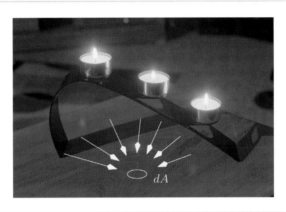

FIGURE 2.1 Irradiance: power incident upon unit area dA.

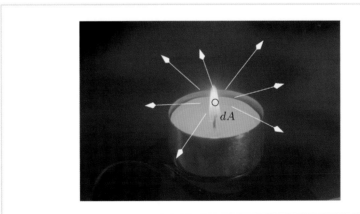

FIGURE 2.2 Radiant exitance: power emitted per unit area.

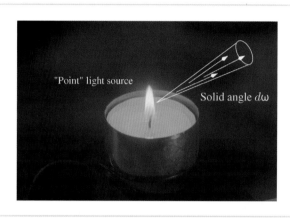

FIGURE 2.3 *Radiant intensity: power per solid angle $d\omega$.*

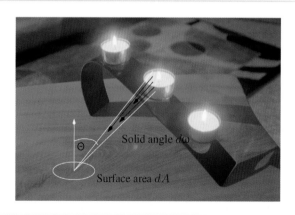

FIGURE 2.4 *Radiance: power incident on a unit surface area dA from a unit set of directions $d\omega$.*

Flux passing through, leaving, or arriving at a point in a particular direction is known as radiance measured in watts per square meter per steradian (Figure 2.4). It is a measure of energy per unit of time as well as per unit of area and per unit of direction. Light that hits a point on a surface from a particular direction is at the heart of image formation. For instance, the combination of shutter, lens, and sensor in a (digital) camera restricts incoming light in this fashion.

When a picture is taken, the shutter is open for a small amount of time. During that time, light is focused through a lens that limits the number of directions from which light is received. The image sensor is partitioned into small pixels, so that each pixel records light over a small area. The light recorded by a pixel may be modeled by the "measurement equation" (see, for example, [66] for details). Because a camera records radiance, it is therefore possible to relate the voltages extracted from the camera sensor to radiance, provided pixels are neither under- nor overexposed [104,105].

Each of the quantities given in Table 2.1 may also be defined per unit wavelength interval, which are then referred to as spectral radiance $L_{e,\lambda}$, spectral flux $P_{e,\lambda}$, and so on. The subscript e indicates radiometric quantities and differentiates them from photometric quantities (discussed in the following section). In the remainder of this book, these subscripts are dropped unless this leads to confusion.

Light may be considered to consist of photons that can be emitted, reflected, transmitted, and absorbed. Photons normally travel in straight lines until they hit a surface. The interaction between photons and surfaces is twofold. Photons may be absorbed by the surface, where they are converted into thermal energy, or they may be reflected in some direction. The distribution of reflected directions, given an angle of incidence, gives rise to a surface's appearance. Matte surfaces distribute light almost evenly in all directions (Figure 2.5), whereas glossy and shiny surfaces reflect light in a preferred direction. Mirrors are the opposite of matte surfaces and emit light specularly in almost a single direction. This causes highlights that may be nearly as strong as light sources (Figure 2.6). The depiction of specular surfaces may therefore require HDR techniques for accuracy.

For the purpose of lighting simulations, the exact distribution of light reflected from surfaces as a function of angle of incidence is important (compare Figures 2.5 and 2.6). It may be modeled with bidirectional reflection distribution functions (BRDFs), which then become part of the surface material description. Advanced

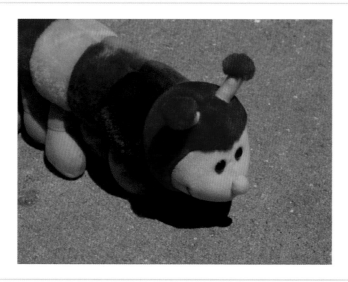

FIGURE 2.5 *This object reflects light predominantly diffusely. Because of the bright lighting conditions under which this photograph was taken, this image should look bright overall and without a large variation in tone.*

rendering algorithms use this information to compute how light is distributed in a scene, from which an HDR of the scene may be generated [24,58].

2.2 PHOTOMETRY

Surfaces reflect light and by doing so may alter the spectral composition of it. Thus, reflected light conveys spectral information of both the light source illuminating a surface point and the reflectance of the surface at that point.

There are many wavelengths that are not detectable by the human eye, which is sensitive to wavelengths between approximately 380 to 830 nanometers (nm).

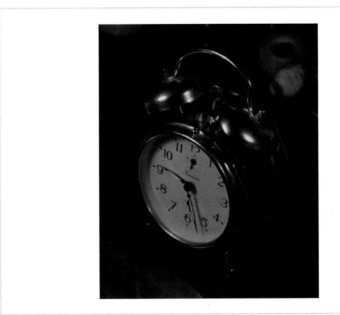

FIGURE 2.6 *The metal surface of this clock causes highlights that are nearly as strong as the light sources they reflect. The environment in which this image was taken is much darker than the one depicted in Figure 2.5. Even so, the highlights are much brighter.*

Within this range, the human eye is not equally sensitive to all wavelengths. In addition, there are differences in sensitivity to the spectral composition of light among individuals. However, this range of sensitivity is small enough that the spectral sensitivity of any human observer with normal vision may be approximated with a single curve. Such a curve is standardized by the Commission Internationale de l'Eclairage (CIE) and is known as the $V(\lambda)$ curve (pronounced vee-lambda), or CIE photopic luminous efficiency curve. This curve is plotted in Figure 2.7.

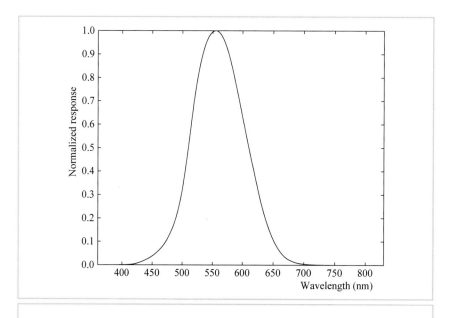

FIGURE 2.7 *CIE standard observer photopic luminous efficiency curve. (This data can be down-loaded from http://www.cvrl.org.)*

In that we are typically interested in how humans perceive light, its spectral composition may be weighted according to $V(\lambda)$. The science of measuring light in units that are weighted in this fashion is called photometry. All radiometric terms introduced in the previous section have photometric counterparts, which are outlined in Table 2.2. By spectrally weighting radiometric quantities with $V(\lambda)$, they are converted into photometric quantities.

Luminous flux (or luminous power) is photometrically weighted radiant flux. It is measured in lumens, which is defined as $1/683$ watt of radiant power at a frequency of 540×10^{12} Hz. This frequency corresponds to the wavelength for which humans are maximally sensitive (about 555 nm). If luminous flux is measured over a differential solid angle, the quantity obtained is luminous intensity, measured in

Quantity	Unit
Luminous power (P_v)	*lm* (lumen)
Luminous energy (Q_v)	*lm s*
Luminous exitance (M_v)	*lm m^{-2}*
Illuminance (E_v)	*lm m^{-2}*
Luminous intensity (I_v)	*lm sr^{-1} = cd* (candela)
Luminance (L_v)	*cd m^{-2} = nit*

TABLE 2.2 *Photometric quantities.*

lumens per steradian. One lumen per steradian is equivalent to one candela. Luminous exitance and illuminance are both given in lumens per square meter, whereas luminance is specified in candela per square meter (a.k.a. "nits").

Luminance is a perceived quantity. It is a photometrically weighted radiance and constitutes an approximate measure of how bright a surface appears. Luminance is the most relevant photometric unit to HDR imaging. Spectrally weighting radiance amounts to multiplying each spectral component with the corresponding value given by the weight function and then integrating all results, as follows.

$$L_v = \int_{380}^{830} L_{e,\lambda} V(\lambda) \, d\lambda$$

The consequence of this equation is that there are many different spectral compositions of radiance L_e possible that would cause the same luminance value L_v. It is therefore not possible to apply this formula and expect the resulting luminance value to be a unique representation of the associated radiance value.

The importance of luminance in HDR imaging lies in the fact that it provides a natural boundary of visible wavelengths. Any wavelength outside the visible range

does not need to be recorded, stored, or manipulated, in that human vision is
not capable of detecting those wavelengths. Many tone-reproduction operators first
extract a luminance value from the red, green, and blue components of each pixel
prior to reducing the dynamic range, in that large variations in luminance over
orders of magnitude have a greater bearing on perception than extremes of color
(see also Section 7.1.2).

2.3 COLORIMETRY

The field of colorimetry is concerned with assigning numbers to physically defined
stimuli such that stimuli with the same specification look alike (i.e., match). One
of the main results from color-matching experiments is that over a wide range of
conditions almost all colors may be visually matched by adding light from three
suitably pure stimuli. These three fixed stimuli are called primary stimuli. Color-
matching experiments take three light sources and project them to one side of a
white screen. A fourth light source, the target color, is projected to the other side
of the screen. Participants in the experiments are given control over the intensity of
each of the three primary light sources and are asked to match the target color.

For each spectral target, the intensity of the three primaries may be adjusted
to create a match. By recording the intensities of the three primaries for each tar-
get wavelength, three functions $\bar{r}(\lambda)$, $\bar{g}(\lambda)$, and $\bar{b}(\lambda)$ may be created. These are
called color-matching functions. The color-matching functions obtained by Stiles
and Burch are plotted in Figure 2.8. They used primary light sources that were
nearly monochromatic with peaks centered on $\lambda_R = 645.2$ nm, $\lambda_G = 525.3$ nm,
and $\lambda_B = 444.4$ nm [122]. The stimuli presented to the observers in these ex-
periments span 10 degrees of visual angle, and hence these functions are called
10-degree color-matching functions. Because the recorded responses vary only a
small amount between observers, these color-matching functions are representative
of normal human vision. As a result, they were adopted by the CIE to describe the
"CIE 1964 standard observer." Thus, a linear combination of three spectral functions
will yield a fourth, Q_λ, which may be visually matched to a linear combination of
primary stimuli as follows.

$$Q_\lambda = \bar{r}(\lambda)R + \bar{g}(\lambda)G + \bar{b}(\lambda)B$$

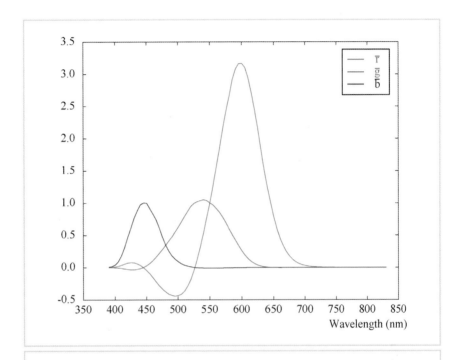

FIGURE 2.8 *Stiles and Burch (1959) 10-degree color-matching functions. (This data can be downloaded from http://www.cvrl.org.)*

Here, R, G, and B are scalar multipliers. Because the primaries are fixed, the stimulus Q_λ may be represented as a triplet by listing R, G, and B. This (R, G, B) triplet is then called the tristimulus value of Q.

For any three real primaries, it is sometimes necessary to supply a negative amount to reach some colors (i.e., there may be one or more negative components of a tristimulus value). In that it is simpler to deal with a color space whose tristimulus values are always positive, the CIE has defined alternative color-matching functions chosen such that any color may be matched with positive primary coef-

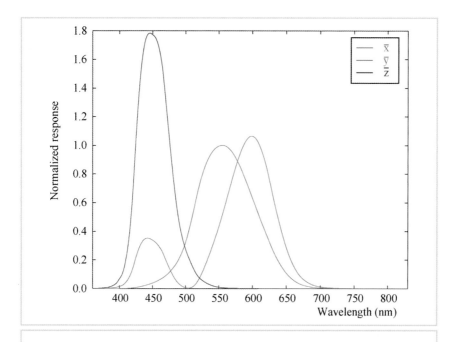

FIGURE 2.9 CIE 1931 2-degree XYZ color-matching functions. (This data can be downloaded from http://www.cvrl.org.)

ficients.[1] These color-matching functions are named $\bar{x}(\lambda)$, $\bar{y}(\lambda)$, and $\bar{z}(\lambda)$ (plotted in Figure 2.9). These functions are the result of experiments in which the stimulus spanned 2 degrees of visual angle and are therefore known as the "CIE 1931 standard observer" [149]. A spectral stimulus may now be matched in terms of these

..

1 Real or realizable primaries are those that can be obtained by physical devices. For such primaries it is not possible to
 supply negative amounts because light cannot be subtracted from a scene. However, although less desirable in practice
 there is no mathematical reason a tristimulus value could not be converted such that it would be represented by a
 different set of primaries. Some of the values might then become negative. Such conversion issues are discussed
 further in Section 2.4.

color-matching functions, as follows.

$$Q_\lambda = \bar{x}(\lambda)X + \bar{y}(\lambda)Y + \bar{z}(\lambda)Z$$

For a given stimulus Q_λ, the tristimulus values (X, Y, Z) are obtained by integration, as follows.

$$X = \int_{380}^{830} Q_\lambda \bar{x}(\lambda) \, d\lambda$$

$$Y = \int_{380}^{830} Q_\lambda \bar{y}(\lambda) \, d\lambda$$

$$Z = \int_{380}^{830} Q_\lambda \bar{z}(\lambda) \, d\lambda$$

The CIE XYZ matching functions are defined such that a theoretical equal-energy stimulus, which would have unit radiant power at all wavelengths, maps to tristimulus value $(1, 1, 1)$. Further, note that $\bar{y}(\lambda)$ is equal to $V(\lambda)$ — another intentional choice by the CIE. Thus, Y represents photometrically weighted quantities.

For any visible color, the tristimulus values in XYZ space are all positive. However, as a result the CIE primaries are not realizable by any physical device. Such primaries are called "imaginary," as opposed to realizable, primaries which are called "real."[2] Associated with tristimulus values are chromaticity coordinates, which may be computed from tristimulus values as follows.

$$x = \frac{X}{X + Y + Z}$$

$$y = \frac{Y}{X + Y + Z}$$

$$z = \frac{Z}{X + Y + Z} = 1 - x - y$$

Because z is known if x and y are known, only the latter two chromaticity coordinates need to be kept. Chromaticity coordinates are relative, which means that

. .

2 This has nothing to do with the mathematical formulation of "real" and "imaginary" numbers.

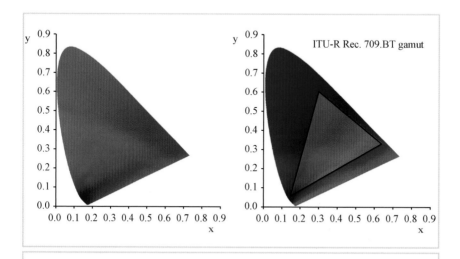

FIGURE 2.10 *CIE xy chromaticity diagram showing the range of colors humans can distinguish (left). On the right, the triangular gamut spanned by the primaries defined by ITU Recommendation (ITU-R) BT.709 color space [57] is shown.*

within a given system of primary stimuli two colors with the same relative spectral power distribution will map to the same chromaticity coordinates. An equal-energy stimulus will map to coordinates $(x = 1/3, y = 1/3)$.

Chromaticity coordinates may be plotted in a chromaticity diagram with two axes. A CIE xy chromaticity diagram is shown in Figure 2.10. All monochromatic wavelengths map to a position along the curved boundary, called the spectral locus, which is of horseshoe shape. The line between red and blue is called the "purple line," which represents the locus of additive mixtures of short- and long-wave stimuli.

The three primaries used for any given color space will map to three points in a chromaticity diagram and thus span a triangle. This triangle contains the range of colors that may be represented by these primaries (assuming nonnegative tristimulus values). The range of realizable colors given a set of primaries is called

the *color gamut*. Colors that are not representable in a given color space are called out-of-gamut colors.

The gamut for the primaries defined by ITU-R (International Telecommunication Union Recommendations) BT.709 is shown on the right in Figure 2.10. These primaries are a reasonable approximation of most CRT computer monitors and officially define the boundaries of the sRGB color space [124] (see Section 2.11). The triangular region shown in this figure marks the range of colors that may be displayed on a standard monitor. The colors outside this triangle cannot be represented on most displays. They also cannot be stored in an sRGB file, such as the one used for this figure. We are therefore forced to show incorrect colors outside the sRGB gamut in all chromaticity diagrams in this book.

The diagrams in Figure 2.10 show two dimensions of what is a 3D space. The third dimension (luminance) goes out of the page, and the color gamut is really a volume of which a slice is depicted. In the case of the sRGB color space, the gamut is shaped as a six-sided polyhedron, often referred to as the "RGB color cube." This is misleading, however, in that the sides are only equal in the encoding (0–255 thrice) and are not very equal perceptually.

It may be possible for two stimuli with different spectral radiant power distributions to match against the same linear combination of primaries, and thus are represented by the same set of tristimulus values. This phenomenon is called metamerism. Whereas metameric stimuli will map to the same location in a chromaticity diagram, stimuli that appear different will map to different locations. The magnitude of the perceived difference between two stimuli may be expressed as the Cartesian distance between the two points in a chromaticity diagram. However, in the 1931 CIE primary system the chromaticity diagram is not uniform (i.e., the distance between two points located in one part of the diagram corresponds to a different perceived color difference than two points located elsewhere in the diagram). Although CIE XYZ is still the basis for all color theory, this nonuniformity has given rise to alternative color spaces (discussed in the following sections).

2.4 COLOR SPACES

Color spaces encompass two different concepts. First, they are represented by a set of formulas that define a relationship between a color vector (or triplet) and the

standard CIE XYZ color space. This is most often given in the form of a 3-by-3 color transformation matrix, although there are additional formulas if the space is nonlinear. Second, a color space is a 2D boundary on the volume defined by this vector, usually determined by the minimum and maximum value of each primary — the color gamut. Optionally, the color space may have an associated quantization if it has an explicit binary representation. In this section, linear transformations are discussed, whereas subsequent sections introduce nonlinear encodings and quantization.

We can convert from one tristimulus color space to any other tristimulus space using a 3-by-3 matrix transformation. Usually the primaries are known by their xy chromaticity coordinates. In addition, the white point needs to be specified, which is given as an xy chromaticity pair (x_W, y_W) plus maximum luminance Y_W. The white point is the color associated with equal contributions of each primary (discussed further in the following section).

Given the chromaticity coordinates of the primaries, first the z chromaticity coordinate for each primary is computed to yield chromaticity triplets for each primary; namely, (x_R, y_R, z_R), (x_G, y_G, z_G), and (x_B, y_B, z_B). From the white point's chromaticities and its maximum luminance, the tristimulus values (X_W, Y_W, Z_W) are calculated. Then, the following set of linear equations is solved for S_R, S_G, and S_B.

$$X_W = x_R S_R + x_G S_G + x_B S_B$$

$$Y_W = y_R S_R + y_G S_G + y_B S_B$$

$$Z_W = z_R S_R + z_G S_G + z_B S_B$$

The conversion matrix to convert from RGB to XYZ is then given by

$$\begin{bmatrix} X \\ Y \\ Z \end{bmatrix} = \begin{bmatrix} x_R S_R & x_G S_G & x_B S_B \\ y_R S_R & y_G S_G & y_B S_B \\ z_R S_R & z_G S_G & z_B S_B \end{bmatrix} \begin{bmatrix} R \\ G \\ B \end{bmatrix}$$

The conversion from XYZ to RGB may be computed by inverting this matrix. If the primaries are unknown, or if the white point is unknown, a second best solution is

	R	G	B	White
x	0.6400	0.3000	0.1500	0.3127
y	0.3300	0.6000	0.0600	0.3290

TABLE 2.3 *Primaries and white point specified by ITU-Recommendation BT.709.*

to use a standard matrix such as that specified by ITU-R BT.709 [57]:

$$\begin{bmatrix} X \\ Y \\ Z \end{bmatrix} = \begin{bmatrix} 0.4124 & 0.3576 & 0.1805 \\ 0.2126 & 0.7152 & 0.0722 \\ 0.0193 & 0.1192 & 0.9505 \end{bmatrix} \begin{bmatrix} R \\ G \\ B \end{bmatrix}$$

$$\begin{bmatrix} R \\ G \\ B \end{bmatrix} = \begin{bmatrix} 3.2405 & -1.5371 & -0.4985 \\ -0.9693 & 1.8760 & 0.0416 \\ 0.0556 & -0.2040 & 1.0572 \end{bmatrix} \begin{bmatrix} X \\ Y \\ Z \end{bmatrix}$$

The primaries and white point used to create this conversion matrix are outlined in Table 2.3.

There are several standard color spaces, each used in a particular field of science and engineering. Each is reached by constructing a conversion matrix, the previous matrix being an example. Several of these color spaces include a nonlinear transform akin to gamma correction, which is explained in Section 2.9. We therefore defer a discussion of other standard color spaces until Section 2.11.

In addition to standard color spaces, most cameras, scanners, monitors, and TVs use their own primaries (called spectral responsivities in the case of capturing devices). Thus, each device may use a different color space. Conversion between these color spaces is thus essential for the faithful reproduction of an image on any given display device.

If a color is specified in a device-dependent RGB color space, its luminance may be computed because the Y component in the XYZ color space represents luminance

(recall that $V(\lambda)$ equals $\bar{y}(\lambda)$). Thus, a representation of luminance is obtained by computing a linear combination of the red, green, and blue components according to the middle row of the RGB-to-XYZ conversion matrix. For instance, luminance may be computed from ITU-R BT.709 RGB as follows.

$$Y = 0.2126R + 0.7152G + 0.0722B$$

Finally, an important consequence of color metamerism is that if the spectral responsivities (primaries) associated with a camera are known, as well as the emissive spectra of the three phosphors of a CRT display, we may be able to specify a transformation between the tristimulus values captured with the camera and the tristimulus values of the display and thus reproduce the captured image on the display. This would, of course, only be possible if the camera and display technologies did not impose restrictions on the dynamic range of captured and displayed data.

2.5 WHITE POINT AND ILLUMINANTS

For the conversion of tristimulus values between XYZ and a specific RGB color space, the primaries of the RGB color space must be specified. In addition, the white point needs to be known. For a display device, the white point is the color emitted if all three color channels are contributing equally.

Similarly, within a given scene the dominant light source will produce a color cast that will affect the appearance of the objects in the scene. The color of a light source (illuminant) may be determined by measuring a diffusely reflecting white patch. The color of the illuminant therefore determines the color of a scene the human visual system normally associates with white.

An often-used reference light source is CIE illuminant D_{65}. This light source may be chosen if no further information is available regarding the white point of a device, or regarding the illuminant of a scene. Its spectral power distribution is shown in Figure 2.11, along with two related standard illuminants, D_{55} (commonly used in photography) and D_{75}.

Cameras often operate under the assumption that the scene is lit by a specific light source, such as a D_{65}. If the lighting in a scene has a substantially different color, an adjustment to the gain of the red, green, and blue sensors in the camera

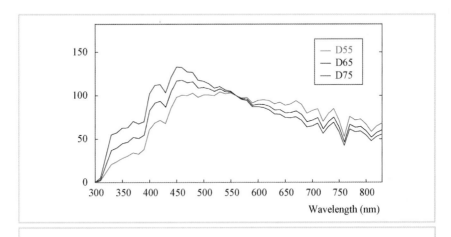

FIGURE 2.11 *Spectral power distribution of CIE illuminants* D_{55}, D_{65}, *and* D_{75}. *(This data can be downloaded from http://www.cvrl.org.)*

may be made. This is known as white balancing [100]. If the white balance chosen for a particular scene were incorrect, white balancing might be attempted as an image-processing step.

The difference between illuminants may be expressed in terms of chromaticity coordinates, but a more commonly used measure is correlated color temperature. Consider a blackbody radiator, a cavity in a block of material heated to a certain temperature. The spectral power distribution emitted by the walls of this cavity is a function of the temperature of the material only. The color of a blackbody radiator may thus be characterized by its temperature, which is measured in degrees Kelvin (K).

The term *color temperature* refers to the temperature of a selective radiator that has chromaticity coordinates very close to that of a blackbody. The lower the temperature the redder the appearance of the radiator. For instance, tungsten illumination (about 3,200° K) appears somewhat yellow. Higher color temperatures have a more bluish appearance.

Scene	T (in °K)	x	y
Candle flame	1850	0.543	0.410
Sunrise/sunset	2000	0.527	0.413
Tungsten (TV/film)	3200	0.427	0.398
Summer sunlight at noon	5400	0.326	0.343
CIE A (incandescent)	2854	0.448	0.408
CIE B (direct sunlight)	4874	0.384	0.352
CIE C (overcast sky)	6774	0.310	0.316
CIE D50 (noon skylight)	5000	0.346	0.359
CIE D65 (average daylight)	6504	0.313	0.329
CIE E (equal energy)	5500	0.333	0.333
CIE F2 (office fluorescent)	4150	0.372	0.375

TABLE 2.4 *Correlated color temperature T and chromaticity coordinates (xy) for common scene types and a selection of CIE luminaires.*

The term *correlated color temperature* is more generally used for illuminants that do not have chromaticity coordinates close to those generated by blackbody radiators. It refers to the blackbody's temperature that most closely resembles the perceived color of the given selective radiator under the same brightness and specified viewing conditions. Table 2.4 outlines the correlated color temperature of several common scene types and CIE luminaires, as well as their associated chromaticity coordinates.

The CIE standard illuminant D_{65}, shown in Figure 2.11, is defined as natural daylight with a correlated color temperature of 6,504 K. The D_{55} and D_{75} illuminants have correlated color temperatures of 5,503 and 7,504 K, respectively. Many color spaces are defined with a D_{65} white point. In photography, D_{55} is often used. Display devices often use a white point of 9,300 K, which tends toward blue. The reason for this is that blue phosphors are relatively efficient and allow the overall display brightness to be somewhat higher, at the cost of color accuracy [100].

Humans are very capable of adapting to the color of the light source in a scene. The impression of color given by a surface depends on its reflectance as well as the light source illuminating it. If the light source is gradually changed in color, humans will adapt and still perceive the color of the surface the same, although light measurements of the surface would indicate a different spectral composition and CIE XYZ tristimulus value [125]. This phenomenon is called chromatic adaptation. The ability to perceive the color of a surface independently of the light source illuminating it is called color constancy.

Typically, when viewing a real scene an observer would be chromatically adapted to that scene. If an image of the same scene were displayed on a display device, the observer would be adapted to the display device and the scene in which the observer viewed the image. It is reasonable to assume that these two states of adaptation will generally be different. As such, the image shown is likely to be perceived differently than the real scene. Accounting for such differences should be an important aspect of HDR imaging, and in particular tone reproduction. Unfortunately, too many tone-reproduction operators ignore these issues, although the photoreceptor-based operator, iCAM, and the Multiscale Observer Model include a model of chromatic adaptation (see Sections 7.2.7, 7.3.3, and 7.3.4), and Akyuz et al. have shown that tone reproduction and color appearance modeling may be separated into two steps [4].

In 1902, von Kries speculated that chromatic adaptation is mediated by the three cone types in the retina [90]. Chromatic adaptation occurs as the red, green, and blue cones each independently adapts to the illuminant.

A model of chromatic adaptation may thus be implemented by transforming tristimulus values into a cone response domain and then individually scaling the red, green, and blue components according to the current and desired illuminants. There exist different definitions of cone response domains leading to different transforms. The first cone response domain is given by the LMS color space, with L, M, and S standing respectively for long, medium, and short wavelengths. The matrix that converts between XYZ and LMS lies at the heart of the von Kries transform and is denoted M_{vonKries}, as in the following.

$$M_{\text{vonKries}} = \begin{bmatrix} 0.3897 & 0.6890 & -0.0787 \\ -0.2298 & 1.1834 & 0.0464 \\ 0.0000 & 0.0000 & 1.0000 \end{bmatrix}$$

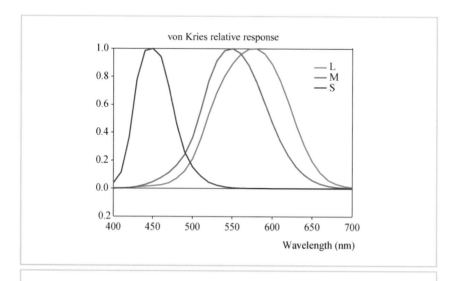

FIGURE 2.12 *Relative response functions for the von Kries chromatic adaptation transform. (Reprinted from [36]. Image courtesy of Society for Imaging Science and Technology Publications.)*

$$M_{\text{vonKries}}^{-1} = \begin{bmatrix} 1.9102 & -1.1121 & 0.2019 \\ 0.3710 & 0.6291 & 0.0000 \\ 0.0000 & 0.0000 & 1.0000 \end{bmatrix}$$

As the LMS cone space represents the response of the cones in the human visual system, it is a useful starting place for computational models of human vision. It is also a component in the iCAM color appearance model (see Section 7.3.3). The relative response as a function of wavelength is plotted in Figure 2.12.

A newer cone response domain is given by the Bradford chromatic adaptation transform [64,76] (see Figure 2.13), as follows.

$$M_{\text{Bradford}} = \begin{bmatrix} 0.8951 & 0.2664 & -0.1614 \\ -0.7502 & 1.7135 & 0.0367 \\ 0.0389 & -0.0685 & 1.0296 \end{bmatrix}$$

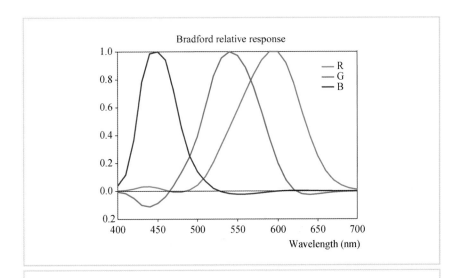

FIGURE 2.13 *Relative response functions for the Bradford chromatic adaptation transform. (Reprinted from [36]. Image courtesy of Society for Imaging Science and Technology Publications.)*

$$M_{\text{Bradford}}^{-1} = \begin{bmatrix} 0.9870 & -0.1471 & 0.1600 \\ 0.4323 & 0.5184 & 0.0493 \\ -0.0085 & 0.0400 & 0.9685 \end{bmatrix}$$

A third chromatic adaptation transform (see Figure 2.14) is used in the CIECAM02 color appearance model (described in Section 2.8), as follows

$$M_{\text{CAT02}} = \begin{bmatrix} 0.7328 & 0.4296 & -0.1624 \\ -0.7036 & 1.6975 & 0.0061 \\ 0.0030 & 0.0136 & 0.9834 \end{bmatrix}$$

$$M_{\text{CAT02}}^{-1} = \begin{bmatrix} 1.0961 & -0.2789 & 0.1827 \\ 0.4544 & 0.4735 & 0.0721 \\ -0.0096 & -0.0057 & 1.0153 \end{bmatrix}$$

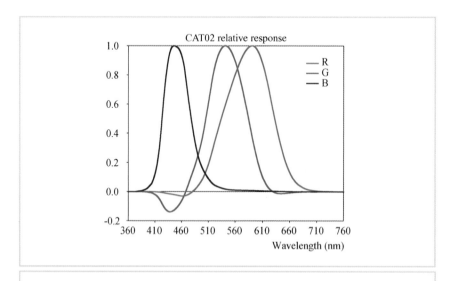

FIGURE 2.14 *Relative response functions for the CAT02 chromatic adaptation transform.* (*Reprinted from slides by Mark Fairchild.*)

These three chromatic adaptation transforms may be used to construct a matrix that will transform XYZ tristimulus values for a given white point to a new white point [126]. If the source white point is given as (X_S, Y_S, Z_S) and the destination white point as (X_D, Y_D, Z_D), their transformed values are

$$\begin{bmatrix} \rho_S \\ \gamma_S \\ \beta_S \end{bmatrix} = M_{\text{cat}} \begin{bmatrix} X_S \\ Y_S \\ Z_S \end{bmatrix}$$

$$\begin{bmatrix} \rho_D \\ \gamma_D \\ \beta_D \end{bmatrix} = M_{\text{cat}} \begin{bmatrix} X_D \\ Y_D \\ Z_D \end{bmatrix},$$

where M_{cat} is one of the three chromatic adaptation matrices M_{vonKries}, M_{Bradford}, or M_{CAT02}. A chromatic adaptation matrix for these specific white points may be constructed by concatenating the previously cited von Kries or Bradford matrices with a diagonal matrix that independently scales the three cone responses, as follows.

$$M = M_{\text{cat}}^{-1} \begin{bmatrix} \rho_D/\rho_S & 0 & 0 \\ 0 & \gamma_D/\gamma_S & 0 \\ 0 & 0 & \beta_D/\beta_S \end{bmatrix} M_{\text{cat}}$$

Chromatically adapting an XYZ tristimulus value is now a matter of transforming it with matrix M, as follows.

$$\begin{bmatrix} X' \\ Y' \\ Z' \end{bmatrix} = M \begin{bmatrix} X \\ Y \\ Z \end{bmatrix}$$

Here, (X', Y', Z') is the CIE tristimulus value whose appearance under the target illuminant most closely matches the original XYZ tristimulus under the source illuminant.

Chromatic adaptation transforms are useful for preparing an image for display under different lighting conditions. Thus, if the scene were lit by daylight and an image of that scene viewed under tungsten lighting, a chromatic adaptation transform might be used to account for this difference. After applying the chromatic adaptation transform, the (X', Y', Z') tristimulus values need to be converted to an RGB color space with a matrix that takes into account the white point of the display environment. Thus, if the image is to be viewed under tungsten lighting, the XYZ-to-RGB transformation matrix should be constructed using the white point of a tungsten light source.

As an example, Figure 2.15 shows an image lit with daylight approximating D_{65}.[3] This figure shows the image prepared for several different viewing environments. In each case, the CAT02 chromatic adaptation transform was used, and the conversion to RGB color space was achieved by constructing a conversion matrix with the appropriate white point.

. .

3 This image was taken in a conservatory in Rochester, New York, under cloud cover. The CIE D_{65} standard light source was derived from measurements originally taken from similar daylight conditions in Rochester.

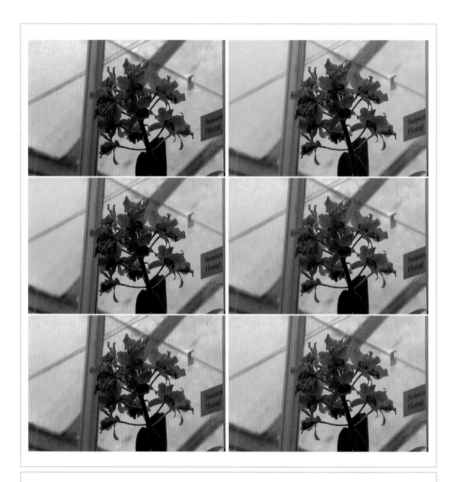

FIGURE 2.15 CAT02 *chromatic adaptation. In reading order: original image, followed by five images chromatically adapted from* D_{65} *to incandescent, tungsten,* D_{50}*, E, and F2.*

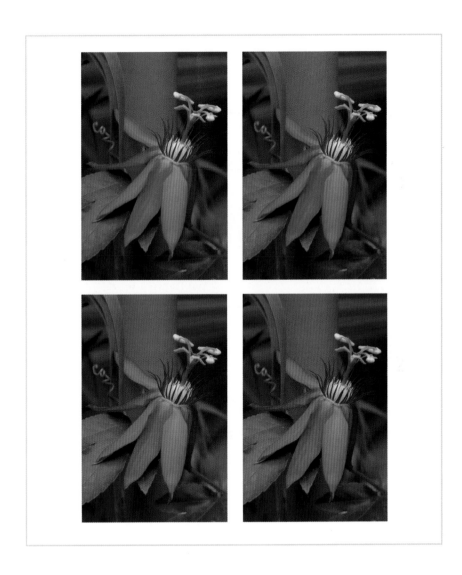

FIGURE 2.16 (continued) *Comparison of different chromatic adaptation transforms. In reading order: the chromatic adaptation transform applied directly in XYZ space, followed by von Kries, Bradford, and CAT02 transforms. The final image is the original. The transform is from D_{65} to tungsten.*

The difference among the three different chromatic adaptation transforms is illustrated in Figure 2.16. Also shown in this figure is a chromatic adaptation performed directly in XYZ space, here termed *XYZ scaling*. The scene depicted here was created with only the outdoor lighting available and was taken in the same conservatory as the images in Figure 2.15. Thus, the lighting in this scene would be reasonably well approximated with a D_{65} luminant. Figure 2.16 shows transforms from D_{65} to tungsten.

The spectral sensitivities of the cones in the human visual system are broadband; that is, each of the red, green, and blue cone types (as well as the rods) are sensitive to a wide range of wavelengths, as indicated by their absorbance spectra (shown

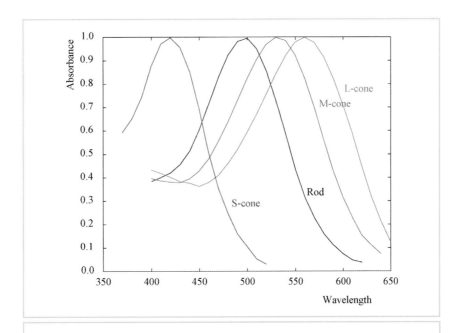

FIGURE 2.17 *Spectral absorbance spectra for the L, M, and S cones, as well as the rods (after [16]). (This data can be downloaded from http://www.cvrl.org.)*

in Figure 2.17) [16]. As a result, there is significant overlap between the different cone types, although their peak sensitivities lie at different wavelengths.

It is possible to construct new spectral response functions that are more narrow-band by computing a linear combination of the original response functions. The graphs of the resulting response functions look sharper, and the method is therefore called "spectral sharpening." Within a chromaticity diagram, the three corners of the color gamut lie closer to the spectral locus, or even outside, and therefore the gamut is "wider" so that a greater range of visible colors can be represented.

A second advantage of applying such a transform is that the resulting tristimulus values become more decorrelated. This has advantages in color constancy algo-

rithms; that is, algorithms that aim to recover surface reflectance from an image that has recorded the combined effect of surface reflectance and illuminance [7]. It also helps to reduce visible errors in color-rendering algorithms [208].

2.6 COLOR CORRECTION

Without the camera response function (Section 4.6), one cannot linearize the input as needed for color correction. Thus, a color-correction value will not apply equally to all parts of the tone scale. For instance, darker colors may end up too blue compared to lighter colors. Furthermore, colors with primary values clamped to the upper limit (255 in an 8-bit image) have effectively been desaturated by the camera. Although users are accustomed to this effect in highlights, after color correction such desaturated colors may end up somewhere in the midtones, where desaturation is unexpected. In a naïve method, whites may even be moved to some nonneutral value, which can be very disturbing.

Figure 2.18 demonstrates the problem of color correction from an LDR original. If the user chooses one of the lighter patches for color balancing, the result may be incorrect due to clamping in its value. (The captured RGB values for the gray patches are shown in red.) Choosing a gray patch without clamping avoids this problem, but it is impossible to recover colors for the clamped patches. In particular, the lighter neutral patches end up turning pink in this example. The final image shows how these problems are avoided when an HDR original is available. Because the camera response curve has been eliminated along with clamping, the simple

FIGURE 2.18 (a) A Macbeth ColorChecker chart captured with the appropriate white balance setting under an overcast sky; (b) the same scene captured using the "incandescent" white balance setting, resulting in a bluish color cast (red dots mark patches that cannot be corrected because one or more primaries are clamped to 255); (c) an attempt to balance white using the second gray patch, which was out of range in the original; (d) the best attempt at correction using the fourth gray patch, which was at least in range in the original; and (e) range issues disappear in an HDR original, allowing for proper post-correction.

(a) White balanced capture

(b) Off-balance capture

(c) LDR white balancing using second patch

(d) LDR white balancing using fourth patch

(e) HDR white balancing

approach of balancing colors by choosing a neutral patch and multiplying the image
by its inverse works quite well.

2.7 COLOR OPPONENT SPACES

With a 3-by-3 matrix, pixel data may be rotated into different variants of RGB color
spaces to account for different primaries. A feature shared by all RGB color spaces is
that for natural images correlations exist between the values in each color channel.
In other words, if a pixel of a natural image has a large value for the red component,
the probability of also finding a large value for the green and blue components is
high. Thus, the three channels are highly correlated.

An example image is shown in Figure 2.19. A set of randomly selected pixels is
plotted three times in the same figure, where the axes of the plot are R-G, R-B, and
G-B. This plot shows a point cloud of pixel data at an angle of about 45 degrees, no
matter which channel is plotted against which. Thus, for this natural image strong
correlations exist between the channels in RGB color space.

This means that the amount of information carried by the three values compris-
ing a pixel is less than three times the amount of information carried by each of
the values. Thus, each color pixel carries some unquantified amount of redundant
information.

The human visual system deals with a similar problem. The information captured
by the photoreceptors needs to be transmitted to the brain through the optic nerve.
The amount of information that can pass through the optic nerve is limited and
constitutes a bottleneck. In particular, the number of photoreceptors in the retina is
far larger than the number of nerve endings that connect the eye to the brain.

After light is absorbed by the photoreceptors, a significant amount of processing
occurs in the next several layers of cells before the signal leaves the eye. One type of
processing is a color space transformation to a *color opponent space*. Such a color space
is characterized by three channels; a luminance channel, a red-green channel, and
a yellow-blue channel.

The luminance channel ranges from dark to light and bears resemblance to the
Y channel in CIE XYZ color space. The red-green channel ranges from red to green
via neutral gray. The yellow-blue channel encodes the amount of blue versus the
amount of yellow in a similar way to the red-green channel (Figure 2.20). This

FIGURE 2.19 *Scatter plot of RGB pixels randomly selected from the image at the top. (From Erik Reinhard, Michael Ashikhmin, Bruce Gooch, and Peter Shirley, 'Color Transfer between Images', IEEE CG&A special issue on Applied Perception, Vol 21, No 5, pp 34–41, September–October 2001.)*

FIGURE 2.20 *Original image (top left) split into a luminance channel (top right), a yellow-blue channel (bottom left), and a red-green channel (bottom right). For the purpose of visualization, the images depicting the yellow-blue and red-green channels are shown with the luminance component present.*

encoding of chromatic information is the reason humans are able to describe colors as reddish yellow (orange) or greenish blue. However, colors such as bluish yellow and reddish green are never described because of this encoding (see [92]).

It is possible to analyze sets of natural images by means of principal components analysis (PCA) [110]. This technique rotates multidimensional data such that the

FIGURE 2.21 *Scatter plot of $L\alpha\beta$ pixels randomly selected from the image of Figure 2.19. (From Erik Reinhard, Michael Ashikhmin, Bruce Gooch, and Peter Shirley, 'Color Transfer between Images', IEEE CG&A special issue on Applied Perception, Vol 21, No 5, pp 34–41, September–October 2001.)*

axes align with the data as well as possible. Thus, the most important axis aligns with the direction in space that shows the largest variation of data points. This is the first principal component. The second principal component describes the direction accounting for the second greatest variation in the data. This rotation therefore decorrelates the data.

If the technique is applied to images encoded in LMS color space (i.e., images represented in a format as thought to be output by the photoreceptors), a new set of decorrelated axes is produced. The surprising result is that the application of PCA to a set of natural images produces a color space that is closely matched to the color opponent space the human visual system employs [110].

A scatter plot of the image of Figure 2.19 in a color opponent space ($L\alpha\beta$, discussed later in this section) is shown in Figure 2.21. Here, the point clouds are reasonably well aligned with one of the axes, indicating that the data is now decorrelated. The elongated shape of the point clouds indicates the ordering of the principal axes, luminance being most important and therefore most elongated.

The decorrelation of data may be important, for instance, for color-correction algorithms. What would otherwise be a complicated 3D problem may be cast into three simpler 1D problems by solving the problem in a color opponent space [107].

At the same time, the first principal component (the luminance channel) accounts for the greatest amount of variation, whereas the two chromatic color opponent channels carry less information. Converting an image into a color space with a luminance channel and two chromatic channels thus presents an opportunity to compress data because the latter channels would not require the same number of bits as the luminance channel to accurately represent the image. The color opponent space $L\alpha\beta$ that results from applying PCA to natural images may be approximated by the following matrix transform, which converts between $L\alpha\beta$ and LMS (see Section 2.5).

$$\begin{bmatrix} L \\ \alpha \\ \beta \end{bmatrix} = \begin{bmatrix} \frac{1}{\sqrt{3}} & 0 & 0 \\ 0 & \frac{1}{\sqrt{6}} & 0 \\ 0 & 0 & \frac{1}{\sqrt{2}} \end{bmatrix} \begin{bmatrix} 1 & 1 & 1 \\ 1 & 1 & -2 \\ 1 & -1 & 0 \end{bmatrix} \begin{bmatrix} L \\ M \\ S \end{bmatrix}$$

$$\begin{bmatrix} L \\ M \\ S \end{bmatrix} = \begin{bmatrix} 1 & 1 & 1 \\ 1 & 1 & -1 \\ 1 & -2 & 0 \end{bmatrix} \begin{bmatrix} \frac{\sqrt{3}}{3} & 0 & 0 \\ 0 & \frac{\sqrt{6}}{6} & 0 \\ 0 & 0 & \frac{\sqrt{2}}{2} \end{bmatrix} \begin{bmatrix} L \\ \alpha \\ \beta \end{bmatrix}$$

This color space has proved useful in algorithms such as the transfer of color between images, where the colors are borrowed from one image and applied to a second image [107]. This algorithm computes means and standard deviations for each channel separately in both source and target images. Then, the pixel data in the target image are shifted and scaled such that the same mean and standard deviation as the source image are obtained. Applications of color transfer include the work of colorists, compositing, and matching rendered imagery with live video footage in mixed-reality applications.

In addition, human sensitivity to chromatic variations is lower than to changes in luminance. Chromatic channels may therefore be represented at a lower spatial resolution than the luminance channel. This feature may be exploited in image encodings by sampling the image at a lower resolution for the color opponent channels than for the luminance channel. This is demonstrated in Figure 2.22, where the

FIGURE 2.22 *The red-green and yellow-blue channels are reduced in spatial resolution by a factor of* 1, 2, 4, 8, 16, *and* 32.

full resolution image is shown on the left. The spatial resolution of the red-green and yellow-blue channels is reduced by a factor of two for each subsequent image. In Figure 2.23, the luminance channel was also reduced by a factor of two. The artifacts in Figure 2.22 are much more benign than those in Figure 2.23.

FIGURE 2.23 *All three channels in $L\alpha\beta$ space are reduced in spatial resolution by a factor of 1, 2, 4, 8, 16, and 32.*

Subsampling of chromatic channels is used, for instance, in the YC_BC_R encoding that is part of the JPEG file format and part of various broadcast standards, including HDTV [100]. Conversion from RGB to YC_BC_R and back as used for JPEG is given by

$$\begin{bmatrix} Y \\ C_B \\ C_R \end{bmatrix} = \begin{bmatrix} 0.299 & 0.587 & 0.114 \\ -0.168 & -0.333 & 0.498 \\ 0.498 & -0.417 & -0.081 \end{bmatrix} \begin{bmatrix} R \\ G \\ B \end{bmatrix}$$

$$\begin{bmatrix} R \\ G \\ B \end{bmatrix} = \begin{bmatrix} 1.000 & 0.000 & 1.397 \\ 1.000 & -0.343 & -0.711 \\ 1.000 & 1.765 & 0.000 \end{bmatrix} \begin{bmatrix} Y \\ C_B \\ C_R \end{bmatrix}.$$

This conversion is based on ITU-R BT.601 [100]. Other color spaces which have one luminance channel and two chromatic channels, such as CIELUV and CIELAB, are discussed in the following section.

2.8 COLOR APPEARANCE

The human visual system adapts to the environment it is viewing (see Chapter 6 for more information). Observing a scene directly therefore generally creates a different visual sensation than observing an image of that scene on a (LDR) display. In the case of viewing a scene directly, the observer will be adapted to the scene. When looking at an image of a display, the observer will be adapted to the light emitted from the display, as well as to the environment in which the observer is located.

There may therefore be a significant mismatch between the state of adaptation of the observer in these two cases. This mismatch may cause the displayed image to be perceived differently from the actual scene. The higher the dynamic range of the scene the larger this difference may be. In HDR imaging, and in particular tone reproduction, it is therefore important to understand how human vision adapts to various lighting conditions and to develop models that predict how colors will be perceived under such different lighting conditions. This is the domain of color appearance modeling [27].

A color's appearance is influenced by various aspects of the viewing environment, such as the illuminant under which the stimulus is viewed. The chromatic adaptation transforms discussed in Section 2.5 are an important component of most color appearance models.

FIGURE 2.24 *Simultaneous color contrast shown for an identical gray patch displayed on dif-ferently colored backgrounds.*

The color of the area surrounding the stimulus also plays an important role, as demonstrated in Figure 2.24, where the same gray patch is shown on different backgrounds. The color of the patch will appear different in each case — an effect known as simultaneous color contrast.

To characterize a stimulus within a specific environment, first its tristimulus value is specified in CIE XYZ color space. Second, attributes of the environment in which the stimulus is viewed need to be provided. If the stimulus is a homoge-

neous reflecting patch of color on a neutral (gray) background, this characterization of the environment may be as simple as the specification of an illuminant.

The appearance of a color is then described by "appearance correlates" that may be computed from the color's tristimulus values as well as the description of the environment. Useful appearance correlates include lightness, chroma, hue, and saturation, which are defined later in this section.

Appearance correlates are not computed directly in XYZ color space, but require an intermediate color space such as the CIE 1976 $L^*u^*v^*$ or CIE 1976 $L^*a^*b^*$ color spaces. The names of these color spaces may be abbreviated as CIELUV and CIELAB, respectively.

For both of these color spaces it is assumed that a stimulus (X, Y, Z) is formed by a white reflecting surface that is lit by a known illuminant with tristimulus values (X_n, Y_n, Z_n). The conversion from CIE 1931 tristimulus values to CIELUV is then given by the following.

$$L^* = 116\left(\frac{Y}{Y_n}\right)^{1/3} - 16$$

$$u^* = 13L^*(u' - u'_n)$$

$$v^* = 13L^*(v' - v'_n)$$

This conversion is under the constraint that $Y/Y_n > 0.008856$. For ratios smaller than 0.008856, L^*_m is applied as follows.

$$L^*_m = 903.3\frac{Y}{Y_n}$$

The primed quantities in these equations are computed from (X, Y, Z) as follows.

$$u' = \frac{4X}{X + 15Y + 3Z} \qquad u'_n = \frac{4X_n}{X_n + 15Y_n + 3Z_n}$$

$$v' = \frac{9Y}{X + 15Y + 3Z} \qquad v'_n = \frac{9Y_n}{X_n + 15Y_n + 3Z_n}$$

This transformation creates a more or less uniform color space, such that equal distances anywhere within this space encode equal perceived color differences. It is

CIE (u', v') chromaticity diagram showing the range of colors humans can distinguish.

therefore possible to measure the difference between two stimuli (L_1^*, u_1^*, v_1^*) and (L_2^*, u_2^*, v_2^*) by encoding them in CIELUV space, and applying the color difference formula

$$\Delta E_{uv}^* = \left[(\Delta L^*)^2 + (\Delta u^*)^2 + (\Delta v^*)^2\right]^{1/2},$$

where $\Delta L^* = L_1^* - L_2^*$, etc.

In addition, u' and v' may be plotted on separate axes to form a chromaticity diagram, as shown in Figure 2.25. Equal distances in this diagram represent approximately equal perceptual differences. For this reason, in the remainder of this book CIE (u', v') chromaticity diagrams are shown rather than perceptually nonuniform CIE (x, y) chromaticity diagrams. The CIELAB color space follows a similar approach. For the ratios X/X_n, Y/Y_n and Z/Z_n, each being larger than 0.008856,

the color space is defined by

$$L^* = 116 f\left(\frac{Y}{Y_n}\right) - 16$$

$$a^* = 500\left[f\left(\frac{X}{X_n}\right) - f\left(\frac{Y}{Y_n}\right)\right]$$

$$b^* = 200\left[f\left(\frac{Y}{Y_n}\right) - f\left(\frac{Z}{Z_n}\right)\right].$$

The function $f(.)$ takes a ratio r as argument in the previous equations, and is defined as:

$$f(r) = \begin{cases} (r)^{1/3} & \text{for } r > 0.008856 \\ 7.787r + \dfrac{16}{116} & \text{for } r \leq 0.008856. \end{cases}$$

Within this color space, which is also approximately perceptually linear, the difference between two stimuli may be quantified with the following color difference formula.

$$\Delta E_{ab}^* = \left[(\Delta L^*)^2 + (\Delta a^*)^2 + (\Delta b^*)^2\right]^{1/2}$$

The reason for the existence of both of these color spaces is largely historical. Both color spaces are in use today, with CIELUV more common in the television and display industries and CIELAB in the printing and materials industries [125].

Although CIELUV and CIELAB by themselves are perceptually uniform color spaces, they may also form the basis for color appearance models. The perception of a set of tristimulus values may be characterized by computing appearance correlates [27]. Our definitions are based on Wyszecki and Stiles' book *Color Science* [149].

> Brightness: The attribute of visual sensation according to which a visual stimulus appears to emit more or less light is called brightness, which ranges from bright to dim.

Lightness: The area in which a visual stimulus is presented may appear to emit more or less light in proportion to a similarly illuminated area that is perceived as a white stimulus. Lightness is therefore a relative measure and may be seen as relative brightness. Lightness ranges from light to dark. In both CIELUV and CIELAB color spaces, L^* is the correlate for lightness. Note that if the luminance value of the stimulus is about 18% of Y_n (i.e., $Y/Y_n = 0.18$), the correlate for lightness becomes about 50, which is halfway on the scale between light and dark. In other words, surfaces with 18% reflectance appear as middle gray. In photography, 18% gray cards are often used as calibration targets for this reason.[4]

Hue: The attribute of color perception denoted by red, green, blue, yellow, purple, and so on is called hue. A chromatic color is perceived as possessing hue. An achromatic color is not perceived as possessing hue. Hue angles h_{uv} and h_{ab} may be computed as follows.

$$h_{uv} = \arctan \frac{v^*}{u^*}$$

$$h_{ab} = \arctan \frac{a^*}{b^*}$$

Chroma: A visual stimulus may be judged in terms of its difference with an achromatic stimulus with the same brightness. This attribute of visual sensation is called chroma. Correlates of chroma may be computed in both CIELUV (C_{uv}^*) and CIELAB (C_{uv}^*) as follows.

$$C_{uv}^* = \left[(u^*)^2 + (v^*)^2\right]^{1/2}$$

$$C_{ab}^* = \left[(a^*)^2 + (b^*)^2\right]^{1/2}$$

. .

4 Although tradition is maintained and 18% gray cards continue to be used, the average scene reflectance is often closer to 13%.

Saturation: Whereas chroma pertains to stimuli of equal brightness, saturation is an attribute of visual sensation which allows the difference of a visual stimulus and an achromatic stimulus to be judged regardless of any differences in brightness. In CIELUV, a correlate for saturation s^*_{uv} may be computed as follows.

$$s^*_{uv} = \frac{C^*_{uv}}{L^*}$$

A similar correlate for saturation is not available in CIELAB.

Several more color appearance models have recently appeared. The most notable among these are CIECAM97 [12,28,54,85], which exists in both full and simplified versions, and CIECAM02 [74,84]. As with the color spaces mentioned previously, their use is in predicting the appearance of stimuli placed in a simplified environment. They also allow conversion of stimuli between different display media, such as different computer displays that may be located in different lighting environments. These recent color appearance models are generally more complicated than the procedures described in this section, but are also deemed more accurate.

The CIECAM97 and CIECAM02 color appearance models, as well as several of their predecessors, follow a general structure but differ in their details. We outline this structure using the CIECAM02 model as an example [74,84].

This model works under the assumption that a target patch with given relative tristimulus value XYZ is viewed on a neutral background and in the presence of a white reflective patch, which acts as the reference white (i.e., it is the brightest part of the environment under consideration). The background is again a field of limited size. The remainder of the visual field is taken up by the surround. This simple environment is lit by an illuminant with given relative tristimulus values $X_W Y_W Z_W$. Both of these relative tristimulus values are specified as input and are normalized between 0 and 100.

Surround	F	c	N_c
Average	1.0	0.69	1.0
Dim	0.9	0.59	0.95
Dark	0.8	0.525	0.8

TABLE 2.5 *Values for intermediary parameters in the CIECAM02 model as a function of the surround description.*

The luminance measured from the reference white patch is then assumed to be the adapting field luminance L_a — the only absolute input parameter, measured in cd/m^2. The neutral gray background has a luminance less than or equal to the adapting field luminance. It is denoted Y_b and is specified as a fraction of L_a, also normalized between 0 and 100.

The final input to the CIECAM02 color appearance model is a classifier describing the surround as average, dim, or dark. This viewing condition parameter is used to select values for the intermediary parameters F, c, and N_c according to Table 2.5. Further intermediary parameters n, N_{bb}, N_{cb}, and z are computed from the input as follows.

$$n = \frac{Y_b}{Y_W}$$

$$N_{cb} = 0.725 \left(\frac{1}{n}\right)^{0.2}$$

$$N_{bb} = N_{cb}$$

$$z = 1.48 + \sqrt{n}$$

Next, a factor F_L is computed from the adapting field luminance, which accounts for the partial adaptation to overall light levels. This takes the following form.

$$k = \frac{1}{5L_a + 1}$$

$$F_L = 0.2k^4(5L_a) + 0.1(1 - k^4)^2(5L_a)^{1/3} \qquad (2.1)$$

The CIECAM02 color appearance model, and related models, proceed with the following three main steps.

- Chromatic adaptation
- Nonlinear response compression
- Computation of perceptual appearance correlates

The chromatic adaptation transform is performed in the CAT02 space, outlined in Section 2.5. The XYZ and $X_W Y_W Z_W$ tristimulus values are first converted to this space, as follows.

$$\begin{bmatrix} R \\ G \\ B \end{bmatrix} = M_{CAT02} \begin{bmatrix} X \\ Y \\ Z \end{bmatrix}$$

Then a degree of adaptation D is computed, which determines how complete the adaptation is. It is a function of the adapting field luminance as well as the surround (through the parameters L_a and F). This takes the following form.

$$D = F\left[1 - \frac{1}{3.6} \exp\left(\frac{-L_a - 42}{92}\right)\right]$$

The chromatically adapted signals are then computed, as follows.

$$R_c = R\left[\left(D\frac{Y_W}{R_W}\right) + (1 - D)\right]$$

$$G_c = G\left[\left(D\frac{Y_W}{G_W}\right) + (1 - D)\right]$$

$$B_c = B\left[\left(D\frac{Y_W}{B_W}\right) + (1 - D)\right]$$

After applying this chromatic adaptation transform, the result is converted back to XYZ space.

The second step of the CIECAM02 model is the nonlinear response compression, which is carried out in the Hunt–Pointer–Estevez color space, which is close to a cone fundamental space such as LMS (see Section 2.5). Conversion from XYZ to this color space is governed by the following matrix.

$$M_{\mathrm{H}} = \begin{bmatrix} 0.3897 & 0.6890 & -0.0787 \\ -0.2298 & 1.1834 & 0.0464 \\ 0.0000 & 0.0000 & 1.0000 \end{bmatrix}$$

The chromatically adapted signal after conversion to the Hunt–Pointer–Estevez color space is indicated with the $(R'G'B')$ triplet. The nonlinear response compression yields a compressed signal $(R'_{\mathrm{a}}G'_{\mathrm{a}}B'_{\mathrm{a}})$, as follows.

$$R'_{\mathrm{a}} = \frac{400(F_{\mathrm{L}}R'/100)^{0.42}}{27.13 + (F_{\mathrm{L}}R'/100)^{0.42}} + 0.1$$

$$G'_{\mathrm{a}} = \frac{400(F_{\mathrm{L}}G'/100)^{0.42}}{27.13 + (F_{\mathrm{L}}B'/100)^{0.42}} + 0.1$$

$$B'_{\mathrm{a}} = \frac{400(F_{\mathrm{L}}B'/100)^{0.42}}{27.13 + (F_{\mathrm{L}}B'/100)^{0.42}} + 0.1$$

This response compression function follows an S shape on a log-log plot, as shown in Figure 2.26.

The final step consists of computing perceptual appearance correlates. These describe the perception of the patch in its environment, and include lightness, brightness, hue, chroma, colorfulness, and saturation. First a set of intermediary parameters is computed, as follows, which includes a set of color opponent signals a and b, a magnitude parameter t, an achromatic response A, hue angle h, and eccentricity factor e.

$$a = R'_{\mathrm{a}} - 12G'_{\mathrm{a}}/11 + B'_{\mathrm{a}}/11$$
$$b = (R'_{\mathrm{a}} + G'_{\mathrm{a}} - 2B'_{\mathrm{a}})/9$$
$$h = \tan^{-1}(b/a)$$

FIGURE 2.26 CIECAM02 *nonlinear response compression on log-log axes.*

$$e = \left(\frac{12{,}500}{13} N_c N_{cb} \right) \left[\cos\left(\frac{h\pi}{180} + 2 \right) + 3.8 \right]$$

$$t = \frac{e\sqrt{a^2 + b^2}}{R'_a + G'_a + 21 B'_a/20}$$

$$A = [2R'_a + G'_a + B'_a/20 - 0.305]N_{bb}$$

The unique hues red, yellow, green, and blue have values for h as given in Table 2.6. The hue angles h_1 and h_2 for the two nearest unique hues are determined from the value of h and Table 2.6. Similarly, eccentricity factors e_1 and e_2 are derived from this table and the value of e. The hue composition term H_i of the next lower unique hue is also read from this table. The appearance correlates may then be computed with the following equations, which are estimates for hue H, lightness

Unique Hue	Hue Angle	Eccentricity Factor	Hue Composition
Red	20.14	0.8	0
Yellow	90.00	0.7	100
Green	164.25	1.0	200
Blue	237.53	1.2	300

TABLE 2.6 Hue angles h, eccentricity factors e, and hue composition H_i for the unique hues red, yellow, green, and blue.

J, brightness Q, chroma C, colorfulness M, and saturation s.

$$H = H_i + \frac{100(h - h_1)/e_1}{(h - h_1)/e_1 + (h2 - h)/e_2}$$

$$J = 100\left(\frac{A}{A_W}\right)^{cz}$$

$$Q = \left(\frac{4}{c}\right)\sqrt{\frac{J}{100}}(A_W + 4)F_L^{0.25}$$

$$C = t^{0.9}\sqrt{\frac{J}{100}}(1.64 - 0.29^n)^{0.73}$$

$$M = CF_L^{0.25}$$

$$s = 100\sqrt{\frac{M}{Q}}$$

These appearance correlates thus describe the tristimulus value XYZ in the context of its environment. Thus, by changing the environment only the perception of this patch will change and this will be reflected in the values found for these appearance

correlates. In practice, this would occur, for instance, when an image displayed on a monitor and printed on a printer needs to appear the same. Although colorimetry may account for the different primaries of the two devices, color appearance modeling additionally predicts differences in color perception due to the state of adaptation of the human observer in both viewing conditions.

If source and target viewing conditions are known, color appearance models may be used to convert a tristimulus value from one viewing condition to the other. The first two steps of the model (chromatic adaptation and nonlinear response compression) would then be applied, followed by the inverse of these two steps. During execution of the inverse model, the parameters describing the target environment (adapting field luminance, tristimulus value of the reference white, and so on) would be substituted into the model.

The field of color appearance modeling is currently dominated by two trends. The first is that there is a realization that the visual environment in which a stimulus is observed is in practice much more complicated than a uniform field with a given luminance. In particular, recent models are aimed at modeling the appearance of a pixel's tristimulus values in the presence of neighboring pixels in an image. Examples of models that begin to address these spatial configurations are the S-CIELAB and iCAM models [29,30,61,86,151].

A second trend in color appearance modeling constitutes a novel interest in applying color appearance models to HDR data. In particular, there is a mismatch in adaptation of the human visual system in a typical scene involving high contrast ratios and a human observer in front of a typical display device. Thus, if an accurate HDR capture of a scene is tone mapped and displayed on a computer monitor, the state of adaptation of the human observer in the latter case may cause the scene to appear different from the original scene.

The iCAM "image appearance model," derived from CIECAM02, is specifically aimed at addressing these issues [29,61], and in fact may be seen as a tone-reproduction operator. This model is presented in detail in Chapter 8.

2.9 DISPLAY GAMMA

Cathode ray tubes have a nonlinear relationship between input voltage V and light output L_v. This relationship is well approximated with the following power

law function.

$$L_v = kV^\gamma$$

The exponent γ models the nonlinearity introduced by the specific operation of the CRT, and is different for different monitors. If V is normalized between 0 and 1, the constant k simply becomes the maximum output luminance L_{max}.

In practice, typical monitors have a gamma value between 2.4 and 2.8. However, further nonlinearities may be introduced by the lookup tables used to convert values into voltages. For instance, Macintosh computers have a default gamma of about 1.8, which is achieved by the interaction of a system lookup table with the attached display device. Whereas the Macintosh display system may have a gamma of 1.8, the monitor attached to a Macintosh will still have a gamma closer to 2.5 [100].

Thus, starting with a linear set of values that are sent to a CRT display, the result is a nonlinear set of luminance values. For the luminances produced by the monitor to be linear, the gamma of the display system needs to be taken into account. To undo the effect of gamma, the image data needs to be gamma corrected before sending it to the display, as explained in material following.

Before the gamma value of the display can be measured, the black level needs to be set appropriately [100]. To set the black point on a monitor, you first display a predominantly black image and adjust the brightness control on the monitor to its minimum. You then increase its value until the black image just starts to deviate from black. The contrast control may then be used to maximize the amount of contrast.

The gamma value of a display device may then be estimated, as in the image shown in Figure 2.27. Based on an original idea by Paul Haeberli, this figure consists of alternating black and white lines on one side and solid gray patches on the other. By viewing this chart from a reasonable distance and matching the solid gray that comes closest to the gray formed by fusing the alternating black and white lines, the gamma value for the display device may be read from the chart. Note that this gamma estimation chart should only be used for displays that follow a power-law transfer function, such as CRT monitors. This gamma estimation technique may not work for LCD displays, which do not follow a simple power law.

Once the gamma value for the display is known, images may be pre-corrected before sending them to the display device. This is achieved by applying the follow-

FIGURE 2.27 *Gamma estimation for CRT displays. The alternating black and white lines should be matched to the solid grays to determine the gamma of a display device.*

ing correction to the values in the image, which should contain normalized values between 0 and 1.

$$R' = R^{1/\gamma}$$
$$G' = G^{1/\gamma}$$
$$B' = B^{1/\gamma}$$

An image corrected with different gamma values is shown in Figure 2.28.

The technology employed in LCD display devices is fundamentally different from CRT displays, and the transfer function for such devices is often very different. However, many LCD display devices incorporate circuitry to mimic the transfer function of a CRT display device. This provides some backward compatibility. Thus, although gamma encoding is specifically aimed at correcting for the nonlinear transfer function of CRT devices, often (but not always) gamma correction may be applied to images prior to display on LCD.

Many display programs perform incomplete gamma correction (i.e., the image is corrected such that the displayed material is intentionally left nonlinear). Often, a gamma value of 2.2 is used. The effect of incomplete gamma correction is that contrast is boosted, which viewers tend to prefer [29]. In addition, display devices reflect some of their environment, which reduces contrast. Partial gamma correction may help regain some of this loss of contrast [145].

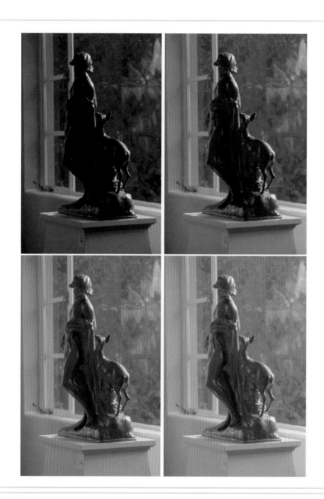

FIGURE 2.28 *An image corrected with different gamma values. In reading order:* $\gamma = 1.0$, *1.5, 2.0, and 2.5. (Albin Polasek (1879–1965) Forest Idyl, 1924, Bronze. Courtesy of the Albin Polasek Museum and Sculpture Gardens, Winter Park, FL.)*

One of the main advantages of using gamma encoding is that it reduces visible noise and quantization artifacts by mimicking the human contrast sensitivity curve. However, gamma correction and gamma encoding are separate issues, as explained next.

2.10 BRIGHTNESS ENCODING

Digital color encoding requires quantization, and errors are inevitable during this process. In the case of a quantized color space, it is preferable for reasons of perceptual uniformity to establish a nonlinear relationship between color values and the intensity or luminance. The goal is to keep errors below the visible threshold as much as possible.

The eye has a nonlinear response to brightness. That is, at most adaptation levels, brightness is perceived roughly as the cube root of intensity (see, for instance, the encoding of $L*$ of the CIELAB and CIELUV color spaces in Section 2.8). Applying a linear quantization of color values would yield more visible steps in darker regions than in the brighter regions, as shown in Figure 2.29.[5] A power-law encoding with a γ value of 2.2 produces a much more even distribution of quantization steps, although the behavior near black is still not ideal. For this reason and others, some encodings (such as sRGB) add a short linear range of values near zero (see Section 2.11).

However, such encodings may not be efficient when luminance values range over several thousand or even a million to one. Simply adding bits to a gamma encoding does not result in a good distribution of steps, because it can no longer be assumed that the viewer is adapted to a particular luminance level, and the relative quantization error continues to increase as the luminance gets smaller. A gamma encoding does not hold enough information at the low end to allow exposure readjustment without introducing visible quantization artifacts.

To encompass a large range of values when the adaptation luminance is unknown, an encoding with a constant or nearly constant relative error is required. A log encoding quantizes values using the following formula rather than the power

. .

5 We have chosen a quantization to 6 bits to emphasize the visible steps.

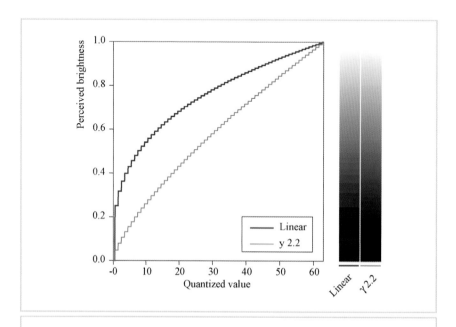

FIGURE 2.29 *Perception of quantization steps using a linear and a gamma encoding. Only 6 bits are used in this example encoding to make the banding more apparent, but the same effect takes place in smaller steps using 8 bits per primary.*

law cited earlier.

$$I_{\text{out}} = I_{\min} \left[\frac{I_{\max}}{I_{\min}} \right]^{v}$$

This formula assumes that the encoded value v is normalized between 0 and 1, and is quantized in uniform steps over this range. Adjacent values in this encoding thus differ by a constant factor equal to

$$\left[\frac{I_{\max}}{I_{\min}} \right]^{1/N},$$

where N is the number of steps in the quantization. This is in contrast to a gamma encoding, whose relative step size varies over its range, tending toward infinity at zero. The advantage of constant steps is offset by a minimum representable value, I_{min}, in addition to the maximum intensity we had before.

Another alternative closely related to the log encoding is a separate exponent and mantissa representation, better known as floating point. Floating-point representations do not have perfectly equal step sizes but follow a slight sawtooth pattern in their error envelope, as shown in Figure 2.30. To illustrate the quantization dif-

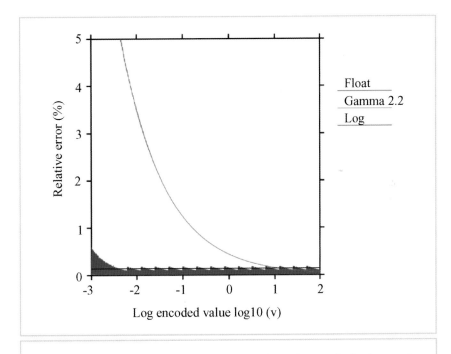

FIGURE 2.30 *Relative error percentage plotted against* \log_{10} *of image value for three encoding methods.*

ferences between gamma, log, and floating-point encodings, a bit size (12) and range (0.001 to 100) are chosen that can be reasonably covered by all three types. A floating-point representation with 4 bits in the exponent, 8 bits in the mantissa, and no sign bit is chosen, because only positive values are required to represent light.

By denormalizing the mantissa at the bottom end of the range, values between I_{min} and zero may also be represented in a linear fashion, as shown in this figure.[6] By comparison, the error envelope of the log encoding is constant over the full range, whereas the gamma encoding error increases dramatically after just two orders of magnitude. Using a larger constant for γ helps this situation somewhat, but ultimately gamma encodings are not well suited to full HDR imagery where the input and/or output ranges are unknown.

2.11 STANDARD RGB COLOR SPACES

Most capture and display devices have their own native color space, generically referred to as device-dependent RGB. Although it is entirely possible to convert an image between two device-dependent color spaces, it is more convenient to define a single standard color space that can serve as an intermediary between device-dependent color spaces.

On the positive side, such standards are now available. On the negative side, there is not one single standard but several competing standards. Most image encodings fall into a class called *output-referred standards*, meaning that they employ a color space corresponding to a particular output device rather than to the original scene they are meant to represent. The advantage of such a standard is that it does not require any manipulation prior to display on a targeted device, and it does not "waste" resources on colors that are out of this device gamut. Conversely, the disadvantage of such a standard is that it cannot represent colors that may be displayable on other output devices or that may be useful in image processing operations along the way.

A *scene-referred* standard follows a different philosophy, which is to represent the original captured scene values as closely as possible. Display on a particular output

..

6 Floating-point denormalization refers to the linear representation of values whose exponent is at the minimum. The mantissa is allowed to have a zero leading bit, which is otherwise assumed to be 1 for normalized values, and this leads to a steady increase in relative error at the very bottom end, rather than an abrupt cutoff.

device then requires some method of mapping the pixels to the device's gamut. This operation is referred to as tone mapping, which may be as simple as clamping RGB values to a 0-to-1 range or something more sophisticated, such as compressing the dynamic range or simulating human visual abilities and disabilities (see Chapters 6 through 8). The chief advantage gained by moving tone mapping to the image decoding and display stage is that correct output can be produced for any display device, now and in the future. In addition, there is the freedom to apply complex image operations without suffering losses due to a presumed range of values.

The challenge of encoding a scene-referred standard is finding an efficient representation that covers the full range of color values. This is precisely where HDR image encodings come into play, as discussed in Chapter 3.

For reference, we discuss several current output referenced standards. In Section 2.4, we already introduced the ITU-R RGB color space. In the remainder of this section conversions to several other color spaces are introduced. Such conversions all follow a matrix multiplication followed by a nonlinear encoding. The sRGB color space is introduced as an example, before generalizing the concept to other color spaces.

The nonlinear sRGB color space is based on a virtual display. It is a standard specified by the International Electrotechnical Commission (IEC 61966-2-1). The primaries as well as the white point are specified in terms of xy chromaticities according to Table 2.7 (this table also shows information for other color spaces, discussed in material following). The maximum luminance for white is specified as 80 cd/m^2.

Because the specification of sRGB is with respect to a virtual monitor, it includes a nonlinearity similar to gamma correction. This makes sRGB suitable for Internet applications as well as scanner-to-printer applications. Many digital cameras now produce images in sRGB space. Because this color space already includes a nonlinear transfer function, images produced by such cameras may be displayed directly on typical monitors. There is generally no further need for gamma correction, except perhaps in critical viewing applications.

The conversion of CIE XYZ tristimulus values to sRGB consists of a 3-by-3 matrix multiplication followed by a nonlinear transfer function. The linear part of the transform is identical to the matrix specified in ITU-R BT.709, introduced in Section 2.4. The resulting RGB values are converted into sRGB using the following

Color Space		R	G	B	White Point (Illuminant)	
Adobe RGB (1998)	x	0.6400	0.2100	0.1500	D65	0.3127
	y	0.3300	0.7100	0.0600		0.3290
sRGB	x	0.6400	0.3000	0.1500	D65	0.3127
	y	0.3300	0.6000	0.0600		0.3290
HDTV (HD-CIF)	x	0.6400	0.3000	0.1500	D65	0.3127
	y	0.3300	0.6000	0.0600		0.3290
NTSC (1953)	x	0.6700	0.2100	0.1400	C	0.3101
	y	0.3300	0.7100	0.0800		0.3161
SMPTE-C	x	0.6300	0.3100	0.1550	D65	0.3127
	y	0.3400	0.5950	0.0700		0.3290
PAL/SECAM	x	0.6400	0.2900	0.1500	D65	0.3127
	y	0.3300	0.6000	0.0600		0.3290
Wide gamut	x	0.7347	0.1152	0.1566	D50	0.3457
	y	0.2653	0.8264	0.0177		0.3584

TABLE 2.7 *Chromaticity coordinates for primaries and white points defining several RGB color spaces.*

transfer function (for R, G, and $B > 0.0031308$).

$$R_{sRGB} = 1.055R^{1/2.4} - 0.055$$

$$G_{sRGB} = 1.055G^{1/2.4} - 0.055$$

$$B_{sRGB} = 1.055B^{1/2.4} - 0.055$$

For values smaller than 0.0031308, a linear function is specified, as follows.

$$R_{sRGB} = 12.92R$$

$$G_{sRGB} = 12.92G$$

$$B_{sRGB} = 12.92B$$

This conversion follows a general pattern that is found in other standards. First, a 3-by-3 matrix is defined, which transforms from XYZ to a color space with different primaries. Then a nonlinear transform is applied to the tristimulus values. This transform takes the following general form [93].

$$R' = \begin{cases} (1+f)R^\gamma - f & \text{for } t \leq R \leq 1 \\ sR & \text{for } 0 < R < t \end{cases}$$

$$G' = \begin{cases} (1+f)G^\gamma - f & \text{for } t \leq G \leq 1 \\ sG & \text{for } 0 < G < t \end{cases}$$

$$B' = \begin{cases} (1+f)B^\gamma - f & \text{for } t \leq B \leq 1 \\ sB & \text{for } 0 < B < t \end{cases}$$

Note that the conversion is linear in a small dark region, and follows a gamma curve for the remainder of the range. The value of s determines the slope of the linear segment, and f is a small offset. Table 2.8 lists several RGB standards, which are defined by their conversion matrices as well as their nonlinear transform specified by the γ, f, s, and t parameters [93]. The primaries and white points for each color space are outlined in Table 2.7. The gamuts spanned by each color space are shown in Figure 2.31. The gamut for the HDTV color space is identical to the sRGB standard and is therefore not shown again.

The Adobe RGB color space was formerly known as SMPTE-240M, but was renamed after SMPTE's gamut was reduced. It has a larger gamut than sRGB, as shown in the chromaticity diagrams of Figure 2.31. This color space was developed with the printing industry in mind. Many digital cameras provide an option to output images in Adobe RGB color, as well as sRGB.

The HDTV and sRGB standards specify identical primaries, but differ in their definition of viewing conditions. As such, the difference lies in the nonlinear transform.

Color Space	XYZ to RGB Matrix	RGB to XYZ Matrix	Nonlinear Transform
Adobe RGB (1998)	$\begin{bmatrix} 2.0414 & -0.5649 & -0.3447 \\ -0.9693 & 1.8760 & 0.0416 \\ 0.0134 & -0.1184 & 1.0154 \end{bmatrix}$	$\begin{bmatrix} 0.5767 & 0.1856 & 0.1882 \\ 0.2974 & 0.6273 & 0.0753 \\ 0.0270 & 0.0707 & 0.9911 \end{bmatrix}$	γ = N/A f = N/A s = N/A t = N/A
sRGB	$\begin{bmatrix} 3.2405 & -1.5371 & -0.4985 \\ -0.9693 & 1.8760 & 0.0416 \\ 0.0556 & -0.2040 & 1.0572 \end{bmatrix}$	$\begin{bmatrix} 0.4124 & 0.3576 & 0.1805 \\ 0.2126 & 0.7152 & 0.0722 \\ 0.0193 & 0.1192 & 0.9505 \end{bmatrix}$	γ = 0.42 f = 0.055 s = 12.92 t = 0.003
HDTV (HD-CIF)	$\begin{bmatrix} 3.2405 & -1.5371 & -0.4985 \\ -0.9693 & 1.8760 & 0.0416 \\ 0.0556 & -0.2040 & 1.0572 \end{bmatrix}$	$\begin{bmatrix} 0.4124 & 0.3576 & 0.1805 \\ 0.2126 & 0.7152 & 0.0722 \\ 0.0193 & 0.1192 & 0.9505 \end{bmatrix}$	γ = 0.45 f = 0.099 s = 4.5 t = 0.018
NTSC (1953)	$\begin{bmatrix} 1.9100 & -0.5325 & -0.2882 \\ -0.9847 & 1.9992 & -0.0283 \\ 0.0583 & -0.1184 & 0.8976 \end{bmatrix}$	$\begin{bmatrix} 0.6069 & 0.1735 & 0.2003 \\ 0.2989 & 0.5866 & 0.1145 \\ 0.0000 & 0.0661 & 1.1162 \end{bmatrix}$	γ = 0.45 f = 0.099 s = 4.5 t = 0.018

TABLE 2.8 Transformations for standard RGB color spaces (after [93]).

Color Space	XYZ to RGB Matrix	RGB to XYZ Matrix	Nonlinear Transform
SMPTE-C	$\begin{bmatrix} 3.5054 & -1.7395 & -0.5440 \\ -1.0691 & 1.9778 & 0.0352 \\ 0.0563 & -0.1970 & 1.0502 \end{bmatrix}$	$\begin{bmatrix} 0.3936 & 0.3652 & 0.1916 \\ 0.2124 & 0.7010 & 0.0865 \\ 0.0187 & 0.1119 & 0.9582 \end{bmatrix}$	$\gamma = 0.45$ $f = 0.099$ $s = 4.5$ $t = 0.018$
PAL/SECAM	$\begin{bmatrix} 3.0629 & -1.3932 & -0.4758 \\ -0.9693 & 1.8760 & 0.0416 \\ 0.0679 & -0.2289 & 1.0694 \end{bmatrix}$	$\begin{bmatrix} 0.4306 & 0.3415 & 0.1783 \\ 0.2220 & 0.7066 & 0.0713 \\ 0.0202 & 0.1296 & 0.9391 \end{bmatrix}$	$\gamma = 0.45$ $f = 0.099$ $s = 4.5$ $t = 0.018$
Wide gamut	$\begin{bmatrix} 1.4625 & -0.1845 & -0.2734 \\ -0.5228 & 1.4479 & 0.0681 \\ 0.0346 & -0.0958 & 1.2875 \end{bmatrix}$	$\begin{bmatrix} 0.7164 & 0.1010 & 0.1468 \\ 0.2587 & 0.7247 & 0.0166 \\ 0.0000 & 0.0512 & 0.7740 \end{bmatrix}$	$\gamma = \text{N/A}$ $f = \text{N/A}$ $s = \text{N/A}$ $t = \text{N/A}$

TABLE 2.8 (continued)

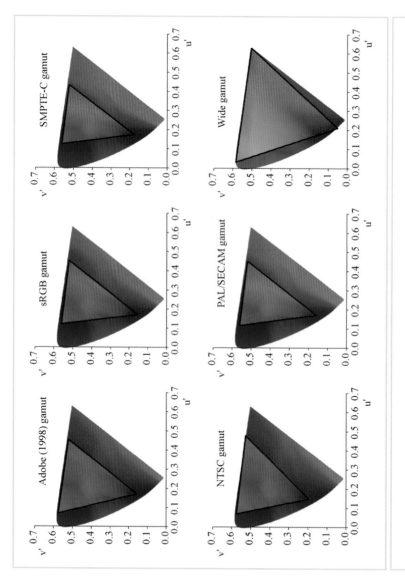

FIGURE 2.31 CIE (u', v') chromaticity diagrams showing the color gamuts for various color spaces.

The National Television System Committee (NTSC) standard was used as the color space for TV in North America. It has now been replaced with SMPTE-C to match phosphors in current display devices, which are more efficient and brighter. Phase Alternating Line (PAL) and Systeme Electronique Couleur Avec Memoire (SECAM) are the standards used for television in Europe.

Finally, the Wide gamut color space is shown for comparison [93]. Its primaries are monochromatic light sources with wavelengths of 450, 525, and 700 nm. This color space is much closer to the spectrally sharpened chromatic adaptation transforms discussed in Section 2.5.

HDR Image Encodings

03

An important consideration for any digital image is how to store it. This is especially true for HDR images, which record a much wider gamut than standard 24-bit RGB and therefore require an efficient encoding to avoid taking an excess of disk space and network bandwidth. Fortunately, several HDR file encodings and formats have already been developed by the graphics community. A few of these formats have been in use for decades, whereas others have just recently been introduced to the public. Our discussion includes these existing encodings, as well as encodings that lie on the horizon.

An *encoding* is defined as the raw bit representation of a pixel value, whereas a *format* includes whatever wrapper goes around these pixels to compose a complete image. The quality of the results is largely determined by the encoding, rather than the format, making encodings the focus of this chapter. File formats that include some type of "lossy" compression are the exceptions to this rule, and must be considered and evaluated as a whole. Lossy HDR formats are only starting to appear at the time of writing, making any comparisons premature. We simply introduce the basic concepts.

3.1 LDR VERSUS HDR ENCODINGS

There is more than bit depth to defining the difference between HDR and LDR encodings. Specifically, a 24-bit RGB image is usually classified as an *output-referred* standard, because its colors are associated with some target output device. In contrast, most HDR images are *scene-referred*, in that their pixels have a direct relation to

radiance in some scene, either real or virtual. This is logical, because most output devices are low in dynamic range, whereas most scenes are high in dynamic range. One cannot refer a color encoding to scene values if those values are beyond what can be represented, and thus LDR images are inappropriate for scene-referred data. On the other hand, an HDR encoding *could* be used to hold output-referred data, but there would be little sense in it because scene-referred data can always be mapped to a particular output device, but not the reverse. A scene-referred to output-referred transformation is a one-way street for the simple reason that no output device can reproduce all we see in the real world. This transformation is called *tone mapping*, a topic we return to frequently in this book. (See Chapters 6 through 8.)

Having just introduced this standard term, it is important to realize that *scene-referred* is really a misnomer, because no image format ever attempts to record *all* of the light projected from a scene. In most cases, there would be little sense in recording infrared and ultraviolet wavelengths, or even completely sampling the visible spectrum, because the eye is *trichromatic*. As explained in Chapter 2, this means that it is sufficient to record three color channels in order to reproduce every color visible to a human observer. These may be defined by the CIE XYZ tristimulus space or any equivalent three-primary space (e.g., RGB, YC_BC_R, CIELUV, and so on). Because we are really interested in what people see, as opposed to what is available, it would be better to use the term *human-referred* or *perceptual* for HDR encodings.

Nonetheless, the term *scene-referred* is still preferred, because sometimes we do wish to record more than the eye can see. Example applications for extrasensory data include the following.

- Satellite imagery, in which the different wavelengths may be analyzed and visualized in false color
- Physically-based rendering, in which lighting and texture maps interact to produce new colors in combination
- Scientific and medical visualization, in which (abstract) data is collected and visualized

In such applications, we need to record more than we could see of a scene with our naked eye, and HDR formats are a necessary means in accomplishing this. Further applications of HDR imagery are outlined in the following section.

3.2 APPLICATIONS OF HDR IMAGES

The demands placed on an HDR encoding vary substantially from one application to another. In an Internet application, file size might be the deciding factor. In an image database, it might be decoding efficiency. In an image-compositing system, accuracy might be most critical. The following describe some of the many applications for HDR, along with a discussion of their requirements.

Physically-based rendering (global illumination): Perhaps the first application to use HDR images, physically-based rendering, and lighting simulation programs must store the absolute radiometric quantities for further analysis and for perceptually based tone mapping [142,143]. In some cases, it is important to record more than what is visible to the human eye, as interactions between source and surface spectra multiply together. Additional accuracy may also be required of the encoding to avoid accumulated errors, and alpha and depth channels may also be desirable. A wide dynamic range is necessary for *image-based lighting*, especially in environments that include daylight. (See Chapter 9.)

Remote sensing: As mentioned in the previous section, satellite imagery often contains much more than is visible to the naked eye [75]. HDR is important for these images, as is multispectral recording and the ability to annotate using image metadata. Accuracy requirements may vary with the type of data being recorded, and flexibility is the key.

Digital photography: Camera makers are already heading in the direction of scene-referred data with their various RAW formats, but these are cumbersome and inconvenient compared to the standard encodings described in this chapter.[1] It is only a matter of time before cameras that directly write HDR images begin to appear on the market. File size is clearly critical to this application. Software compatibility is also important, although this aspect is largely neglected by camera RAW formats. Adobe's Digital Negative specification and software works toward alleviating this problem [3].

..

1 Each camera manufacturer employs its own proprietary format, which is usually not compatible with other manufacturers' RAW formats or even with popular image-editing software. These formats are collectively called RAW, because the camera's firmware applies only minimal processing to the data that are read from the sensor.

Image editing: Image-editing applications with support for HDR image data are now available. Photoshop CS 2 incorporates reading and writing of 32-bit pixel data, as does Photogenics (*www.idruna.com*), and a free open-source application called Cinepaint (*www.cinepaint.org*). A vast number of image-editing operations are possible on HDR data that are either difficult or impossible using standard output-referred data, such as adding and subtracting pixels without running under or over range, extreme color and contrast changes, and white balancing that works. Accuracy will be an important requirement here, again to avoid accumulating errors, but users will also expect support for all existing HDR image formats.

Digital cinema (and video): Digital cinema is an important and fast-moving application for HDR imagery. Currently, the trend is heading in the direction of a medium-dynamic-range output-referred standard for digital film distribution. Film editing and production, however, will be done in some HDR format that is either scene-referred or has some intermediate reference, such as movie film stock. For intermediate work, resolution and color accuracy are critical, but file size is also a consideration in that there are over 200,000 frames in a two-hour movie, and each of these may be composited from dozens of intermediate layers. Rendering a digital movie in HDR also permits HDR projection. (See Chapter 5, on display devices.) Looking further ahead, an exciting possibility is that HDR video may eventually reach the small screen. At least one HDR MPEG extension has already been proposed, which we discuss at the end of the next section.

Virtual reality: Many web experiences require the efficient transmission of images, which are usually encoded as JPEG or some other lossy representation. In cases in which a user is attempting to view or move around a virtual space, image exposure is often a problem. If there were a version of QuicktimeVR that worked in HDR, these problems could be solved. Establishing standards for lossy HDR compression is therefore a high priority for virtual reality on the Web.

Format	Encoding(s)	Compression	Metadata	Support/Licensing
HDR	RGBE	Run-length	Calibration, color space,	Open source software (*Radiance*)
	XYZE	Run-length	+user-defined	Quick implementation
TIFF	IEEE RGB	None	Calibration, color space,	Public domain library (*libtiff*)
	LogLuv24	None	+registered, +user-defined	
	LogLuv32	Run-length		
EXR	Half RGB	Wavelet, ZIP	Calibration, color space, +windowing, +user-defined	Open source library (*OpenEXR*)

TABLE 3.1 *Established HDR image file formats.*

Each of these applications, and HDR applications not yet conceived, carries its own particular requirements for image storage. The following section lists and compares the established HDR formats and discusses upcoming formats.

3.3 HDR IMAGE FORMATS

Table 3.1 lists three existing HDR image formats and compares some of their key attributes. The encodings within these formats are broken out in Table 3.2, where the basic parameters are given. In some cases, one format may support multiple encodings (e.g., TIFF). In other cases, we list encodings that have not yet appeared in any format but are the subject of published standards (e.g., scRGB). The standard 24-bit RGB (sRGB) encoding is also included in Table 3.2, as a point of comparison.

Encoding	Color Space	Bits/pixel	Dynamic Range (\log_{10})	Relative Step
sRGB	RGB in [0,1] range	24	1.6 orders	Variable
RGBE	Positive RGB	32	76 orders	1.0%
XYZE	(CIE) XYZ	32	76 orders	1.0%
IEEE RGB	RGB	96	79 orders	0.000003%
LogLuv24	Log Y + (u',v')	24	4.8 orders	1.1%
LogLuv32	Log Y + (u',v')	32	38 orders	0.3%
Half RGB	RGB	48	10.7 orders	0.1%
scRGB48	RGB	48	3.5 orders	Variable
scRGB-nl	RGB	36	3.2 orders	Variable
scYCC-nl	YC_BC_R	36	3.2 orders	Variable

TABLE 3.2 HDR pixel encodings, in order of introduction.

Formats based on logarithmic encodings, LogLuv24 and LogLuv32, maintain a constant relative error over their entire range.[2] For the most part, the floating-point encodings RGBE, XYZE, IEEE RGB, and Half RGB also maintain a constant relative error. The dynamic ranges quoted for the encodings sRGB, scRGB48, scRGB-nl, and scYCC-nl are based on the point at which their relative steps pass 5%. Above 5%, adjacent steps in the encoding are easily distinguished. If one were to view an sRGB image on an HDR display, regions below 0.025 of the maximum would exhibit visible banding, similar to that shown in Figure 3.1.[3] For luminance quantization to be completely invisible, the relative step size must be held under 1% [149]. This

. .

[2] Relative step size is the difference between adjacent values divided by the value. The relative error is generally held to half the relative step size, and is the difference between the correct value and the representation divided by the correct value.

[3] Thus, the dynamic range of sRGB is 0.025:1, which is the same ratio as $1:10^{1.6}$. In Table 3.2, we just report the number of orders (powers of 10).

FIGURE 3.1 *Banding due to quantization at the 5% level.*

is the goal of most HDR encodings, and some have relative step sizes considerably below this level. Pixel encodings with variable quantization steps are difficult to characterize in terms of their maximum dynamic range and are ill suited for HDR applications in which the display brightness scaling is not predetermined.

3.3.1 THE HDR FORMAT

The HDR format, originally known as the *Radiance* picture format (.hdr, .pic), was first introduced as part of the Radiance lighting simulation and rendering system in 1989 [144], and has since found widespread use in the graphics community, particularly for HDR photography and image-based lighting [17,18]. (See Chapters 4 and 9.) The file wrapper consists of a short ASCII header, followed by a resolution string that defines the image size and orientation, followed by the run-length en-

FIGURE 3.2 *Bit breakdown for the 32-bit/pixel RGBE (and XYZE) encodings.*

coded pixel data. The pixel data comes in two flavors: a 4-byte RGBE encoding [138] and a CIE variant, XYZE. The bit breakdown is shown in Figure 3.2.

The RGBE components R_M, G_M, and B_M are converted from the scene-referred color (R_W, G_W, B_W) via the following formula.

$$E = \lceil \log_2(\max(R_W, G_W, B_W)) + 128 \rceil$$

$$R_M = \left\lfloor \frac{256\, R_W}{2^{E-128}} \right\rfloor$$

$$G_M = \left\lfloor \frac{256\, G_W}{2^{E-128}} \right\rfloor$$

$$B_M = \left\lfloor \frac{256\, B_W}{2^{E-128}} \right\rfloor$$

There is also a special case for an input in which $\max(R_W, G_W, B_W)$ is less than 10^{-38}, which is written out as $(0,0,0,0)$. This gets translated to $(0,0,0)$ on the reverse conversion. The reverse conversion for the normal case is as follows.

$$R_W = \frac{R_M + 0.5}{256}\, 2^{E-128}$$

$$G_W = \frac{G_M + 0.5}{256}\, 2^{E-128}$$

$$B_W = \frac{B_M + 0.5}{256}\, 2^{E-128}$$

The conversions for XYZE are precisely the same, with the exception that CIE X, Y, and Z are substituted for R, G, and B, respectively. Because the encoding does not support negative values, using XYZE instead of RGBE extends the range to cover the entire visible gamut. (See Chapter 2 for details on the CIE XYZ space.) The dynamic range for these encodings is quite large (over 76 orders of magnitude), and the accuracy is sufficient for most applications. Run-length encoding achieves an average of 25% compression (1:1.3), making the image files about as big as uncompressed 24-bit RGB.

3.3.2 THE TIFF FLOAT AND LOGLUV FORMATS

For over a decade, the Tagged Image File Format (.tif, .tiff) has included a 32-bit/component IEEE floating-point RGB encoding [2]. This standard encoding is in some ways the ultimate in HDR image representations, covering nearly 79 orders of magnitude in miniscule steps. The flip side to this is that it takes up more space than any other HDR encoding — over three times the space of the Radiance format (described in the preceding section). The TIFF library does not even attempt to compress this encoding, because floating-point data generally do not compress very well. Where one might get 30% compression from run-length encoding of RGBE data, 10% is the most one can hope for using advanced entropy compression (e.g., ZIP) on the same data stored as IEEE floats. This is because the last 12 bits or more of each 24-bit mantissa will contain random noise from whatever camera or global illumination renderer generated them. There simply are no image sources with 7 decimal digits of accuracy, unless they are completely synthetic (e.g., a smooth gradient produced by a pattern generator).

Nevertheless, 96-bit/pixel RGB floats have a place, and that is as a lossless intermediate representation. TIFF float is the perfect encoding for quickly writing out the content of a floating-point frame buffer and reading it later without loss. Similarly, raw floats are a suitable means of sending image data to a compositor over a high-bandwidth local connection. They can also serve as a "gold standard" for evaluating different HDR representations, as shown in Section 3.4. However, most programmers and users are looking for a more compact representation, and within TIFF there are two: 24-bit and 32-bit LogLuv.

The LogLuv encoding was introduced as a perceptually based color encoding for scene-referred images [71]. Like the IEEE float encoding just described,

LogLuv is implemented as part of the popular public domain TIFF library. (See *www.remotesensing.org/libtiff.* Appropriate examples are also included on the companion DVD-ROM.) The concept is the same for the 24-bit and 32-bit/pixel variants, but they achieve a different range and accuracy. In both cases, the scene-referred data is converted to separate luminance (Y) and CIE (u, v) channels. (Review Chapter 2 for the conversions between CIE and RGB color spaces.) The logarithm of luminance is then taken, and the result is quantized into a specific range, which is different for the two encodings, although both reserve the 0 code for $Y = 0$ (black). In the case of the 24-bit encoding, only 10 bits are available for the log luminance value. Quantization and recovery are computed as follows.

$$L_{10} = \left\lfloor 64 \left(\log_2 Y_{W+12} \right) \right\rfloor$$

$$Y_{W=2} \quad \frac{L_{10} + 0.5}{64} - 12$$

This encoding covers a world luminance (Y_W) range of 0.00025:15.9, or 4.8 orders of magnitude in uniform (1.1%) steps. In cases in which the world luminance is skewed above or below this range, we can divide the scene luminances by a constant and store this calibration factor in the TIFF STONITS tag.[4] When decoding the file, applications that care about absolute values consult this tag and multiply the extracted luminances accordingly.

The remaining 14 bits of the 24-bit LogLuv encoding are used to represent chromaticity, based on a lookup of CIE (u, v) values, as diagrammed in the lower portion of Figure 3.3. A zero lookup value corresponds to the smallest v in the visible gamut, and subsequent table entries are built up left to right, then bottom to top, in the diagram. The uniform step size for u and v is 0.0035, which is just large enough to cover the entire visible gamut in 2^{14} codes. The idea is that employing a *perceptually uniform* color space, in which equal steps correspond to equal differences in color, keeps quantization errors below the visible threshold. Unfortunately, both the (u, v) step size and the luminance step size for the 24-bit encoding are slightly larger than the ideal. This quantization was chosen to cover the full gamut over a reasonable luminance range in a 24-bit file, and the TIFF library applies dithering

4 STONITS stands for "sample-to-nits." Recall from Chapter 2 that the term *nits* is shorthand for candelas/meter2.

FIGURE 3.3 Bit breakdown for 24-bit LogLuv encoding and method used for CIE (u, v) lookup.

by default to hide steps where they might otherwise be visible.[5] Because there is no compression for the 24-bit LogLuv encoding, there is no penalty in dithering.

The 32-bit LogLuv TIFF encoding is similar to the 24-bit LogLuv variant, but allows a greater range and precision. The conversion for luminance is as follows.

$$L_{15} = \lfloor 256 \left(\log_2 Y_{W+64} \right) \rfloor$$

$$Y_{W=2} \frac{L_{15} + 0.5}{256} - 64$$

5 Dithering is accomplished during encoding by adding a random variable in the (−0.5, 0.5) range immediately before integer truncation.

FIGURE 3.4 Bit breakdown for 32-bit LogLuv encoding. Upper- and lower-order bytes are separated per scan line during run-length compression to reduce file size.

This 15-bit encoding of luminance covers a range of $5.5 \times 10^{-20} : 1.8 \times 10^{19}$, or 38 orders of magnitude in 0.3% steps. The bit breakdown for this encoding is shown in Figure 3.4. The leftmost bit indicates the sign of luminance, permitting negative values to be represented.[6] The CIE u and v coordinates are encoded in 8 bits each, which allows for sufficiently small step sizes without requiring a lookup. The conversion for chromaticity is simply

$$u_8 = \lfloor 410\, u' \rfloor$$
$$v_8 = \lfloor 410\, v' \rfloor$$
$$u' = \frac{u_8 + 0.5}{410}$$
$$v' = \frac{v_8 + 0.5}{410}.$$

Again, dithering may be applied by the TIFF library to avoid any evidence of quantization, but it is not used for 32-bit LogLuv by default because the step sizes are below the visible threshold and run-length compression would be adversely affected. The compression achieved by the library for undithered output is 10 to 70%. Average compression is 40% (1:1.7).

Most applications will never see the actual encoded LogLuv pixel values, in that the TIFF library provides conversion to and from floating-point XYZ scan lines. However, it is possible through the use of lookup on the raw encoding to combine

. .

6 This is useful for certain image-processing operations, such as compositing and error visualizations.

the reading of a LogLuv file with a global tone-mapping operator, thus avoiding floating-point calculations and providing for rapid display [70]. The TIFF library provides raw data access for this purpose.

3.3.3 THE OPENEXR FORMAT

The EXtended Range format (.exr) was made available as an open-source C++ library in 2002 by Industrial Light and Magic (see *www.openexr.com*) [62]. It is based on a 16-bit *half* floating-point type, similar to IEEE float with fewer bits. Each RGB pixel occupies a total of 48 bits, broken into 16-bit words (as shown in Figure 3.5). The Half data type is also referred to as S5E10, for "sign, five exponent, ten mantissa." The OpenEXR library also supports full 32-bit/channel (96-bit/pixel) floats and a new 24-bit/channel (72-bit/pixel) float type introduced by Pixar. We have already discussed the 32-bit/channel IEEE representation in the context of the TIFF format, and we have no further information on the 24-bit/channel type at this time. We will therefore restrict our discussion to the 16-bit/channel Half encoding.

The formula for converting from an encoded Half value follows. Here, S is the sign bit, E the exponent (0 to 31), and M the mantissa (0 to 1,023).

$$h = \begin{cases} (-1)^S \, 2^{E-15} \left(1 + \dfrac{M}{1024}\right) & 1 \leq E \leq 30 \\ (-1)^S \, 2^{-14} \, \dfrac{M}{1024} & E = 30 \end{cases}$$

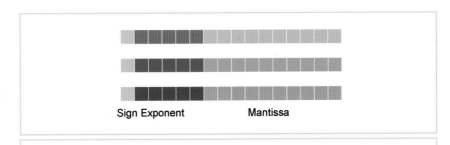

Sign Exponent Mantissa

FIGURE 3.5 *Bit breakdown for the OpenEXR Half pixel encoding.*

If the exponent E is 31, the value is infinity if $M = 0$ and NaN (not a number) otherwise. Zero is represented by all zero bits. The largest representable value in this encoding is 65,504, and the smallest normalized (i.e., full accuracy) value is 0.000061. This basic dynamic range of 9 orders is enhanced by the "denormalized" values below 0.000061, which have a relative error below 5% down to 0.000001, for a total dynamic range of 10.7 orders of magnitude. Over most of this range, the quantization step size is under 0.1%, which is far below the visible threshold. This permits extensive image manipulations before artifacts become evident, which is one of the principal strengths of this encoding. Another advantage of the Half encoding is that the selfsame 16-bit representation is specified in NVidia's Cg language [79]. This will ultimately make transfer to and from graphics hardware straightforward and is promising for future hardware standardization as well.

The OpenEXR library contains C++ classes for reading and writing EXR image files, with support for lossless compression, tiling, and mip mapping. Compression is accomplished using the ZIP deflate library as one alternative, or Industrial Light and Magic's (ILM) more efficient PIZ lossless wavelet compression. From our experiments, PIZ achieves a 60% reduction on average compared to uncompressed 48-bit/pixel RGB. OpenEXR also supports arbitrary data channels, including alpha, depth, and user-defined image data. Similar to the TIFF format, standard attributes are provided for color space, luminance calibration, pixel density, capture date, camera settings, and so on. User-defined attributes are also supported, and unique to OpenEXR is the notion of a "display window" to indicate the active region of an image. This is particularly useful for special effects compositing, wherein the notion of what is on-screen and what is off-screen may evolve over the course of a project.

3.3.4 OTHER ENCODINGS

There are a few other encodings that have been used or are being used to represent medium-dynamic-range image data (i.e., between 2 and 4 orders of magnitude). The first is the Pixar log encoding, which is available in the standard TIFF library along with LogLuv and IEEE floating point. This 33-bit/pixel encoding assigns each of 11 bits to red, green, and blue using a logarithmic mapping designed to fit the range of movie film. The implementation covers about 3.8 orders of magnitude in 0.4% steps, making it ideal for film work but marginal for HDR work. Few people have used this encoding outside of Pixar, and they have themselves moved to a

higher-precision format. Another image standard that is even more specific to film is the Cineon format, which usually records logarithmic density in 10 bits/channel over a 2.0 range (*www.cineon.com*). Although these 2.0 orders of magnitude may correspond to slightly more range once the film response curve has been applied, it does not qualify as an HDR encoding, and it is not scene-referred. Mechanically, the Cineon format will handle greater bit depths, but the meaning of such an extension has never been defined.

More recently, the IEC has published a standard that defines the scRGB48, scRGB-nl, and scYCC-nl encodings, listed in Table 3.2 [56]. As shown in Table 3.2, these encodings also encompass a relatively small dynamic range, and we are not aware of any software product or file format that currently uses them. We will therefore leave this standard out of this discussion, although an analysis may be found at *www.anyhere.com/gward/hdrenc* as well as on the companion DVD-ROM.

3.3.5 EMERGING "LOSSY" HDR FORMATS

All of the HDR image formats we have discussed so far, and indeed all of the HDR standards introduced to date, are *lossless* insofar as once the original scene values have been converted into the encoding, no further loss takes place during storage or subsequent retrieval. This is a desirable quality in many contexts, especially when an image is expected to go through multiple storage and retrieval steps (with possible manipulations) before reaching its final state. However, there are some applications for which a *lossy* format is preferred, particularly when the storage costs are onerous or no further editing operations are anticipated or desired. Two such applications lie just around the corner, and they will need suitable lossy standards to meet their needs: HDR photography and HDR video. At the time of writing, two lossy encoding methods have been introduced for HDR: one for still images and one for video.

HDR Disguised as JPEG: The Sub–band Encoding Method Ward and Simmons developed a still image format that is backward compatible with the 8-bit JPEG standard [136]. This *sub-band encoding* method stores a tone-mapped image as a JPEG/JFIF file, packing restorative information in a separate 64-Kbyte marker. Naïve applications ignore this marker as extraneous, but newer software can recover the

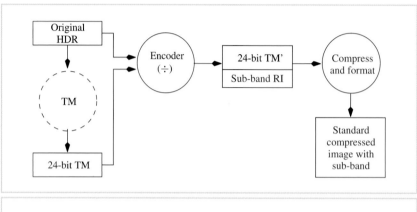

FIGURE 3.6 *The sub-band encoding pipeline. (Reprinted from [136].)*

full HDR data by recombining the encoded information with the tone-mapped image. In other words, 64 Kbytes is enough to create a scene-referred original from an output-referred JPEG. Since most JPEG images produced by today's digital cameras are over 1 Mbyte, this is only a 5% increase in file size. By comparison, the most compact lossless HDR format requires 16 times as much storage space as JPEG.

Figure 3.6 shows the encoding pipeline, including the to-be-specified tone-mapping operator (TM). In principle, any tone-mapping operator can work, but we found that the photographic operator [109] (see Section 7.3.6) and the bilateral filter operator [23] (see Section 8.1.2) worked the best with this method. Once the tone-mapped image is derived, its pixels are divided into the original to obtain a grayscale "ratio image," which is then compressed and incorporated in the JPEG file as a sub-band marker.

Figure 3.7 shows an HDR image of a church that has been decomposed into a tone-mapped image and the corresponding ratio image. The ratio image is down-sampled and log encoded before being passed to the JPEG compressor to squeeze it into 64 Kbytes. This size is the upper limit for a JFIF marker, and the ratio image size and compression quality are optimized to fit within a single marker, although multiple markers might be used in some cases. Loss of detail is prevented either by

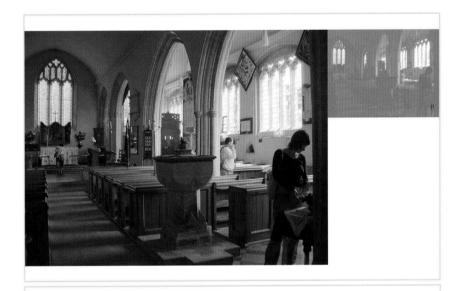

FIGURE 3.7 *An HDR image of a church divided into a tone-mapped version and the downsampled ratio image that is stored as a sub-band.*

enhancing edges in the tone-mapped image to compensate for the downsampled ratio image or by synthesizing high frequencies in the ratio image during upsampling, depending on the application and user preference. The dynamic range of the format is unrestricted in the sense that the log encoding for the ratio image is optimized to cover the input range with the smallest step size possible.

Figure 3.8 illustrates the decode process. A naïve application extracts the tone-mapped pixels and treats them as a standard output-referred image. An HDR application, however, recognizes the sub-band and decompresses both this ratio image and the tone-mapped version, multiplying them together to recover the original scene-referred data.

Two clear benefits arise from this strategy. First, a tone-mapped version of the HDR image is immediately available — for naïve applications that cannot handle

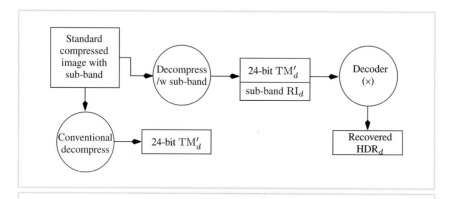

FIGURE 3.8 *The sub-band decoding pipeline. The lower left shows the backward-compatible path for naïve applications, and the upper right shows the path for an HDR decoder.*

anything more and for HDR applications that may be able to perform their own tone-mapping given time but wish to provide the user with immediate feedback. Second, by making the format *backward compatible* with the most commonly used image type for digital cameras an important barrier to adoption has been removed for the consumer, and hence for camera manufacturers.

Ward and Simmons tested the sub-band encoding method on 15 different HDR images, passing them through a single encoding-decoding cycle and comparing them to the original using Daly's visible differences predictor (VDP) [15]. With the exception of a single problematic image, VDP showed that fewer than 0.2% of the pixels had visible differences at the maximum quality setting in any one image, which went up to an average of 0.6% at a 90% quality setting.

The problem image was a huge (5,462 × 4,436) Radiance rendering of a car in a tunnel, with stochastic samples whose local variance spanned about 5 orders of magnitude. This proved too much for the downsampled ratio image to cope with, leading to the conclusion that for some large renderings it may be necessary to break the 64-Kbyte barrier and record multiple markers to improve accuracy. In most cases, however, the authors found that 64 Kbytes was ample for the sub-

band, and the overall image size was therefore comparable to a JPEG file of the same resolution. This makes a strong argument for lossy HDR compression when file size is critical. In addition to digital photography, Internet sharing of HDR imagery is a prime candidate for such a format.

An HDR Extension to MPEG Mantiuk et al. have introduced an HDR encoding method built on the open-source XviD library and the MPEG-4 video standard [78]. The diagram in Figure 3.9 shows the standard MPEG compression pipeline in black. Extensions to this pipeline for HDR are shown in blue. The modified MPEG encoding pipeline proceeds as follows for each frame.

1 A 32-bit/channel XYZ is taken on input rather than 8-bit/channel RGB.
2 XYZ is converted into CIE (u, v) coordinates of 8 bits each and an 11-bit perceptual luminance encoding, L_p.
3 This 11/8/8 bit encoding is passed through a modified discrete cosine transform (DCT), which extracts high-contrast edges from the luminance channel for separate run-length encoding.
4 The DCT blocks are quantized using a modified table and passed through a variable-length coder.
5 The edge blocks are joined with the DCT blocks in an HDR-MPEG bit stream.

The decoding process is essentially the reverse of this, recombining the edge blocks at the DCT reconstruction stage to get back L_p (u, v) color values for each pixel. These may then be decoded further, into CIE XYZ floats, or passed more efficiently through appropriate lookup tables for real-time display (e.g., tone mapping).

One of the key optimizations in this technique is the observation that the entire visible range of luminances, 12 orders of magnitude, can be represented in only 11 bits using invisible quantization steps. By taking advantage of the human contrast versus intensity (CVI) curve, it is possible to find a varying step size from the minimum perceivable luminance to the maximum, avoiding wasted codes in the darker regions (where the eye is less sensitive) [35].[7] This implicitly assumes that the encoded information has some reasonable calibration, and that the ultimate

. .

7 The CVI curve is equal to the threshold versus intensity (TVI) curve divided by adaption luminance. The TVI function is discussed in detail in Chapter 6.

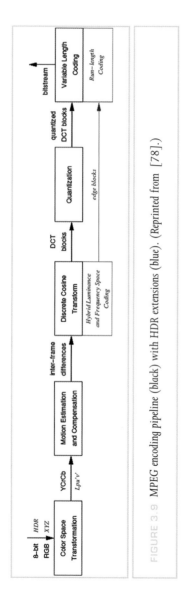

FIGURE 3.9 *MPEG encoding pipeline (black) with HDR extensions (blue). (Reprinted from [78].)*

consumer is a human observer as opposed to a rendering algorithm in need of HDR input. These are defensible assumptions for compressed video. Even if the absolute calibration of the incoming luminances is unknown, a suitable multiplier could be found to take the maximum input value to the maximum L_p representation, thus avoiding clipping. In that an observer would not be able to see more than 12 orders of magnitude below any safe maximum, such a scaling would provide full input visibility. The only exception to this is if the input contains an unreasonably bright source in the field of view, such as the sun.

Figure 3.10 shows the human CVI curve compared to the quantization errors for the encodings we have discussed. The blue line shows the error associated with Mantiuk et al.'s L_p encoding, which mirrors human contrast sensitivity while staying comfortably below the visible threshold. When HDR video displays enter the

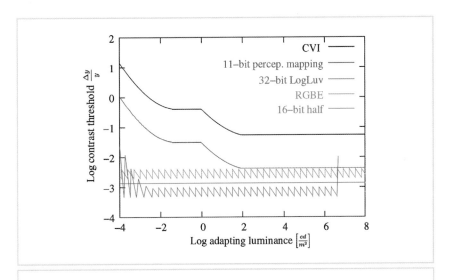

FIGURE 3.10 *Quantization error of HDR encodings as a function of adapting luminance. (The sawtooth form of the floating point encodings has been exaggerated for clarity.)*

market, an extended video standard will be needed, and this research is an important step toward such a standard.

3.4 HDR ENCODING COMPARISON

To compare HDR image formats, we need a driving application. Without an application, there are no criteria, just speculation. The application determines the context and sets the requirements.

For our example comparison, we have chosen a central application for HDR: scene-referred image archival. Specifically, we wish to store HDR images from any source to be displayed at some future date on an unknown device at the highest quality it supports. Assuming this display has not been invented, there is no basis for writing to an output-referred color space, and hence a scene-referred encoding is the only logical representation. Thus, the need for HDR.

A reasonable assumption is that a full spectral representation is not necessary, because humans perceive only three color dimensions. (Refer to Chapter 2.) Further, we assume that it is not necessary to record more than the visible gamut, although it is not safe to assume we can store less. Likewise, the quantization steps must be kept below the visible threshold, but because we plan no further manipulations prior to display, extra accuracy only means extra storage. The requirements for image archiving are therefore as follows.

- Cover the visible gamut with a tristimulus color space (XYZ, RGB, and so on)
- Cover the full range of perceivable luminances
- Have quantization steps below the visible threshold at all levels

Furthermore, it is desirable for the format to:

- Minimize storage costs (Mbytes/Mpixel)
- Encode and decode quickly

Considering the previous requirements list, we can rule out the use of the RGBE encoding (which does not cover the visible gamut) and the 24-bit LogLuv encoding, which does not cover the full luminance range. This leaves us with the XYZE

encoding (.hdr), the IEEE floating-point and 32-bit LogLuv encodings (.tif), and the Half encoding (.exr). Of these, the IEEE float representation will clearly lose in terms of storage costs, but the remaining choices merit serious consideration. These are as follows.

- The 32-bit Radiance XYZE encoding
- The 32-bit LogLuv encoding
- The 48-bit OpenEXR Half encoding

On the surface, it may appear that the XYZE and LogLuv encodings have a slight edge in terms of storage costs, but the OpenEXR format includes a superior compression engine. In addition, the extra bits in the Half encoding may be worthwhile for some archiving applications that need or desire accuracy beyond normal human perception. To evaluate the candidate formats, the following test was conducted on a series of IEEE floating-point images, some captured and some rendered.

1 The data is encoded into the test format, noting the CPU time and disk space requirements.
2 The data is then decoded, noting the CPU time required.
3 The decoded data can then be compared to the original using CIE ΔE^* 1994 perceptual color difference metric.

CIE ΔE^* 1994 is an updated version of the perceptual difference metric presented in Chapter 2 [80]. Using this metric, an encoded pixel color can be compared to the original source pixel by computing the visible difference. However, we must first modify the difference metric to consider local adaptation in the context of HDR imagery. To do this, the brightest Y value within a fixed region about the current pixel is found, and this value is used as the reference white. This simulates the effect of a viewer adapting their vision (or display) locally, as we would expect them to do with an HDR image. The only question is how large a region to use, and for this a reasonable choice is to use a radius of 50 pixels, as this tends to be the size of interesting objects in our test image set.

Among the test images, we included a synthetic pattern that covered the full visible gamut and dynamic range with sufficient density to sample quantization errors at all levels. This pattern, a spiral slice through the visible gamut from 0.01

FIGURE 3.11 *The gamut test pattern, spanning eight orders of magnitude. This image was tone mapped with the histogram adjustment technique for the purpose of reproduction in this book (see Section 7.2.8).*

to 1,000,000 cd/m^2, is shown in Figure 3.11. (This image is included on the companion DVD-ROM as an IEEE floating-point TIFF.) Each peak represents one revolution through the visible color gamut, and each revolution spans one decade (factor of 10) in luminance. The gray-looking regions above and below the slice actually contain random colors at each luminance level, which provide an even more thorough testing of the total space. Obviously, tone mapping has been used to severely compress the original dynamic range and colors in order to print this otherwise undisplayable image.

Figure 3.12 shows the CIE ΔE^* encoding errors associated with a 24-bit sRGB file, demonstrating how ill suited LDR image formats are for archiving real-world colors. Only a narrow region covering under two orders of magnitude with an incomplete gamut is below the visible difference threshold (2.0 in ΔE^*). In contrast, the three HDR encodings we have chosen for this application do quite well on this test pattern, as shown in Figure 3.13. Errors are held below the visible threshold in each encoding over all eight orders, except for a few highly saturated colors near the top of the EXR Half range. The average ΔE^* values for Radiance XYZE, 32-bit LogLuv, and EXR Half were 0.2, 0.3, and 0.06, respectively.

Figure 3.14 shows the two encodings we rejected on the basis that they did not cover the full dynamic range and gamut, and indeed we see they do not. As expected, the Radiance RGBE encoding is unable to represent highly saturated colors, although it easily spans the dynamic range. The 24-bit LogLuv encoding, on the

other hand, covers the visible gamut, but only spans 4.8 orders of magnitude. Although they may not be well suited to our proposed application, there are other applications to which these encodings are perfectly suited. In some applications, for example, there is no need to represent colors outside those that can be displayed on an RGB monitor. Radiance RGBE has slightly better resolution than XYZE in the same number of bits and does not require color transformations. For other applications, 4.8 orders of magnitude may be sufficient because they only need to cover the human *simultaneous* range; that is, the range over which an observer can comfortably adapt without the use of blinders. Because 24-bit LogLuv covers the full gamut in this range as well, applications that need to fit the pixel data into a 24-bit buffer for historical reasons may prefer it to the 32-bit alternatives. It was used in a proprietary hardware application in which a prepared 24-bit lookup translates scene-referred colors to device space via a 16-million entry table. Such a lookup would be impossible with a 32-bit encoding, which would require 4 billion entries.

In addition to color gamut and dynamic range, we are also interested in the statistical behavior of these formats on real images, especially with regard to file size and compression times. Figure 3.15 shows a test set of 34 images. Of these, 19 are HDR photographs of real scenes and 15 are computer generated, and sizes range from 0.2 to 36 Mpixels, with 2.4 Mpixels being average.

FIGURE 3.12 *This false color plot shows the visible error behavior of the 24-bit sRGB encoding on the test pattern shown in Figure 3.11. (CIE ΔE^* values above 2 are potentially visible, and above 5 are evident.)*

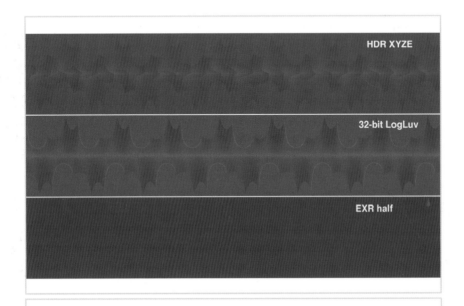

Error levels for the chosen HDR encodings applied to the gamut test pattern from Figure 3.11, using the same scale as shown in Figure 3.12.

Figure 3.16 charts the read/write performance and file size efficiency for each of the three selected formats. This figure shows that the Radiance HDR format has the fastest I/O performance, but creates larger files. The OpenEXR library is considerably slower with its I/O, but creates smaller files than Radiance, despite the 48 bits of the Half pixel encoding. The 32-bit LogLuv TIFF format has intermediate I/O performance, and produces the smallest files.

The average CIE ΔE^* error performance of the three encodings is the same over the entire image set as we reported for the gamut test alone, with the following exceptions. One of the test images from ILM, "Desk," contained pixel values that are completely outside the visible gamut and could not be reproduced with either Radiance XYZE or 32-bit LogLuv. Because we do not expect a need for archiving

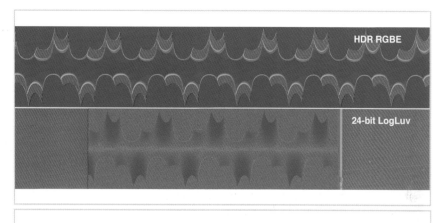

FIGURE 3.14 *The CIE ΔE^* associated with the gamut test pattern in Figure 3.11 for the Radiance RGBE and 24-bit LogLuv encodings, using the same scale as Figure 3.12.*

colors that cannot be seen or reproduced, this should not count against these two encodings for this application. A few of the renderings had pixels outside the representable dynamic range of EXR's Half data type. In those cases, we did not resort to scaling the images to fit within the $10^{-6}:10^4$ range as we might have.

In summary, we found that the XYZE and LogLuv encodings are restricted to the visible gamut, and the Half encoding has a slightly smaller dynamic range. Neither of these considerations is particularly bothersome, and thus we conclude that all three encodings perform well for HDR image archiving.

3.5 CONCLUSIONS

The principal benefit of using scene-referred HDR images is their independence from the display process. A properly designed HDR format covers the full range and sensitivity of human vision, and is thus prepared for *any* future display technology intended for humans. Many HDR formats offer the further benefit, through additional range and accuracy, of permitting complex image operations without

FIGURE 3.15 The test set of 34 HDR images.

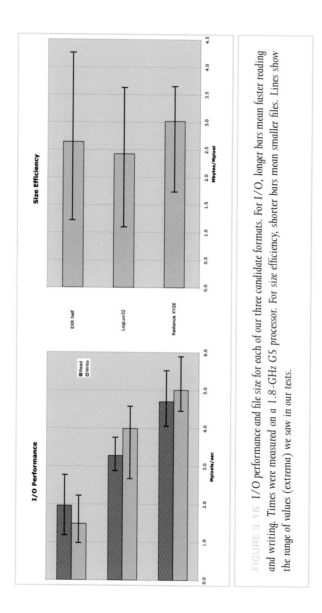

FIGURE 3.16 *I/O performance and file size for each of our three candidate formats. For I/O, longer bars mean faster reading and writing. Times were measured on a 1.8-GHz G5 processor. For size efficiency, shorter bars mean smaller files. Lines show the range of values (extrema) we saw in our tests.*

exposing quantization and range errors typical of more conventional LDR formats. The cost of this additional range and accuracy is modest — similar to including an extra alpha channel in an LDR format. This burden can be further reduced in cases in which accuracy is less critical (i.e., when multiple image read/edit/write cycles are not expected).

All of the existing HDR file formats are "lossless" in the sense that they do not lose information after the initial encoding, and repeated reading and writing of the files does not result in further degradation. However, it seems likely that "lossy" HDR formats will soon be introduced that offer much better compression, on a par with existing JPEG images. This will remove an important barrier to HDR adoption in markets such as digital photography and video and in web-based applications such as virtual reality tours.

The Resources section of the DVD-ROM includes complete demonstration software and images employing the JPEG-HDR lossy compression format described as preliminary work in this chapter.

HDR Image Capture

04

HDR images may be captured from real scenes or rendered using 3D computer graphics (CG) techniques such as radiosity and raytracing. A few modern graphics cards are even capable of generating HDR images directly. The larger topic of CG rendering is well covered in other textbooks [24,37,58,117,144]. In this chapter, the focus is on practical methods for capturing high-quality HDR images from real scenes using conventional camera equipment. In addition, commercial hardware designed to capture HDR images directly is beginning to enter the market, which is discussed toward the end of this chapter.

4.1 PHOTOGRAPHY AND LIGHT MEASUREMENT

A camera is essentially an imperfect device for measuring the radiance distribution of a scene, in that it cannot capture the full spectral content and dynamic range. (See Chapter 2 for definitions of color and radiance.) The film or image sensor in a conventional or digital camera is exposed to the color and dynamic range of a scene, as the lens is a passive element that merely refocuses the incoming light onto the image plane. All of the information is there, but limitations in sensor design prevent cameras from capturing all of it. Film cameras record a greater dynamic range than their digital counterparts, especially when they expose a negative emulsion.

Standard black-and-white film emulsions have an inverse response to light, as do color negative films. Figure 4.1 shows example response curves for two film emulsions, demonstrating a sensitive range of nearly 4 log units, or a 10,000:1

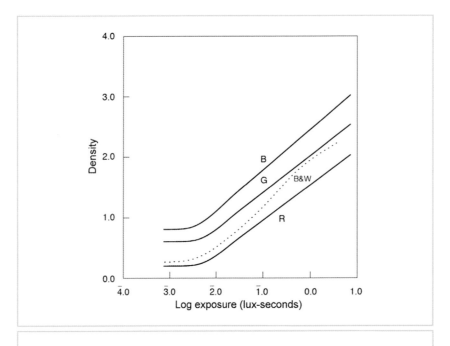

FIGURE 4.1 *Characteristic film curves showing response for color (R, G, and B) and black-and-white negative films over nearly four orders of magnitude.*

contrast ratio. Depending on the quality of the lens and the blackness of the camera's interior, some degree of "flare" may inhibit this range, particularly around a bright point such as the sun or its reflection. Although the capability of recording 4 log units of dynamic range is there, flare may reduce the effective dynamic range somewhat.

The film development process may also limit or enhance the information retrieved from the exposed emulsion, but the final constraining factor is of course the printing process. It is here where tone mapping takes place, in that the effective dynamic range of a black-and-white or color print is about 100:1 at best. Darkroom

techniques such as dodge-and-burn may be used to get the most out of a negative, although in an industrial film processing lab what usually happens is more akin to autoexposure after the fact.

To extract the full dynamic range from a negative, we need to digitize the developed negative or apply a "dry developing method" such as that developed by Applied Science Fiction and marketed in the Kodak Film Processing Station [25]. Assuming that a developed negative is available, a film scanner would be required that records the full log range of the negative in an HDR format. Unfortunately, no such device exists, although it is technically feasible. However, one can take a standard film scanner, which records either into a 12-bit linear or an 8-bit sRGB color space, and use multiple exposures to obtain a medium-dynamic-range result from a single negative. The process is identical to the idealized case for multiple-exposure HDR capture, which we describe in the following section. The same method may be used to obtain an HDR image from a sequence of exposures using a standard digital camera, or to enhance the dynamic range possible with a film camera.

4.2 HDR IMAGE CAPTURE FROM MULTIPLE EXPOSURES

Due to the limitations inherent in most digital image sensors, and to a lesser degree in film emulsions, it is not possible to capture the full dynamic range of an image in a single exposure. However, by recording multiple exposures a standard camera with the right software can create a single HDR image (i.e., a *radiance map*, as defined in Chapter 2). These exposures are usually captured by the camera itself, although in the case of recovering HDR information from a single negative the same technique may be applied during the film-scanning phase.

By taking multiple exposures, each image in the sequence will have different pixels properly exposed, and other pixels under- or overexposed. However, each pixel will be properly exposed in one or more images in the sequence. It is therefore possible and desirable to ignore very dark and very bright pixels in the subsequent computations.

Under the assumption that the capturing device is perfectly linear, each exposure may be brought into the same domain by dividing each pixel by the image's expo-

sure time. From the recorded radiance values L_e, this effectively recovers irradiance values E_e by factoring out the exposure duration.[1]

Once each image is in the same unit of measurement, corresponding pixels may be averaged across exposures — excluding, of course, under- and overexposed pixels. The result is an HDR image.

In practice, cameras are not perfectly linear light measurement devices, objects frequently do not remain still between individual exposures, and the camera is rarely kept still. Thus, in practice this procedure needs to be refined to include camera response curves, image alignment techniques, and ghost and lens flare removal.

Extracting a medium-dynamic-range radiance map from a single negative is relatively straightforward because it does not require alignment of multiple frames, and does not suffer from object displacement that may occur during the capture of several exposures. It therefore serves as the basis for the techniques presented later in this chapter.

4.3 FILM SCANNING

In the ideal case for creating an HDR image from multiple LDR exposures, the scene or image should be completely static (e.g., an exposed and developed negative). We assume that the response curve of the film is known. In addition, the LDR capture device (such as an 8-bit/primary film scanner with known response curves) should provide some means of exactly controlling the exposure during multiple captures.

Creating an HDR image under these conditions starts by taking scans with multiple exposures. In addition, the system response is inverted to get back to a linear relation between scene radiances and pixel values. Each scanned image is multiplied by a calibration factor related to its exposure, and combined into an HDR result. The only question is what weighting function to use in averaging together the linear exposures. Of course, the lightest and darkest pixels at the limits of each exposure should be excluded from consideration because these pixels are under- or overexposed. But how should the pixels between be weighted?

. .

1 The quantity captured by the camera is spectrally weighted radiance. As such, calling this quantity "radiance" is inappropriate. However, the spectral response curve is typically not the same as the CIE $V(\lambda)$ curve, and therefore this quantity also cannot be called "luminance" [18]. When the term *radiance* or *irradiance* is used, it should be understood that this refers to spectrally weighted radiance and irradiance.

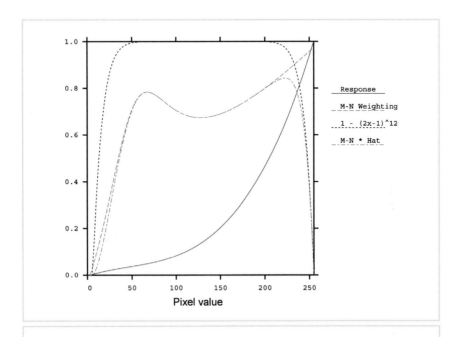

FIGURE 4.2 *The inverted system response function (solid line) and recommended Mitsunaga–Nayar weighting function, multiplied by an additional hat function* $1 - (2x - 1)^{12}$ *to devalue the extrema, which are often suspect.*

Mann and Picard proposed a certainty/weighting function equal to the derivative of the system response curve for each color channel, using the argument that greater response sensitivity corresponds to greater certainty [5]. Debevec and Malik used a simple hat function based on the assumption that mid-range pixels are more reliable [18]. Mitsunaga and Nayar used signal theory to argue for multiplying Mann and Picard's weight by the response output, in that larger values are less influenced by a constant noise floor [82]. Any of these methods will yield a satisfactory result, although the latter weighting function is better supported by signal theory. The Mitsunaga–Nayar weighting seems to work best when multiplied by a broad hat

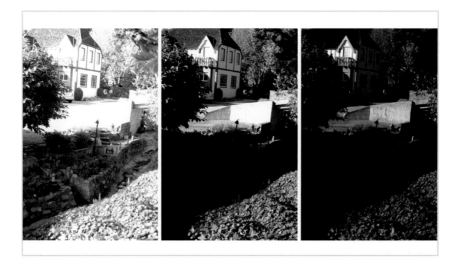

FIGURE 4.3 *Our example exposure sequence. Each image is separated by two f-stops (equal to a factor of 4, or 0.6 log$_{10}$ units).*

function, as shown in Figure 4.2. This avoids dubious pixels near the extremes, where gamut limitations and clamping may affect the output values unpredictably.

Figure 4.3 shows a sequence of perfectly aligned exposures. Figure 4.4 (left) shows the weighting used for each of the three contributing exposures, where blue is used for the longest exposure, green for the middle exposure, and red for the shortest exposure. As this figure shows, most pixels are a mixture of multiple exposures, with some pixels relying solely on the extremes of the exposure range. Figure 4.4 (right) shows the combined result, tone mapped using a histogram adjustment operator [142].

If the multiple exposures come not from multiple scans of a single negative but from multiple negatives or digital images, combining images may become problematic. First, the camera may shift slightly between exposures, which will result in some subtle (and possibly not-so-subtle) misalignments that will blur the re-

FIGURE 4.4 The combined HDR result, tone mapped using the histogram adjustment operator (described in Section 7.2.8) in the right-hand image. The left-hand image shows contributing input image weights, where blue shows where the longer exposure dominates, green the middle, and red the shorter exposure. Most output pixels are an average of two or more input values, which reduces noise in the final result.

sults. Second, if the actual system response function is unknown the images must be aligned before this function can be estimated from the given exposures. Third, objects in the scene may shift slightly between frames or even make large movements, such as people walking in the scene as the photos are taken. Finally, flare in the camera lens may fog areas surrounding particularly bright image regions, which may not be noticeable in a standard LDR image. We will address each of these problems in turn and present some workarounds in the following sections.

4.4 IMAGE REGISTRATION AND ALIGNMENT

Although several techniques have been developed or suggested for image alignment and registration, most originating from the computer vision community, only two techniques to our knowledge address the specific problem of aligning differently exposed frames for the purpose of HDR image creation. The first technique, from Kang et al. [63], handles both camera movement and object movement in a scene, and is based on a variant of the Lucas and Kanade motion estimation technique [77]. In an off-line postprocessing step, for each pixel a motion vector is computed between successive frames. This motion vector is then refined with additional techniques, such as hierarchical homography (introduced by Kang et al.), to handle degenerate cases.

Once the motion of each pixel is determined, neighboring frames are warped and thus registered with one another. Then, the images are ready to be combined into an HDR radiance map. The advantage of this technique is that it compensates for fairly significant motion, and is suitable (for instance) for capturing HDR video by exposing successive frames by different amounts of time.

Although this method is suitable for significant motion, it relies on knowing the camera response function in advance. This presents a catch-22: alignment is needed to register samples to derive the camera response function, but the camera response function is needed to determine alignment. If the camera response is known or can be computed once and stored based on a set of perfectly aligned images, the catch-22 is solved.

A second alignment technique (described in following material) employs a *mean threshold bitmap* (MTB), which does not depend on the camera response function for proper alignment [141]. This technique is also about 10 times faster than the Kang et al. method, in that it performs its alignment operations on bitmaps rather than 8-bit grayscale images, and does not perform image warping or resampling. However, the MTB alignment algorithm does not address moving objects in the scene, and is not appropriate for arbitrary camera movements such as zooming and tilting. The method of Kang et al. may therefore be preferred in cases where arbitrary camera movement is expected. In the case of object motion, we recommend a simpler and more robust postprocessing technique in Section 4.7.

4.5 THE MEAN THRESHOLD BITMAP ALIGNMENT TECHNIQUE

In this section, we describe a method for the automatic alignment of HDR exposures [141].[2] Input to this exposure algorithm is a series of N 8-bit grayscale images, which may be approximated using only the green channel, or derived as follows from 24-bit sRGB with integer arithmetic.[3]

$$Y = (54\ R + 183\ G + 19\ B)/256$$

One of the N images is arbitrarily selected as the reference image, and the output of the algorithm is a series of N-1 (x, y) integer offsets for each of the remaining images relative to this reference. These exposures may then be recombined efficiently into an HDR image using the camera response function, as described in Section 4.6.

The computation focuses on integer pixel offsets, because they can be used to quickly recombine the exposures without resampling. Empirical evidence suggests that handheld sequences do not require rotational alignment in about 90% of cases. Even in sequences in which there is some discernible rotation, the effect of a good translational alignment is to push the blurred pixels out to the edges, where they are less distracting to the viewer.

Conventional approaches to image alignment often fail when applied to images with large exposure variations. In particular, edge-detection filters are dependent on image exposure (as shown in the left side of Figure 4.5, where edges appear and disappear at different exposure levels). Edge-matching algorithms are therefore ill suited to the exposure alignment problem when the camera response is unknown. The MTB approach incorporates the following features.

- Alignment is done on bilevel images using fast bit-manipulation routines.
- The technique is insensitive to image exposure.
- For robustness, it includes noise filtering.

..

2 Reprinted by permission of A.K. Peters, Ltd., from Greg Ward, "Fast, Robust Image Registration for Compositing High Dynamic Range Photographs from Hand-Held Exposures," *Journal of Graphics Tools*, 8(2):17–30, 2003.

3 This is a close approximation of the computation of luminance as specified by ITU-R BT.709.

FIGURE 4.5 *Two unaligned exposures (middle) and their corresponding edge bitmaps (left) and median threshold bitmaps (right). The edge bitmaps are not used precisely because of their tendency to shift dramatically from one exposure level to another. In contrast, the MTB is stable with respect to exposure.*

The results of a typical alignment are discussed in Section 4.5.4. If we are to rely on operations such as moving, multiplying, and subtracting pixels over an entire high-resolution image, the algorithm is bound to be computationally expensive, unless our operations are very fast. Bitmap images allow us to operate on 32 or 64 pixels at a time using bitwise integer operations, which are very fast compared to byte-wise arithmetic. We use a bitmap representation that facilitates image alignment independent of exposure level, the a forementioned *median threshold bitmap*. The MTB is defined as follows.

1 Determine the median 8-bit value from a low-resolution histogram over the grayscale image pixels.
2 Create a bitmap image with 0s where the input pixels are less than or equal to the median value, and 1s are where the pixels are greater.

Figure 4.5 shows two exposures of an Italian stairwell (middle), and their corresponding edge maps (left) and MTBs (right). In contrast to the edge maps, the MTBs are nearly identical for the two exposures. Taking the difference of these two bitmaps with an exclusive-or (XOR) operator shows where the two images are misaligned, and small adjustments in the x and y offsets yield predictable changes in this difference due to object coherence. However, this is not the case for the edge maps, which are noticeably different for the two exposures, even though we attempted to compensate for the camera's nonlinearity with an approximate response curve. Taking the difference of the two edge bitmaps would not give a good indication of where the edges are misaligned, and small changes in the x and y offsets yield unpredictable results, making gradient search problematic. More sophisticated methods of determining edge correspondence are necessary to use this information, and we can avoid these and their associated computational costs with the MTB-based technique.

The constancy of an MTB with respect to exposure is a very desirable property for determining image alignment. For most HDR reconstruction algorithms, the alignment step must be completed before the camera response can be determined, in that the response function is derived from corresponding pixels in the different exposures. An HDR alignment algorithm that depends on the camera response function poses a catch-22 problem, as described earlier. By its nature, an MTB is the same for any exposure within the usable range of the camera, regardless of the

response curve. As long as the camera's response function is monotonic with re-
spect to world radiance, the same scene will theoretically produce the same MTB
at any exposure level. This is because the MTB partitions the pixels into two equal
populations: one brighter and one darker than the scene's median value. Because
the median value does not change in a static scene, the derived bitmaps likewise do
not change with exposure level.[4]

There may be certain exposure pairs that are either too light or too dark to use the
median value as a threshold without suffering from noise, and for these we choose
either the 17th or 83rd percentile as the threshold, respectively. Although the offset
results are all relative to a designated reference exposure, we actually compute offsets
between adjacent exposures and thus the same threshold may be applied to both
images. Choosing percentiles other than the 50th (median) results in fewer pixels
to compare, and this makes the solution less stable and thus we may choose to limit
the maximum offset in certain cases. The behavior of percentile threshold bitmaps
is otherwise the same as the MTB, including stability over different exposures. In
the remainder of this section, when we refer to the properties and operations of
MTBs, the same applies for other percentile threshold bitmaps.

Once the threshold bitmaps corresponding to the two exposures have been com-
puted, there are several ways to align them. One brute force approach is to test every
offset within the allowed range, computing the XOR difference at each offset and
taking the coordinate pair corresponding to the minimum difference. A more ef-
ficient approach might follow a gradient descent to a local minimum, computing
only local bitmap differences between the starting offset (0,0) and the nearest min-
imum. We prefer a third method, based on an image pyramid that is as fast as
gradient descent in most cases but more likely to find the global minimum within
the allowed offset range.

Multiscale techniques are well known in the computer vision and image-
processing communities, and image pyramids are frequently used for registration
and alignment. (See, for example, [127].) This technique starts by computing an
image pyramid for each grayscale image exposure, with $\log_2(\text{max_offset})$ levels past
the base resolution. The resulting MTBs are shown for two example exposures in
Figure 4.6. For each smaller level in the pyramid, we take the previous grayscale

..

4 Technically, the median value could change with changing boundaries as the camera moves, but such small changes in
 the median are usually swamped by noise, which is removed by this algorithm.

FIGURE 4.6 *A pyramid of MTBs is used to align adjacent exposures one bit at a time. The smallest (rightmost) image pair corresponds to the most significant bit in the final offset.*

image and filter it down by a factor of two in each dimension, computing the MTB from the grayscale result. The bitmaps themselves should *not* be subsampled, as the result will be subtly different and could potentially cause the algorithm to fail.

To compute the overall offset for alignment, we start with the lowest-resolution MTB pair and compute the minimum difference offset between them within a range of ±1 pixel in each dimension. At the next resolution level, we multiply this offset by 2 (corresponding to the change in resolution) and compute the minimum difference offset within a ±1 pixel range of this previous offset. This continues to the highest-resolution (original) MTB, where we get the final offset result. Thus, each level in the pyramid corresponds to a binary bit in the computed offset value.

At each level, we need to compare exactly nine candidate MTB offsets, and the cost of this comparison is proportional to the size of the bitmaps. The total time required for alignment is thus linear with respect to the original image resolution and independent of the maximum offset, in that the registration step is linear in the number of pixels, and the additional pixels in an image pyramid are determined by the size of the source image and the (fixed) height of the pyramid.

4.5.1 THRESHOLD NOISE

The algorithm just described works well in images that have a fairly bimodal brightness distribution, but can run into trouble for exposures that have a large number of pixels near the median value. In such cases, the noise in near-median pixels shows up as noise in the MTB, which destabilizes the difference computations.

The inset in Figure 4.7 shows a close-up of the pixels in the dark stairwell exposure MTB, which is representative of the type of noise seen in some images. Computing the XOR difference between exposures with large areas such as these yields noisy results that are unstable with respect to translation because the pixels themselves tend to move around in different exposures. Fortunately, there is a straightforward solution to this problem.

Because this problem involves pixels whose values are close to the threshold, these pixels can be excluded from our difference calculation with an *exclusion bitmap*. The exclusion bitmap consists of 0s wherever the grayscale value is within some specified distance of the threshold, and 1s elsewhere. The exclusion bitmap for the

FIGURE 4.7 *Close-up detail of noisy area of MTB in dark stairwell exposure (full resolution).*

exposure in Figure 4.7 is shown in Figure 4.8, where all bits are zeroed for pixels within ±4 of the median value.

We compute an exclusion bitmap for each exposure at each resolution level in the MTB pyramid, and then take the XOR difference result for each candidate offset, ANDing it with both offset exclusion bitmaps to compute the final difference.[5] The effect is to disregard differences that are less than the noise tolerance in our images.

...

5 If we were to AND the exclusion bitmaps with the original MTBs before the XOR operation, we would inadvertently count disagreements about what was noise and what was not as actual pixel differences.

FIGURE 4.8 *An exclusion bitmap, with zeroes (black) wherever pixels in our original image are within the noise tolerance of the median value.*

This is illustrated in Figure 4.9, which shows the XOR difference of the unaligned exposures before and after applying the exclusion bitmaps. By removing those pixels that are close to the median, the least-reliable bit positions in the smooth gradients are cleared but the high-confidence pixels near strong boundaries (such as the edges

FIGURE 4.9 *The original XOR difference of the unaligned exposures (left), and with the two exclusion bitmaps ANDed into the result to reduce noise in the comparison (right).*

of the window and doorway) are preserved. Empirically, this optimization seems to be very effective in eliminating false minima in the offset search algorithm.

4.5.2 OVERALL ALGORITHM

The full algorithm with the exclusion operator is given in the recursive C function (GetExpShift), shown in Figure 4.10. This function takes two exposure images, and determines how much to move the second exposure (img2) in x and y to align it with the first exposure (img1). The maximum number of bits in the

```
GetExpShift (const Image *img1, const Image *img2,
             int shift_bits, int shift_ret[2])
{
  int    min_err;
  int    cur_shift[2];
  Bitmap tb1, tb2;
  Bitmap eb1, eb2;
  int    i, j;
  if (shift_bits > 0) {
    Image sml_img1, sml_img2;
    ImageShrink2(img1, &sml_img1);
    ImageShrink2(img2, &sml_img2);
    GetExpShift(&sml_img1, &sml_img2, shift_bits-1, cur_shift);
    ImageFree(&sml_img1);
    ImageFree(&sml_img2);
    cur_shift[0] *= 2;
    cur_shift[1] *= 2;
  } else
    cur_shift[0] = cur_shift[1] = 0;
  ComputeBitmaps(img1, &tb1, &eb1);
  ComputeBitmaps(img2, &tb2, &eb2);
  min_err = img1->xres * img1->yres;
  for (i = -1; i <= 1; i++)
    for (j = -1; j <= 1; j++) {
      int    xs = cur_shift[0] + i;
      int    ys = cur_shift[1] + j;
      Bitmap  shifted_tb2;
      Bitmap  shifted_eb2;
      Bitmap  diff_b;
      int    err;
      BitmapNew(img1->xres, img1->yres, &shifted_tb2);
      BitmapNew(img1->xres, img1->yres, &shifted_eb2);
      BitmapNew(img1->xres, img1->yres, &diff_b);
      BitmapShift(&tb2, xs, ys, &shifted_tb2);
      BitmapShift(&eb2, xs, ys, &shifted_eb2);
```

FIGURE 4.10 The GetExpShift algorithm.

```
    BitmapXOR(&tb1, &shifted_tb2, &diff_b);
    BitmapAND(&diff_b, &eb1, &diff_b);
    BitmapAND(&diff_b, &shifted_eb2, &diff_b);
    err = BitmapTotal(&diff_b);
    if (err < min_err) {
      shift_ret[0] = xs;
      shift_ret[1] = ys;
      min_err = err;
    }
    BitmapFree(&shifted_tb2);
    BitmapFree(&shifted_eb2);
  }
  BitmapFree(&tb1); BitmapFree(&eb1);
  BitmapFree(&tb2); BitmapFree(&eb2);
}
```

FIGURE 4.10 (*Continued.*)

final offsets is determined by the shift_bits parameter. The more important functions called by GetExpShift are as follows.

ImageShrink2 (const Image *img, Image *img_ret): Sub-sample the image img by a factor of two in each dimension and put the result into a newly allocated image img_ret.

ComputeBitmaps (const Image *img, Bitmap *tb, Bitmap *eb): Allocate and compute the threshold bitmap tb and the exclusion bitmap eb for the image img. (The threshold and tolerance to use are included in the Image struct.)

BitmapShift (const Bitmap *bm, int xo, int yo, Bitmap *bm_ret): Shift a bitmap by (xo,yo) and put the result into the preallocated bitmap bm_ret, clearing exposed border areas to zero.

`BitmapXOR (const Bitmap *bm1, const Bitmap *bm2, Bit-map *bm_ret):` Compute the XOR of `bm1` and `bm2` and put the result into `bm_ret`.

`BitmapTotal (const Bitmap *bm):` Compute the sum of all 1 bits in the bitmap.

Computing the alignment offset between two adjacent exposures is simply a matter of calling the `GetExpShift` routine with the two image structs (`img1` and `img2`), which contain their respective threshold and tolerance values. (The threshold values must correspond to the same population percentiles in the two exposures.) We also specify the maximum number of bits allowed in the returned offset, `shift_bits`. The shift results computed and returned in `shift_ret` will thus be restricted to a range of $\pm 2^{shift_bits}$.

There is only one subtle point in this algorithm, which is what happens at the image boundaries. Unless proper care is taken, non-zero bits may inadvertently be shifted into the candidate image. These would then be counted as differences in the two exposures, which would be a mistake. It is therefore crucial that the `BitmapShift` function shifts 0s into the new image areas, so that applying the shifted exclusion bitmap to the XOR difference will clear these exposed edge pixels as well. This also explains why the maximum shift offset needs to be limited. In the case of an unbounded maximum shift offset, the lowest-difference solution will also have the least pixels in common between the two exposures (one exposure will end up shifted completely off the other). In practice, we have found a `shift_bits` limit of 6 (± 64 pixels) to work fairly well most of the time.

4.5.3 EFFICIENCY CONSIDERATIONS

Clearly, the efficiency of the MTB alignment algorithm depends on the efficiency of the bitmap operations, as nine shift tests with six whole-image bitmap operations apiece are performed. The `BitmapXOR` and `BitmapAND` operations are easy enough to implement, as we simply apply bitwise operations on 32-bit or 64-bit words, but the `BitmapShift` and `BitmapTotal` operators may not be as obvious.

For the `BitmapShift` operator, any 2D shift in a bitmap image can be reduced to a 1D shift in the underlying bits, accompanied by a clear operation on one or two

edges for the exposed borders. Implementing a 1D shift of a bit array requires at most a left or right shift of B bits per word, with a reassignment of the underlying word positions. Clearing the borders then requires clearing words where sequences of 32 or 64 bits are contiguous, and partial clears of the remaining words. The overall cost of this operator, although greater than the XOR or AND operators, is still modest. This `BitmapShift` implementation includes an additional Boolean parameter that turns off border clearing. This optimizes the shifting of the threshold bitmaps, which have their borders cleared later by the exclusion bitmap, and thus the `BitmapShift` operator does not need to clear them.

For the `BitmapTotal` operator, a table of 256 integers is computed corresponding to the number of 1 bits in the binary values from 0 to 255 (i.e., 0, 1, 1, 2, 1, 2, 2, 3, 1, ..., 8). Each word of the bitmap can then be broken into chunks (measured in bytes), and used to look up the corresponding bit counts from the precomputed table. The bit counts are then summed to yield the correct total. This results in a speedup of at least 8 times over counting individual bits, and may be further accelerated by special-case checking for zero words, which occur frequently in this application.

4.5.4 RESULTS

Figure 4.11 shows the results of applying the MTB image alignment algorithm to all five exposures of the Italian stairwell, with detailed close-ups showing before and after alignment. The misalignment shown is typical of a handheld exposure sequence, requiring translation of several pixels on average to bring the exposures back atop each other. We have found that even tripod exposures sometimes need minor adjustments of a few pixels for optimal results.

After applying this translational alignment algorithm to over 100 handheld exposure sequences, a success rate of about 84% was found, with 10% giving unsatisfactory results due to image rotation. About 3% failed due to excessive scene motion — usually waves or ripples on water that happened to be near the threshold value and moved between frames — and another 3% had too much high-frequency content, which made the MTB correspondences unstable. Most of the rotation failures were mild, leaving at least a portion of the HDR image well aligned. Other failures were more dramatic, throwing alignment off to the point where it was better not to apply any translation at all.

FIGURE 4.11 *An HDR image composited from unaligned exposures (left) and detail (top center). Exposures aligned with the MTB algorithm yield a superior composite (right) with clear details (bottom center).*

4.6 DERIVING THE CAMERA RESPONSE FUNCTION

Combining LDR exposures into an HDR image requires knowledge of the camera response function to linearize the data. In general, the response function is not provided by camera makers, who consider it part of their proprietary product differentiation. Assuming an sRGB response curve (as described in Chapter 2) is unwise, because most makers boost image contrast beyond the standard sRGB gamma to produce a livelier image. There is often some modification as well at the ends of the curves, to provide softer highlights and reduce noise visibility in shadows. However, as long as the response is not altered by the camera from one exposure to the next, it is possible to deduce this function given a proper image sequence.

4.6.1 DEBEVEC AND MALIK TECHNIQUE

Debevec and Malik [18] demonstrated a simple and robust technique for deriving the camera response function from a series of aligned exposures, extending earlier work by Mann and Picard [5]. The essential idea is that by capturing different exposures of a static scene one is effectively sampling the camera response function at each pixel. This is best demonstrated graphically.

Figure 4.12 shows three separate image positions sampled at five different exposures (Figure 4.13). The relative exposure ratios at each of the three positions are

FIGURE 4.12 Plot of $g(Z_{ij})$ from three pixels observed in five images, assuming unit radiance at each pixel. The images are shown in Figure 4.13.

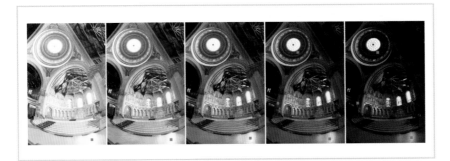

FIGURE 4.13 *Three sample positions over five exposures shown in Figure 4.12.*

given by the speed settings on the camera, and thus we know the shape of the response function at three different parts of the curve. However, we do not know how these three curve fragments fit together. Debevec and Malik resolved this problem using linear optimization to find a smooth curve that minimizes the mean-squared error over the derived response function. The objective function they use to derive the logarithmic response function $g(Z_{ij})$ is as follows.

$$\mathcal{O} = \sum_{i=1}^{N} \sum_{j=1}^{P} \left\{ w(Z_{ij}) \left[g(Z_{ij}) - \ln E_i - \ln \Delta t_j \right] \right\}^2$$

$$+ \lambda \sum_{z=Z_{\min}+1}^{Z_{\max}-1} \left[w(z) \, g''(z) \right]^2$$

There, Δt_j is the exposure time for exposure j, E_i is the film irradiance value at image position i, and Z_{ij} is the recorded pixel at position i and exposure j. The weighting function $w(Z_{ij})$ is a simple hat function, as follows.

$$w(z) = \begin{cases} z - Z_{\min} & \text{for } z \leq \frac{1}{2}(Z_{\min} + Z_{\max}) \\ Z_{\max} - z & \text{for } z > \frac{1}{2}(Z_{\min} + Z_{\max}) \end{cases}$$

This equation is solved using singular-value decomposition to obtain an optimal value for $g(Z)$ for every possible value of Z, or 0 to 255 for an 8-bit image. Each of the RGB channels is treated separately, yielding three independent response functions. This assumes that interactions between the channels can be neglected. Although this assumption is difficult to defend from what we know about camera color transformations, it seems to work fairly well in practice.

Figure 4.14 shows the result of aligning the three curves from Figure 4.12, and by applying the minimization technique to many image samples it is possible to obtain a smooth response function for each channel.

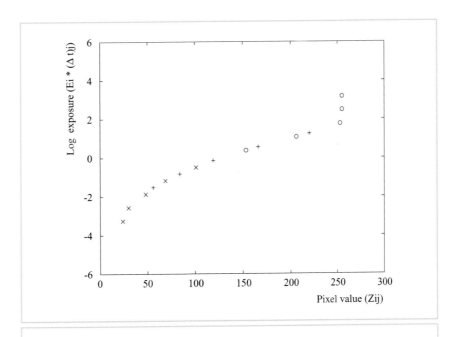

FIGURE 4.14 Normalized plot of $g(Z_{ij})$ after determining pixel exposures.

4.6.2 MITSUNAGA AND NAYAR TECHNIQUE

Mitsunaga and Nayar presented a similar approach, in which they derive a poly-nomial approximation to the response function [82] rather than the enumerated table of Debevec and Malik. The chief advantage they cite in their technique is the ability to resolve the exact exposure ratios in addition to the camera response func-tion. This proves important for lower-cost consumer equipment whose aperture and shutter speed may not be known exactly. Mitsunaga and Nayar define the following N-dimensional polynomial for their response function:

$$f(M) = \sum_{n=0}^{N} c_n M^n$$

For consistency with Debevec and Malik, we suggest the following variable replace-ments:

$$N \rightarrow K$$
$$n \rightarrow k$$
$$M \rightarrow Z$$
$$Q \rightarrow P$$
$$q \rightarrow j$$

The final response function is thus defined by the $N + 1$ coefficients of this poly-nomial, $\{c_0, \ldots c_N\}$. To determine these coefficients, they minimize the following error function for a given candidate exposure ratio, $R_{q,q+1}$ (the scale ratio between exposure q and $q + 1$):

$$\varepsilon = \sum_{q=1}^{Q-1} \sum_{p=1}^{P} \left[\sum_{n=0}^{N} c_n M_{p,q}^n - R_{q,q+1} \sum_{n=0}^{N} c_n M_{p,q+1}^n \right]^2$$

The minimum is found by determining where the partial derivatives with respect to the polynomial coefficients are all zero (i.e., solving the following system of

$N + 1$ linear equations).

$$\frac{\partial \varepsilon}{\partial c_n} = 0$$

As in previous methods, they only solve for the response up to some arbitrary scaling. By defining $f(1) = 1$, they reduce the dimensionality of their linear system by one coefficient, substituting

$$c_N = 1 - \sum_{n=0}^{N-1} c_n.$$

The final $N \times N$ system can be written as follows.

$$\begin{bmatrix} \sum_{q=1}^{Q-1} \sum_{p=1}^{P} d_{p,q,0}(d_{p,q,0} - d_{p,q,N}) & \cdots & \sum_{q=1}^{Q-1} \sum_{p=1}^{P} d_{p,q,0}(d_{p,q,N-1} - d_{p,q,N}) \\ \cdots & \cdots & \cdots \\ \sum_{q=1}^{Q-1} \sum_{p=1}^{P} d_{p,q,N-1}(d_{p,q,0} - d_{p,q,N}) & \cdots & \sum_{q=1}^{Q-1} \sum_{p=1}^{P} d_{p,q,N-1}(d_{p,q,N-1} - d_{p,q,N}) \end{bmatrix}$$

$$\times \begin{bmatrix} c_0 \\ \cdots \\ c_{N-1} \end{bmatrix} = \begin{bmatrix} -\sum_{q=1}^{Q-1} \sum_{p=1}^{P} d_{p,q,0} d_{p,q,N} \\ \cdots \\ -\sum_{q=1}^{Q-1} \sum_{p=1}^{P} d_{p,q,N-1} d_{p,q,N} \end{bmatrix}$$

Here,

$$d_{p,q,n} = M_{p,q}^n - R_{q,q+1} M_{p,q+1}^n.$$

The original Mitsunaga and Nayar formulation only considers adjacent exposures. In practice, the system is more stable if all exposure combinations are considered. The error function becomes a triple sum by including a sum over $q' \neq q$ instead of just comparing q to $q + 1$. This then gets repeated in the sums of the combined system of equations, where $d_{p,q,n}$ is replaced by

$$d_{p,q,q',n} = M_{p,q}^n - R_{q,q'} M_{p,q'}^n.$$

To compute the actual exposure ratios between images, Mitsunaga and Nayar apply an interactive technique, where the previous system of equations is solved repeatedly, and between each solution the exposure ratios are updated using the following.

$$R_{q,q+1}^{(k)} = \sum_{p=1}^{P} \frac{\sum_{n=0}^{N} c_n^{(k)} M_{p,q}^n}{\sum_{n=0}^{N} c_n^{(k)} M_{p,q+1}^n}$$

Iteration is complete when the polynomial is no longer changing significantly, as follows.

$$\left| f^{(k)}(M) - f^{(k-1)}(M) \right| < \varepsilon, \quad \forall M$$

This leaves just one final problem: What is the polynomial degree N? The authors recommend solving for every degree polynomial up to some maximum exponent (e.g., 10), accepting the solution with the smallest error, ε. Fortunately, the solution process proceeds quickly and this is not much of a burden. It is a good idea to ensure that the same degree is selected for all color channels, and thus a combined ε function is preferable for this final test.

4.6.3 CHOOSING IMAGE SAMPLES FOR RESPONSE RECOVERY

Each of the techniques described for camera response recovery requires a set of intelligently selected samples from the exposure sequence. In principle, one could use every pixel from every image, but this would only add to the computation time while actually reducing stability in the solution due to misaligned and noisy data. Once the exposures have been aligned, the following procedure for selecting sample patches is recommended.

1 Sort the exposures from lightest to darkest.
2 Select an appropriate sample patch size and an optimal number of patches, and initialize (clear) the patch list.

3 Determine how many patches from the previous exposure are still valid for this one.

4 Compute how many more patches are needed for this exposure. If none, go to the next exposure (Step 3).

5 Search for valid patches using randomized rejection sampling. A valid patch is brighter than any of the previous exposure's patches, does not overlap any other patch, and possesses a low internal variance. It is also within the valid range for this exposure.

6 Once we have found enough patches or given up due to an excess of rejected samples, we continue to the next exposure (Step 3).

A target of 50 12-by-12 pixel patches per exposure seems to work well. In cases where the darker exposures do not use their full range, it becomes difficult to find new patches that are brighter than the previous exposure. In practice, this does not affect the result significantly, but it is important for this reason to place a limit on the rejection sampling process in Step 5, lest we go into an infinite loop.

Figure 4.15 shows an exposure sequence and the corresponding patch locations. Adjacent exposures have nearly the same patch samples, but no patch sample survives in all exposures. This is due to the range restriction applied in Step 5 to avoid unreliable pixel values. Figure 4.16 shows a close-up of the middle exposure with the patches shown as boxes, demonstrating the low variance in the selected regions. By rejecting high-contrast areas, errors due to exposure misalignment and sensor noise are minimized.

Finally, Figure 4.17 shows the recovered response function for this sequence fitted with a third-order polynomial using Mitsunaga and Nayar's method, and compares it to the standard sRGB response function. The camera produces an artificially exaggerated contrast with deeper blacks on its LDR exposures. This type of response manipulation is fairly standard for consumer-grade cameras, and many professional SLRs as well.

4.6.4 CAVEATS AND CALIBRATION

To apply these techniques successfully, it helps to follow some additional guidelines, as follows.

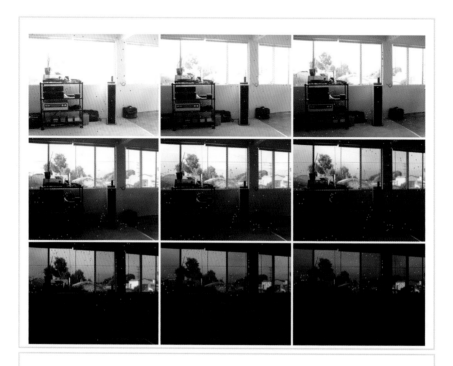

FIGURE 4.15 *Red squares indicate size and location of patch samples in each exposure.*

- Use aperture priority or manual exposure mode, so that only the exposure time is allowed to vary. This reduces problems associated with vignetting (light falloff toward the edge of the image).
- Fix the camera's white balance on a specific setting for the entire sequence, preferably daylight (i.e., D_{65}).
- If the camera offers an "optimized color and contrast" mode, switch it off. The more settings you can fix manually, the less likely the camera will be altering the response function between exposures. This applies particularly to automatic ISO/ASA and programmed exposure modes.

FIGURE 4.16 *Close-up of central exposure showing selected patch regions.*

- Use a tripod if possible, and control your camera via a tether to a laptop computer if this option is available. The less touching of the camera during a sequence the fewer alignment problems you will experience.

In general, it works best to calibrate your camera's response one time, and then reuse this calibration for later exposure sequences. In this way, the scene and exposure sequence may be optimized for camera response recovery. For such a sequence, perform the following.

- Set the camera on a tripod and use a tether if available. Alignment may still be necessary between exposures if the camera is touched during the sequence, but the method described in the previous section will work far better with

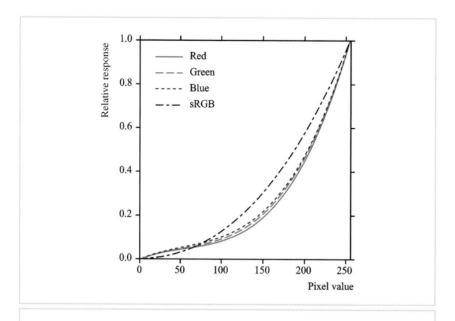

Recovered red, green, and blue response functions for the image sequence shown in Figure 4.15.

a tripod than a handheld sequence in which the exposure is being changed manually.

- Choose a scene with large gray or white surfaces that provide continuous gradients for sampling. The closer your scene is to a neutral color the less likely color transforms in the camera will undermine the response recovery process.
- Choose a scene with very bright and very dark areas, and then take a long sequence of exposures separated by 1 EV (a factor of two in exposure time). The darkest exposure should have no RGB values greater than 200 or so, and the lightest exposure should have no RGB values less than 20 or so. Do not

include an excess of exposures beyond this range, as it will do nothing to help with response recovery and may hurt.

- If you have access to a luminance meter, take a reading on a gray card or uniform area in your scene to provide absolute response calibration.

Once a camera has been characterized in this way, it is possible to combine handheld bracketed sequences that are too short to reliably recover the response function.

4.7 GHOST REMOVAL

Once the exposures are aligned with each other and the camera's response curve is determined, we may safely combine the images (as described in Section 4.3). However, if some person or object was moving during the image sequence acquisition they may appear as "ghosts" in the combined result, due to their multiple locations. The technique described by Kang et al. [63] attempts to address this problem during alignment by warping pixels according to local content, but even if this can be done correctly in the presence of people who change posture as well as position it still leaves the problem of filling in holes that were obstructed in some views but not in others.

A simpler approach is based on the observation that each exposure in the sequence is self-consistent, which means that we can simply choose one exposure or another in specific regions to obtain a ghost-free result. The HDR capacity may be lost within these selected regions, but as long as the ghosts are local and compact, the overall image will still capture the full range of light.

Figure 4.18 shows an HDR image captured from a bracketed sequence of five exposures, excerpted in the left-hand side of the figure. People walking in and out of the temple result in a trail of ghosts appearing in the combined result.

Fortunately, it is relatively easy to detect motion of this type in exposure sequences. As the images are combined using the weighted average (described in Section 4.3), the weighted variance can be computed simultaneously at each pixel, shown in Figure 4.19. The weighted variance is defined as the weighted sum of squares at each pixel over the square of the weighted average, the quantity minus 1. (We compute these quantities separately for red, green, and blue channels and then take the maximum at each pixel.) In addition to the moving people, some variance

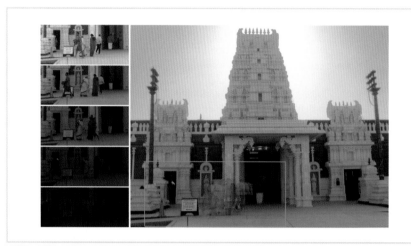

FIGURE 4.18 *Five exposures combined into a single HDR image, where people moving through the scene have caused ghosting in the result.*

is detected at high-contrast edges due to imperfections in the lens and sensor. These regions will usually be rejected by a minimum area constraint, but may cause false positives on small stationary objects.

At this point, the variance image could simply be thresholded and a single exposure selected to substitute for all high-variance pixels. However, this would incur significant artifacts. First, parts of moving objects whose pixels happened to correspond to the background locally would break apart. Second, and more seriously, choosing a single exposure for all high-variance pixels would result in excessive information loss, as problem pixels may be found in very different brightness regions.

The algorithm could be modified to pick the best exposure for each problem pixel, but this would create an even more serious breakup problem because different parts of the same object will be better exposed in different frames, where

FIGURE 4.19 *Variance computed at each pixel over our exposure sequence, showing where information is changing unexpectedly due to movement.*

the object's position is also different. It is therefore important to isolate separable, high-variance regions and choose the best exposure for each. Such a segmentation is shown in Figure 4.20. This segmentation is computed as follows.

1 Reduce the variance image by a factor of 10 in each dimension to save computation.
2 Compute the threshold bitmap where local variance is greater than 0.18.
3 Smear the threshold bitmap around a radius of 3 pixels to cover edges and join adjacent ghost regions.

FIGURE 4.20 *Segmented regions corresponding to isolated ghosts in our exposure sequence. Segment colors were randomly selected.*

4 Compute a "background" bitmap segment from a union of contiguous (flood-filled) low-variance regions that cover at least 0.1% of the image.

5 Identify "ghost" bitmap segments as disjoint flood-filled regions within the background segment, with each ghost also covering at least 0.1% of the image.

In Figure 4.20, the tops of the two silhouetted poles were inadvertently picked, due to the high variance at their edges. In addition, a large region in which people where passing each other on the walk ended up as one segment (violet). Fortunately, this segment is contained in a similarly lighted region, and thus a single exposure is adequate to capture its dynamic range. The uneven edges of some regions indicate

FIGURE 4.21 *The combined HDR result with ghosts removed.*

low-variance pixels, where we limit our ghost removal using linear interpolation as explained below.

To choose which exposure to use in which region, a histogram is generated from the floating-point values for each ghost segment. We then consider the largest value after ignoring the top 2% as outliers and choose the longest exposure that includes this 2% maximum within its valid range. We apply the corresponding exposure multiplier for each ghost segment then linearly interpolate between this exposure and the original HDR result using each pixel's variant as our mixing coefficient. This ensures that extremely low-variance pixels within an identified ghost segment are left unaltered. Figure 4.21 shows the combined result with ghosts removed. The final image is not perfect, and one man's bare foot has been summarily amputated,

but the overall result is an improvement, and this technique is quick and relatively straightforward.

4.8 LENS FLARE REMOVAL

After eliminating motion between exposures, there may still be artifacts present due to the camera's optics. Most digital cameras are equipped with optics that are consistent with the inherent limitations of 24-bit digital images. In other words, manufacturers generally do not expect more than two orders of magnitude to be captured in the final image, and thus certain parameters may be relaxed in the lens and sensor design relative to a 35-mm-film camera, for example. For an HDR capture process, however, the limitations of the system's optics are more apparent, even in a well-made digital camera. Small issues such as the thickness and finish of the aperture vanes can make a big difference in the distribution of light on the sensor. The quality of coatings on the lenses and the darkness and geometry of the interior surrounding the sensor also come into play. Overall, there are many components that affect the scattering of light in an image, and it is difficult or impossible to arrive at a single set of measurements that characterize the system and its dependencies. Therefore, we prefer a dynamic solution to the lens flare problem, based only on the captured image.

Because it is important to keep all of the optical properties of the camera consistent during HDR capture, normally only the shutter speed should be manipulated between exposures. Thus, the actual distribution of light on the sensor plane never varies, only the length of time the sensor is exposed to it. Therefore, any flare effects present in one exposure are present to the same degree in all exposures and will sum consistently into our HDR result. For this reason, there is no need to work on individual exposures, as it would only serve to increase our computational burden. The camera's *point spread function* (PSF) is a physical measure of the system optics, and it may be characterized directly from the recorded radiances in an HDR image.

4.8.1 THE POINT SPREAD FUNCTION

The PSF as it is defined here is an idealized radially symmetric characterization of the light falloff surrounding a point of light in a perfectly dark surrounding. It

FIGURE 4.22 *An isolated spot of light in a darkened environment for the purpose of measuring the point spread function of a camera.*

could be measured by making a pinhole in a piece of aluminum foil in front of a lightbulb in a box and photographing it in a completely dark environment, as shown in Figure 4.22. The edge of the hole ought to be perfectly sharp, but it generally is not. The spread of light around the hole corresponds to light scattered within the lens of the digital camera.

This photograph of the pinhole could then be used to correct the combined HDR result for other photographs made with precisely the same lens settings — zoom and aperture. However, this procedure is a lot to expect of even the most meticulous photographer, and because lens flare also depends strongly on dust and oils that come and go over time it is not practical to maintain a set of calibrated PSFs for any but the most critical applications.

However, there is a technique whereby the PSF may be approximated based on image content, as we will demonstrate with the HDR capture shown in Figure 4.23.

FIGURE 4.23 *Our input test image for estimating lens flare using the same aperture and zoom as in Figure 4.22 (tone mapped with the histogram equalization operator, described in Section 7.2.8).*

Despite the fact that this image contains no localized bright spots, and hence no easily measured PSF, a reasonable estimate of lens flare may still be obtained.

It is assumed that in the image there exist some dark pixels near very bright (or "hot") pixels. To the extent this is true, it will be possible to estimate the PSF

for the camera.[6] It is also assumed that the lens flare is radially symmetric. This is admittedly a crude approximation, but required by the estimation procedure. Thus, the goal is to find and remove the radially symmetric component of flare. Streaks and other asymmetrical artifacts generated by the camera optics will remain. The automatic flare removal consists of the following steps.

1 Compute two reduced-resolution HDR images: one in color and one in grayscale. Call these I_{CR} and I_{GR}, respectively.
2 Identify "hot" pixels in I_{GR}, which are over some threshold.
3 Draw annuli around each hot pixel to compute a least squares approximation to the PSF using the method described in the following section.
4 Apply the PSF to remove flare from the final HDR image.

Reducing the working resolution of our HDR image achieves a major speedup without significantly impacting the quality of the results, in that flare tends to be a distributed phenomenon. A reduced image size of at most 128 pixels horizontally or vertically is sufficient. The threshold setting for Step 2 is not particularly important, but we have found a value of 1,000 times the minimum (reduced) pixel value to work well for most images. Of course, a different threshold is advisable if the minimum is zero. Steps 3 and 4 require some explanation, which we give in the following subsections.

4.8.2 ESTIMATING THE PSF

The PSF defines how light falls off around bright points in the image.[7] To estimate the PSF, the minimum pixel values around all "hot" pixels in the image are measured, thus arriving at a conservative estimate of the PSF. To do this, the potential contributions of all hot pixels at a certain distance from the darker (non-hot) pixels are summed to build up an estimate of the PSF from the corresponding minima, radius by radius. For example, Figure 4.24 shows an image with exactly three of

6 If this assumption is false, and there are no dark pixels near sources, lens flare will probably go unnoticed and there is no need to remove it.

7 In fact, it defines how light falls off around any point in the image, but only the bright points matter because the falloff is so dramatic.

FIGURE 4.24 *An example image with exactly three bright pixels, surrounded by circles showing where their PSF influences overlap. Each PSF radius will contain exactly one minimum, marked with an X in this example.*

these super-bright pixels. The same radius is drawn around all three pixels, creating three overlapping circles. If the PSF were known a priori, we could compute the contribution of these hot pixels at this distance by multiplying the PSF, which is a function of radius, by each hot pixel value. Conversely, dividing the darker pixels around each circle by the circle's center gives an upper bound of the PSF.

Furthermore, the PSF at this distance cannot be greater than the minimum of all darker-pixel/hot-pixel ratios. Where the circles overlap, the sum of hot pixel contributions should be considered. In fact, a convenient approach is to sum all three hot pixel values around each circle in another grayscale image. (This example shows three distinct circles, but in general there are many hot pixels adjacent to each other, which create a great deal of overlap in the contributing annuli.) The PSF upper bound at that radius will then equal the minimum ratio of the darker pixels in the circles to their hot pixel sums (the point marked with an X in the example). This

technique extends directly to any number of hot pixels. The estimation procedure
is as follow.

1 For each radius we wish to consider:
 a Sum the hot pixel values into a radius range (annulus) in a separate
 grayscale image.
 b Find the minimum ratio of darker-pixel/hot-pixel sum for all annuli.
2 If the minimum ratio is not less than the previous (smaller) radius, discard
 it (because we assume the PSF is monotonically decreasing).
3 For each minimum ratio pixel, identified for each sample radius, consider all
 flare contributions to this pixel over the entire image as described below.

Once we have an estimate of the upper limit of the PSF at each radius, these mini-
mum pixels can be used to fit a third-degree polynomial, $p(x)$, using the reciprocal
of the input radius for x.[8] For each identified minimum pixel position with value
P_i, we can write the following equation.

$$P_i = \sum_j P_j \left(C_0 + \frac{C_1}{r_{ij}} + \frac{C_2}{r_{ij}^2} + \frac{C_3}{r_{ij}^3} \right)$$

Here, the P_js are the contributing pixel values over the rest of the image, and the
r_{ij}s are the distances between the minimum pixel P_i and each contributing pixel
position. This equation can be rewritten as follows.

$$P_i = C_0 \sum_j P_j + C_1 \sum_j \frac{P_j}{r_{ij}} + C_2 \sum_j \frac{P_j}{r_{ij}^2} + C_3 \sum_j \frac{P_j}{r_{ij}^3}$$

The sums in this equation then become coefficients in a linear system in which the
four fitting parameters (C_0 through C_3) are the unknowns. As long as there are
more than four minimum pixel values, P_i, it should be possible to solve this as an
overdetermined system using standard least squares minimization. Heuristically, a
better solution may be obtained if we assign minimum and maximum permitted

. .

8 The use of a third-degree polynomial and fitting to the reciprocal of distance are heuristic choices we have found to
 produce good results at an economical cost.

values for the distance between pixels, r_{ij}. Anytime the actual distance is less than the minimum radius (3 pixels in the reduced image), we use a distance of 3, instead. Similarly, the distance is clamped to a maximum of half the image width. This avoids stability problems and sensitivity to local features in our image. It also avoids the possibly incorrect removal of flare too close to light sources. This is generally impossible anyway, in that flare from the lens can be so great that the underlying information is washed out. In such cases, no recovery can be made. This often happens at bright source boundaries.

Figure 4.25 compares the point spread function measured in Figure 4.22 to our estimate derived solely from the input image in Figure 4.23. Other than the artificial plateau we imposed by constraining the minimum r_{ij} to 3 pixels, the two curves

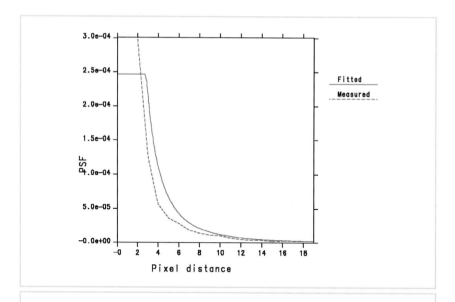

FIGURE 4.25 Comparison between directly measured PSF from Figure 4.22 and function fitted using image in Figure 4.23.

are a reasonable match. The fitted function shows a slightly greater flare than the measured one, but this is explained by the fact that the measurement was based on a spot near the center of the image. Optical flare becomes more pronounced as one moves farther toward the edges of an image, especially in a wide-angle lens. Since the fitting function was applied over the entire image, we would expect the globally estimated PSF to be slightly greater than a PSF measured at the center.

4.8.3 REMOVING THE PSF

Given an estimate of the PSF, flare removal is straightforward. For each hot pixel in the image, we subtract the PSF times this pixel value from its surroundings. Because the neighborhood under consideration may extend all the way to the edge of the image, this can be an expensive operation. Once again, working with a reduced image lowers the computational cost to manageable levels. The steps for removing the PSF are as follows.

1. Create a reduced-resolution flare image, \mathbf{F}_{CR}, and initialize it to black.
2. For each hot pixel in the reduced image \mathbf{I}_{CR}, multiply by the PSF and add the product into \mathbf{F}_{CR}.
3. If the value of any pixel in \mathbf{F}_{CR} is larger than its corresponding pixel in \mathbf{I}_{CR}, reduce the magnitude of \mathbf{F}_{CR} uniformly to compensate.
4. Upsample \mathbf{F}_{CR} using linear interpolation and subtract from the original HDR image.

Step 3 ensures that no negative pixels are generated in the output and is necessary because the fitting method does not guarantee the most conservative PSF. Dependent on the interpolation and the local variance of the original pixels, we may still end up with negative values during Step 4 and should truncate these where they occur. An example result of automatic flare removal is shown in Figure 4.26, along with the reduced resolution flare image generated during Step 2.

4.9 DIRECT CAPTURE OF HDR IMAGERY

With the possible exception of lens flare removal, the techniques explained in the last section might be unnecessary if we had a digital sensor that could record the

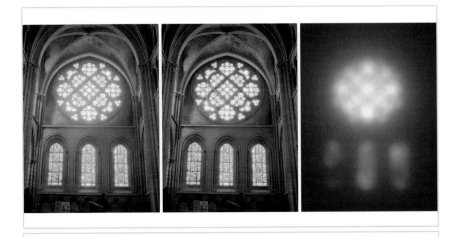

FIGURE 4.26 *An image of a rosette window, before flare removal (left) and after (center). The right-hand image shows the estimated PSF applied to hot pixels in the image.*

full dynamic range of a scene in a single shot. In fact, such sensors are being actively developed, and some are even being marketed, but only a few integrated solutions are commercially available: the Autobrite cameras from SMaL Camera Technologies, the SpheroCam HDR panoramic camera from SpheronVR, and the Ladybug spherical camera from Point Grey Research. We will describe each of these systems briefly in this section.

4.9.1 VIPER FILMSTREAM

Grass Valley, a division of Thomson, introduced the Viper FilmStream camera for digital cinematography in the Fall of 2002 (*www.thomsongrassvalley.com/products/cameras/viper/*). This is currently the top-end performer for digital capture, and it produces an enormous amount of data (up to 444 Mbytes/sec!). The camera contains three HDTV 1080i (1,920 × 1,080-resolution) CCD sensors (one each for red, green,

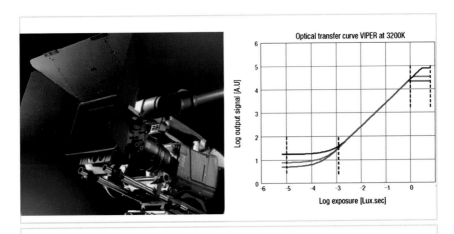

FIGURE 4.27 *The Viper FilmStream camera and its response curve. (Photo courtesy of Grass Valley.)*

and blue) and records directly into a 10-bit/channel log format. The camera and its response functions are shown in Figure 4.27.

This chart shows that the Viper captures about three orders of magnitude, which is at least 10 times that of a standard digital video camera, and begins to rival film. The equipment is currently available for lease from Thomson.

4.9.2 SMaL

SMaL Camera Technologies of Cambridge, Massachusetts (www.smalcamera.com), markets a low-cost VGA-resolution CMOS sensor (the IM-001 Series) which is capable of recording extended-range images at twice video rates (60 fps). Through its unique design, individual pixel sensitivities are adjusted so that the chip captures about twice the dynamic range (in log units) of a standard CCD or CMOS sensor, or about four orders of magnitude. They currently offer two products that incorporate their Autobrite (TM) technology, a credit-card-size still camera, and a video surveillance camera (a prototype is shown in Figure 1.9). They also market a "digital

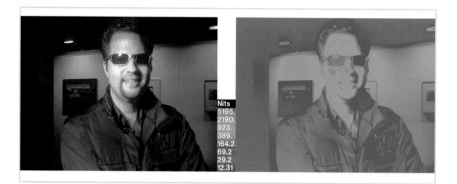

FIGURE 4.28 *An HDR image of one of the authors, captured using a SMaL Ultra-Pocket digital camera directly to RGBE format. As we can see in false color, the dynamic range captured in this image is about three orders of magnitude.*

imaging kit" to OEMs and system integrators who wish to incorporate the SMaL sensor in their products.

Figure 4.28 shows an image captured using the SMaL Ultra-Pocket camera. Due to its limited resolution (482 × 642), the SMaL sensor is not well suited to serious photographic applications, but this may change with the introduction of larger Autobrite arrays. Other aspects of chip performance, such as signal-to-noise ratio at each pixel and fill factor, may also affect the applicability of this technology.

4.9.3 PIXIM

Pixim of Mountain View, California (www.pixim.com), offers two 720 × 480 CMOS image sensors that boast a 10-bit digital video output with a 95-dB signal-to-noise ratio, corresponding to roughly four orders of magnitude. These sensors grew out of the Programmable Digital Camera Project headed by Abbas El Gamal and Brian Wandell at Stanford University, and employ "multisampling" on picture elements to minimize noise and saturation. Pixels are grouped with independent analog-to-digital converters (ADCs), and sampled multiple times during each video frame.

Conversion at each sensor group stops when either the frame time is up or the value nears saturation. In effect, each pixel group has its own electronic shutter and dynamic exposure system. For additional processing, the sensor chip is paired with a custom digital image processor, which handles video conversion and control. Pixim currently markets the sensors and development kits to OEMs, and it has been picked up by a few security camera makers. Smartvue (*www.smartvue.com*) has based its S2 line of wireless surveillance cameras on the Pixim chip set, and Baxall (*www.baxall.com*) recently introduced its Hyper-D camera.

4.9.4 SPHERONVR

SpheronVR of Kaiserslautern, Germany (*www.spheron.com*), has what is undeniably the highest-resolution and highest-performance HDR camera in existence; the Sphero-Cam HDR. This device boasts the ability to capture full spherical panoramas at a resolution of up to $13,000 \times 5,300$ pixels, covering nearly eight orders of magnitude in dynamic range (a $10^8 : 1$ contrast ratio). However, because they use a line-scan CCD for their capture the process takes from 15 to 30 minutes to complete a full 360-degree scan at this resolution. Lower resolutions and dynamic ranges will scan faster, but one can never achieve a single-shot capture with a line-scan camera because the device must mechanically pan over the scene for its exposure. Nevertheless, this is the system to beat for panoramic capture and critical image-based lighting applications, and their deluxe package comes with an advanced software suite as well. Figure 4.29 shows a SpheroCam HDR image captured in Napa Valley, California, at a resolution of about $3,000 \times 2,100$. The dynamic range is 5.5 orders of magnitude.

4.9.5 POINT GREY RESEARCH

Point Grey Research, of Vancouver, Canada (*www.ptgrey.com*), recently came out with an upgrade of the SDK for their LadyBug spherical video camera, which enables it to capture six perspective HDR images in a single shot. Five 1/3-inch SVGA sensors ($1,024 \times 768$) look in a circle of horizontal directions to obtain a panorama, and a sixth sensor looks straight up, yielding a final image that covers 75% of the full sphere. Data are delivered in real time via a firewire cable to a tethered host computer. Figure 4.30 shows an example HDR result with a resolution of $3,600 \times 1,500$

FIGURE 4.29 *An HDR panorama captured by Spheron's SpheroCam HDR line-scan camera, tone mapped using a histogram adjustment operator.*

and a dynamic range in excess of four orders of magnitude. Notably, there is no evidence of ghosting or smearing problems, which one would see if the image were multiply exposed.

4.10 CONCLUSIONS

In the not-too-distant future digital still and motion picture photography may become exclusively HDR. After all, traditional film photography has provided medium-dynamic-range capture for nearly a century, and professionals expect and

FIGURE 4.30 *An HDR panorama captured in a single shot using the six CCD sensors of Point Grey Research's LadyBug camera system. Image acquired using Point Grey Research's Ladybug spherical video camera (www.ptgrey.com).*

require this latitude during postproduction (i.e., printing). The current trend toward mixed reality in special effects is also driving the movie industry, which is increasingly digital, toward HDR. Advances in dynamic range will hit the professional markets first and slowly trickle into the semiprofessional price range over a period of years.

Unfortunately, consumers will continue to be limited to LDR digital cameras in the short term, as HDR equipment will be priced out of reach for some years to come. During this interim period, software algorithms such as those described in this chapter will be the most affordable way of obtaining and experimenting with HDR imagery, and applications will hopefully push the market forward.

Display Devices

05

Image output devices fall into two major categories: printing (or hardcopy) devices and display (or softcopy) devices. The image printing category includes traditional ink presses, photographic printers, and dye-sublimation, thermal, laser, and ink-jet printers — any method for depositing a passive image onto a 2D medium. Some of these devices are capable of producing transparencies, but most are used to produce reflective prints. The image display category includes traditional cathode-ray tubes (CRTs), LCD flat-panel displays, and LCD and DLP projectors — any method for the interactive display of imagery on a 2D interface. Most, but not all, display devices include an integrated light source, whereas printed output usually relies on ambient illumination. In general, hardcopy output is static and passive, and softcopy output is dynamic and active. The challenges for presenting HDR imagery within these two classes is quite different. We will look first at printing devices and then at interactive displays.

5.1 HARDCOPY DEVICES

The first image-duplication systems were hardcopy devices, going all the way back to Johann Gutenberg's invention of movable type and oil-based inks for the printing press in the fifteenth century. This was truly a digital device, requiring dextrous fingers to place the letters and designs in frames for creating master plates. (Wood block printing dating back to eighth-century China was more of an engraving transfer process.) Hand presses eventually gave way to powered flatbed cylinder presses

in the 1800s, which are still used for many printing applications today. More significant to this discussion, the dawn of photography in the latter half of the same century opened a new horizon not only to the printing process but to what could in fact be printed.

Significantly, the chemistry of black-and-white film (and later color negative stock) has been tailored to record HDR information. As discussed in Chapter 4, the photographic printing/enlargement process is where the original range of the negative is reduced to fit the constrained range of a standard reflection print. The additional depth in the shadowed and highlighted areas of the negative permit the photographer or the processing lab to perform adjustments to the image exposure a posteriori to optimize the final image. This was the original use of the term *tone mapping*, now recognized to be so important to computer graphics rendering [131].

Figure 5.1 shows a color negative of an HDR scene next to a typical LDR print. The false color image on the right shows that the range recorded by the negative is actually quite large (nearly four orders of magnitude), and some information in the shadows is lost during standard printing. Using dodge-and-burn techniques, a skilled darkroom specialist could bring these areas out in a handmade print. By scanning the full dynamic range of the negative, one could alternatively apply one of the latest digital tone-mapping operators to compress this information in an LDR output. This fits with the idea of storing a scene-referred image and applying device-dependent tone mapping prior to final output. (See Chapters 6 through 8 on dynamic range reduction and tone-reproduction operators, for further information.)

5.1.1 THE REFLECTION PRINT

As implicitly illustrated in all the figures of this and every other book, reflective print media is inherently LDR. Two factors are responsible for this. First, the brightest pixel in a reflection print is dictated by the ambient lighting. This same ambient light illuminates the area around the print, which we can generally assume to be a medium color (midgray being 18% reflectance, but see footnote 4 in Chapter 2). Thus, even the whitest paper stock with a 90% reflectance is perhaps five times as bright as its surroundings. A typical specular highlight on a sunny day is 500 times as bright as its surroundings, and light sources can be even brighter. Would it be

FIGURE 5.1 *A color photograph of an HDR scene. The negative shown on the left stores scene luminance with its native logarithmic response. The middle image shows an LDR print, whereas the right-hand image shows the actual range available from the negative.*

possible to represent these outstanding highlights in a reflection print? Early artists recognized this problem and added gilding to their paintings and manuscripts [40], but this would be unreliable (not to mention expensive) in a commercial print setting.

The second limitation of the contrast of reflection prints is maximum absorption, which is generally no better than 99.5% for most dyes and pigments. Even if we had a perfectly absorbing ink, the surface of the print itself reflects enough light to undermine contrast in the deep-shadow regions. Unless the illumination and background are very carefully controlled, the best contrast one can hope for in a good viewing environment is about 100:1, and it is often much less.

Figure 5.2 shows a density chart, where adjacent bars differ by roughly 11% (well above the visible difference threshold) and are spaced for optimum visibility.

FIGURE 5.2 *A density chart, demonstrating that it is difficult to resolve differences at or below 1% reflectance ($-2.0 \log_{10}$ density) in printed images.*

Even though we have given the image a black background in order to improve contrast visibility, the steps become indistinguishable well before a $\log_{10}(-2.0)$ density (1% reflectance). On an HDR display, these steps would be clearly visible all the way to the bottom of the chart. The fact that they are not demonstrates one of the inherent limitations of diffusely reflective media: LDR output.

5.1.2 TRANSPARENT MEDIA

Not all hardcopy media are reflective. Some media are transparent and are designed to be projected. The most obvious example is movie film, although 35-mm slide transparencies and overhead transparencies bear mention as well. Fundamentally, transparencies overcome the two major limitations of reflective media: ambient lighting and maximum density. Because transparencies rely on a controlled light

source and optics for display, the ambient environment is under much tighter control. Most transparencies are viewed in a darkened room, with a dark surrounding. For maximum density, we are only limited by film chemistry and printing method as to how dark our transparency can get. Three orders of magnitude are regularly produced in practice, and there is no physical limit to the density that can be achieved.

Are slides and movies really HDR? Not really. They certainly have more dynamic range than standard reflection prints — perhaps by as much as a factor of 10. However, viewers prefer higher contrast for images with a dark surround [29], and thus manufacturers of film oblige by creating high-contrast films for projection. The sensitive dynamic range of slide transparency film is actually quite narrow — about two orders of magnitude at most. Professional photographers are well aware of this limitation. It is imperative to get the exposure and lighting exactly right, or there is no advantage in shooting transparency film. Cinematographers have a little more room to move because they go through an additional transfer step in which the exposure can be adjusted, but the final print represents only a narrow range of luminances from the original scene.

Although transparency film is not traditionally used as an HDR medium, it has this potential. Something as simple as a slide viewer with a powerful backlight could serve as a low-tech HDR display if there were some way of producing a suitable transparency for it. An example of such an approach is demonstrated in the following section.

5.1.3 HDR STILL IMAGE VIEWER

Figure 5.3 shows an HDR still-image viewer composed of three elements: a bright, uniform backlight, a pair of layered transparencies, and a set of wide-field stereo optics. The view mapping for the optics and the method of increasing dynamic range by layering transparencies are the two challenges faced [140]. The original prototype of this HDR viewer was created at the Lawrence Berkeley Laboratory in 1995 to evaluate HDR tone-mapping operators, but it has only recently been put to this task [72]. In the configuration shown, the viewer provides a nearly 120-degree field of view, a maximum luminance of 5,000 cd/m^2, and a dynamic range of over 10,000:1. It employs the Large Expanse Extra Perspective (LEEP) ARV-1 optics,

12 V, 50-W lamps
Heat absorbing glass

Reflector for
uniformity

Cooling fan

Diffuser

ARV–1 optics

FIGURE 5.3 *An HDR viewer relying on layered film transparencies. The transparency position is shown in red on the right-hand diagram.*

which were designed by Eric Howlett and used in the original NASA virtual reality experiments [26].[1]

The LEEP ARV-1 optics use a *hemispherical fisheye projection*, wherein the distance from the center of the image is proportional to the sine of the eccentricity (i.e., the angle from the central view direction). In addition, the optics exhibit significant chromatic aberration, which will cause colored fringes at the edges of view. This was originally corrected for by a matched camera with chromatic aberration in the opposite direction, but because we seek to render our views on a computer we apply an equivalent correction during image preparation (the $Ca()$ function, described in the following material). The image must be high resolution in order not to appear blurred in the viewer (we found a resolution of 800 dpi ($2{,}048 \times 2{,}048$) to be the minimum). A 4-by-5 film recorder is essential in producing transparencies at this size and resolution.

. .

1 The ARV-1/diffuser assembly was obtained from Ulrecth Figge of Boston, MA.

A film recorder typically consists of a small slow-scan CRT with a white phosphor, which is carefully scanned three times with each of three colored filters interposed between the CRT and a film camera with a macro lens. The process is slow and the equipment is increasingly rare, making the production of high-resolution transparencies a costly proposition. Because the LEEP optics require a 2.5-by-5-inch transparency pair, we must split the job into two 4-by-5 outputs, because film cannot be printed to its borders. Furthermore, due to the difficulty of controlling transparency exposures to achieve densities whereby the film response is highly nonlinear it is necessary to create two transparency layers per eye, doubling the cost again.[2]

Figure 5.4 shows the method for splitting a single HDR image into two transparency layers, which will later be mounted one atop the other in the viewer. Because the same image separation is needed to drive the HDR softcopy displays (described in the next section), we explain the process here. The incoming image must be normalized such that the maximum pixel value is no greater than 1.0 (i.e., maximum transmission). First, the pixels in the original image are blurred, which circumvents the otherwise insurmountable problems of misregistration and parallax between the two layers. We use a Gaussian blur function to reduce the apparent resolution of the back image to roughly 32×32, although we have found that resolutions as low as 16×16 will work. We then take the square root to cut the original dynamic range of our back layer in half. This is the key to getting an HDR result, in that standard film recorders cannot handle more than an 8-bit/primary input file.

By subsequently dividing this back layer into the original, we obtain the front image, which is passed through the $C_a(\)$ function to correct for the aforementioned chromatic aberration. The $C_a(\)$ function simply makes the red channel in the image 1.5% larger than the blue, with green halfway between. By construction, the front layer will have enhanced edges that precisely compensate for the blurred back layer, as explained in material following. Because densities add in layered transparencies (i.e., transmittances multiply), the original HDR view is reproduced almost perfectly.

Figure 5.5 demonstrates the recombination of image layers. By dividing our original image (reproduced on the right) by the blurred back image (shown on the left),

..

2 The cost per image is about $50 U.S., and four images are required per view.

$$I_{\text{front}} = Ca \left(\frac{I_{\text{orig}}}{I_{\text{back}}} \right)$$

I_{orig}

$$I_{\text{back}} = \sqrt{I_{\text{orig}}^{\overline{\text{blur}}}}$$

FIGURE 5.4 *The process whereby the original fisheye image for one eye is split into two transparency layers, which when combined in the HDR viewer will reproduce the original luminances.*

we obtain by construction the foreground image necessary to recover the original. As long as the dynamic range of the foreground transparency is not exceeded, this result is guaranteed. This method is called dual modulation.

However, even if the dynamic range of the front image is exceeded, the limitations of the human visual system help mask the artifacts. At the point where we overtax the capacity of the front image, a contrast on the order of 100:1, scattering in the eye makes it impossible to distinguish sharp boundaries. Figure 5.6 (left) shows the approximate point spread function of the human eye. Figure 5.6 (right) shows the desired and the reproduced image for a device such as this. Due to the blurring of the back image, there is some spillover at the edges of this high-contrast

FIGURE 5.5 *Demonstration of how a blurred background image recombines with a carefully constructed foreground image to reproduce the original.*

boundary. However, due to scattering in the eye, the human observer cannot see it. The bright central region effectively masks this error as an even greater amount of light spills over on the retina.

The HDR transparency viewer described is an interesting device, as it demonstrates the feasibility of splitting the image into two layers that together produce an HDR view. However, its limitation to still imagery for a single observer makes it impractical for anything outside the laboratory. Even so, the same principles we have introduced here apply equally to HDR softcopy displays, particularly those developed by Sunnybrook Technologies (discussed in the following section).

The point spread function of the human eye (left) and its effect on the visibility of spillover at high-contrast boundaries in a dual modulator's output (right).

5.2 SOFTCOPY DEVICES

For the purposes of discussion, we define a *softcopy* device as an electronic device that can be used in an interactive setting. This excludes movie film projectors that display in real time something whose preparation is far from it. This section therefore focuses on the two most popular display technologies before we venture into some of the newer and less well-known devices.

5.2.1 CATHODE–RAY TUBES AND LIQUID CRYSTAL DISPLAYS

The first softcopy device was the cathode-ray tube (CRT), invented by German physicist Karl Ferdinand Braun in 1897. A CRT is a vacuum tube configured to dynamically control the aim, intensity, and focus of an electron beam, which strikes a phosphor-coated surface that converts the energy into photons. By depositing red, green, and blue phosphors in a tight matrix and scanning the display surface at 30 Hz or more, the eye can be fooled into believing it sees a continuous 2D

color image. Through these and other refinements, the CRT has held its place as the leading softcopy display device over 100 years later, making it the most successful and longest-lived electronics technology ever developed.[3] Only in the past decade has the liquid crystal display (LCD) begun to supplant a substantial portion of traditionally CRT-based applications, and LCDs currently dominate today's portable electronics market.

A good part of the success of the CRT is its inherent simplicity, although a century of tinkering has brought many variations and tens of thousands of patents to the basic technology. By tracing an electron beam (usually a triple beam for RGB) across a fixed phosphor-coated-matrix, the actual number of electronic connections in a CRT is kept to a minimum. By comparison, an active-matrix LCD has an associated circuit deposited on the glass by each pixel, which holds the current color and drives the liquid crystal. This adds up to millions of components on a single LCD display, with commensurate manufacturing costs and challenges (up to 40% of displays off the assembly line are discarded due to "stuck" pixels and other problems). Even today there are only a handful of electronics makers capable of fabricating large active-matrix LCD screens, which other manufacturers then assemble into final products.

Figure 5.7 compares the anatomy of a CRT pixel to that of an LCD. In a CRT, each pixel is scanned once per frame, and the phosphor's gradual decay (coupled with the brain's integration of flashed illumination faster than 60 Hz) makes the pixel appear as though it were constant. In an active-matrix LCD, the pixel is held constant by the combination of a capacitor and a thin-film transistor (TFT), which acts as a short-term memory circuit between refreshes. As we mentioned, this circuitry adds to the cost and complexity of the LCD relative to the CRT, although these costs will reach parity soon. When one considers the end-to-end cost of CRTs, it is seen that their additional bulk and weight create shipping, handling, and disposal difficulties far beyond those of LCDs (and most other replacement technologies). LCDs have already surpassed CRT sales in the computer display market and are poised to take over the television market next.

Regarding dynamic range, CRTs and LCDs have some important differences. The fundamental constraint for CRTs is their maximum brightness, which is limited

..

3 Technically, the battery has been in use longer, but the battery does not fit within the standard definition of "electronics," which is the behavior of free electrons in vacuum, gasses, and semiconductors.

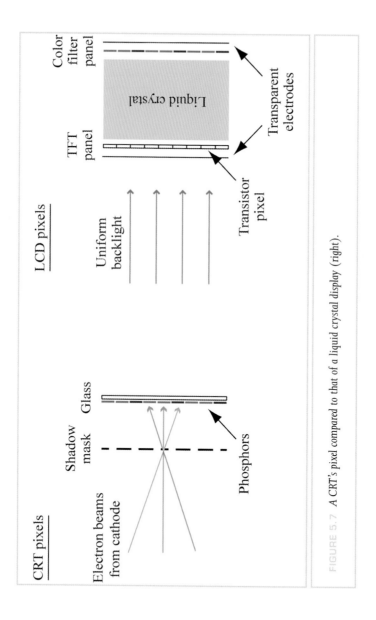

FIGURE 5.7 *A CRT's pixel compared to that of a liquid crystal display (right).*

by the amount of energy we can safely deposit on a phosphorescent pixel without damaging it or generating unsafe quantities of X-ray radiation. By comparison, there is no fundamental limit to the amount of light one can pass through an LCD screen, and in fact the LCD itself need not change (only the backlight source). However, CRTs have one advantage over standard LCDs, which is that a CRT pixel can be switched off completely, whereas an LCD pixel will always leak some small but significant quantity of light (limiting its effective dynamic range). Technically, a CRT display has a very high dynamic range, but it is not useful to us because the range is all at the low end, where we cannot see it under normal viewing conditions. Conversely, the LCD can achieve high brightness, but with a limited dynamic range.

The only way to improve the dynamic range of an LCD is to modulate the backlight. Because most LCD backlights are uniform sources, one can only alter the overall output of the display in such a configuration. Of course, uniform modulation would not improve the dynamic range for a single frame or image, but over a sequence of frames one could achieve any dynamic range one desires. Indeed, some manufacturers appear to have implemented such an idea, and there is even a patent on it. However, having a video get drastically brighter and dimmer over time does not fulfill the need for additional dynamic range within a single frame. This gives rise to alternative technologies for providing local LCD backlight modulation. Two such approaches are described in the following.

5.2.2 SUNNYBROOK TECHNOLOGIES' HDR DISPLAYS

Sunnybrook Technologies of Vancouver, Canada (*www.sunnybrooktech.com*), has explored both projector-based and light-emitting diode (LED)-based backlight modulators in its HDR display systems [114,115]. Similar to the concept presented in Section 5.1.3, a low-resolution modulator is coupled with a compensated high-resolution front image (the LCD) to provide an HDR display free of pixel registration problems. The principal difference is that the Sunnybrook displays are dynamic and can show video at real-time rates. As these are otherwise conventionally configured displays, they have the external appearance of a standard monitor and unlike the original LBL transparency viewer are not restricted to a single observer.

A diagram of Sunnybrook's projector-based display is shown in Figure 5.8. The original prototype employed an LCD-based projector, and the later models use a

FIGURE 5.8 *Sunnybrook Technologies' projector-based display* [114].

modified black-and-white DLP projector (see Section 5.2.3). All units employ a high-resolution LCD panel as the final view portion of their display. By using the projector to effectively modulate the backlight of the front LCD, they are able to present images with a dynamic range in excess of 50,000:1. Depending on the exact configuration, the maximum luminance can be up to 2,700 cd/m^2 for a single observer — at least 8 times brighter than today's standard LCD displays, and 15 times brighter than the best CRTs.

However, there are a number of important drawbacks to using a projector as a backlight. First, the optical path required by the projector means that the display itself is large — about 100 cm in depth. Custom optics or some mirror arrangement could reduce this dimension, but similar to a projection-based television it will never be as small as a CRT display of similar display area and resolution. Second, the incorporation of a Fresnel lens to boost brightness and improve uniformity incurs a cost in terms of light falloff at wider viewing angles.[4] Finally, the light source for the projector must be extremely bright in order to support a high maximum

. .

4 The Fresnel lens is a thick sheet of acrylic, embossed with a circular pattern that simulates a much thicker lens. This is preferred in applications where cost and weight are more important than image quality. Because the rear image is low resolution and the Fresnel lens is followed by a diffuser, this arrangement has no impact on image quality.

FIGURE 5.9 *Sunnybrook Technologies' LED-based display* [114].

luminance through two modulators, and this translates to a high (and unvarying) power consumption with associated heat dissipation issues.

In consideration of these problems, Sunnybrook subsequently developed the LED-based display shown in Figure 5.9. Replacing the projector as a backlight, this newer display employs a low-resolution honeycomb (hexagonal) array of white LEDs mounted directly behind the LCD's diffuser. No Fresnel lens is needed to compensate for projector beam spread, and because the LEDs are individually powered consumption is no longer constant but is directly related to display output. Because most HDR images will have only a fraction of very bright pixels (less than 10%), the average power consumption of this device is on par with a standard CRT display. Furthermore, because the LED array is inherently low resolution, Sunnybrook is able to encode the data needed in the first scan line of the incoming video signal, rather than providing a separate video feed as required by the projector-based display.

The LED-based display has a higher maximum output (8,500 cd/m^2), with a similar dynamic range. The chief drawback of this new design is the current cost of the high-output white LEDs used in the backlight. Fortunately, the cost of these

relatively new components is dropping rapidly as the market ramps up, and the price point is expected to be in the reasonable range by the time the display is ready for market. In contrast, the cost of high-output digital projectors has largely leveled off, and the price of the projector-based display will always be greater than the projector inside it.

5.2.3 OTHER DISPLAY TECHNOLOGIES

Most other work on HDR display technology is happening in the nascent field of *digital cinema*, whereby major studios and theater chains are hoping to replace their current film-based equipment with electronic alternatives. Already, over a hundred theaters in the United States have installed digital projection systems. Most of these projectors use the Texas Instruments Digital Light Processing (DLP) system, based on their patented Digital Micromirror Device (DMD).

These devices were the first large-scale commercial application of microelectro-mechanical systems (MEMS). A DMD chip consists of a small high-resolution array of electrically-controlled two-position mirrors, a subsection of which is pictured in Figure 5.10. Each mirror is individually controlled and held in position by an underlying circuit, similar to that of an active-matrix LCD. The chief difference is that rather than transmitting a percentage of the light and absorbing the rest, the DMD reflects about 85% of the incident radiation, but in a controlled way that permits the desired fraction to continue onto the screen and the rest to be deflected by 10 to 12 degrees onto an absorbing baffle. Thus, the DMD can handle much greater light intensities without risk of overheating or light-associated damage, despite its small area. Because it is inherently a binary device, time modulation is used to control the average output at each pixel. For example, a micromirror at 25% output is in the "off" orientation 75% of the time. Color is achieved either by ganging three chips through a beam splitter or by using a flying color wheel whereby red, green, and blue images are presented sequentially to the screen. This is all made possible by the fast switching times of the micromirror elements (about 15 microseconds).

In principle, there is no reason to believe that DMD technology would not enable direct HDR display. In practice, however, the dynamic range is limited by the amount of light scattering from mirror edges, hinges, and the spacing required for clearance. Hence, the actual, delivered dynamic range of commercial DLP chips is on the order

FIGURE 5.10 *Twelve pixels on a Texas Instruments micromirror (DMD) array, and a section detailing two neighboring pixels. Each square mirror is 16 microns on a side, and DMD resolutions up to 1,024 × 768 are available. (Images acquired from the Texas Instruments DLP™ Technology Image Library.)*

of 500:1, despite some manufacturers' more optimistic claims (usually based on "all-on" versus "all-off" measurements). With time, we can hope that this ratio will continue to improve, and Texas Instruments, latest DDR DMD chips employ a dark inner coating to minimize unwanted reflections. However, there appear to be practical limits to how far DMD technology can go.

An even more promising projection technology, which has been on the horizon for some years now, is Silicon Light Machines' grating light valve (GLV), shown in Figure 5.11. This MEMS device provides rapid and efficient control of laser reflection via a tiny, controllable diffraction grating. Similar to the DMD in concept, the GLV uses smaller-scale elements (a few microns wide), with displacements smaller than the wavelength of visible light. This yields rapid, continuous control (about 0.1 microseconds from 0 to 100%) between mirror and diffraction grating in what is inherently an analog device. Although no commercial displays are yet available using this technology, the design trend is toward vertical (column) arrays, swept across the

FIGURE 5.11 *Silicon Light Machines' micrograting (GLV) pixel. Each ribbon is about 5 microns wide. (GLV is a trademark of Silicon Light Machines.)*

screen to make a complete image using laser scanning or similar techniques [14]. It is difficult to predict what to expect of these devices in terms of dynamic range, but there are several parameters available for tuning and few apparent limitations to the ultimate control that may be achieved [97]. Operating at wavelength scales provides new opportunities for control efficiency that larger devices such as LCDs and DMDs cannot easily match.

Finally, the HDR potential of LED-based displays bears mentioning. An active matrix of LEDs would solve nearly all of the problems discussed so far. Outputs could go down to zero at each pixel, potentially generous maximum outputs would be possible, and cross-talk between pixels would be negligible.

Unfortunately, the technical barriers involved in constructing such a display are formidable. The large-scale microcircuit fabrication requirements are similar to those of LCD panels, except that the power levels are greater by several orders of magnitude. In addition, the color and output variation in current LED manufacturing is high, causing makers to rely on "binning" individual LEDs into groups for consistency. It is difficult to see how binning could be used in the manufacture of

a display with over a million such devices, but manufacturing methods continue to improve, and we expect that production will be more consistent in a few years.

However, heat dissipation is critical, as LED output is very sensitive to temperature and efficacies are too low at present for a practical large HDR display. So far, only Kodak and Sony have marketed products using organic light-emitting diode (OLED) displays, and these are comparatively small, low-output devices.[5] Nevertheless, because LED displays are inherently HDR, the potential is there.

. .
5 Kodak's NUVUE AM550L device is 44×33 mm^2 at 520×220 resolution, with a 120-cd/m^2 maximum output level.

The Human Visual System and HDR Tone Mapping

06

The dynamic range of illumination in a real-world scene is high — on the order of 10,000 to 1 from highlights to shadows, and higher if light sources are directly visible. A much larger range of illumination can also occur if the scene includes both an outdoor area illuminated by sunlight and an indoor area illuminated by interior light (see, for example, Figure 6.1). Using techniques discussed in Chapter 4, we are able to capture this dynamic range with full precision. Unfortunately, most display devices and display media available to us come with only a moderate absolute output level and a useful dynamic range of less than 100 to 1. The discrepancy between the wide ranges of illumination that can be captured and the small ranges that can be reproduced by existing displays makes the accurate display of the images of the captured scene difficult. This is the HDR display problem, or HDR tone-mapping problem. We introduce the tone-mapping problem in this chapter and discuss individual solutions in detail in the following two chapters.

6.1 TONE-MAPPING PROBLEM

For a display to exhibit realism, the images should be faithful visual representations of the scenes they depict. This is not a new problem. Artists and photographers have been addressing this problem for a long time. The core problem for the artist (canvas), photographer (positive print), and us (display device) is that the light intensity level in the environment may be completely beyond the output level reproduced by the display medium. In addition, the contrast experienced in a real

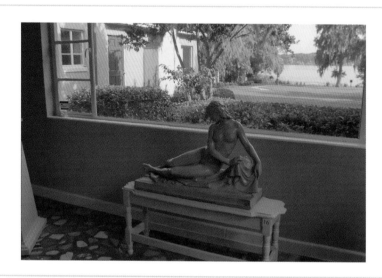

FIGURE 6.1 *Image depicting both indoor and outdoor areas. The different lighting conditions in these areas gives rise to an HDR. (Albin Polasek (1879–1965) Awakening Spring, 1926, Plaster. Courtesy of the Albin Polasek Museum and Sculpture Gardens, Winter Park, FL.)*

environment may greatly exceed the contrast range that can be reproduced by those display devices. Appearance of a scene depends upon the level of illumination and the contrast range [31]. Some commonly noticed examples are that scenes appear more colorful and contrasty on a sunny day, colorful scenes of the day appear gray during night, and moonlight has a bluish appearance. Hence, simple scaling or compression of the intensity level and the contrast range to fit them into the display limits is not sufficient to reproduce the accurate visual appearance of the scene. Tumblin and Rushmeier [131] formally introduced this problem and suggested the use of visual models for solving this problem (see Figure 6.2 for a pictorial outline). Ever since, developing tone-mapping algorithms that incorporate visual models has

FIGURE 6.2 *Pictorial outline of the tone-mapping problem. The ultimate goal is a visual match between the observed scene and the tone-mapped version of the captured HDR image on the display.*

been an active area of research within the computer graphics and digital-imaging communities.

Reproducing the visual appearance is the ultimate goal in tone mapping. However, defining and quantifying visual appearance itself is not easy and is a current research topic [31]. Instead of delving deep into appearance-related issues in tone mapping, in this chapter we address one basic issue for realistic display of HDR images. First, the HDR must be reduced to fit the display range. This can be achieved by simple scaling of the image. However, such simple scaling often generates images with complete loss of detail (contrast) in the resulting display (Figure 6.3). That gives us a seemingly simpler problem to solve: how to compress the dynamic range of the HDR image to fit into the display range while preserving detail.

The human visual system deals with a similar problem on a regular basis. The signal-to-noise ratio of individual channels in the visual pathway (from retina to brain) is about 32 to 1, less than 2 orders of magnitude [19,55]. Even with this dynamic range limitation, the human visual system functions well: it allows us

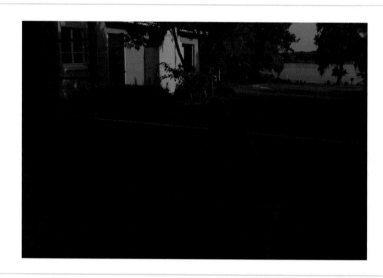

FIGURE 6.3 *HDR image depicting both indoor and outdoor areas. Linear scaling was applied to demonstrate the lack of detail afforded by linear scaling. (Image courtesy of the Albin Polasek Museum, Winter Park, Florida.)*

to function under a wide range of illumination, and allows us to simultaneously perceive the detailed contrast in both the light and dark parts of an HDR scene. Thus, if the goal is to match this perceived realism in the display of HDR images it is important to understand some of the basics of the human visual system. Hence, this chapter focuses on aspects of the human visual system relevant to HDR imaging. We show that most tone-mapping algorithms currently available make use of one of a small number of visual models to solve the HDR problem.

The material described in the following sections has been distilled from the psychophysics and electrophysiology literature, wherein light is variously measured as quanta, intensity, luminance, radiance, or retinal illuminance. To avoid confusion,

wherever possible we will use the term *luminance*. If any unit other than luminance is required, we provide the units in which they originally appeared in the literature.

6.2 HUMAN VISUAL ADAPTATION

A striking feature of the human visual system is its capacity to function over the huge range of illumination it encounters during the course of a day. Sunlight can be as much as a million times more intense than moonlight. The intensity of starlight can be one-thousandth of the intensity of moonlight. Thus, the effective range of illumination is more than a billion to one [135]. The dynamic range simultaneously available in a single scene at a given time is much smaller, but still hovers at about four orders of magnitude.

The visual system functions in this range by adapting to the prevailing conditions of illumination. Thus, adaptation renders our visual system less sensitive in daylight and more sensitive at night. For example, car headlights that let drivers drive at night go largely unnoticed in daylight, as shown in Figure 6.4.

In psychophysical studies, human visual adaptation is evaluated by measuring the minimum amount of incremental light by which an observer distinguishes a test

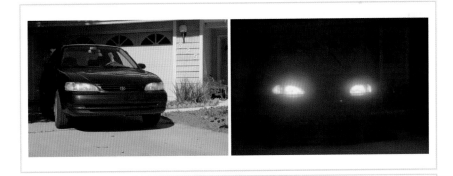

FIGURE 6.4 *Although the headlights are on in both images, during daylight our eyes are less sensitive to car headlights than at night.*

object from the background light. This minimum increment is called a *visual threshold* or *just-noticeable difference* (JND). In a typical threshold measurement experiment, a human subject stares at a wide blank screen for a sufficient amount of time to adjust to its uniform background intensity, I_b. Against this uniform background a small test spot of intensity $I_b + \Delta I$ is flashed. This test spot is called the *stimulus*. The increment ΔI is adjusted to find the smallest detectable ΔI_b. The value of this threshold depends on the value of the background, as shown in Figure 6.5. This figure plots typical threshold versus intensity (TVI) measurements at various

FIGURE 6.5 Threshold versus intensity (TVI) relation. *The plot on the right shows the visual threshold* ΔI_b *at different background intensities* I_b.

background intensities. Over much of the background intensity range, the ratio

$$\frac{\Delta I_b}{I_b}$$

is nearly constant, a relation known for over 140 years as Weber's law. The value of this constant fraction is about 1% [135], which can vary with the size of the test spot and the duration for which the stimulus is shown. The constant nature of this fraction suggests that visual adaptation acts as a normalizer, scaling scene intensities to preserve our ability to sense contrasts within scenes.

Visual adaptation to varying conditions of illumination is thought to be possible through the coordinated action of the pupil, the rod-cone system, photochemical reactions, and photoreceptor mechanisms. The role of each of these factors is discussed in the following sections.

6.2.1 THE PUPIL

After passing through the cornea and the aqueous humor, light enters into the visual system through the pupil, a circular hole in the iris (Figure 6.6) [38,48,49]. One of the mechanisms that allows us to adapt to a specific lighting condition is regulation of the amount of light that enters the eye via the size of the opening of the pupil. In fact, the pupil changes its size in response to the background light level. Its diameter changes from a minimum of about 2 mm in bright light to a maximum of about 8 mm in darkness. This change accounts for a reduction in light intensity entering the eye by only a factor of 16 (about 1 log unit). In a range of about 10 billion to 1, the intensity regulation by a factor of 16 is not very significant. Hence, the pupil's role in visual adaptation may be ignored for the purpose of tone reproduction.

6.2.2 THE ROD AND CONE SYSTEMS

Light that has passed through the pupil travels through the lens and the vitreous body before reaching the retina, where it is reflected from a pigmented layer of cells before being absorbed by photoreceptors. The latter convert light into neural signals before they are relayed to other parts of the visual system. The human retina

FIGURE 6.6 *Schematic diagram of the human eye and its various components. (From Aaron Lefohn, Richard Caruso, Erik Reinhard, Brian Budge and Peter Shirley, 'An Ocularist's Approach to Human Iris Synthesis', IEEE Computer Graphics and Applications, 23(6), November/December 2003.)*

has two distinct types of photoreceptors: rods and cones. Rods are very sensitive to light and are responsible for vision from twilight illumination to very dark lighting conditions. Cones are relatively less sensitive and are responsible for vision in daylight to moonlight. Depending on whether the vision is mediated by cones or rods, illumination is broadly divided respectively into *photopic* and *scotopic* ranges. The boundary between photopic and scotopic is fuzzy, with some overlap occurring. A range of illumination between indoor light to moonlight in which both rods and cones are active is referred to as the *mesopic* range. Rods and cones divide the huge range of illumination into approximately two smaller ranges, and individually adapt to this range.

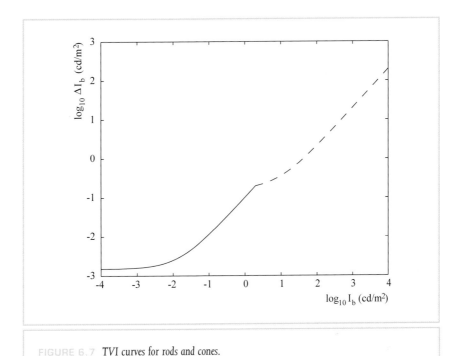

FIGURE 6.7 *TVI curves for rods and cones.*

The manifestation of adaptation of rods and cones in their respective ranges of illumination is shown in the TVI plots in Figure 6.7. The solid line corresponds to the thresholds for rods, and the dashed line corresponds to the threshold for cones. In scotopic illumination conditions, rods are more sensitive than cones and have a much lower threshold, and the vision in those illumination conditions is mediated by the rod system.

As illumination is increased, cones become increasingly sensitive (demonstrated by the crossover of the cone and rod TVI curves). At higher illuminations, rods begin to saturate and eventually the rod system becomes incapable of discriminating between two lights that differ in intensity by as much as a factor of one

hundred [51]. The equation of the rod curve shown in Figure 6.7 is

$$\Delta I_b = 0.1(I_b + 0.015),$$

and the equation describing the cone curve is

$$\Delta I_b = 0.02(I_b + 8).$$

These equations are due to Rushton and MacLeod and fit their threshold data [111]. In this case, the equations are given in trolands (td), which is a measure of retinal illuminance. A value of 1 td is obtained when a surface with a luminance of 1 cd/m^2 is viewed through a pupil opening of 1 mm^2. Thus, trolands are given as luminance times area of the pupil.

The diameter d of the circular pupil as a function of background luminance may be estimated [149]. Moon and Spencer [83] propose the following relation between luminance and pupil diameter.

$$d = 4.9 - 3\tanh\big(0.4(\log L + 1.0)\big)$$

Alternatively, de Groot and Gebhard [89] estimate the pupil diameter to be

$$\log d = 0.8558 - 4.01 \times 10^{-4}(\log L + 8.6)^3.$$

In both of these equations the diameter d is given in mm, and L is the luminance in cd/m^2.

The role of rods and cones in adaptation is important, and deserves consideration when dealing with intensities of extreme dynamic range. However, the individual operating ranges of rods and cones are still very large (a million to one). Thus, additional processes must play a significant role in their adaptation.

6.2.3 PHOTO-PIGMENT DEPLETION AND REGENERATION

Light is absorbed by the rod and cone photoreceptors through a photochemical reaction. This reaction breaks down photosensitive pigments and temporarily ren-

ders them insensitive—a process called bleaching. The pigments are regenerated in a relatively slow process. Thus the visual adaptation as a function of light intensity could be attributed to the depletion and regeneration of photo-pigment. Rod photo-pigments are completely depleted when exposed to light intensity above the mesopic range. It is believed that this depletion renders rods inoperable in the photopic range.

However, cone photo-pigments are not significantly depleted even in bright sunlight, but as demonstrated in the TVI relationship the sensitivity of the cones continues to diminish as a function of background intensity. This lack of correlation between photo-pigment concentration and visual sensitivity, as well as other experimental evidence, suggests that unless virtually all pigments are bleached the visual adaptation to different illumination conditions cannot be completely attributed to photo-pigment concentration [19].

6.2.4 PHOTORECEPTOR MECHANISMS

Photoreceptors convert absorbed light energy into neural responses. Intercellular recordings show that the response characteristics of rods and cones have the following behavior.[1] Compared to the broad range of background light intensities over which the visual system performs, photoreceptors respond linearly to a rather narrow range of intensities. This range is only about 3 log units, as shown in Figure 6.8. The log-linear plot in this figure of the intensity-response function is derived from measurements of the response of dark-adapted vertebrate rod cells on brief exposures to various intensities of light [19].

The response curve of cones follows the same shape as the response curve of rod cells. However, because of the higher sensitivity of rod cells to light the response curve for the cones appears to the right on the log intensity axis. Figure 6.9 shows the response curves for both rods and cones.

. .

1 Electrophysiology is a field of study that may be used to detect the response of individual cells in the human visual system. Whereas the visual system is stimulated with a pattern of light, single-cell recordings are made whereby a thin electrode is held near the cell (extracellular recordings) or inside the cell (intercellular recordings), thus measuring the cell's electrical behavior [92].

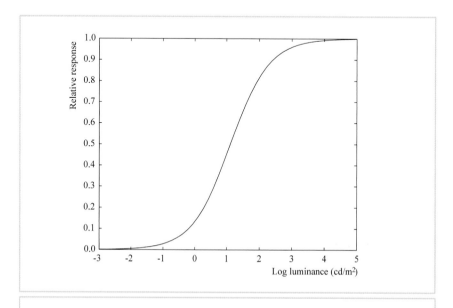

FIGURE 6.8 *Response of dark-adapted vertebrate rod cells to various intensities. The intensity axis in the image is shown in arbitrary units* [19].

The response curves for both rods and cones can be fitted with the following equation.

$$\frac{R}{R_{\text{max}}} = \frac{I^n}{I^n + \sigma^n}.$$ (6.1)

Here, R is the photoreceptor response ($0 < R < R_{\text{max}}$), R_{max} is the maximum response, I is light intensity, and σ is the semisaturation constant (the intensity that causes the half-maximum response). Finally, n is a sensitivity control exponent that has a value generally between 0.7 and 1.0 [19].

This equation, known as the Michaelis–Menten equation (or Naka–Rushton equation), models an S-shaped function (on a log-linear plot) that appears re-

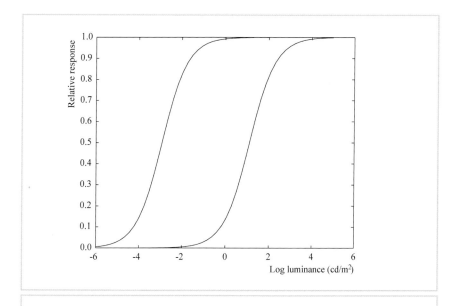

FIGURE 6.9 *Response of dark-adapted rod and cone cells to various intensities in arbitrary units.*

peatedly in both psychophysical experiments [1,50,134,147] and widely diverse direct-neural measurements [19,41,44,65,87,133]. The role of σ in Equation 6.1 is to control the position of the response curve on the (horizontal) intensity axis. It is thus possible to represent the response curves of rods and cones shown in Figure 6.9 by simply using two different values of σ, say σ_{rod} and σ_{cone}, in Equation 6.1.

Photoreceptor Adaptation The response curves shown in Figures 6.8 and 6.9 demonstrate that when the dark-adapted photoreceptor is exposed to a brief light of moderately high intensity the response reaches its maximum and the photoreceptor is saturated. The photoreceptor loses sensitivity to any additional light intensity. This initial saturation of the photoreceptor matches with our visual experience of

blinding brightness when exposed to light about a hundred or more times more intense than the current background intensity. However, this initial experience does not continue for long. If exposed to this high background intensity for a while, the human visual system adapts to this new environment and we start to function normally again.

Measurements have shown that if photoreceptors are exposed continuously to high background intensities the initial saturated response does not continue to remain saturated. The response gradually returns toward the dark-adapted resting response, and the photoreceptor's sensitivity to incremental responses is gradually restored. Figure 6.10 shows the downward shift in the measured response at two different background intensities (shown in vertical lines). An interesting observation is that the response never completely returns to the resting response. Rather, it stabilizes on a plateau. Figure 6.10 shows the plateau curve (lower curve) for a range of background intensities. In addition to the restoration of sensitivity, the intensity-response curve measured at any given background intensity shows a right shift of the response-intensity curve along the horizontal axis, thus shifting the narrow response range to lie around the background intensity. The shifted curves are shown in Figure 6.11.

Independent measurements have verified that the shapes of the intensity-response curves at any background are independent of the background. However, with background intensity the position of the response function shifts horizontally along the intensity axis. This shift indicates that given sufficient time to adapt the visual system always maintains its log-linear property for about 3 log units of intensity range around any background. This shift is also modeled by the Michaelis–Menten equation by simply increasing the value of the semisaturation constant σ as a function of the background intensity. This yields the modified equation

$$\frac{R}{R_{\max}} = \frac{I^n}{I^n + \sigma_{\mathrm{b}}^n},$$

(6.2)

where σ_{b} is the value of the half-saturation constant that takes different values for different background intensities, I_{b}. Thus, the photoreceptor adaptation modeled by the Michaelis–Menten equation provides us with the most important mechanism of adaptation.

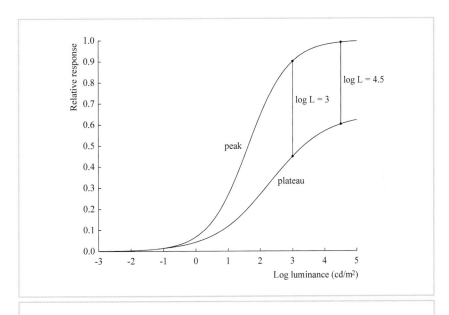

FIGURE 6.10 *Recovery of response after a long exposure to background intensities* [19].

Response–threshold Relation The observed linear relationship between the visual threshold and background intensity (the TVI relationship from Section 6.2) can be derived from the cellular adaptation model. (See Figure 6.12 for an intuitive derivation.) For this derivation we assume that the threshold ΔI_b is the incremental intensity required to create an increase in cellular response by a small criterion amount δ [45,134]. Based on this assumption, we derive ΔI_b from the response equation as follows. Rearranging Equation 6.2 yields

$$I = \sigma_b \left(\frac{R}{R_{max} - R} \right)^{\frac{1}{n}}.$$

FIGURE 6.11 Photoreceptor response adaptation to different background intensities. *The plateau of Figure 6.10 is shown in gray. It represents the locus of the photoreceptor response to the background intensity itself.*

FIGURE 6.12 Pictorial illustration of the response-threshold relation. *The figure at the top plots three photoreceptor response functions at three different background luminances (L_1, L_2, L_3 from left to right) about 2 log units apart from each other. The response to the background luminance itself is shown by the $*$ symbol on the plots. ΔR is a small and fixed amount of response above the response to the background luminance and ΔL_is are the increments in luminance required to cause the same ΔR response change. The figure at the bottom plots the ΔL_i values as a function the background luminances L_i. The three values corresponding to background luminances L_1, L_2, and L_3 are shown in solid dots. The curve passing through the plotted ΔL_i values has a shape similar to the TVI function shown in the earlier part of this chapter.*

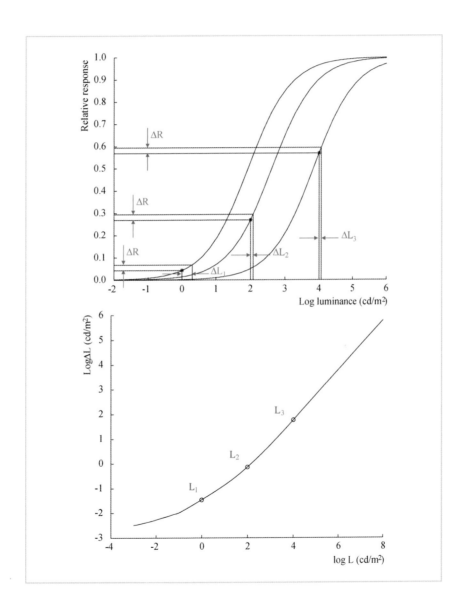

By differentiating this expression with respect to R, we get

$$\frac{dI}{dR} = \sigma_b \cdot \frac{1}{n} \cdot \left(\frac{R}{R_{max} - R}\right)^{\frac{1}{n} - 1} \left(\frac{R_{max}}{(R_{max} - R)^2}\right)$$

$$= \sigma_b \cdot \frac{1}{n} \cdot \frac{R_{max}}{(R_{max} - R)^{\frac{n+1}{n}}} R^{\frac{1-n}{n}}.$$

This gives an expression for the incremental intensity (i.e., dI) required to increase the response of the system by dR. If we assume that the criterion response amount δ for the threshold condition is small enough, from the previous equation it is possible to compute the expression for ΔI as

$$\frac{\Delta I}{\delta} \cong \frac{dI}{dR}$$

$$= \sigma_b \cdot \frac{1}{n} \cdot \frac{R_{max}}{(R_{max} - R)^{\frac{n+1}{n}}} R^{\frac{1-n}{n}}.$$

Note that in all these equations R is the response of the cellular system exposed to intensity I, which may be different from the background intensity I_b to which the system is adapted. For threshold conditions, we can write $R = R_b + \delta$, where R_b is the plateau response of the system at the background intensity I_b. Thus,

$$\Delta I = \delta \cdot \sigma_b \cdot \frac{1}{n} \cdot \frac{R_{max}}{(R_{max} - R_b - \delta)^{\frac{n+1}{n}}} (R_b + \delta)^{\frac{1-n}{n}}.$$

For dark-adapted cells, the response of the system $R_b = 0$. Thus, the expression of the threshold under a dark adaptation condition is

$$\Delta I_{dark} = \delta \cdot \sigma_{dark} \cdot \frac{1}{n} \cdot \frac{R_{max}}{(R_{max} - \delta)^{\frac{n+1}{n}}} \delta^{\frac{1-n}{n}}.$$

The relative threshold, $\Delta I / \Delta I_{\text{dark}}$, for adaptation at any other background intensity I_{b} is

$$
\frac{\Delta I}{\Delta I_{\text{dark}}} = \frac{\sigma_{\text{b}}}{\sigma_{\text{dark}}} \cdot \left(\frac{R_{\text{b}} + \delta}{\delta} \right)^{\frac{1-n}{n}} \left(\frac{R_{\text{max}} - \delta}{R_{\text{max}} - R_{\text{b}} - \delta} \right)^{\frac{n+1}{n}}
$$

$$
\approx \frac{\sigma_{\text{b}}}{\sigma_{\text{dark}}} \cdot \left(\frac{\delta}{R_{\text{b}}} \right)^{\frac{n-1}{n}} \left(\frac{R_{\text{max}}}{R_{\text{max}} - R_{\text{b}}} \right)^{\frac{n+1}{n}}
$$

$$
= \frac{\sigma_{\text{b}}}{\sigma_{\text{dark}}} \cdot \left(\frac{\delta}{R_{\text{max}}} \right)^{\frac{n-1}{n}} \left(\frac{I_{\text{b}}^n + \sigma_{\text{b}}^n}{I_{\text{b}}^n} \right)^{\frac{n-1}{n}} \left(\frac{I_{\text{b}}^n + \sigma_{\text{b}}^n}{\sigma_{\text{b}}^n} \right)^{\frac{n+1}{n}}
$$

$$
= \frac{1}{\sigma_{\text{dark}}} \cdot \left(\frac{\delta}{R_{\text{max}}} \right)^{\frac{n-1}{n}} \frac{(I_{\text{b}}^n + \sigma_{\text{b}}^n)^2}{I_{\text{b}}^{n-1} \sigma_{\text{b}}^n}.
$$

For $n = 1$ and $I_{\text{b}} = \sigma_{\text{b}}$, $\frac{\Delta I}{\Delta I_{\text{dark}}}$ is directly proportional to I_{b}. This relation is in agreement with the Weber relation seen in TVI measurements. Thus, Weber's law may be considered as a behavioral manifestation of photoreceptor adaptation. The preceding discussion of the various mechanisms of visual adaptation affords the following conclusions.

- Photoreceptor adaptation plays a very important role in visual adaptation. An appropriate mathematical model of this adaptation (for example, Equation 6.2) can be effectively used to tone map HDR images. The TVI relation can be derived from the photoreceptor adaptation model, and hence can be used as an alternate mathematical model for tone mapping.
- The rod and cone combination extends the effective range over which the human visual system operates. Depending on the range of intensities present in an image, the appropriate photoreceptor system or combination of them may be chosen to achieve realistic tone mapping.

6.3 VISUAL ADAPTATION MODELS FOR HDR TONE MAPPING

Figure 6.13 outlines a basic framework for HDR tone mapping using models of visual adaptation. The two key features of the framework are forward and inverse adaptation models. The forward adaptation model will process the scene luminance values and extract visual appearance parameters appropriate for realistic tone mapping. The inverse adaptation model will take the visual appearance parameters and the adaptation parameters appropriate to the display viewing condition and will output the display luminance values. Either of the visual adaptation models discussed in the previous section (photoreceptor adaptation model or threshold adaptation model) may be used for forward and inverse adaptation. Most tone-mapping algorithms available today make use of one of these models. To achieve the goal of realistic HDR compression, these algorithms use photoreceptor responses or JNDs

FIGURE 6.13 *Framework for solving tone-mapping problem using visual adaptation.*

as the correlates of the visual appearance. In this section, we explore various algorithms and show their relation to the visual adaptation models discussed in the previous section.

6.3.1 PHOTORECEPTOR ADAPTATION MODEL FOR TONE MAPPING

This section brings together a large number of tone-mapping algorithms. The common relationship between them is the use of an equation similar to the photoreceptor adaptation equation (Equation 6.2) presented in Section 6.2. In the following paragraphs we only show the similarity of the equation used to the photoreceptor adaptation equation, and defer the discussion of the details of these algorithms to the following two chapters. Here we show the actual form of the equations used in the algorithms, and where required rewrite them such as to bring out the similarity with Equation 6.2. In their rewritten form they are functionally identical to their original forms. It is important to note that although these equations may be derived from the same adaptation equations they largely differ in their choice of the value of the parameters, and only a few of them specifically claim the algorithm to be based on visual adaptation. Thus, all but a few of these algorithms (see [94,95]) ignore the inverse adaptation. They use Equation 6.2 because of its several desirable properties. These properties are as follows.

- Independent of input intensity, the relative response is limited to between 0 and 1. Thus, the relative response output can be directly mapped to display pixel values.
- The response function shifts along the intensity axis in such a way that the response of the background intensity is well within the linear portion of the response curve.
- The equation has a near linear response to the intensity in the log domain for about 4 log units. The intensity ranges of most natural scenes without any highlights or directly visible light sources do not exceed 4 log units. Thus, such scenes afford an approximately logarithmic relation between intensity and response.

Rational Quantization Function Schlick used the following mapping function for computing display pixel values from pixel intensity (I) [113].

$$F(I) = \frac{pI}{pI - I + I_{\max}} \qquad \text{[Original form]}$$

$$= \frac{I}{I + \frac{I_{\max} - I}{p}}. \qquad \text{[Rewritten form]}$$

Here I_{\max} is the maximum pixel value, and p takes a value in the range $[1, \infty]$. We can directly relate this equation to Equation 6.2 by substituting 1 for n and $\frac{I_{\max} - I}{p}$ for σ_b in that equation. Note that the value of σ_b depends on the value of I itself, which may be interpreted as if the value of every pixel served as the background intensity in the computation of the cellular response.

Gain Control Function Pattanaik et al. introduced a gain control function for simulating the response of the human visual system and used this gain-controlled response for tone mapping [94]. They proposed two different equations for modeling the response of rod and cone photoreceptors. The equations are

$$F_{\text{cone}}(I) = \frac{I}{c_1(I_b + c_2)^n} \quad \text{and}$$

$$F_{\text{rod}}(I) = \frac{r_1}{r_2(I_b^2 + r_1)^n} \frac{I}{r_3(I_b + r_4)^n},$$

where the cs and rs are constants chosen to match certain psychophysical measurements. In their formulation, the Is represent light intensity of the image pixels of successively low-pass filtered versions of the image, and for every level of the image the background intensity I_b is chosen as the intensity of the pixel at the next level. These equations have a vague similarity with Equation 6.2 and have been given here for completeness.

S-shaped Curve Tumblin et al. used an S-shaped curve (sigmoid) as their tone-mapping function [129]. The equation of this curve is

$$F(I) = \left[\frac{\left(\frac{I}{I_{\mathrm{b}}} \right)^n + \frac{1}{k}}{\left(\frac{I}{I_{\mathrm{b}}} \right)^n + k} \right] \cdot D \qquad \text{[Original form]}$$

$$= \left[\frac{I^n}{I^n + kI_{\mathrm{b}}^n} + \frac{I_{\mathrm{b}}^n}{k(I^n + kI_{\mathrm{b}}^n)} \right] \cdot D, \qquad \text{[Rewritten form]}$$

where k, D, and n are the parameters for adjusting the shape and size of the S-shaped curve. According to the authors, this function is inspired by Schlick's quantization function, shown previously. The rewritten equation has two parts. The first part is identical to Equation 6.2. The second part of the equation makes it an S-shaped function on a log-log plot.

Photoreceptor Adaptation Model Pattanaik et al. [95] and Reinhard and Devlin [108] made explicit use of Equation 6.2 for tone mapping. Pattanaik et al. used separate equations for rods and cones to account for the intensity in scotopic and photopic lighting conditions. The σ_{b} values for rods and cones were computed from the background intensity using

$$\sigma_{\mathrm{b,rod}} = \frac{c_1 I_{\mathrm{b,rod}}}{c_2 j^2 I_{\mathrm{b,rod}} + c_3 (1 - j^2)^4 I_{\mathrm{b,rod}}^{1/6}}$$

$$\sigma_{\mathrm{b,cone}} = \frac{c_4 I_{\mathrm{b,cone}}}{k^4 I_{\mathrm{b,cone}} + c_5 (1 - k^4)^2 I_{\mathrm{b,cone}}^{1/3}},$$

where

$$j = \frac{1}{c_6 I_{\mathrm{b,rod}} + 1}$$

$$k = \frac{1}{c_7 I_{\mathrm{b,cone}} + 1}$$

and $I_{b,rod}$, $I_{b,cone}$ are respectively the background intensities for the rods and cones. Pattanaik and Yee extended the use of these functions to tone map HDR images [96]. Reinhard and Devlin provided the following much simpler equation for computing σ_b at a given background intensity.

$$\sigma_b = (f I_b)^m.$$

Here, f and m are constants and are treated as user parameters in this tone-mapping algorithm.

Photographic Tone–mapping Function The photographic tone-mapping function used by Reinhard et al. [106,109] is very similar to Equation 6.2. The equation can be written in the following form.

$$
\begin{aligned}
F(I) &= \frac{a\dfrac{I}{I_b}}{1 + a\dfrac{I}{I_b}} \qquad \text{[Original form]} \\[2em]
&= \frac{I}{I + \dfrac{I_b}{a}} \qquad \text{[Rewritten form]}
\end{aligned}
$$

Here, a is a scaling constant appropriate to the illumination range (key) of the image scene.

6.3.2 THRESHOLD VERSUS INTENSITY MODEL FOR TONE MAPPING

In the previous section we have shown the relationship between the TVI model and the photoreceptor adaptation model. Thus, it is obvious that the TVI model can be used for tone reproduction. Ward's [139] tone-mapping algorithm is the first to make use of the TVI model. In his algorithm, Ward used a JND (just-noticeable difference), the threshold ΔI_b at any background I_b, as a unit to compute the correlate of the visual appearance parameter. From the scene pixel luminance I_{scene} and the scene background luminance $I_{b,scene}$, Ward computed the ratio $\frac{I - I_{b,scene}}{\Delta I_{b,scene}}$.

This ratio represents the number of JNDs by which the pixel differs from the background. Using the display background luminance $I_{b,display}$, and display adaptation threshold $\Delta I_{b,scene}$ he inverted the JNDs to compute the display pixel luminance. The inversion expression is as follows.

$$I_{display} = JNDs \times \Delta I_{b,display} + I_{b,display} \qquad (6.3)$$

Ferwerda et al. [35] later adapted this concept to compute JNDs specific to rods and cones for the purpose of tone-mapping images with a wide range of intensities. If the background intensity is locally adapted, the log-linear relationship of the threshold-to-background intensity provides the necessary range compression for HDR images. The issue of local versus global adaptation is discussed in the next section.

6.4 BACKGROUND INTENSITY IN COMPLEX IMAGES

In the previous sections we introduced two important adaptation models: the photoreceptor response model and the TVI model. Both of these adaptation models require knowledge of the background intensity I_b. For any use of either of these models in tone reproduction, I_b has to be computed from the intensity of the image pixels. In this section we describe various methods commonly used to estimate I_b from an image.

6.4.1 IMAGE AVERAGE AS I_b

The average of the intensity of the image pixels is often used as the value of I_b. The average could be the arithmetic average

$$\frac{1}{n}\sum_{i=1}^{n} I_i$$

or geometric average

$$\prod_{i=1}^{n}(I_i + \varepsilon)^{\frac{1}{n}},$$

where n in the equations is the total number of pixels in the image, and ε (an arbitrary small increment), is added to the pixel intensities to take into account the possibility of any zero pixel values in the image. The geometric average can also be computed as

$$\exp\left(\frac{1}{n}\sum_{i=1}^{n}\log(I_i + \varepsilon)\right),$$

where the exponent $\frac{1}{n}\sum_{i=1}^{n}\log(I_i + \varepsilon)$ is the log average of the image pixels.

In the absence of any knowledge of the actual scene, one of these image averages is probably the most appropriate estimate of I_b for most images. A visual adaptation model using such an average is referred to as a global adaptation, and the tone-mapping method is referred to as global tone mapping. The geometric average is often the preferred method of average computation. This is largely because (1) the computed background intensity is less biased toward outliers in the image and (2) the relationship between intensity and response is log-linear.

6.4.2 LOCAL AVERAGE AS I_b

In images with a very high dynamic range, the intensity change from region to region can be drastic. Hence, the image average (also called global average) is not sufficiently representative of the background intensity of the entire image. The proper approach in such cases would be to segment the image into regions of LDR and use the average of pixels in each region. Yee and Pattanaik's work shows that such segmentation in natural images is not always easy, and that tone mapping using the local average from regions obtained using existing segmentation techniques may introduce artifacts at region boundaries [150].

An alternative and popular approach is to compute a local average for every pixel p in the image from its neighboring pixels. The various techniques under this category include box filtering and Gaussian filtering. These techniques are easily computed. The computation may be expressed as

$$I_{b,p} = \frac{1}{\sum_{i\in\Omega} w(p,i)} \sum_{i\in\Omega} w(p,i)I_i. \tag{6.4}$$

For Gaussian filtering

$$w(p, i) = \exp\left(-\frac{\|p - i\|^2}{s^2}\right).$$

For box filtering, it is expressed as

$$w(p, i) = \begin{cases} 1 & \text{for } \|p - i\| < s, \\ 0 & \text{otherwise.} \end{cases}$$

In these equations, Ω represents all pixels of the image around p, $\|.\|$ is the spatial distance function, and s is a user-defined size parameter in these functions. Effectively, the value of s represents the size of a circular neighborhood around the pixel p that influences the average value.

Although for most pixels in the image the local average computed in this fashion is representative of the background intensity, the technique breaks down at HDR boundaries. This is due to the fact that the relatively large disparity in pixel intensities in the neighborhood of the boundary biases the average computation. Thus, the background intensity computed for pixels on the darker side of the boundary is positively biased, and those computed for the pixels on the brighter side are negatively biased. This biasing gives rise to halo artifacts in the tone-mapped images. Figure 6.14 highlights the problem. The image shown is computed using local box-filtered values for the background intensity. Note the dark band on the darker side of the intensity boundary. Although not noticeable, similar bright banding exists on the brighter side of the boundary.

This problem can be avoided by computing the average from only those pixels whose intensities are within a reasonable range of the intensity of the pixel under consideration. The tone-mapped image in Figure 6.15 shows the result using background intensity from such an adaptive computational approach. There is a significant improvement in the image quality, but at an increased cost of computation. Two such computational approaches are discussed in the following sections.

Local Average Using Variable Size Neighborhood In this approach, the size parameter s in Equation 6.4 is adaptively varied. Reinhard et al. and Ashikhmin

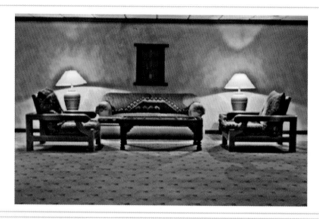

FIGURE 6.14 Halo artifacts associated with the use of I_b computed by local averaging. The artifacts are most noticeable at the illumination boundaries. (HDR image courtesy Columbia University.)

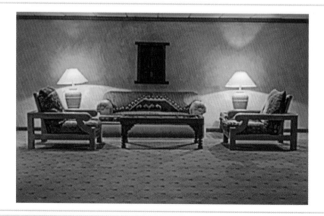

FIGURE 6.15 Tone mapping using adaptive local averaging. (HDR image courtesy Columbia University.)

simultaneously proposed this very simple algorithm [6,109]. Starting from a value of s equal to 1, they iteratively double its value until the pixels from across the HDR boundary start to bias the average value. They assume that the average is biased if it differs from the average computed with the previous size by a tolerance amount. They use this s in Equation 6.4 for computing their local average.

Local Average Using Bilateral Filtering In this approach, the size parameter s remains unchanged, but the pixels around p are used in the average summation only if their intensity values are similar to the intensity of p. The similarity can be user defined. For example, the intensities may be considered similar if the difference or the ratio of the intensities is less than a predefined amount. Such an approach may be implemented by filtering both in spatial and intensity domains. The name "bilateral" derives from this dual filtering. The filter can be expressed as

$$I_{b,p} = \frac{1}{\displaystyle\sum_{i\in\Omega} w(p,i)g(I_p, I_i)} \sum_{i\in\Omega} w(p,i)g(I_p, I_i)I_i, \tag{6.5}$$

where $w()$ and $g()$ are the two weighting functions that take into account the dual proximity. The forms of these weighting functions can be similar, but their parameters are different: for $g()$ the parameters are the intensities of the two pixels, and for $w()$ the parameters are the positions of the two pixels.

Durand and Dorsey use Gaussian functions for both domains [23]. Pattanaik and Yee use a circular box function for $w()$, and an exponential function for $g()$ [96]. Choudhury and Tumblin have proposed an extension to this technique to account for gradients in the neighborhood. They named their extension "trilateral filtering" [10].

Figure 6.16 shows the linearly scaled version of the original HDR image and the images assembled from intensities computed for each pixel using some of the adaptive local adaptation techniques discussed in this section.

6.4.3 MULTISCALE ADAPTATION

Although the use of local averages as the background intensity is intuitive, the choice of the size of the locality is largely ad hoc. In this section we provide some empirical

(a)

(b)

(continued on next page)

FIGURE 6.16 *Local averages for a sample HDR image (a). Images (b) and (c) were computed using Equation 6.4, and images (d) and (e) were computed using Equation 6.5. Equal weighting is used for images (b) and (d) and Gaussian weighting for images (c) and (e). g() for image (d) is from Pattanaik [96] and for image (e) from Durand and Dorsey [23]. (HDR image courtesy Columbia University.)*

(c)

(d)

(continued on next page)

FIGURE 6.16 (Continued.)

(e)

FIGURE 6.16 (Continued.)

support for the use of local averages and the associated importance to the size of the locality.

Physiological and psychophysical evidence indicates that the early stages of visual processing can be described as the filtering of the retinal image by bandpass mechanisms sensitive to patterns of different scales [146]. These bandpass mechanisms adapt independently to the average intensity within a region of a scene defined by their spatial scale. In a complex scene, this average will be different at different scales and thus the mechanisms will all be in different states of adaptation. Thus, to correctly account for the changes in vision that occur with changes in the level of illumination we need to consider local adaptation at different spatial scales within HDR environments. Peli suggests that an appropriate way of characterizing the effects of local adaptation on the perception of scenes is to use low-pass images that represent the average local luminance at each location in the image at different spatial scales [98]. Reinhard et al. [109] and Ashikmin [6] use this multiscale approach to adaptively decide the effective neighborhood size. Pattanaik et al.'s [94]

multiscale adaptation also demonstrates the usefulness of the multiscale nature of the visual system in HDR tone mapping.

6.5 DYNAMICS OF VISUAL ADAPTATION

In earlier sections we discussed the adaptation of the visual system to background intensity. However, visual adaptation is not instantaneous. In the course of the day, light gradually changes from dim light at dawn to bright light at noon, and back to dim light at dusk. This gradual change gives the visual system enough time to adapt, and hence the relatively slow nature of visual adaptation is not noticed. However, any sudden and drastic change in illumination, from light to dark or dark to light, makes the visual system lose its normal functionality momentarily. This loss of sensitivity is experienced as total darkness during a light-to-dark transition, and as a blinding flash during a dark-to-light transition. Following this momentary loss in sensitivity, the visual system gradually adapts to the prevailing illumination and recovers its sensitivity. This adaptation is also experienced as a gradual change in perceived brightness of the scene.

The time course of adaptation, the duration over which the visual system gradually adapts, is not symmetrical. Adaptation from dark to light, known as *light adaptation*, happens quickly (in a matter of seconds), whereas *dark adaptation* (adaptation from light to dark) occurs slowly (over several minutes). We experience the dark-adaptation phenomenon when we enter a dim movie theater for a matinee. Both adaptation phenomena are experienced when we drive into and out of a tunnel on a sunny day. The capability of capturing the full range of light intensities in HDR images and video poses new challenges in terms of realistic tone mapping of video-image frames during the time course of adaptation.

In Section 6.2 we argued that vision is initiated by the photochemical interaction of photons with the photo-pigments of the receptor. This interaction leads to bleaching and hence to loss of photo-pigments from receptors. The rate of photon interaction and hence the rate of loss in photo-pigments is dependent on the intensity of light, on the amount of photo-pigment present, and on photosensitivity. A slow chemical regeneration process replenishes lost photo-pigments. The rate of regeneration depends on the proportion of bleached photo-pigments and on the time constant of the chemical reaction.

From the rate of bleaching and the rate of regeneration it is possible to compute the equilibrium photo-pigment concentration for a given illumination level. Because the rate of photon interaction is dependent on the amount of photo-pigments present, and because the bleaching and regeneration of bleached photo-pigments are not instantaneous, visual adaptation and its time course were initially thought to be directly mediated by the concentration of unbleached photo-pigments present in the receptor.

Direct cellular measurements on isolated and whole rat retinas by Dowling ([19] Chapter 7) show that dark adaptation in both rods and cones begins with a rapid decrease in threshold followed by a slower decrease toward the dark-adaptation threshold. The latter slow adaptation is directly predicted by photo-pigment concentrations, whereas the rapid adaptation is attributed almost entirely to a fast neural adaptation process that is not well understood.

The Michaelis–Menten equation (Equation 6.1) models the photoreceptor response and accounts for visual adaptation by changing the σ_b value as a function of background intensity. Photoreceptor adaptation and pigment bleaching have been proposed to account for this change in σ_b value. Valeton and van Norren have modeled the contribution of these two mechanisms to the increase in σ_b with

$$\sigma_b = \sigma_{dark}\sigma_{b,neural}\sigma_{b,bleach}, \tag{6.6}$$

where σ_{dark} is the semisaturation constant for dark conditions, $\sigma_{b,neural}$ accounts for the loss in sensitivity due to neural adaptation, and $\sigma_{b,bleach}$ accounts for the loss in sensitivity due to loss of photo-pigment [133]. The value of $\sigma_{b,bleach}$ is inversely proportional to the fraction of unbleached photo-pigments at the background light.

Pattanaik et al. extended the use of the adaptation model to compute the time course of adaptation for simulating visual effects associated with a sudden change in intensities from dark to light, or vice versa [95]. They use a combination of Equations 6.1 and 6.6 to carry out the simulation, as follows.

$$\frac{R}{R_{max}} = \frac{I^n}{I^n + \sigma_b^n(t)}$$

$$\sigma_b(t) = \sigma_{dark}\sigma_{b,neural}(t)\sigma_{b,bleach}(t)$$

Here, time-dependent changes of $\sigma_{b,neural}$ and $\sigma_{b,bleach}$ are modeled with exponential decay functions.

6.6 SUMMARY

This chapter proposed the view that the modeling of human visual adaptation is key to realistic tone mapping of HDR images. We saw that photoreceptor adaptation is the most important factor responsible for visual adaptation, with Equation 6.1 being the mathematical model for this adaptation. The relation between various tone-mapping algorithms and the photoreceptor adaptation model was made evident. Background intensity is a key component in this model. Some of the commonly used methods for computing this background intensity in images were discussed. We also saw the usefulness of a human visual model in realistic simulation of visual effects associated with the wide range of real-life illuminations. Whereas this chapter explored the similarities between several current tone-reproduction operators, the following two chapters discuss their differences and present each tone-reproduction operator in detail.

Spatial Tone Reproduction

07

In this and the following chapter we discuss specific algorithms that prepare HDR images for display on LDR display devices. These algorithms are called tone-reproduction or tone-mapping operators (we do not distinguish between these two terms). For each operator we describe how dynamic range reduction is achieved, which user parameters need to be specified, and how these user parameters affect the displayed material. These chapters are intended as a reference for those who want to understand specific operators with a view toward implementing them.

Tone-reproduction operators may be classified in several ways. The classification followed here is to distinguish operators loosely based on how light reflects from a diffuse surface (as discussed in the following chapter) from operators working directly on pixels (i.e., operating in the spatial domain).

A common classification of spatial tone-reproduction operators distinguishes between "local" and "global" operators, as discussed in Chapter 6. In summary, a local operator would compute a local adaptation level for each pixel based on the pixel value itself, as well as a neighborhood of pixels surrounding the pixel of interest. This local adaptation level then drives the compression curve for this pixel. Because the neighborhood of a pixel helps determine how this pixel is compressed, a bright pixel in a dark neighborhood will be treated differently than a bright pixel in a bright neighborhood. A similar argument can be made for dark pixels with bright and dark neighborhoods.

If an operator uses the entire image as the neighborhood for each pixel, such operators are called global. Within an image, each pixel is compressed through a

compression curve that is the same for all pixels. As a result, global operators are frequently less expensive to compute than local operators.

Alternatively, tone reproduction may be achieved by transforming the image into a different representation, such as with use of the Fourier domain or by differentiation. These operators form different classes, and are discussed in the following chapter. Thus, four different approaches to dynamic range reduction are distinguished in this book, and each tone-reproduction operator may be classified as one of the following four broad categories.

- *Global operators:* Compress images using an identical (nonlinear) curve for each pixel.
- *Local operators:* Achieve dynamic range reduction by modulating a nonlinear curve by an adaptation level derived for each pixel independently by considering a local neighborhood around each pixel.
- *Frequency domain operators:* Reduce the dynamic range of image components selectively, based on their spatial frequency (Chapter 8).
- *Gradient domain operators:* Modify the derivative of an image to achieve dynamic range reduction (Chapter 8).

Factors common to most tone-reproduction operators are discussed first, including treatment of color, homomorphic filtering, and Fourier domain decompositions. Then, global operators are cataloged in Section 7.2, followed by local operators in Section 7.3.

7.1 PRELIMINARIES

Because all tone-reproduction operators are aimed at more or less the same problem (namely, the appropriate reduction of dynamic range for the purpose of display), there are several ideas and concepts that are shared by many of them. In particular, the input data are often expected to be calibrated in real-world values. In addition, color is treated similarly by many operators. At the same time, several operators apply compression in logarithmic space, whereas others compress in linear space. Finally, most local operators make use of suitably blurred versions of the input image. Each of these issues is discussed in the following sections.

7.1.1 CALIBRATION

Several tone-reproduction operators are inspired by aspects of human vision. The human visual response to light at different levels is nonlinear, and photopic and scotopic lighting conditions in particular lead to very different visual sensations (as discussed in the preceding chapter). For those tone-reproduction operators, it is important that the values to be tone mapped are specified in real-world units (i.e., in cd/m^2). This allows operators to differentiate between a bright daylit scene and a dim night scene. This is not generally possible if the image is given in arbitrary units (see, for example, Figure 7.1).

However, unless image acquisition is carefully calibrated images in practice may be given in arbitrary units. For several tone-reproduction operators, this implies (for instance) that an uncalibrated night image may be tone mapped as if it were a representation of a daylit scene. Displaying such an image would give a wrong impression.

Images may be calibrated by applying a suitably chosen scale factor. Without any further information, the value of such a scale factor can realistically only be approximated, either by trial and error or by making further assumptions on the nature of the scene. In this chapter and the next we show a progression of images for each operator requiring calibrated data. These images are generated with different scale factors such that the operator's behavior on uncalibrated data becomes clear. This should facilitate the choice of scale factors for other images.

Alternatively, it is possible to use heuristics to infer the lighting conditions for scenes depicted by uncalibrated images. In particular, the histogram of an image may reveal if an image is overall light or dark, irrespective of the actual values in the image. Figure 7.2 shows histograms of dark, medium, and light scenes. For many natural scenes, a dark image will have pixels with values located predominantly toward the left of the histogram. A light image will often display a peak toward the right of the histogram, with images between having a peak somewhere in the middle of the histogram.

An important observation is that the shape of the histogram is determined both by the scene being captured and the capture technique employed. In that our main tool for capturing HDR images uses a limited set of differently exposed LDR im-

FIGURE 7.1 This image is given in arbitrary units, and is tone mapped three times with different parameters using the photoreceptor-based technique discussed in Section 7.2.7. Without knowing the actual scene, it is difficult to assess which of these three renditions is most faithful to the actual scene. If the data were properly calibrated, the absolute values in the image would allow the overall brightness to be determined.

ages (discussed in Chapter 4), images with the sun directly visible will still contain burned-out regions. Similarly, low-level details in nighttime scenes may also not be represented well in an HDR image captured with this method. These limitations affect the shape of the histogram, and therefore the estimation of the key of the scene. A number that correlates to the peak found in a histogram, but is not equal to the location of the peak, is the log average luminance found in the image, calculated as

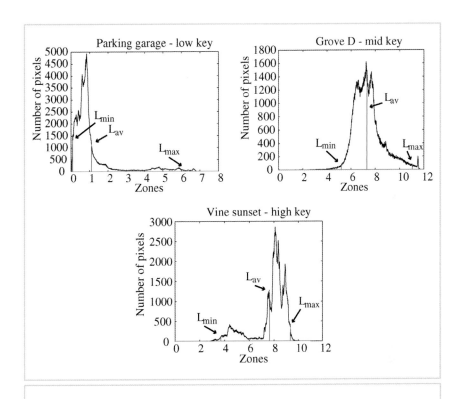

FIGURE 7.2 *Histograms for scenes that are overall dark (left), medium (middle), and light (right).*

$$L_{av} = \exp\left(\frac{1}{N}\sum_{x,y}\log\left(L_W(x,y)\right)\right), \qquad (7.1)$$

where the summation is only over non-zero pixels.

The key of a scene, a unitless number that relates to the overall light level, may be inferred from a histogram. It is thus possible to empirically relate the log average

luminance to the minimum and maximum luminance in the histogram (all three are shown in the histograms of Figure 7.2). The key α may be estimated using the following [106].

$$f = \frac{2\log_2 L_{\mathrm{av}} - \log_2 L_{\min} - \log_2 L_{\max}}{\log_2 L_{\max} - \log_2 L_{\min}} \qquad (7.2)$$

$$\alpha = 0.18 \times 4^f \qquad (7.3)$$

Here, the exponent f computes the distance of the log average luminance to the minimum luminance in the image relative to the difference between the minimum and maximum luminance in the image. To make this heuristic less dependent on outliers, the computation of the minimum and maximum luminance should exclude about 1% of the lightest and darkest pixels. For the photographic tone-reproduction operator (discussed in Section 7.3.6), a sensible approach is to first scale the input data such that the log average luminance is mapped to the estimated key of the scene, as follows.

$$L'_{\mathrm{W}}(x, y) = \frac{\alpha}{L_{\mathrm{av}}} L_{\mathrm{W}}(x, y) \qquad (7.4)$$

Although unproven, this heuristic may also be applicable to other tone-reproduction techniques that require calibrated data. However, in any case the best approach would be to always use calibrated images.

7.1.2 COLOR IMAGES

The human visual system is a complex mechanism with several idiosyncrasies that need to be accounted for when preparing an image for display. Most tone-reproduction operators attempt to reduce an image in dynamic range while keeping the human visual system's response to the reduced set of intensities constant. This has led to various approaches that aim at preserving brightness, contrast, appearance, and visibility.

However, it is common practice among many tone-reproduction operators to exclude a comprehensive treatment of color. With few exceptions, it is generally accepted that dynamic range compression should be executed on a single-luminance

channel. Although this is the current state of affairs, this may change in the near future, as the fields of color-appearance modeling and tone reproduction are growing closer together. This is seen in Pattanaik's multiscale observer model [94] and in more recent developments, such as Johnson and Fairchild's iCAM model [29,30] and Reinhard and Devlin's photoreceptor-based operator [108].

Most other operators derive a luminance channel from the input RGB values (as discussed in Section 2.4) and then compress the luminance channel. The luminance values computed from the input image are called world luminance (L_w). The tone-reproduction operator of choice will take these luminance values and produce a new set of luminance values L_d. The subscript d indicates "display" luminance. After compression, the luminance channel needs to be recombined with the uncompressed color values to form the final tone-mapped color image.

To recombine luminance values into a color image, color shifts will be kept to a minimum if the ratio between the color channels before and after compression are kept constant [47,113,119]. This may be achieved if the compressed image $R_d G_d B_d$ is computed as follows.

$$\begin{bmatrix} R_D \\ G_D \\ B_D \end{bmatrix} = \begin{bmatrix} L_D \dfrac{R_W}{L_W} \\ L_D \dfrac{G_W}{L_W} \\ L_D \dfrac{B_W}{L_W} \end{bmatrix}$$

Should there be a need to exert control over the amount of saturation in the image, the fraction in the previous equations may be fitted with an exponent s, resulting in a per-channel gamma correction as follows.

$$\begin{bmatrix} R_D \\ G_D \\ B_D \end{bmatrix} = \begin{bmatrix} L_D \left(\dfrac{R_W}{L_W} \right)^s \\ L_D \left(\dfrac{G_W}{L_W} \right)^s \\ L_D \left(\dfrac{B_W}{L_W} \right)^s \end{bmatrix}$$

The exponent s is then given as a user parameter that takes values between 0 and 1. For a value of 1, this method defaults to the standard method of keeping color ratios

FIGURE 7.3 *The saturation parameter s is set to 0.6, 0.8, and 1.0 (in reading order).*

constant. For smaller values, the image will appear more desaturated. Figure 7.3 demonstrates the effect of varying the saturation control parameter s. Full saturation is achieved for a value of $s = 1$. Progressively more desaturated images may be obtained by reducing this value.

An alternative and equivalent way of keeping the ratios between color channels constant is to convert the image to a color space that has a luminance channel and two chromatic channels, such as the Yxy color space. If the image is converted to Yxy space first, the tone-reproduction operator will compress the luminance

channel Y and the result will be converted to RGB values for display. This approach is functionally equivalent to preserving color ratios.

7.1.3 HOMOMORPHIC FILTERING

The "output" of a conventional 35-mm camera is a roll of film that needs to be developed, which may then be printed. The following examines the representation of an image as a negative toward defining terminology used in the remainder of this and the following chapter. Under certain conditions, it may be assumed that the image recorded by a negative is formed by the product of illuminance E_v and the surface reflectance r, as follows.

$$L_v = E_v r$$

This is a much simplified version of the rendering equation, which ignores specular reflection, directly visible light sources, and caustics and implicitly assumes that surfaces are diffuse. This simplification does not hold in general, but is useful for developing the idea of homomorphic filtering.

 If luminance is given, it may be impossible to retrieve either of its constituent components, E_v or r. However, for certain applications (including tone reproduction) it may be desirable to separate surface reflectance from the signal. Although this is generally an underconstrained problem, it is possible to transform the previous equation to the log domain, where the multiplication of E_v and r becomes an addition. Then, under specific conditions the two components may be separated. Horn's lightness computation, discussed in the following chapter, relies on this observation.

 In general, processing applied in the logarithmic domain is called homomorphic filtering. We call an image represented in the logarithmic domain a density image for the following reason. A developed photographic negative may be viewed by shining a light through it and observing the transmitted pattern of light, which depends on the volume concentrations of amorphous silver suspended in a gelatinous emulsion. The image is thus stored as volume concentrations $C(z)$, where z denotes depth, given that a transparency has a certain thickness. Transmission of light through media is governed by Beer's law, and therefore the attenuation of luminance as a

function of depth may be expressed in terms of the previous volume concentrations as

$$\frac{dL_v}{dz} = -kC(z)L_v,$$

with k the attenuation constant. In the following, the luminance at a point on the surface is denoted with $L_v(0)$. This equation may be solved by integration, yielding the following solution.

$$\int_{L_v(0)}^{L_v} \frac{di}{i} = -k \int_0^{z_t} C(z)\,dz$$

$$\ln\left(\frac{L_v}{L_v(0)}\right) = -kd$$

$$L_v = L_v(0)\exp(-kd)$$

Thus, if we integrate along a path from a point on the surface of the transparency to the corresponding point on the other side of the transparency we obtain a luminance value L_v attenuated by a factor derived from the volume concentrations of silver suspended in the transparency along this path. For a photographic transparency, the image is represented by the quantities d, which have a different value for each point of the transparency. The values of d have a logarithmic relationship with luminance L_v. This relationship is well known in photography, although it is usually represented in terms of density D, as follows.

$$D = \log_{10}\left(\frac{L_v(0)}{L_v}\right)$$

The density D is proportional to d and is related to the common logarithm of L_v in a manner similar to the definition of the decibel [123]. Because all such representations are similar (barring the choice of two constant parameters), logarithmic representations are also called density representations. The general transformation between luminance and a density representation may be written as follows.

$$D = \ln(L_v)$$

$$L_v = \exp(D)$$

Although a luminance representation of an image necessarily contains values that are nonnegative, in a density representation the range of values is not bound, as in the following.

$$-\infty < D = \ln(E_v) + \ln(r) < \infty$$

$$-\infty < \qquad \ln(E_v) \qquad < \infty$$

$$r_{min} < \qquad \ln(r) \qquad < 0$$

In addition, reflectance and illuminance are now added rather than multiplied, which is a direct result of operating in the log domain. Filtering operations such as tone reproduction may be carried out in this domain, which is then called homomorphic filtering. The advantage of this representation is that under circumstances in which light behavior may be modeled as a product of illuminance and reflectance homomorphic filtering allows this product to be represented as an addition, which makes separation of the two components simpler.

7.1.4 GAUSSIAN BLUR

Several operators require the computation of local averages for each pixel. A local average may be viewed as a weighted average of the pixel and some of its neighbors. In most cases the weights are chosen according to a Gaussian distribution. Images filtered by a Gaussian filter kernel may be computed directly in the image domain, where the computation is a convolution, as follows.

$$L^{blur}(x, y) = \int_{-\infty}^{\infty} \int_{-\infty}^{\infty} L(x, y) \frac{1}{2\pi\sigma^2} \exp\left(-\frac{x^2 + y^2}{2\sigma^2}\right) dx\, dy$$

For discrete images, the integrals are replaced by summations. In this chapter we will use the shorthand notation

$$L^{blur} = L \otimes R$$

to indicate that image L is convolved with filter kernel R.

The Gaussian filter kernel is sampled at discrete points, normally at positions corresponding to the midpoints of each pixel. For very small filter kernels, point

sampling a Gaussian function with very few samples leads to a large error. To account for the spacing between sample points, a fast way of integrating a Gaussian function over an area may be achieved by expressing the Gaussian in terms of the error function, which is given by[1]

$$\text{erf}(x) = \frac{2}{\sqrt{\pi}} \int_{-\infty}^{x} \exp\left(-x^2\right) dx.$$

We may therefore build an image $R(x, y)$ the size of the input image, which represents the Gaussian filter (with the peak at pixel $(0, 0)$), as follows.

$$R(x, y) = \frac{1}{4}\left(\text{erf}\left(\frac{x - 0.5}{\sigma}\right) - \text{erf}\left(\frac{x + 0.5}{\sigma}\right)\right)$$
$$\times \left(\text{erf}\left(\frac{y - 0.5}{\sigma}\right) - \text{erf}\left(\frac{y + 0.5}{\sigma}\right)\right)$$

The computational cost of the error function is not higher than evaluating the exponential function. In this scheme, four error functions are executed per pixel, and therefore the accuracy obtained by integration over each pixel's area comes at a slight computational cost. This extra expense is acceptable because for certain applications (such as the photographic tone-reproduction operator discussed in Section 7.3.6) the extra accuracy is nonnegligible. For all results shown in this and the following chapter (involving Gaussian blurred images) we have used this scheme.

The cost of blurring an image lies in the convolution operator. Because for every pixel every other pixel needs to be considered, direct convolution takes $O(N^2)$ time in the number of pixels. For convolution kernels larger than 3 by 3 pixels (for example), this is too costly in practice. In such cases we may transform both filter kernel and image to the Fourier domain by means of a fast Fourier transform (FFT). The convolution then becomes a pointwise multiplication that takes $O(N)$ time. The FFT and inverse FFT each take $O(N \log(N))$ time, and thus the time complexity of blurring an image with a Gaussian filter kernel takes $O(N \log(N))$ time in total.

. .

1 This idea was developed by Mike Stark and became part of the photographic tone-reproduction operator [109], whereby the robustness of the scale-selection mechanism improved as a result (see Section 7.3.6 for further details on scale selection).

Before the FFT of the filter kernel can be computed, the Gaussian needs to be mirrored in the center of the kernel image. The center of the Gaussian is then replicated in each of the four corners of the image. The process of blurring an image is shown in Figure 7.4. Note that the FFT of the Gaussian filter kernel is again a Gaussian function, albeit now as a function of frequency. It would therefore be possible to construct the Gaussian filter kernel directly in the Fourier domain, thereby saving one FFT transform.

Alternatively, it may be possible to truncate the Gaussian filter kernel to reduce the computational cost, or resort to fast approaches that are not based on Fourier decomposition. Examples are the elliptically weighted average approach [46] and Burt and Adelson's approximation [8]. The 2D Gaussian filter is separable (i.e., it may be expressed as the multiplication of two 1D Gaussian filters), as follows.

$$R(x, y) = R_x(x) R_y(y)$$

$$\frac{1}{2\pi\sigma^2} \exp\left(-\frac{x^2 + y^2}{2\sigma^2}\right) = \frac{1}{\sqrt{2\pi}\sigma} \exp\left(-\frac{x^2}{2\sigma^2}\right) \frac{1}{\sqrt{2\pi}\sigma} \exp\left(-\frac{y^2}{2\sigma^2}\right)$$

This means that the Gaussian convolution may be computed in x and y directions separately, providing a further opportunity to reduce the computational cost in that two 1D FFTs are quicker to execute than one 2D transform.

7.1.5 VALIDATION

To allow more informed decisions as to which operator is suitable for which task, there is a need for validation studies. At the time of writing, only two such studies exist [20,31,68], with more beginning to emerge [73]. In addition, the CIE has formed a technical committee (TC8-08) to study the issue of how tone-reproduction operators might be validated [60].[2]

Currently, visual comparison remains one of the most practical ways of assessing tone-reproduction operators, but this approach is not without pitfalls. In particular, the choice of parameter settings for each of the operators will have a large impact on the outcome of such visual comparisons. To avoid subconscious comparisons, we

. .

2 See also the web site for CIE Division 8: Image Technology at *www.colour.org*.

FIGURE 7.4 *Top row: input image and Gaussian filter kernel. Middle row: Fourier representation of the image and the filter kernel. After pointwise multiplication of these images followed by the inverse Fourier transform, the Gaussian blurred image shown at the bottom is obtained.*

have purposely chosen to use different images for each of the operators discussed in this and the following chapter. Until proper validation studies start to show a pattern and reach agreement on which operators perform well, visual comparison, taste, and other secondary considerations will dominate the decision-making process.

7.2 GLOBAL OPERATORS

The simplest functions that reduce an image's dynamic range treat each pixel independently. Such functions usually take for each pixel its value and a globally derived quantity, usually an average of some type (see Section 6.4).

Global operators share one distinct advantage: they are computationally efficient. Many of them may be executed in real time. Because global operators are generally much faster than any of the other classes of operators, applications that require this level of performance should consider global operators over all others.

On the other hand, if the dynamic range of an image is extremely high the global tone-reproduction operators may not always preserve visibility as well as other operators. However, there are also differences among global operators. Some operators are able to handle a larger class of HDR images than others. This issue is discussed further in the following sections.

7.2.1 MILLER BRIGHTNESS-RATIO-PRESERVING OPERATOR

The first global tone-reproduction operator we know of was documented in 1984 by Miller and colleagues [186]. They aimed to introduce the field of computer graphics to the lighting engineering community. For rendering algorithms to be useful in lighting design, they should output radiometric or photometric quantities,

rather than arbitrarily scaled pixel intensities. Physically based rendering algorithms therefore produce imagery that is typically not directly displayable on LDR display devices, thus requiring tone reproduction for display (see Chapter 4).

As a result, Miller et al. developed a tone-reproduction operator that aims at preserving the sensation of brightness of the image before and after dynamic range reduction. Brightness is a complex function of both luminance and spatial configuration that may be simplified for the purposes of this work. Here, brightness Q is approximated as a power function of luminance L_v, as follows.

$$Q = kL_v^b$$

Miller et al. assert that the visual equivalence of an image before and after dynamic range reduction may be modeled by keeping brightness ratios constant. Thus, for two elements Q_1 and Q_2 to be visually equivalent to their compressed counterparts Q_1' and Q_2', their ratios should be constant. That is,

$$\frac{Q_1}{Q_2} = \frac{Q_1'}{Q_2'}.$$

It should be noted that visual equivalence between pairs of brightness values is not the same as being equal (i.e., in general, Q_1 will be different from Q_1', and Q_2 will not be equal to Q_2').

The procedure for preparing an image for display starts by converting an image to brightness values $Q_w(x, y)$. Then the maximum brightness of the image $Q_{w,max}$ is determined. The image's brightness values are then normalized by dividing each pixel's brightness representation by the image's maximum brightness.

The display device's maximum brightness $Q_{d,max}$ is then determined from its maximum luminance value using the same luminance brightness relationship. Display brightnesses $Q_d(x, y)$ are determined using the following.

$$Q_d(x, y) = \frac{Q_w(x, y)}{Q_{w,max}} Q_{d,max}$$

These brightnesses are then converted to luminances by applying the inverse of the brightness function. There exist different formulas for determining brightness

values from luminances. Miller et al. experimented with three different formulations, and determined that the one proposed by Stevens [121] produced the most plausible results. Fitting functions to Stevens' psychophysical data, Miller created functional forms for k and b, as follows.

$$b = 0.338 L_v^{0.034}$$

$$k = -1.5 \log_{10}(L_v) + 6.1$$

The relationship between luminance and brightness then becomes

$$Q = (-1.5 \log_{10}(L_v) + 6.1) L_v^{0.338 L_v^{0.034}}$$

A plot of this function is shown in Figure 7.5. The function monotonically increases until about 2,000 cd/m^2, and then steeply declines. This is a result of fitting the previous function to psychophysical data that are only valid for a limited range (up to about 1,000 cd/m^2).

As Miller et al.'s work is aimed at lighting design, their operator is suitable for compressing luminance ranges that are typically found in indoor situations. They assert that actual room luminances range between 100 and 1,000 cd/m^2, whereas display devices are typically limited to the range of 1 to 33 cd/m^2. Current display devices can be brighter, though. Most tone-reproduction operators requiring an estimate of the maximum display luminance use values in the range of 30 to 100 cd/m^2.

A second implication of the sharp decline of the previous function is that this brightness equation is not analytically invertible, which is necessary for Miller's operator to be useful. However, the inverse of this function may be approximated with a lookup table of sufficiently high resolution, allowing us to experiment with this tone-reproduction operator.

For practical purposes, we normalize each image within the range between 0 and 1,000 cd/m^2. This places an assumption on the input image, which is that it depicts an indoor scene. This is not unreasonable, in that the operator is not suitable for images with a higher dynamic range.

The maximum display luminance depends on the display device, and therefore the maximum brightness of the display device for which the operator should compress will also vary. To simulate tone reproduction for different display devices, we

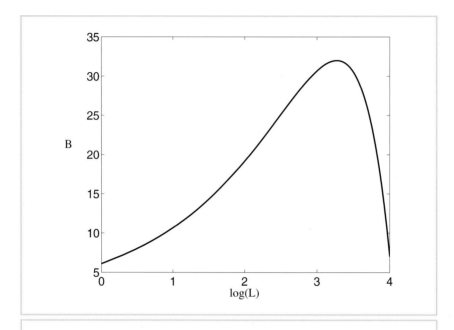

FIGURE 7.5 Miller's mapping of log luminance to brightness. This mapping is valid over its monotonically increasing domain (i.e., up to a luminance of about 1,000 cd/m^2).

make $Q_{d,max}$, the maximum display brightness, a user parameter. Varying this parameter for an image with a dynamic range comparable to an indoor scene, the set of images in Figure 7.6 was produced. This parameter behaves as expected: higher maximum monitor brightness values result in lighter images.

Other than the invertibility of the brightness function, which is solved by employing a lookup table, this operator is both simple to implement and fast. However, the previously cited limitations make this operator mainly of interest for historical reasons.

FIGURE 7.6 Using Miller's operator, the maximum monitor brightness Q_{max} was set from 10 (top left) and incremented by 10 in subsequent images.

7.2.2 TUMBLIN–RUSHMEIER BRIGHTNESS-PRESERVING OPERATOR

Where Miller et al. were the first to introduce computer graphics to the field of lighting design, focusing on tone reproduction to accomplish this goal, it was Tumblin and Rushmeier who introduced the problem of tone reproduction to the field of computer graphics in 1993 [131]. Tumblin and Rushmeier also based their work on Stevens' psychophysical data, realizing that the human visual system is already solving the dynamic range reduction problem.

The Tumblin–Rushmeier operator exists in two different forms: the original operator [131] and a revised version [132] (which corrects a couple of shortcomings including the fact that it was calibrated in sieverts, a unit that is not in wide use). For this reason, we limit our discussion to the revised Tumblin–Rushmeier operator and will refer to it simply as the Tumblin–Rushmeier operator.

Although the Tumblin–Rushmeier operator is based on the same psychophysical data as Miller's operator, the brightness function is stated slightly differently, as follows.

$$Q(x, y) = C_0 \left(\frac{L(x, y)}{L_a} \right)^\gamma$$

Here, Q is brightness (or perceived luminance), measured in brils. L is luminance in cd/m^2 and L_a is the adaptation luminance, also measured in cd/m^2. The constant $C_0 = 0.3698$ is introduced to allow the formula to be stated in SI units. Finally, γ is a measure of contrast sensitivity and is itself a function of the adaptation luminance L_a.

This function may be evaluated for an HDR image as well as for the intended display device. This leads to two sets of brightness values as a function of input luminances (or world luminances) and display luminances. In the following, the subscripts w and d indicate world quantities (measured or derived from the HDR image) and display quantities. Whereas Miller et al. conjecture that image and display brightness ratios should be matched, Tumblin and Rushmeier simply equate the image and display brightness values, as follows.

$$Q_w(x, y) = C_0 \left(\frac{L_w(x, y)}{L_{wa}} \right)^{\gamma(L_{wa})}$$

$$Q_d(x, y) = C_0\left(\frac{L_d(x, y)}{L_{da}}\right)^{\gamma(L_{da})}$$

$$Q_w(x, y) = Q_d(x, y)$$

The gamma function $\gamma(L)$ models Stevens' human contrast sensitivity for the image and the display by plugging in L_{wa} and L_{da}, respectively, given by

$$\gamma(L) = \begin{cases} 2.655 & \text{for } L > 100 \text{ cd/m}^2 \\ 1.855 + 0.4\log_{10}(L + 2.3 \cdot 10^{-5}) & \text{otherwise.} \end{cases}$$

These equations may be solved for $L_d(x, y)$, the display luminance that is the quantity we wish to display. The result is

$$L_d(x, y) = L_{da}\left(\frac{L_w(x, y)}{L_{wa}}\right)^{\gamma(L_{wa})/\gamma(L_{da})}.$$

The adaptation luminances are L_{da} for the display and L_{wa} for the image. The display adaptation luminance is typically between 30 and 100 cd/m^2, although this number will be higher when HDR display devices are used. The image adaptation luminance is given as the log average luminance L_{wa} (Equation 7.1). The mid-range scene luminances now map to mid-range display luminances close to L_{da}, which for dim scenes results in a uniform gray appearance in the display. This may be remedied by introducing a scale factor $m(L_{wa})$, which depends on the world adaptation level L_{da}, as follows.

$$m(L_{wa}) = \left(\sqrt{C_{max}}\right)^{\gamma_{wd}-1}$$

$$\gamma_{wd} = \frac{\gamma_w}{1.855 + 0.4\log(L_{da})}$$

Here, C_{max} is the maximum displayable contrast, which is typically between 30 and 100 for an LDR display device. The full operator is then given by

$$L_d(x, y) = m(L_{wa})L_{da}\left(\frac{L_w(x, y)}{L_{wa}}\right)^{\frac{\gamma(L_{wa})}{\gamma(L_{da})}}.$$

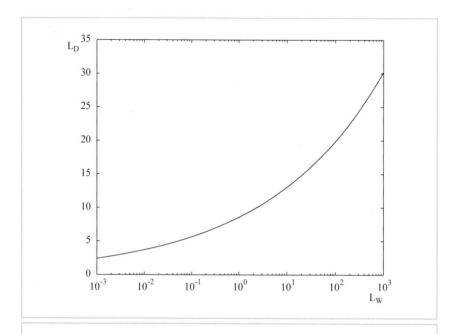

FIGURE 7.7 *Mapping of world luminances to display luminances for the Tumblin–Rushmeier operator.*

For suitably chosen input parameters, a plot of this function is given in Figure 7.7. As this operator is calibrated in SI units, the image to be tone mapped also needs to be specified in SI units. For an image in unknown units, we experimented with different scale factors prior to tone reproduction, the results of which are shown in Figure 7.8. This image was scaled by factors of 0.1, 1, 10, 100, and 1,000, with the scaling resulting in progressively lighter images. For this particular image, a scale factor of close to 1,000 would be optimal. Our common practice of normalizing the image, applying gamma correction, and then multiplying by 255 was abandoned for this image sequence, because this operator already includes a display gamma correction step.

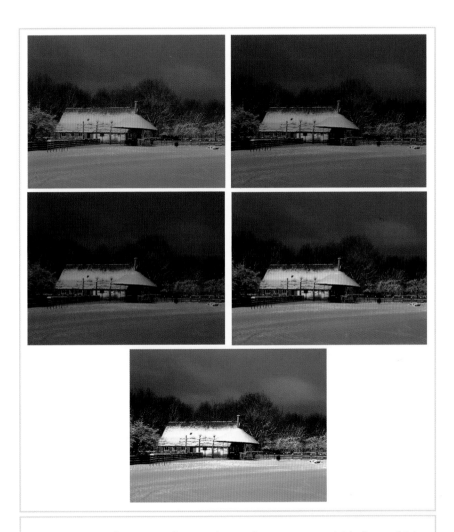

FIGURE 7.8 In this sequence of images, the input luminances were scaled by factors of 0.1, 1, 10, 100, and 1,000 prior to applying Tumblin and Rushmeier's revised tone-reproduction operator.

In summary, the revised Tumblin–Rushmeier tone-reproduction operator is based on the same psychophysical data as Miller's operator, but the crucial difference is that Miller et al. aim to preserve brightness ratios before and after compression whereas Tumblin–Rushmeier attempt to preserve the brightness values themselves. In our opinion, the latter leads to a useful operator that produces plausible results, provided the input image is specified in cd/m^2. If the image is not specified in cd/m^2, it should be converted to SI units. In that case, the image may be pre-scaled by a factor that may be determined by trial and error, as shown in Figure 7.8.

7.2.3 WARD CONTRAST-BASED SCALE FACTOR

Whereas both Miller's and Tumblin and Rushmeier's operators aim at preserving the sensation of brightness, other operators focus less on brightness perception and attempt to preserve contrasts instead. An early example is Ward's contrast-based scale factor [139]. The model matches JNDs one might discern in the image with JNDs an observer of an LDR display device may distinguish. Thus, differences are preserved without spending the limited number of display steps on differences undetectable by the human visual system. The operator maps image or world luminances to display luminances linearly, as follows.

$$L_d(x, y) = mL_w(x, y)$$

The scale factor m is chosen to match threshold visibility in image and display. This requires a threshold-versus-intensity function (TVI) $t(L_a)$, which maps a threshold luminance that is just visible for adaptation luminance L_a. We also need to estimate the adaptation level for an observer of the image (L_{wa}), as well as for an observer viewing the display (L_{da}). The scale factor m may then be chosen such that

$$t(L_{da}) = mt(L_{wa}).$$

Solving for m yields

$$m = t(L_{da})/t(L_{wa}).$$

Based on Blackwell's studies [11], this yields the following scale factor.

$$m = \frac{1}{L_{d,max}} \left(\frac{1.219 + (\frac{L_{d,max}}{2})^{0.4}}{1.219 + L_{wa}^{0.4}} \right)^{2.5}$$

In this equation, the display adaptation level is estimated to be half the maximum display luminance, which is specified as $L_{d,max}$. The maximum display luminance should be specified by the user, and is typically in the range of 30 to 100 cd/m^2. The world adaptation level may be estimated as the log average of the image's luminance values, as follows.

$$L_{wa} = \exp\left(\frac{1}{N} \sum_{x,y} \log\left(10^{-8} + L_{x,y}\right) \right)$$

In this equation, we sum the log luminance values of all pixels and add a small offset to avoid the singularity that occurs for black pixels. This log average computation is slightly different from the one used in the preceding section. The small offset could be omitted, but then the summation should only include non-zero pixels. Because the offset is small, the difference between the two log average computations should also be small. The division is by N, the number of pixels in the image.

As with tone-reproduction operators discussed earlier, the input image needs to be specified in SI units. In Figure 7.9 we show the effect of pre-scaling an uncalibrated image with various values. Scaling the image to larger values produces a brighter result, which should not be surprising.

As this operator scales the input linearly, choices of pre-scaling and values of maximum display luminance amount to choosing which luminances in the image are mapped to middle gray on the display device. As such, the images shown in Figure 7.9 are effectively brighter or darker versions of each other.

7.2.4 FERWERDA MODEL OF VISUAL ADAPTATION

The concept of matching JNDs as explored by Ward was also used by Ferwerda et al. in their operator. They based their operator on different psychophysical data,

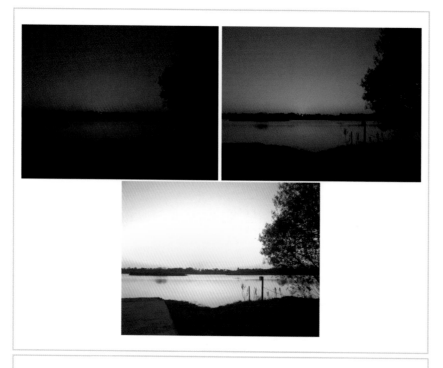

FIGURE 7.9 *Scaling of an image given in uncalibrated units prior to application of Ward's contrast-based scale factor. From left to right we scaled the image by factors of 0.01, 0.1, and 1.*

with a somewhat different functional shape as a result. The operator, however, is still intrinsically a linear mapping between world and display luminances. Whereas Ward's contrast-based scale factor incorporates only photopic lighting conditions, Ferwerda et al. added a scotopic component. They also modeled the loss of visual acuity under scotopic lighting, as well as the process of light and dark adaptation, which takes place over time.

In Ferwerda's operator, display intensities are computed from world intensities by multiplying the latter with a scale factor m and adding an offset b, which allows contrast and overall brightness to be controlled separately. This is calculated as follows.

$$R_d(x, y) = d\big(m R_w(x, y) + b L_w(x, y)\big)$$

$$G_d(x, y) = d\big(m G_w(x, y) + b L_w(x, y)\big)$$

$$B_d(x, y) = d\big(m B_w(x, y) + b L_w(x, y)\big)$$

$$m = \frac{t_p(L_{da})}{t_p(L_{wa})}$$

$$b = \frac{t_s(L_{da})}{t_s(L_{da})}$$

$$d = \frac{L_{max}}{L_{d,max}}$$

This operator thus scales each of the three red, green, and blue channels by a factor m, but adds an achromatic term that depends on the pixel's luminance. The scale factor m governs photopic conditions, whereas the b term handles scotopic conditions. Both depend on TVI functions.

Modeling cones, which are active under photopic lighting conditions, the TVI function $t_p(L_a)$ is approximated by the following.

$$\log_{10} t_p(L_a) = \begin{cases} -0.72 & \text{if } \log_{10}(L_a) \leq -2.6 \\ \log_{10}(L_a) - 1.255 & \text{if } \log_{10}(L_a) \geq 1.9 \\ (0.249 \log_{10}(L_a) + 0.65)^{2.7} - 0.72 & \text{otherwise} \end{cases}$$

For the rods, active under scotopic lighting conditions, the TVI function $t_s(L_a)$ is approximated by the following.

$$\log_{10} t_s(L_a) = \begin{cases} -2.86 & \text{if } \log_{10}(L_a) \leq -3.94 \\ \log_{10}(L_a) - 0.395 & \text{if } \log_{10}(L_a) \geq -1.44 \\ (0.405 \log_{10}(L_a) + 1.6)^{2.18} - 2.86 & \text{otherwise} \end{cases}$$

For both the photopic and scotopic range, a separate scale factor (m_p and m_s, respectively) may be computed using the previous TVI curves, as follows.

$$m_p = \frac{t_p(L_{da})}{t_p(L_{wa})}$$

$$m_s = \frac{t_s(L_{da})}{t_s(L_{wa})}$$

These scale factors depend on the display adaptation luminance L_{da} and the world (or image adaptation) luminance L_{wa}. The display adaptation luminance may be estimated to be half the maximum display luminance. For typical LDR displays, the maximum display luminance is about 100 cd/m², and thus the display adaptation luminance is estimated as 50 cd/m². For this operator, the world adaptation luminance is approximated by half the maximum world luminance L_{max}.

In addition to mapping luminances to a displayable range, tone reproduction may attempt to preserve other aspects of human vision across viewing conditions. One of these is visual acuity. Under scotopic lighting conditions, the human visual system may not resolve as much detail as under photopic lighting conditions. Ferwerda et al. outline a solution that may be applied in addition to the previously cited mapping. This involves removing from the displayable image frequencies that would not have been resolvable by the world observer. This may be accomplished in the Fourier domain by removing frequencies higher than the threshold frequency for the world observer, as follows.

$$f^*\big(w_c(L_{wa})\big) = \frac{t(L_{wa})}{L_{wa}}$$

As with Ward's contrast-based scale factor and Tumblin and Rushmeier's operator, Ferwerda's operator is based on psychophysical measurements, and is calibrated in SI units. An example of different pre-scaling factors for an uncalibrated image is shown in Figure 7.10, which reveals that for images that are scaled to small values the range of input values covers the scotopic range (in which vision is achromatic). For larger scale factors, the HDR data covers the mesopic and photopic ranges, where color is retained. Note that in this figure the change in visual acuity as a function of world adaptation level was not modeled.

FIGURE 7.10 Pre-scaling factors of 0.1, 1, 10, 33, 66, and 100 applied prior to tone mapping with Ferwerda's operator.

Ferwerda's operator was later adapted by Durand and Dorsey [22] for the purpose of interactive tone reproduction. They also proposed various computationally efficient extensions that allow modeling the blue shift (associated with scotopic lighting conditions), light adaptation, and chromatic adaptation.

Although Ferwerda's operator is a linear scale factor (like Ward's contrast-based scale factor), it models visual acuity and includes an achromatic component that models scotopic vision. It is therefore a more complete model than Ward's. However, it is still a linear model, which means that the maximum dynamic range that may be successfully tone mapped for display on an LDR device is limited. For very high dynamic range images, a nonlinear mapping may be a better approach.

7.2.5 LOGARITHMIC AND EXPONENTIAL MAPPINGS

Of all nonlinear mappings, logarithmic and exponential mappings are among the most straightforward. Their main use is in providing a baseline result against which all other operators may be compared. After all, any other operator is likely to be more complex and we may expect other operators to provide improved visual performance compared with logarithms and exponential mappings (although we would like to keep the notion of visual performance deliberately vague).

For medium-dynamic-range images (i.e., images with a dynamic range somewhat higher than can be accommodated by current LDR display devices), these very simple solutions may in fact be competitive with more complex operators. The logarithm is a compressive function for values larger than 1, and therefore range compression may be achieved by mapping luminances as follows.

$$L_d(x, y) = \frac{\log_{10}(1 + L_w(x, y))}{\log_{10}(1 + L_{max})} \tag{7.5}$$

A second mapping converts world luminances to display luminances by means of the exponential function [33], as follows.

$$L_d(x, y) = 1 - \exp\left(-\frac{L_w(x, y)}{L_{av}}\right) \tag{7.6}$$

This function is bound between 0 for black pixels and 1 for infinitely bright pixels. Because world luminances are always smaller than infinity, the resulting display

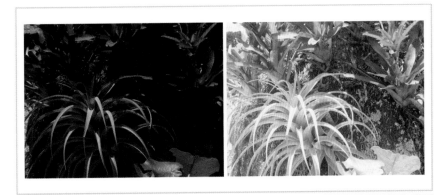

FIGURE 7.11 Left: logarithmic mapping using L_{\max}. Right: exponential mapping using L_{av}. Compare with Figure 7.12, where the roles of maximum and average luminance are reversed.

luminances $L_d(x, y)$ will in practice never quite reach 1. Subsequent normalization would therefore somewhat expand the range of display values.

The division by the average luminance L_{av} in the previous exponential function causes pixels with this value to be mapped to $1 - 1/e \approx 0.63$. Because this value is slightly above 0.5, the arithmetic average is employed rather than the more commonly used log average luminance.

Figure 7.11 shows example results of the logarithmic and exponential mappings. Both images successfully map world luminances to display luminances. However, the logarithmic mapping produces an image that is somewhat dull. The exponential mapping, on the other hand, is overall much lighter. The original scene appeared to sit somewhere between these two renditions, and thus neither algorithm produced a displayable image that was faithful to the original scene.

The differences between the images produced with logarithmic and exponential mappings could be due to the shape of the compression curve, but we also note that the logarithmic mapping is anchored to the maximum luminance value in

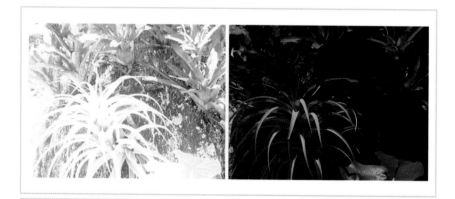

FIGURE 7.12 Left: *logarithmic mapping using* L_{av}. *Right: exponential mapping using* L_{max}. *Compare with Figure 7.11.*

the image, whereas the exponential mapping uses the average luminance value. Figure 7.12 shows the same two algorithms, but now we have swapped L_{av} and L_{max} in both operators. This small change to these operators has also caused their appearance to be reversed.

Plots of logarithmic and exponential mappings with either L_{av} or L_{max} used to anchor the mapping are shown in Figure 7.13. The functional form, as well as the choice of anchor value, has a significant impact on the shape of the compressive function. Although more experimentation would be required to draw definite conclusions, it appears that the value chosen to anchor the mapping — L_{max} or L_{av} — has the more profound effect on the result.

In summary, logarithmic and exponential mappings are among the most straightforward nonlinear mappings. For images with a dynamic range that only just exceeds the capabilities of the chosen display device, these approaches may well suffice. For images with a higher dynamic range, however, other approaches may be more suitable.

FIGURE 7.13 *Plots of Equations 7.5 and 7.6 using L_{av} and L_{max}.*

7.2.6 DRAGO LOGARITHMIC MAPPING

Building upon the observation that the human visual system to a first approxima-
tion uses a logarithmic response to intensities, Drago et al. show how logarithmic
response curves may be extended to handle a wider dynamic range than the simple
operators discussed in the preceding section [21].

The operator effectively applies a logarithmic compression to the input lumi-
nances, but the base of the logarithm is adjusted according to each pixel's value.
The base is varied between 2 and 10, allowing contrast and detail preservation in
dark and medium luminance regions while still compressing light regions by larger
amounts. A logarithmic function of arbitrary base b may be constructed from log-

arithmic functions with a given base (for instance, base 10), as follows.

$$\log_b(x) = \frac{\log_{10}(x)}{\log_{10}(b)}$$

To smoothly interpolate between different bases, use is made of Perlin and Hoffert's bias function. In this function, the amount of bias is controlled by user parameter p [99], as follows.

$$\text{bias}_p(x) = x^{\log(p)/\log(0.5)}$$

The basic tone-reproduction curve is the same as the logarithmic mapping presented in the preceding section, but with a base b (which is a function of each pixel's luminance), as follows:

$$L_d(x, y) = \frac{\log_b(1 + L_w(x, y))}{\log_b(1 + L_{w,max})}$$

To smoothly interpolate between different bases, the preceding three equations are combined as follows.

$$L_d(x, y) = \frac{L_{d,max}/100}{\log_{10}(1 + L_{w,max})} \cdot \frac{\log_{10}(1 + L_w(x, y))}{\log_{10}[2 + 8\{(\frac{L_w(x,y)}{L_{w,max}})^{\log_{10}(p)/\log_{10}(0.5)}\}]}$$

The constants 2 and 8 bound the chosen base between 2 and 10. The maximum display luminance $L_{d,max}$ is display dependent and should be specified by the user. In most cases, a value of 100 cd/m^2 would be appropriate.

This leaves the bias parameter p to be specified. For many practical applications, a value between 0.7 and 0.9 produces plausible results, with a value of $p = 0.85$ being a good initial value. Figure 7.14 shows an image created with different bias values. The bias parameter steers the amount of contrast available in the tone-mapped

FIGURE 7.14 For Drago's logarithmic mapping, increasing values for the bias parameter p result in reduced contrast. In reading order, the bias parameter varied between 0.6 and 1.0 in increments of 0.1.

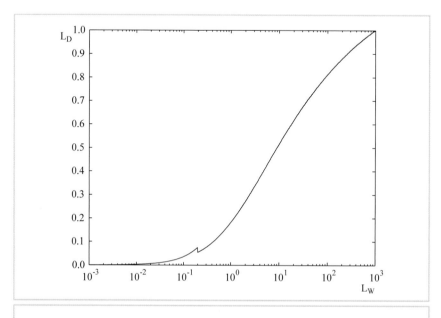

FIGURE 7.15 *Drago's logarithmic mapping. The discontinuity at $L_W = 0.2$ is most likely an artifact of our implementation.*

image in a well-controlled manner. Higher values result in less contrast and better compression, whereas smaller values increase the available contrast.

A curve of this operator is plotted in Figure 7.15. The small discontinuity near $L_W = 0.2$ is in all likelihood an artifact of our implementation.

7.2.7 REINHARD AND DEVLIN PHOTORECEPTOR MODEL

Logarithmic compression may be viewed as effectively computing a density image. The output therefore resembles the information stored in a negative. Although this metaphor holds, logarithmic responses are also sometimes attributed to parts of

the human visual system. This is intrinsically incorrect, although the human visual system responds approximately logarithmically over *some* of its operating range (see Section 6.2). Cells in the human visual system communicate with impulse trains, wherein the frequency of these impulse trains carries the information. Notable exceptions are the first few layers of cells in the retina, which communicate by generating graded potentials. In any case, this physiological substrate does not enable communication of negative numbers. The impulse frequency may become zero, but there is no such thing as negative frequencies. There is also an upper bound to realizable impulse frequencies.

Logarithms, on the other hand, may produce negative numbers. For large input values, the output may become arbitrarily large. At the same time, over a range of values the human visual system may produce signals that appear to be logarithmic. Outside this range, responses are no longer logarithmic but tail off instead. A class of functions that approximates this behavior reasonably well are sigmoids, or S-shaped functions, as discussed in Chapter 6. When plotted on a log-linear graph, the middle portion of such sigmoids is nearly linear and thus resembles logarithmic behavior. Moreover, sigmoidal functions have two asymptotes: one for very small values and one for large values.

This gives sigmoidal functions the right mathematical properties to be a possible candidate for modeling aspects of the human visual system. Evidence from electrophysiology confirms that photoreceptors of various species produce output voltages as a function of light intensity received that may be accurately modeled by sigmoids.

Naka and Rushton were the first to measure photoreceptor responses, and managed to fit a sigmoidal function to their data [87]. For the purpose of tone reproduction, the following formulation by Hood et al. is practical [52].

$$V(x, y) = \frac{I(x, y)}{I(x, y) + \sigma(I_a(x, y))}$$

Here, I is the photoreceptor input, V is the photoreceptor response, and σ is the semisaturation constant (which is a function of the receptor's adaptation level I_a). The semisaturation constant thus determines to which value of V the adaptation level is mapped, and therefore provides the flexibility needed to tailor the curve to the image being tone mapped. For practical purposes, the semisaturation constant

may be computed from the adaptation value I_a as follows.

$$\sigma\big(I_a(x, y)\big) = \big(f\,I_a(x, y)\big)^m$$

In this equation, f and m are user parameters that need to be specified on a per-image basis. The scale factor f may be used to steer the overall luminance of the tone-mapped image and can initially be estimated as 1. Images created with different values of f are shown in Figure 7.16.

It should be noted that in electrophysiological studies the exponent m also features and tends to lie between 0.2 and 0.9 [52]. A reasonable initial estimate for m may be derived from image measures such as the minimum, maximum, and average luminance, as follows.

$$m = 0.3 + 0.7k^{1.4}$$

$$k = \frac{L_{\max} - L_{av}}{L_{\max} - L_{\min}}$$

The parameter k may be interpreted as the key of the image (i.e., a measure of how light or dark the image is on average). The nonlinear mapping from k to exponent m is determined empirically. The exponent m is used to steer the overall impression of contrast, as shown in Figure 7.17.

A tone-reproduction operator may be created by equating display values to the photoreceptor output V, as demonstrated by Reinhard and Devlin [108]. Note that this operator is applied to each of the red, green, and blue color channels separately. This is similar to photoreceptor behavior, in which each of the three different cone types is thought to operate largely independently. Also note that sigmoidal functions that are part of several color appearance models — such as the Hunt model [55], CIECAM97 [54], and CIECAM02 [84] (see Section 2.8) — are executed independently to the red, green, and blue channels. This approach may account for the Hunt effect, which predicts desaturation of colors for both light and dark pixels, but not for pixels with intermediate luminances [55].

The adaptation level I_a may be computed in traditional fashion, for instance, as the (log) average luminance of the image. However, additional interesting features, such as light adaptation and chromatic adaptation, may be modeled by a slightly more elaborate computation of I_a.

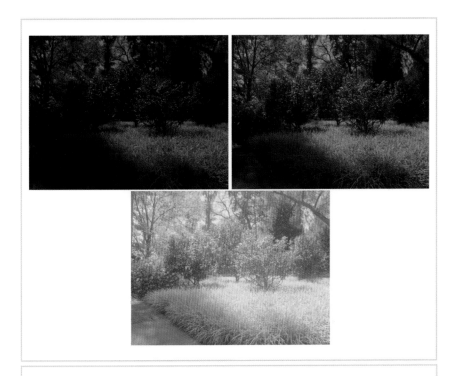

FIGURE 7.16 *Luminance control with user parameter f in Reinhard and Devlin's photorecep-tor-based operator. User parameter f, set here to $\exp(-8)$, $\exp(0) = 1$ and $\exp(8)$. The top right-hand image shows the default value.*

Strong color casts may be removed by interpolating between the luminance value $L(x, y)$ of the pixel and the red, green, and blue values of each pixel $I_{r|g|b}(x, y)$. This produces a different adaptation level for each pixel individually, which is controlled by a user-specified interpolation weight c, as follows.

$$I_a(x, y) = cI_{r|g|b}(x, y) + (1 - c)L(x, y)$$

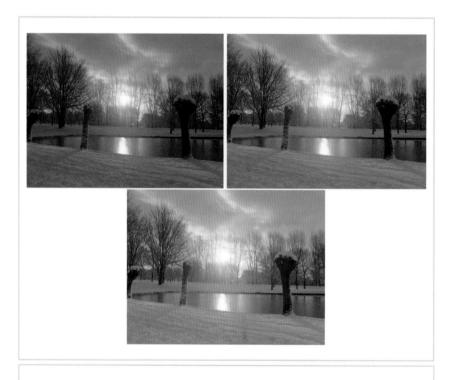

FIGURE 7.17 *The exponent m in Reinhard and Devlin's operator. Images are shown with exponent m set to 0.6, 0.7, and 0.8 (in reading order).*

This approach achieves a von Kries style of color correction by setting c equal to 1, whereas no color correction is applied if c equals 0. We also call this color adjustment "chromatic adaptation." Its effect is shown in Figure 7.18 for three values of c.

Similarly, the adaptation level (see Figure 7.19) may be thought of as determined by the current light level to which a receptor is exposed, as well as levels to which the receptor was exposed in the recent past. Because the eye makes saccadic eye

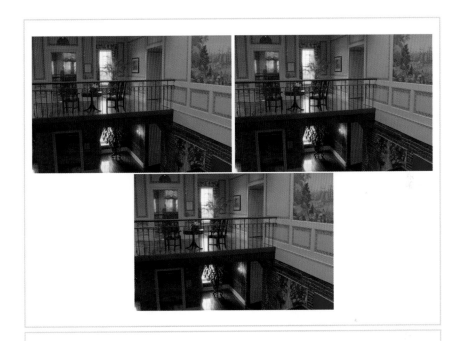

FIGURE 7.18 *Simulation of chromatic adaptation in Reinhard and Devlin's photoreceptor-based operator. The level of chromatic adaptation may be approximated by setting user parameter c (shown here with values of 0.0, 0.5, and 1.0).*

movements, and because there is the possibility of lateral connectivity within the retina, we may assume that the current adaptation level is a function of the pixel value itself and all other pixels in the image. This has given rise to all manner of spatially varying tone-reproduction models (see Section 7.3), but here a much faster and simpler solution is used (namely, interpolation between pixel values and global averages), as follows.

$$I_{a}(x, y) = a I_{r|g|b}(x, y) + (1 - a) I_{r|g|b}^{av}$$

FIGURE 7.19 *Simulation of light adaptation in Reinhard and Devlin's operator. The level of light adaptation was approximated by setting user parameter a to 0, 1/3, 2/3, and 1. (Albin Polasek (1879–1965) Maiden of the Roman Campagna, 1911, Bronze. Courtesy of the Albin Polasek Museum and Sculpture Gardens, Winter Park, FL.)*

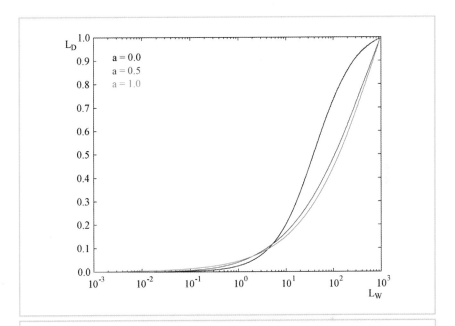

FIGURE 7.20 Luminance mapping by the photoreceptor-based operator for different values of user parameter a.

The interpolation weight a is user specified and controls image appearance, which to some extent correlates with light adaptation. Plots of the operator for different values of a are presented in Figure 7.20. Light adaptation and chromatic adaptation may be combined by bilinear interpolation, as follows.

$$I_a^{\text{local}}(x, y) = cI_{\text{r}|\text{g}|\text{b}}(x, y) + (1 - c)L(x, y)$$

$$I_a^{\text{global}} = cI_{\text{r}|\text{g}|\text{b}}^{\text{av}} + (1 - c)L^{\text{av}}$$

$$I_a(x, y) = aI_a^{\text{local}}(x, y) + (1 - a)I_a^{\text{global}}$$

This operator is directly inspired by photoreceptor physiology. Using default parameters, it provides plaussible results for a large class of images. Most other results may be optimized by adjusting the four user parameters. The value of c determines to what extent any color casts are removed, a and m affect the amount of contrast in the tone-mapped image, and f' make the overall appearance lighter or darker. Because each of these parameters has an intuitive effect on the final result, manual adjustment is fast and straightforward.

7.2.8 WARD HISTOGRAM ADJUSTMENT

Most global operators define a parametric curve with a few parameters that are estimated from the input image or that need to be specified by the user. Histogram enhancement techniques provide a mechanism for adjusting the mapping in a more fine-grained, albeit automatic, manner. Image enhancement techniques manipulate images that are already LDR to maximize visibility or contrast. On the other hand, Ward et al. borrow key ideas from histogram enhancement techniques to reproduce HDR images on LDR displays, simulating both visibility and contrast [142]. Their technique is termed *histogram adjustment*.

The simulation of visibility and contrast serves two purposes. First, the subjective correspondence between the real scene and its displayed image should be preserved so that features are only visible in the tone-mapped image if they were also visible in the original scene. Second, the subjective impression of contrast, brightness, and color should be preserved.

The histogram adjustment operator computes a histogram of a density image (i.e., the log of all pixels taken first) to assess the distribution of pixels over all possible luminance values. The shape of its associated cumulative histogram may be directly used to map luminance values to display values. However, further restrictions are imposed on this mapping to preserve contrast based on the luminance values found in the scene and on how the human visual system would perceive those values. As a postprocessing step, models of glare, color sensitivity, and visual acuity may further simulate aspects of human vision.

The histogram is calculated by first downsampling the image to a resolution that corresponds roughly to 1 degree of visual angle. Then the logarithm of the downsampled image is taken and its histogram is computed. The minimum and

maximum log luminance values are taken to define the range of the histogram, with the exception that if the minimum log luminance value is smaller than -4 this value is used as the lower bound of the histogram. This exception models the lower threshold of human vision. The number of bins in the histogram is 100, which in practice provides a sufficiently accurate result. If $f(b_i)$ counts the number of pixels that lie in bin b_i, the cumulative histogram $P(b)$, normalized by the total number of pixels T, is defined as

$$P(b) = \sum_{b_i < b} f(b_i)/T$$

$$T = \sum_{b_i} f(b_i).$$

A naïve contrast equalization formula may be constructed from the cumulative histogram and the minimum and maximum display luminances, as follows.

$$\log\big(L_d(x, y)\big) = \log(L_{d,\min}) + \big(\log(L_{d,\max}) - \log(L_{d,\min})\big) P\big(\log L_w(x, y)\big)$$

This approach has a major flaw in that wherever there is a peak in the histogram, contrasts may be expanded rather than compressed. Exaggeration of contrast is highly undesirable and is avoidable through the following refinement. Based on the observation that linear tone mapping produces reasonable results for images with a limited dynamic range, contrasts due to histogram adjustment should not exceed those generated by linear scaling. That is,

$$\frac{dL_d}{dL_w} \leq \frac{L_d}{L_w}.$$

Because the cumulative histogram is the numerical integration of the histogram, we may view the histogram itself as the derivative of the cumulative histogram—provided it is normalized by T and the size of a bin δb is small, and thus

$$\frac{dP(b)}{db} = \frac{f(b)}{T\delta b}$$

$$\delta b = \frac{1}{N}\log(L_{\max}) - \log(L_{\min}).$$

This naïve histogram equalization gives an expression for the display luminance L_d as a function of world luminance L_w. Its derivative may therefore be plugged into the previous inequality to yield a ceiling on $f(b)$, as follows.

$$L_d \frac{f(\log(L_w))}{T\delta b} \frac{\log(L_{d,\max}) - \log(L_{d,\min})}{L_w} = \frac{L_d}{L_w}$$

$$\frac{T\delta b}{\log(L_{d,\max}) - \log(L_{d,\min})} \geq f(b)$$

This means that as long as $f(b)$ does not exceed this ceiling, contrast will not be exaggerated. For bins with a higher pixel count, the simplest solution is to truncate $f(b)$ to the ceiling. Unfortunately, this changes the total pixel count T in the histogram, which by itself will affect the ceiling. This may be solved by an iterative scheme that stops if a certain tolerance is reached. Details of this approach are given in [142].

A second refinement is to limit the contrast according to human vision. The linear ceiling described previously assumes that humans detect contrast equally well over the full range of visible luminances. This assumption is not correct, prompting a solution that limits the contrast ceiling according to a just-noticeable difference function δL_t. This function takes an adaptation value L_a as a parameter, as follows. (This is the same as the function used by Ferwerda's model of visual adaptation. See Section 7.2.4.)

$$\delta L_t(L_a) = \begin{cases} -2.86 \text{ for } \log_{10}(L_a) < -3.94 \\ (0.405 \log_{10}(L_a) + 1.6)^{2.18} - 2.86 \text{ for } -3.94 \leq \log_{10}(L_a) < -1.44 \\ \log_{10}(L_a) - 0.395 \text{ for } -1.44 \leq \log_{10}(L_a) < -0.0184 \\ (0.249 \log_{10}(L_a) + 0.65)^{2.7} - 0.72 \text{ for } -0.0184 \leq \log_{10}(L_a) < 1.9 \\ \log_{10}(L_a) - 1.255 \text{ for } \log_{10}(L_a) \geq 1.9 \end{cases}$$

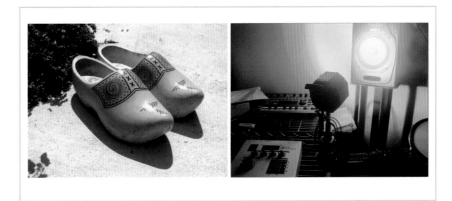

FIGURE 7.21 *Example images tone mapped with the histogram adjustment operator. The mappings produced for these images are plotted in Figure 7.22.*

This yields the following inequality and ceiling on $f(b)$, which also requires an iterative scheme to solve.

$$\frac{dL_d}{dL_w} \leq \frac{\delta L_t(L_d)}{\delta L_t(L_w)}$$

$$f(b) \leq \frac{\delta L_t(L_d)}{\delta L_t(L_w)} \cdot \frac{T\delta b L_w}{(\log_{10}(L_{d,\max}) - \log_{10}(L_{d,\min}))L_d}$$

The result is a practical hands-off tone-reproduction operator that produces plausible results for a wide variety of HDR images. Because the operator adapts to each image individually, the mapping of world luminance values to display values will be different for each image. As an example, two images are shown in Figure 7.21. The mappings for these two images are shown in Figure 7.22.

Further enhancements model human visual limitations such as glare, color sensitivity, and visual acuity. Veiling glare is caused by bright light sources in the periphery of vision, which cause light scatter in the ocular media. Light scatter causes a reduction of contrast near the projection of the glare source on the retina.

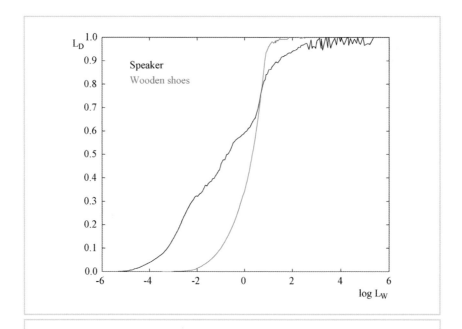

FIGURE 7.22 *Mapping of world luminances to display luminance for the images shown in Figure 7.21.*

In dark environments, color sensitivity is lost because only one type of receptor is active. In brighter environments, the three cone types are active and their relative activity is used by the human visual system to infer the spectral composition of the scene it is viewing. Finally, in dark environments visual acuity is lost because only very few rods are present in the fovea.

The histogram adjustment technique may accommodate each of these effects, and we refer to Ward's original paper for a full description [142]. Figure 7.23 shows a daytime image processed with the various options afforded by this operator, and Figure 7.24 shows the same applied to a nighttime image.

FIGURE 7.23 Histogram adjustment with its various simulations of human visual limitations for a daylight scene. In reading order: histogram adjustment, histogram adjustment with simulation of visual acuity loss, veiling glare, color sensitivity, and contrast sensitivity. The final image shows a combination of all of these. Compare with Figure 7.24, which shows the same techniques applied to a nighttime image.

FIGURE 7.24 Histogram adjustment with its various simulations of human visual limitations for a night scene. In reading order: histogram adjustment, histogram adjustment with simulation of visual acuity loss, veiling glare, color sensitivity, and contrast sensitivity. The final image shows a combination of all of these.

7.2.9 SCHLICK UNIFORM RATIONAL QUANTIZATION

Uniform rational quantization is aimed at providing an improved tone-reproduction operator as compared with simple logarithmic mappings and ad hoc procedures (such as gamma correction) for the purpose of dynamic range reduction. It was not developed to be an alternative to more complete perceptually-based operators. However, this method does provide a simple scheme with only two user parameters.

A rational function is defined as the quotient of two polynomials. The specific mapping function proposed by Schlick is [113] as follows.

$$L_d(x, y) = \frac{p L_w(x, y)}{(p - 1) L_w(x, y) + L_{max}} \quad \text{where } p \in [1, \infty)$$

This function bears some resemblance to sigmoidal functions (see also Section 6.3.1), although instead of a semisaturation constant the maximum world luminance L_{max} is used, and instead of an exponent to control the overall appearance a scale factor p is introduced.

The value of p may be estimated such that the smallest value that is not black remains just visible after tone mapping. This JND δL_0 in quantized display luminance steps should be specified by the user. A simple way of determining this value is to show an image with various patches on a black background. The patches will vary in gray level. The user then selects the darkest patch that is just visible. The parameter p may then be approximated by

$$p = \frac{\delta L_0}{N} \cdot \frac{L_{max}}{L_{min}},$$

where N is the number of different luminance levels that can be reproduced by the display device. For 8-bit display devices, its value will be 256. Figure 7.25 shows results created with different values of δL_0. A plot of this operator is shown in Figure 7.26. An empirically determined refinement to the previous uniform rational quantization scheme uses the following slightly different form, which also depends on the pixel's luminance value.

$$p = \frac{\delta L_0}{N} \cdot \frac{L_{max}}{L_{min}} \left(1 - k + k \frac{L_w(x, y)}{\sqrt{L_{min} L_{max}}} \right)$$

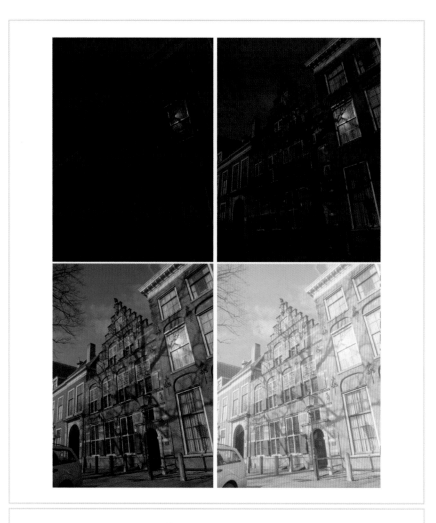

FIGURE 7.25 Using Schlick's uniform rational quantization, the just-noticeable difference from black was set to 10^{-7}, 10^{-6}, 10^{-5}, and 10^{-4}.

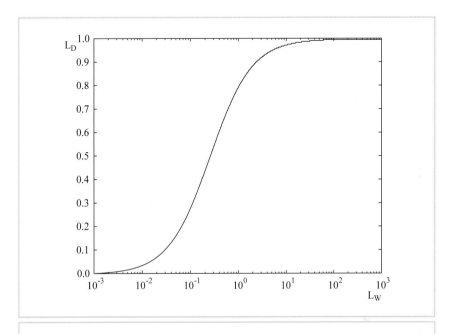

FIGURE 7.26 *Schlick's uniform rational quantization shown for a value of $L_0 = 1$.*

Schlick's original intent was to extend the uniform rational quantization function to be spatially varying. The pixel's luminance value in this formulation would then be replaced by a weighted average of the pixel's luminance and its neighbors. However, he found that the best results were obtained by making the local neighborhood no larger than the pixel itself. This yields the previous formulation, which is no longer spatially varying.

The user parameter k should be specified in the range $[0,1]$. Its effect on a tone-mapped image is shown in Figure 7.27.

Schlick's operator produces plausible results and is computationally efficient. However, it may be somewhat difficult to find values for the two user parameters without some experimentation.

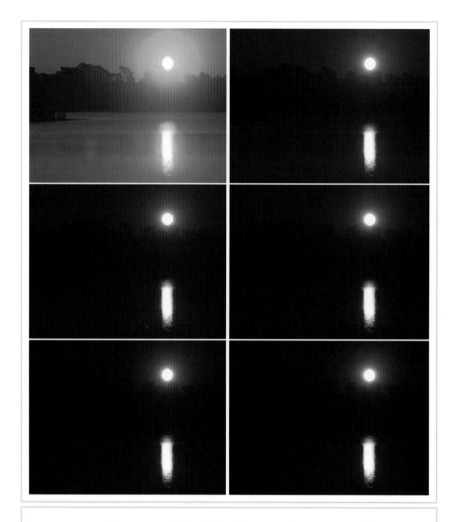

FIGURE 7.27 User parameter k of Schlick's uniform rational quantization varied between 0.0 and 1.0 in steps of 0.2.

7.3 LOCAL OPERATORS

Global operators are characterized by a mapping of world luminances to display luminances that is identical for all pixels (i.e., a single tone-mapping curve is used throughout the image). This makes them computationally efficient, but there is a limit to the dynamic range of the input image beyond which successful compression becomes difficult. Global operators are of necessity monotonically increasing operators. Otherwise, visually unpleasant artifacts will be introduced. Because display devices can usually not accommodate more than 256 levels, all world luminances must be mapped to that range and quantized to unit increments. The higher the dynamic range of an image, the more values must be mapped to 256 different numbers by a monotonically increasing function. For extreme HDR images this will almost inevitably lead to loss of visibility or contrast, or both.

Thus, global operators are limited in their capacity to compress HDR images. To some extent this limit may be lifted by local operators by compressing each pixel according to its luminance value, as well as to the luminance values of a set of neighboring pixels. Thus, instead of anchoring the computation to a globally derived quantity (such as the image's log average value) for each pixel the computation is adjusted according to an average over a local neighborhood of pixels.

Local operators more often than not mimic features of the human visual system. For instance, a reasonable assumption is that a viewer does not adapt to the scene as a whole, but to smaller regions instead. An active observer's eyes tend to wander across the scene, focusing on different regions. For each focus point, there is a surrounding region that helps determine the state of adaptation of the viewer.

For tone-reproduction operators this has the implication that we may be able to compute an adaptation level individually for each pixel by considering the pixel itself and a set of neighboring pixels. Classic problems to be solved by local tone-reproduction operators are to determine how many neighboring pixels need to be included in the computation, how to weight each neighboring pixel's contribution to the local adaptation level, and how to use this adaptation level within a compressive function. These issues are solved differently by the operators described in this section.

7.3.1 CHIU SPATIALLY VARIANT OPERATOR

The first to observe that a spatially varying operator may be useful for tone reproduction were Chiu et al. [9]. They noted that artists frequently make use of spatially varying techniques to fool the eye into thinking that a much larger dynamic range is present in artwork than actually exists. In particular, the areas around bright features may be dimmed somewhat to accentuate them. The basic formulation of their operator, as follows, multiplies each pixel's luminance by a scaling factor $s(x, y)$, which depends on the pixel itself and its neighbors.

$$L_d(x, y) = s(x, y)L_w(x, y)$$

For $s(x, y)$ to represent a local average, we may produce a low-pass filtered version of the input image. Chiu et al. note that most low-pass filters produce similar results. For demonstration purposes, we show the technique with a Gaussian filter with a width controlled by a user parameter (see Section 7.1.4).

In a blurred image, each pixel represents a weighted local average of the pixel in the corresponding position in the input image. The reciprocal of these blurred pixels may be used to compress HDR images, as follows.

$$L_d(x, y) = \frac{1}{kL_w^{\text{blur}}(x, y)} L_w(x, y)$$

Here, k is a constant of proportionality (a user parameter) that controls the weight given to the blurred image relative to the unblurred input. This approach immediately highlights one of the main problems faced by all local operators: halos arise around bright features. These halos, or contrast reversals, are more often disturbing than helpful. However, at the same time we have argued that artists use such dimming of areas around bright objects with great success. We conclude that some halos are good and some are bad. Finding a spatially variant tone-reproduction operator that does not produce obtrusive halos is a challenge. In our opinion, some operators succeed better than others.

To illustrate the haloing problem, we created a series of images (using the previous formulation) with different values of k, shown in Figure 7.28. This places more or less weight on the Gaussian blurred image, which was chosen with a kernel size of 128 pixels in each case. In that k controls the relative contribution of the

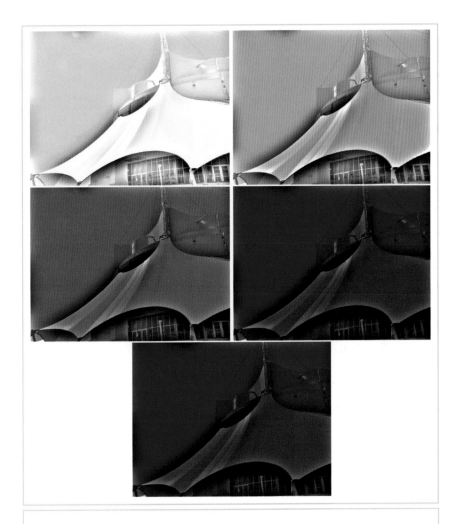

FIGURE 7.28 The relative weight of the Gaussian-blurred image was controlled by specifying user parameter k, which was given values of 1, 2, 4, 8, and 16. This parameter thus varies the strength of the halo.

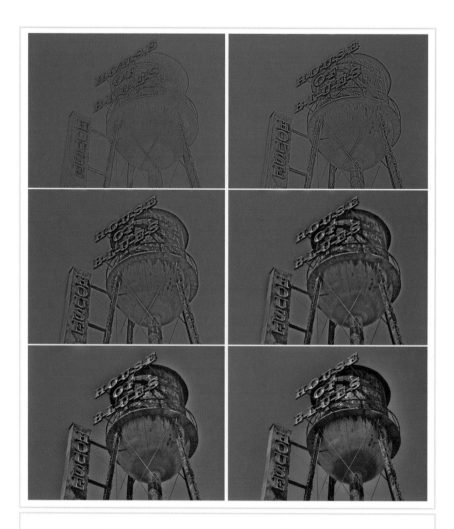

FIGURE 7.29 *Effect of kernel size on image quality in Chiu's operator. The width of the Gaussian kernel was varied from 4 pixels to 128 pixels, doubling its width with each consecutive image.*

Gaussian blurred image to the final result, it affects the strength of the halos and the amount of achievable compression.

Whereas k controls the depth of the Gaussian, the kernel size may also be varied by a user parameter. Its effect is shown in Figure 7.29. The extreme haloing effect seen for small Gaussians starts to disappear for larger Gaussians. The image created with a kernel size of 128 pixels looks plausible. Although the halos in the bottom right-hand image of Figure 7.29 are not absent, we believe that here the transition between bad halos and good halos can be seen. This figure is in agreement with the observation made by Chiu et al. that wide filter kernels need to be used for local operators of this form to produce plausible results.

Chiu's original implementation included a smoothing stage that would iterate at least 1,000 times over the image with a small filter kernel. This would somewhat reduce the effect of contrast reversals. This approach is too expensive to be practical, however, and we therefore did not include this stage in our experimentation.

Chiu's work is intended to be exploratory and is of interest because it highlights the issues faced by other local tone-reproduction operators. Dependent on the application, halos may be desirable or completely undesirable. In any case, contrast reversals are a feature of most spatially varying operators. The extent to which they are visible depends on the method chosen and the amount of parameter tuning applied.

7.3.2 RAHMAN RETINEX

Whereas Chiu's work is exploratory and is not advertised as a viable tone-reproduction operator, Rahman and Jobson developed their interpretation of the retinex theory for use in various applications, including tone reproduction [59, 102,103]. However, the differences between their approach and Chiu's are relatively minor. They too divide the image by a Gaussian-blurred version with a wide filter kernel.

Their operator comes in two different forms: single-scale and multiscale. In the single-scale version, Chiu's model is followed closely, although the algorithm operates in the log domain. However, the placements of the logarithms are somewhat pe-

culiar (namely, after the image is convolved with a Gaussian filter kernel), as follows.

$$I_d(x, y) = \exp\big(\log\big(I_w(x, y)\big) - k \log\big(I_w^{\text{blur}}(x, y)\big)\big)$$

This placement of logarithms is empirically determined to produce visually improved results. We add exponentiation to the results to return to a linear image.

Note that this operator works independently on the red, green, and blue channels, rather than on a single luminance channel. This means that the convolution that produces a Gaussian-blurred image needs to be repeated three times per image.

In the multiscale retinex version, this equation is repeated several times for Gaussians with different kernel sizes. This results in a stack of images, each image blurred by increasing amounts. In the following, an image at level n will be denoted $I_{w,n}^{\text{blur}}$. In the examples we show in this section, we used a stack of six levels and made the smallest Gaussian filter kernel two pixels wide. Each successive image is convolved with a Gaussian twice as large as that of the previous image in the stack.

The multiscale retinex version is then simply the weighted sum of a set of single-scale retinexed images. The weight given to each scale is determined by the user. We have found that for experimentation it is convenient to weight each level by a power function, which gives straightforward control over the weights. For an image stack with N levels, the normalized weights are then computed by

$$w_n = \frac{(N - n - 1)^f}{\sum_{m=0}^{N}(N - m - 1)^f}.$$

A family of curves of this function is plotted in Figure 7.30. The user parameter f determines the relative weighting of each of the scales. For equal weighting, f should be set to 0. To give smaller scales more weight, f should be given a positive value (such as 0.1 or 0.2). If the larger scales should be emphasized, f should be given negative values. The multiscale retinex takes the following form.

$$I_d(x, y) = \exp\left(\sum_{n=0}^{N} w_n \big(\log\big(I_w(x, y)\big) - k \log\big(I_{w,n}^{\text{blur}}(x, y)\big)\big)\right)$$

The two user parameters are k and f, which are in many ways equivalent to the user parameters required to control Chiu's operator. The value of k specifies the relative weight of the blurred image. Larger values of k will cause the compression to be

FIGURE 7.30 *Weight factors w_n as function of scale n for different user parameters f. The values for f used a range from -0.3 to 0.3 in steps of 0.1.*

more dramatic, but also create bigger halos. Parameter f, which controls the relative weight of each of the scales, determines which of the Gaussian-blurred images carries the most importance. This is more or less equivalent to setting the spatial extent of the Gaussian in Chiu's method. With these two parameters we therefore expect to be able to control the operator, balancing amount of compression against severity of the artifacts. This is indeed the case, as Figures 7.31 and 7.32 show.

In summary, Rahman and Jobson's interpretation of Land's retinex theory is similar to the exploratory work by Chiu. There are three main differences. The algorithm works in the log domain, which causes contrasts at large image values to lie closer together. This generally results in fewer issues with haloing. Second, the algorithm operates on the three color channels independently. This approach is routinely fol-

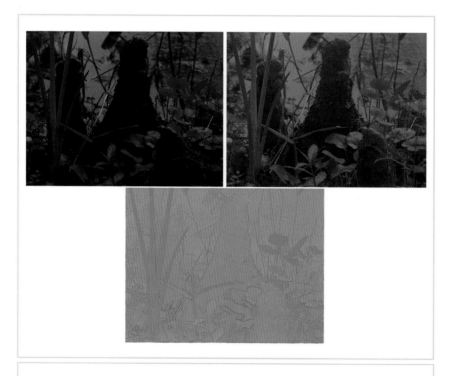

FIGURE 7.31 In Rahman's retinex implementation, parameter k controls the relative weight of the Gaussian-blurred image stack. Here, k is varied from 0.0 to 0.5, and 1.0 (in reading order).

FIGURE 7.32 In Rahman's retinex implementation, the Gaussian-blurred images may be weighted according to scale. The most important scales are selected with user parameter f, which is varied between -2 to 2. Equal weight is given for a value of $f = 0$, shown on the left of the middle row.

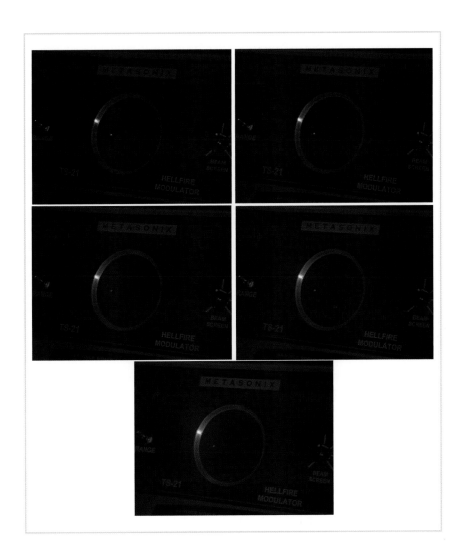

lowed by various color appearance models (see, for instance, the CIECAM02 model discussed in Section 2.8, and the iCAM model discussed in material following). Finally, this work operates on multiple scales that are weighted relative to one another by a user-specified parameter. Multiscale techniques are well known in the literature, including the tone-reproduction literature. Other examples of multiscale techniques are the multiscale observer model, Ashikhmin's operator, and photographic tone reproduction, described respectively in Sections 7.3.4, 7.3.5, and 7.3.6.

7.3.3 FAIRCHILD iCAM

Although most operators discussed in this chapter are aimed at dynamic range reduction, Pattanaik's multiscale observer model [94] (discussed in the following section) and Fairchild's iCAM model [30] are both color appearance models.

Most color appearance models — such as CIECAM97, CIECAM02 and the Hunt model — are intended for use in simplified environments. It is normally assumed that a uniform patch of color is viewed on a larger uniform background with a different color. The perception of this patch of color may then be predicted by these models with the XYZ tristimulus values of the patch and a characterization of its surround as input, as described in Section 2.8.

Images tend to be more complex than just a patch on a uniform background. The interplay between neighboring pixels may require a more complex spatially variant model that can account for the local adaptation of regions around each pixel. This argument in favor of spatially variant color appearance models is effectively the same as the reasoning behind spatially variant tone-reproduction operators. The parallels between the iCAM model described here and operators such as Chiu's and Rahman's are therefore unmistakable. However, there are also sufficient differences to make a description of the model worthwhile.

The iCAM image appearance model is a direct refinement and simplification of the CIECAM02 color appearance model [30,61]. It omits the sigmoidal compression found in CIECAM02 but adds spatially variant processing in the form of two separate Gaussian-blurred images that may be viewed as adaptation levels. Like most color appearance models, the model needs to be applied in the forward direction and in the reverse direction.

The input to the model is expected to be specified in XYZ device-independent coordinates. Like CIECAM02, the model uses various color spaces to execute the stages of the algorithm. The first stage is a chromatic adaptation transform, for which sharpened cone responses are used. Sharpened cone responses are obtained with the M_{CAT02} transform, given in Section 2.4.

The chromatic adaptation transform pushes the colors in the image toward the D_{65} white point. The amount of adaption in this von Kries transform is determined by a user parameter D, which specifies the degree of adaptation. In addition, for each pixel a white point $W(x, y)$ is derived from the XYZ image by applying a low-pass filter with a kernel a quarter the size of the image. This may be applied to each color channel independently for chromatic adaptation, or on the Y channel only for achromatic adaptation. This low-pass filtered image is then also converted with the M_{CAT02} matrix. Finally, the D_{65} white point — given by the $Y_w = 95.05, 100.0,$ 108.88 triplet — is also converted to sharpened cone responses. The subsequent von Kries adaptation transform is given by the following.

$$R_c(x, y) = R'(x, y)\left(Y_w\frac{D}{W_{R'}(x, y)} + 1 - D\right)$$

$$G_c(x, y) = G'(x, y)\left(Y_w\frac{D}{W_{G'}(x, y)} + 1 - D\right)$$

$$B_c(x, y) = B'(x, y)\left(Y_w\frac{D}{W_{B'}(x, y)} + 1 - D\right)$$

This transform effectively divides the image by a filtered version of the image. This step of the iCAM model is therefore similar to Chiu's and Rahman's operators. In those operators, the trade-off between amount of available compression and presence of halos is controlled by a scaling factor k. Here, D plays the role of the scaling factor. We may therefore expect this parameter to have the same effect as k in Chiu's and Rahman's operators. However, in the previous equation D also determines the amount of chromatic adaptation. It serves the same role as the degree of adaptation parameter found in other color appearance models (compare, for instance, with CIECAM02, described in Section 2.8).

For larger values of D, the color of each pixel is pushed closer to the D_{65} white point. Hence, in the iCAM model the separate issues of chromatic adaptation, haloing, and amount of compression are directly interrelated.

Figure 7.33 shows the effect of parameter D, which was given values of 0.0, 0.5, and 1.0. This figure also shows the effect of computing a single white point shared between the three values of each pixel and computing a separate white point for each color channel independently. For demonstration purposes, we have chosen an image with a higher dynamic range than usual. The halo visible around the light source is therefore more pronounced than for images with a medium dynamic range. Like Chiu's and Rahman's operators, the iCAM model appears most suited for medium-dynamic-range images.

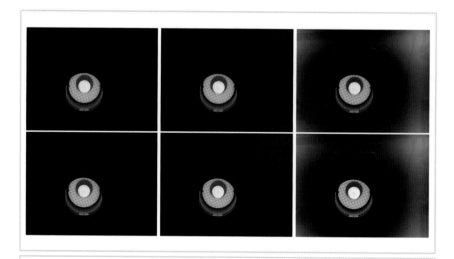

FIGURE 7.33 The iCAM image appearance model. Top row: luminance channel used as adaptation level for all three channels. Bottom row: channels are processed independently. From left to right the adaptation parameter D was varied from 0.0 to 0.5 and 1.0.

After the chromatic adaptation transform, further compression is achieved by an exponential function executed in LMS cone space (see Section 2.4). The exponential function that compresses the range of luminances is given by the following.

$$L'(x, y) = |L(x, y)|^{0.43 F_L(x,y)}$$

$$M'(x, y) = |M(x, y)|^{0.43 F_L(x,y)}$$

$$S'(x, y) = |S(x, y)|^{0.43 F_L(x,y)}$$

The exponent is modified on a per-pixel basis by F_L, which is a function of a spatially varying surround map derived from the luminance channel (Y channel) of the input image. The surround map $S(x, y)$ is a low-pass filtered version of this channel with a Gaussian filter kernel size of one-third the size of the image. The function F_L is then given by the following.

$$F_L(x, y) = \frac{1}{1.7}\left(0.2\left(\frac{1}{5S(x, y) + 1}\right)^4 (5S(x, y))\right.$$
$$\left. + 0.1\left(1 - \left(\frac{1}{5S(x, y)}\right)^4\right)^2 \sqrt[3]{5S(x, y)}\right)$$

Thus, this computation of F_L may be seen as the spatially variant extension of CIECAM02's factor for partial adaptation, given in Equation 2.1.

This step completes the forward application of the iCAM model. To prepare the result for display, the inverse model should be applied. The model requires the same color spaces to be used as in the forward model in each of the steps. The first step is to invert the previous exponentiation, as follows.

$$L'(x, y) = |L(x, y)|^{1/0.43}$$

$$M'(x, y) = |M(x, y)|^{1/0.43}$$

$$S'(x, y) = |S(x, y)|^{1/0.43}$$

The inverse chromatic adaptation transform does not require a spatially variant white point, but converts from a global D_{65} white point $Y_w = 95.05, 100.0, 108.88$

to an equiluminant white point $Y_e = 100,100,100$. Because full adaptation is assumed, D is set to 1 and this transform simplifies to the following scaling, which is applied in sharpened cone response space.

$$R' = R\frac{Y_e}{Y_w}$$

$$G' = G\frac{Y_e}{Y_w}$$

$$B' = B\frac{Y_e}{Y_w}$$

After these two steps are executed in their appropriate color spaces, the final steps consist of clipping the top 99% of all pixels, normalization, and gamma correction. The user parameters for this model are D, as discussed previously, and a prescaling of the input image. This prescaling may be necessary because the iCAM model requires the input to be specified in cd/m^2. For arbitrary images, this requires the user to scale the image to its appropriate range prior to tone mapping. The effect of pre-scaling is shown in Figure 7.34. For images that contain values that are too small, a red shift is apparent. If the values in the image are too large, the overall appearance of the image becomes too dark.[3]

Further parameters for consideration are the kernel sizes of the two Gaussian filters. For the images shown in this section, we used the recommended kernel sizes of 1/4 and 1/3 the size of the image, but other sizes are possible. As with Chiu's and Rahman's operators, the precise kernel size is unimportant, as long as the filter width is chosen to be large.

FIGURE 7.34 *Effect of pre-scaling on the iCAM model. The factor used for the top left-hand image was 0.01 and each subsequent image was scaled with a factor 10 times larger than the previous image.*

3 The images in this figure, as with similar image sequences for other operators, were scaled beyond a reasonable range — too small and too large — to show the effect of the parameter. It should be noted that in practice a reasonable parameter setting should be chosen to avoid such extremes.

In summary, the iCAM model consists of two steps: a chromatic adaptation step followed by an exponential function. The achromatic adaptation step strongly resembles Chiu's and Rahman's operators because the image is divided by a blurred version of the image. The second step may be viewed as an advanced form of gamma correction, whereby the gamma factor is modulated on a per-pixel basis. The forward model needs to be followed by the inverse application of the model to prepare the image for display. A final clipping and normalization step brightens the overall appearance. The model is best suited for images with a medium dynamic range, in that the trade-off between compression and presence of halos is less critical for this class of images than for extreme HDR images.

7.3.4 PATTANAIK MULTISCALE OBSERVER MODEL

Pattanaik's multiscale observer model ranks among the more complete color appearance models and consists of several steps executed in succession [94]. The output of this model (and all other color appearance models) are color appearance correlates, as discussed in Section 2.8. A tone-reproduction operator may be derived from these correlates by executing the inverse model and substituting characteristics of the display device into the equations in the appropriate place.

For simplicity, we present a version of the model that is reduced in complexity. For the purpose of tone reproduction, some of the forward and backward steps of the model cancel out and may therefore be omitted. In addition, compared to the original model we make small changes to minimize visual artifacts, for instance by choosing the filter kernel sizes smaller than in the original model. We first give a brief overview of the full model and then detail a simplified version.

The first step in the forward model is to account for light scatter in the ocular media, followed by spectral sampling to model the photoreceptor output. This yields four images representing the rods and the L, M, and S cones. These four images are then each spatially decomposed into seven-level Gaussian pyramids and subsequently converted into four six-level difference-of-Gaussian (DoG) stacks that represent bandpass behavior as seen in the human visual system. DoGs are computed by subtracting adjacent images in the pyramid.

The next step consists of a gain control system applied to each of the DoGs in each of the four channels. The shape of the gain control function resembles TVI

curves such that the results of this step may be viewed as adapted contrast pyramidal images. The cone signals are then converted into a color opponent scheme that contains separate luminance, red-green, and yellow-blue color channels. The rod image is retained separately.

Contrast transducer functions that model human contrast sensitivity are then applied. The rod and cone signals are recombined into an achromatic channel, as well as red-green and yellow-blue color channels. A color appearance map is formed next, which is the basis for the computation of the aforementioned appearance correlates. This step cancels in the inverse model, and we therefore omit a detailed description. We also omit computing the rod signals because we are predominantly interested in photopic lighting conditions.

The model calls for low-pass filtered copies with spatial frequencies of 0.5, 1, 2, 4, 8, and 16 cycles per degree (cpd). Specifying spatial frequencies in this manner is common practice when modeling the human visual system. However, for a practical tone-reproduction operator this would require knowledge of the distance of the observer to the display device and the spatial resolution of the display device. Because viewer distance is difficult to control, let alone anticipate, we restate spatial frequencies in terms of cycles per pixel (cpp).

Further, we omit the initial modeling of light scatter in the ocular media. Modeling light scatter would have the effect of introducing a small amount of blur in the image, particularly near areas of high luminance. On occasion, modeling of glare may be important and desirable and should be included in a complete implementation of the multiscale observer model. However, for simplicity we omit this initial processing. This set of simplifications allows us to focus on the part of the multiscale observer model that achieves dynamic range reduction.

The model expects input to be specified in LMS cone space, discussed in Section 2.4. The compressive function applied in all stages of the multiscale observer model is given by the following gain control.

$$G(L) = \frac{1}{0.555(L+1)^{0.85}}$$

Multiplying either a low-pass or bandpass image by this gain control amounts to applying a sigmoid. Using the techniques presented in Section 7.1.4, a stack of seven increasingly blurred images is created next. The amount of blur is doubled

at each level, and for the smallest scale we use a filter kernel the size of which is determined by a user parameter (discussed later in this section). An image at level s is represented by the following triplet.

$$\left(L_s^{\text{blur}}(x, y), M_s^{\text{blur}}(x, y), S_s^{\text{blur}}(x, y)\right)$$

From this stack of seven Gaussian-blurred images we may compute a stack of six DoG images that represent adapted contrast at six spatial scales, as follows.

$$L_s^{\text{DoG}}(x, y) = \left(L_s^{\text{blur}}(x, y) - L_{s+1}^{\text{blur}}(x, y)\right)G\left(L_{s+1}^{\text{blur}}(x, y)\right)$$

$$M_s^{\text{DoG}}(x, y) = \left(M_s^{\text{blur}}(x, y) - M_{s+1}^{\text{blur}}(x, y)\right)G\left(M_{s+1}^{\text{blur}}(x, y)\right)$$

$$S_s^{\text{DoG}}(x, y) = \left(S_s^{\text{blur}}(x, y) - S_{s+1}^{\text{blur}}(x, y)\right)G\left(S_{s+1}^{\text{blur}}(x, y)\right)$$

The DoG scheme involves a division by a low-pass filtered image (through the gain control function), which may be viewed as a normalization step. This approach was followed in both Ashikhmin's operator (see following section) and in the photographic tone-reproduction operator (Section 7.3.6). DoGs are reasonable approximations of some of the receptive fields found in the human visual system.[4] They are also known as center-surround mechanisms.

The low-pass image at level $s = 7$ is retained and will form the basis for image reconstruction. In the final step of the forward model, pixels in this low-pass image are adapted to a linear combination of themselves and the mean value $(\bar{L}_7^{\text{blur}}, \bar{M}_7^{\text{blur}}, \bar{S}_7^{\text{blur}})$ of the low-pass image, as follows.

$$L_7^{\text{blur}}(x, y) = L_7^{\text{blur}}(x, y)G\left((1 - A)\bar{L}_7^{\text{blur}} + AL_7^{\text{blur}}(x, y)\right)$$

$$M_7^{\text{blur}}(x, y) = M_7^{\text{blur}}(x, y)G\left((1 - A)\bar{M}_7^{\text{blur}} + AM_7^{\text{blur}}(x, y)\right)$$

$$S_7^{\text{blur}}(x, y) = S_7^{\text{blur}}(x, y)G\left((1 - A)\bar{S}_7^{\text{blur}} + AS_7^{\text{blur}}(x, y)\right)$$

The amount of dynamic range reduction is determined by user parameter A in these equations, which takes a value between 0 and 1. The effect of this parameter on the appearance of tone-mapped images is shown in Figure 7.35.

..

4 A receptive field may be seen as the pattern of light that needs to be present to optimally stimulate a cell in the visual pathway.

FIGURE 7.35 Using the multiscale observer model, the interpolation parameter A was set to 0, 0.25, 0.50, 0.75, and 1. (Image courtesy of the Cornell University Program of Computer Graphics.)

The forward version of the multiscale observer model is based on the human visual system. Although we could display the result of the forward model, the viewer's visual system would then also apply a similar forward model (to the extent that this model is a correct reflection of the human visual system). To avoid applying the model twice, the computational model should be reversed before an image is displayed. During the reversal process, parameters pertaining to the display device are inserted in the model so that the result is ready for display.

In the first step of the inverse model, the mean luminance $L_{d,mean}$ of the target display device needs to be determined. For a typical display device, this value may be set to about 50 cd/m^2. A gain control factor for the mean display luminance is determined, and the low-pass image is adapted once more, but now for the mean display luminance, as follows.

$$L_7^{blur}(x, y) = \frac{L_7^{blur}(x, y)}{G(L_{d,mean})}$$

$$M_7^{blur}(x, y) = \frac{M_7^{blur}(x, y)}{G(M_{d,mean})}$$

$$S_7^{blur}(x, y) = \frac{S_7^{blur}(x, y)}{G(S_{d,mean})}$$

The stack of DoGs is then added to the adapted low-pass image one scale at a time, starting with $s = 6$ and followed by $s = 5, 4, \ldots, 0$, as follows.

$$L_7^{blur}(x, y) = \max\left(L_7^{blur}(x, y) + \frac{L_s^{DoG}(x, y)}{G(L_7^{blur}(x, y))}, 0 \right)$$

$$M_7^{blur}(x, y) = \max\left(M_7^{blur}(x, y) + \frac{M_s^{DoG}(x, y)}{G(M_7^{blur}(x, y))}, 0 \right)$$

$$S_7^{blur}(x, y) = \max\left(S_7^{blur}(x, y) + \frac{S_s^{DoG}(x, y)}{G(S_7^{blur}(x, y))}, 0 \right)$$

Finally, the result is converted to XYZ and then to RGB, where gamma correction is applied. The original formulation of this model shows haloing artifacts similar

to those of other local operators discussed in this chapter. One of the reasons for this is that the model is calibrated in degrees of visual angle rather than in pixels. The transformation between degrees of visual angle to pixels requires assumptions on the size of the display and its resolution, as well as the distance between the observer and the display. The size of the filter kernel used to create the low-pass images is directly affected by these assumptions. For the purpose of demonstration, Figure 7.36 shows a sequence of images produced with different kernel sizes. Note that we only adjust the size of the smallest Gaussian. By specifying the kernel size for the smallest Gaussian, the size of all other Gaussians is determined. The figure shows that smaller Gaussians produce smaller halos, which are less obtrusive than the larger halos of the original model.

The reconstruction of a displayable image proceeds by successively adding bandpass images back to the low-pass image. These bandpass images by default receive equal weight. It may be beneficial to weight bandpass images such that higher spatial frequencies contribute more to the final result. Although the original multiscale observer model does not feature such a weighting scheme, we have found that contrast in the final result may be improved if higher frequencies are given a larger weight. This is shown in Figure 7.37, where each successive image places more emphasis on higher frequencies. The scale factor k used for these images relates to the index number s of the bandpass pyramid in the following manner.

$$k = (6 - s)g$$

The constant g is a user parameter, which we vary between 1 and 5 in Figure 7.37. A larger value for g produces more contrast in the tone-mapped image, but if this value is chosen too large the residual halos present in the image are emphasized (which is generally undesirable). For uncalibrated images tone mapped with the multiscale observer model, different prescale factors cause the overall image appearance to be lighter or darker, as shown in Figure 7.38.

The computational complexity of this operator remains high, and we would only recommend this model for images with an extreme dynamic range. If the amount of compression required for a particular image is less, simpler models likely suffice. The Fourier transforms used to compute the low-pass images are the main factor determining running time. There are seven levels in the Gaussian pyramid, and four color channels in the original model, resulting in 28 low-pass filtered images.

FIGURE 7.36 Using the multiscale observer model, the filter kernel size is set to 0.03, 0.06, 0.12, 0.25, and 0.5 in this sequence of images. (Image courtesy of the Cornell University Program of Computer Graphics.)

FIGURE 7.37 Relative scaling in the multiscale observer model. For a filter kernel size of 0.03, the relative scaling parameter was set to 1, 2, 3, 4, and 5. (Image courtesy of the Cornell University Program of Computer Graphics.)

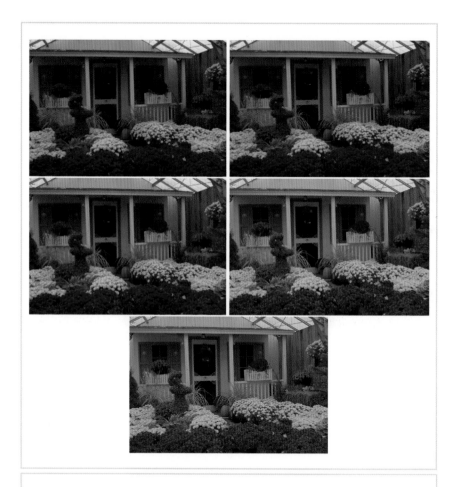

FIGURE 7.38 Effect of pre-scaling on the multiscale observer model. Images are pre-scaled by factors of 0.001, 0.01, 0.1, 1, and 10.

In our simplified model, we only compute three color channels, resulting in a total of 21 low-pass images.

The multiscale observer model is the first to introduce center-surround processing to the field of tone reproduction, which is also successfully employed in Ashikhmin's operator (see following section) and in Reinhard et al.'s photographic tone-reproduction operator (see Section 7.3.6). The halos present in the original model may be minimized by carefully choosing an appropriate filter kernel size.

7.3.5 ASHIKHMIN SPATIALLY VARIANT OPERATOR

The multiscale observer model aims at completeness in the sense that all steps of human visual processing that are currently understood well enough to be modeled are present in this model. It may therefore account for a wide variety of appearance effects. One may argue that such completeness is not strictly necessary for the more limited task of dynamic-range reduction.

Ashikhmin's operator attempts to model only those aspects of human visual perception that are relevant to dynamic-range compression [6]. This results in a significantly simpler computational model consisting of three steps. First, for each point in the image a local adaptation value $L_{wa}(x, y)$ is established. Next, a compressive function is applied to reduce the image's dynamic range. As this step may cause some detail to be lost, a final pass reintroduces detail. Ashikhmin's operator is aimed at preserving local contrast, which is defined as

$$c_w(x, y) = \frac{L_w(x, y)}{L_{wa}(x, y)} - 1.$$

In this definition, L_{wa} is the world adaptation level for pixel (x, y). The consequence of local contrast preservation is that visible display contrast $c_d(x, y)$, which is a function of display luminance $L_d(x, y)$ and its derived local display adaptation level $L_{da}(x, y)$, equals $c_w(x, y)$. This equality may be used to derive a function for computing display luminances, as follows.

$$c_d(x, y) = c_w(x, y)$$

$$\frac{L_d(x, y)}{L_{da}(x, y)} - 1 = \frac{L_w(x, y)}{L_{wa}(x, y)} - 1$$

$$L_d(x, y) = L_{da}(x, y) \frac{L_w(x, y)}{L_{wa}(x, y)}$$

The unknown in these equations is the local display adaptation value $L_{da}(x, y)$. Ashikhmin proposes to compute this value for each pixel from the world adaptation values. Thus, the display adaptation luminances are tone-mapped versions of the world adaptation luminances, as follows.

$$L_{da}(x, y) = F\big(L_{wa}(x, y)\big)$$

The complete tone-reproduction operator is then given by

$$L_d(x, y) = F(L_{wa}(x, y)) \frac{L_w(x, y)}{L_{wa}(x, y)}.$$

There are now two subproblems to be solved. The functional form of the tone-mapping function $F()$ needs to be given, and an appropriate local world adaptation level $L_{wa}(x, y)$ needs to be computed.

To derive the compressive function $F()$, Ashikhmin introduces the notion of perceptual capacity of a range of luminance values. Human sensitivity to luminance changes is given by TVI functions (see also Chapter 6). This may be used as a scaling factor for a small range of luminance values ΔL. The intuition behind this approach is that the perceptual importance of a JND is independent of the absolute luminance value for which it is computed. For a range of world luminances between 0 and L, perceptual capacity $C(L)$ may therefore be defined as follows.

$$C(L) = \int_0^L \frac{dx}{T(x)}$$

Here, $T(x)$ is the threshold versus intensity function. The perceptual capacity for an arbitrary luminance range from L_1 to L_2 is then $C(L_2) - C(L_1)$. Following others, the TVI function is approximated by four linear segments (in log-log space), and

thus the perceptual capacity function becomes

$$C(L) = \begin{cases} L/0.0014 & \text{for } L < 0.0034 \\ 2.4483 + \log_{10}(L/0.0034)/0.4027 & \text{for } 0.0034 \leq L < 1 \\ 16.5630 + (L-1)/0.4027 & \text{for } 1 \leq L < 7.2444 \\ 32.0693 + \log_{10}(L/7.2444)/0.0556 & \text{otherwise.} \end{cases}$$

World adaptation luminances may now be mapped to display adaptation luminances such that perceptual world capacity is linearly mapped to a displayable range. Assuming the maximum displayable luminance is given by $L_{d,\max}$, the compressive function $F(L_{wa}(x, y))$ is given by

$$F\big(L_{wa}(x, y)\big) = L_{d,\max} \frac{C(L_{wa}(x, y)) - C(L_{w,\min})}{C(L_{w,\max}) - C(L_{w,\min})}.$$

In this equation, $L_{w,\min}$ and $L_{w,\max}$ are the minimum and maximum world adaptation luminances. Finally, the spatially variant world adaptation luminances are computed in a manner akin to Reinhard's dodge-and-burn operator, discussed in the following section. The world adaptation luminance of a pixel is a Gaussian weighted average of pixel values taken over some neighborhood. The success of this method lies in the fact that the neighborhood should be chosen such that the spatial extent of the Gaussian filter does not cross any major luminance steps. As such, for each pixel its neighborhood should be chosen as large as possible without crossing sharp luminance gradients.

To compute if a pixel neighborhood contains any large gradients, consider a pixel of a Gaussian-filtered image with a filter kernel R of size s, as well as the same pixel position of a Gaussian-filtered image with a kernel of size $2s$. Because Gaussian filtering amounts to computing a weighted local average, the two blurred pixels represent local averages of two differently sized neighborhoods. If these two averages are similar, no sharp gradients occurred in the pixel's neighborhood. In other words, if the difference of these two Gaussian-filtered pixels is close to 0 the pixel's neighborhood of size $2s$ is LDR. The difference of Gaussians is normalized by one of the Gaussian-filtered images, yielding a measure of band-limited local contrast V_s, as follows.

$$V_s = \frac{L_w \otimes R_s - L_w \otimes R_{2s}}{L_w \otimes R_s}$$

These arguments are valid for any scale s. We may therefore compute a stack of band-limited local contrasts for different scales s. The smallest scale is $s = 1$, and each successive scale in Ashikhmin's operator is 1 pixel larger than the previous. The largest scale is 10 pixels wide.

Each successive larger scale difference of Gaussians tests a larger pixel neighborhood. For each pixel, the smallest scale s_t for which $V_{s_t}(x, y)$ exceeds a user-specified threshold t is chosen. By default, the value of this threshold may be chosen to be $t = 0.5$. The choice of threshold has an impact on the visual quality of the operator. If a value of 0.0 is chosen, Ashikhmin's operator defaults to a global operator. If the threshold value is chosen too large, halo artifacts will result. The size of these halos is limited to 10 pixels around any bright features because this is the size of the largest center. To demonstrate the effect of this threshold, we have reduced an image in size prior to tone mapping and enlarged the tone-mapped result, which is shown in Figure 7.39.

The size of a locally uniform neighborhood is now given by s_t. The local world adaptation value $L_{wa}(x, y)$ is a Gaussian-blurred pixel at scale s_t, as follows.

$$L_{wa}(x, y) = (L_w \otimes R_{s_t})(x, y)$$

Note that the scale s_t will be different for each pixel so that the size of the local neighborhood over which L_{wa} is computed varies according to image content. The

FIGURE 7.39 Effect of thresholding on results obtained with Ashikhmin's operator. From left to right: threshold values are 0.0, 0.5, and 1.0.

idea of using the largest possible filter kernel without crossing large contrast steps is in some sense equivalent to the output of edge-preserving smoothing operators such as the bilateral and trilateral filters discussed in Sections 8.1.2 and 8.1.3.

Other than the threshold value discussed previously, this operator does not have any user parameters, which is good if plausible results need to be obtained automatically. However, as with several other operators the input needs to be specified in appropriate SI units. If the image is in arbitrary units, it needs to be pre-scaled. The effect of pre-scaling an image is shown in Figure 7.40. We note that there appears to be a discontinuity in visual appearance between the image that was pre-scaled by a factor of 10 (top right) and 100 (bottom left in Figure 7.40). We suspect that this is due to the C_1 discontinuity in the TVI function used in the perceptual capacity function. The C_1 discontinuity in the TVI function is due to the different luminance levels at which rods and cones in the human visual system operate.

In summary, Ashikhmin's operator is based on sufficient knowledge of the human visual system to be effective without aiming for completeness. The operator is not developed to be predictive but to provide a reasonable hands-off approach to producing visually pleasing output in which local contrast is preserved.

7.3.6 REINHARD ET AL. PHOTOGRAPHIC TONE REPRODUCTION

The problem of mapping a range of world luminances to a smaller range of display luminances is not a new problem. Tone reproduction has existed in conventional photography since photography was invented. The goal of photographers is often to produce renderings of captured scenes that appear realistic. With photographic paper (like all paper) being inherently LDR, photographers have to find ways to work around the limitations of the medium.

Although many common photographic principles were developed in the last 150 years, and a host of media response characteristics were measured, a disconnect existed between the artistic and technical sides of photography. Ansel Adams' zone system, which is still in use today, attempts to bridge this gap. It allows the photographer to use field measurements to improve the chances of creating a good final print.

FIGURE 7.40 Pre-scaling applied to Ashikhmin's operator with factors ranging from 0.1 to 10,000. Each successive image was scaled by a factor 10 times the factor of the preceding image.

The zone system may be used to make informed choices in the design of a tone-reproduction operator [109]. First, a linear scaling is applied to the image, which is analogous to setting exposure in a camera. Then, contrast may be locally adjusted using a computational model akin to photographic dodging and burning, which is a technique to selectively expose regions of a print for longer or shorter periods of time. This may bring up selected dark regions, or bring down selected light regions.

The key of a scene in photography is an indicator of how light or dark the overall impression of a scene is. Following other tone-reproduction operators, Reinhard et al. view the log average luminance \bar{L}_w (Equation 7.1) as a useful approximation of a scene's key. For average-key scenes, the log average luminance should be mapped to 18% of the display range, which is in line with common photographic practice (although see footnote 4 of Chapter 2). Higher-key scenes should be mapped to a higher value, and lower-key scenes should be mapped to a lower value. The value to which the log average is mapped is given as a user parameter a. The initial scaling of the photographic tone-reproduction operator is then given by the following.

$$L_m(x, y) = \frac{a}{\bar{L}_w} L_w(x, y)$$

The subscript m denotes values obtained after the initial linear mapping. In that this scaling precedes any nonlinear compression, the operator does not necessarily expect the input to be specified in SI units. If the image is given in arbitrary units, the user parameter a could be adjusted accordingly. An example of this parameter's effect is shown in Figure 7.41. For applications that require hands-off operation, the value of this user parameter may be estimated from the histogram of the image [106]. This technique is detailed in Section 7.1.1.

Many scenes have a predominantly average dynamic range with a few high-luminance regions near highlights or in the sky. Traditional photography uses S-shaped transfer functions (sigmoids) to compress both high- and low-luminance values while emphasizing the midrange. However, modern photography uses transfer functions that predominantly compress high luminances. This may be modeled with the following compressive function.

$$L_d(x, y) = \frac{L_m(x, y)}{1 + L_m(x, y)}$$

FIGURE 7.41 Pre-scaling the image data is an integral part of the photographic tone-reproduction operator and may be automated. Here, user parameter a was set to 0.01, 0.04, 0.18 (default), and 0.72.

This function scales small values linearly, whereas higher luminances are compressed by larger amounts. The function has an asymptote at 1, which means that all positive values will be mapped to a display range between 0 and 1. However, in practice the input image does not contain infinitely large luminance values, and therefore the largest display luminances do not quite reach 1. In addition, it may be artistically desirable to let bright areas burn out in a controlled fashion. This effect may be achieved by blending the previous transfer function with a linear mapping, yielding the following tone-reproduction operator:

$$L_d(x, y) = \frac{L_m(x, y)\left(1 + \dfrac{L_m(x, y)}{L_{\text{white}}^2}\right)}{1 + L_m(x, y)}$$

This equation introduces a new user parameter, L_{white}, which denotes the smallest luminance value that will be mapped to white. By default, this parameter is set to the maximum world luminance (after the initial scaling). For lower-dynamic-range images, setting L_{max} to a smaller value yields a subtle contrast enhancement. Figure 7.42 shows various choices of L_{white} for an LDR image. Note that for hands-off operation this parameter may also be estimated from the histogram of the input image [106].

The previous equation is a reasonable global tone-reproduction operator. However, it may be modified to become a local tone-reproduction operator by applying an algorithm akin to photographic dodging and burning. In traditional dodging and burning, the area that receives a different exposure from the remainder of the print is bounded by sharp contrasts. This is a key observation that should be reproduced by any automatic dodge-and-burn algorithm.

For each pixel, we would therefore like to find the largest surrounding area that does not contain any sharp contrasts. A reasonable measure of contrast for this purpose is afforded by traditional center-surround computations. A Gaussian-weighted average is computed for a pixel (the center), and is compared with a Gaussian-weighted average over a larger region (the surround), both centered over the same pixel. If there are no significant contrasts in the pixel's neighborhood, the difference of these two Gaussians will be close to 0. However, if there is a contrast edge that overlaps the surround but not the center Gaussian the two averages will be significantly different.

If a Gaussian-blurred image at scale s is given by

$$L_s^{\text{blur}}(x, y) = L_{\text{m}}(x, y) \otimes R_s(x, y),$$

the center-surround mechanism at that scale is computed with

$$V_s(x, y) = \frac{L_s^{\text{blur}} - L_{s+1}^{\text{blur}}}{2^\Phi a/s^2 + L_s^{\text{blur}}}.$$

The normalization by $2^\Phi a/s^2 + L_s^{\text{blur}}$ allows this result to be thresholded by a common threshold that is shared by all scales, in that V_s is now independent of absolute luminance values. In addition, the $2^\Phi a/s^2$ term prevents the normalization from breaking for small values of L_s^{blur}. The user parameter Φ may be viewed as a sharpening parameter, the effect of which is shown in Figure 7.43. For small values of Φ, its effect is very subtle. If the value is chosen too large, haloing artifacts may occur. In practice, a setting of $\Phi = 8$ yields plausible results.

This process yields a set of differences of Gaussians, each providing information about how much contrast is available within increasingly large areas around the pixel of interest. To find the largest area that has relatively low contrast for a given pixel, we seek the largest scale s_{max} for which the difference of Gaussians remains below a threshold, as follows.

$$s_{\text{max}} : \left| V_{s_{\text{max}}}(x, y) \right| < \epsilon$$

For this scale, the corresponding center Gaussian may be taken as a local average. The local operator that implements a computational model of dodging and burning

FIGURE 7.43 The sharpening parameter Φ in the photographic tone-mapping operator is chosen to be 4 and 8 (top row) and 16 and 32 (bottom row).

is then given by the following.

$$L_d(x, y) = \frac{L_m(x, y)}{1 + L_{s_{max}}^{blur}(x, y)}$$

The luminance of a dark pixel in a relatively bright region will satisfy $L < L_{s_{max}}^{blur}$, and thus this operator will decrease the display luminance L_d, thereby increasing the contrast at that pixel. This is akin to photographic "dodging." Similarly, a pixel

in a relatively dark region will be compressed less, and thus "burned." In either case the pixel's contrast relative to the surrounding area is increased.

The memory efficiency of the dodge-and-burn version may be increased by realizing that the scale selection mechanism could be executed on the fly. The original implementation computes a Gaussian pyramid as a preprocess. Then, during tone mapping for each pixel the most appropriate scale is chosen. Goodnight et al. show that the preprocessing step may be merged with the actual tone-reproduction stage and thus avoid computing the low-pass images that will not be used [43]. Their work also shows how this operator may be implemented in graphics hardware.

In summary, the photographic tone-reproduction technique [109] exists in both global and local variants. For medium-dynamic-range images, the global operator is fast and provides sufficient compression. For very high-dynamic-range images, local contrast may be preserved better with the local version that implements dodging and burning. The local operator seeks for each pixel the largest area that does not contain significant contrast steps. This technique is therefore similar to edge-preserving smoothing filters such as the bilateral filter discussed in Section 8.1.2. We could therefore replace the scale selection mechanism with the more practical and efficient bilateral filter to produce a spatially localized average. This average would then serve the purpose of finding the average exposure level to which the pixel will be adjusted.

7.3.7 PATTANAIK ADAPTIVE GAIN CONTROL

Thus far, we have discussed several tone-reproduction operators that compute a local average. The photographic tone-reproduction operator uses a scale-space mechanism to select how large a local area should be and computes a weighted average for this local area. It is then used to adjust exposure level. Ashikhmin's operator does the same, but provides an alternative explanation in terms of human vision. Similarly, the bilateral filter is effectively an edge-preserving smoothing operator. Smoothing by itself can be viewed as computing an average over a local neighborhood. The edge-preserving properties of the bilateral filter are important, because it allows the space over which the average is computed to be maximized.

The defining characteristic of the bilateral filter is that pixels are averaged over local neighborhoods, provided their intensities are similar. The bilateral filter

is defined as

$$L^{\text{smooth}}(x, y) = \frac{1}{w(x, y)} \sum_u \sum_v b(x, y, u, v) L(x - u, y - v) \tag{7.7}$$

$$w(x, y) = \sum_u \sum_v b(x, y, u, v)$$

$$b(x, y, u, v) = f\left(\sqrt{(x - u)^2 + (y - v)^2}\right) g\big(L(x - u, y - v) - L(x, y)\big),$$

with $w()$ a weight factor normalizing the result and $b()$ the bilateral filter consisting of components $f()$ and $g()$. There is freedom to choose the shape of the spatial filter kernel $f()$, as well as the luminance-domain filter kernel $g()$. Different solutions were independently developed in the form of SUSAN [118] and the bilateral filter [128]. At the same time, independent and concurrent developments led to alternative tone-reproduction operators: one based on the bilateral filter [23] and one based on the SUSAN filter [96].

Whereas Durand and Dorsey experimented with Gaussian filters and Tukey's filter, Pattanaik and Yee employed a near box-shaped filter kernel in the luminance domain to steer the amount of compression in their tone-reproduction operator [96]. The latter used the output of their version of the bilateral filter as a local adapting luminance value, rather than as a mechanism to separate the image into a base layer and a detail layer as Durand and Dorsey did.

Taking their cue from photography, Pattanaik and Yee note that white tends to be five times as intense as medium gray and black is one-fifth the luminance of medium gray. Their local gain control is derived from a weighted local average in which each surrounding pixel is weighted according to its luminance in relation to the luminance of the pixel of interest. Pixels more than five times as intense as the center pixel, and pixels less than one-fifth its luminance, are excluded from consideration. For a circularly symmetric area around pixel (x, y), the local average is then computed for all pixels as follows.

$$\frac{1}{5} \leq \frac{L_{\text{w}}(x - u, y - v)}{L_{\text{w}}(x, y)} \leq 5$$

The circularly symmetric local area is determined by bounding the value of u and v by the radius r of the area under consideration, as follows.

$$\sqrt{u^2 + v^2} \leq r$$

An alternative notation for the same luminance-domain constraint may be formulated in the log domain, with the base of the log being 5, as follows.

$$\left| \log_5\left(L_w(x - u, y - v)\right) - \log_5\left(L_w(x, y)\right) \right| \leq 1$$

This implies a box filter in the luminance domain and a "box filter" (albeit circularly symmetric) in the spatial domain. A box filter in the luminance domain suffices if the image consists solely of sharp edges. Smoother high-contrast edges are best filtered with a luminance-domain filter that has a somewhat less abrupt cutoff. This may be achieved with the following luminance-domain filter kernel $g()$.

$$g(x - u, y - v) = \exp\left(-|\log_5\left(L_w(x - u, y - v)\right) - \log_5\left(L_w(x, y)\right)|^{25}\right)$$

The spatial filter kernel $f()$ is circularly symmetric and unweighted, as follows.

$$f(x - u, y - v) = \begin{cases} 1 & \text{if } \sqrt{u^2 + v^2} \leq r \\ 0 & \text{otherwise} \end{cases}$$

The result of producing a filtered image with this filter is an image that is blurred, except in areas where large-contrast steps occur. This filter may therefore be viewed as an edge-preserving smoothing filter, as are the bilateral and trilateral filters. The output of this filter may therefore be used in a manner similar to tone-reproduction operators that split an image into a base layer and a detail layer. The base layer is then compressed and recombined with the detail layer under the assumption that the base layer is HDR and the detail layer is LDR.

Alternatively, the output of this filter may be viewed as a local adapting luminance. Any of the global operators that make use of a global average may thus be extended to become local operators. For instance, the output of any edge-preserving smoothing operator, as well as the scale selection mechanism of Reinhard et al.'s photographic operator, may serve as a local adaptation luminance. In each case, the typical trade-off between amount of achievable compression and visibility of

haloing artifacts will return. However, by using edge-preserving smoothing opera-
tors or the aforementioned scale selection mechanism, the local average is ensured
to be relatively close to the pixel value itself. Although halos may not be avoided
altogether, they are minimized with these approaches.

7.3.8 YEE SEGMENTATION-BASED APPROACH

Many HDR images contain large areas that are relatively dark and large areas that are
bright. An often-quoted example of such a configuration is a room with a window.
In such cases, it may be desirable to apply different compression functions for the
bright and dark regions.

Any algorithm that uses a local adaptation level — such as the semisaturation
constant in the Michaelis–Menten equations (6.1) — may be modified to explicitly
use an adaptation level based on segmentation of the bright and dark areas into
separate regions.

At least two operators are currently known that segment an image into separate
regions for the purpose of tone reproduction [67,150]. In this section, we discuss
Yee and Pattanaik's approach. They effectively segment the image into separate re-
gions, and then determine a suitable adaptation level for each region [150]. Their
approach consists of the four following steps.

1 *Segmentation:* Based on the histogram of a density representation, the image is
 segmented into regions. A histogram is created with a specific number of
 bins (as discussed in material following).
2 *Grouping:* Pixels in the segmented image are grouped, and each pixel within a
 group is assigned the average density of the group.
3 *Assimilation:* Small groups and groups with only one neighbor are merged.
 The result of the assimilation process is called a *layer.*
4 *Layer averaging:* The previous three steps are repeated several times for his-
 tograms with different bin sizes (and numbers of bins), and for each pixel
 the results are averaged.

After layer averaging is complete, the resulting image provides a local adaptation
level (in the log domain) for each pixel. Several user parameters are introduced to
steer the quality of the results. The layer-averaging step has the effect of smoothing

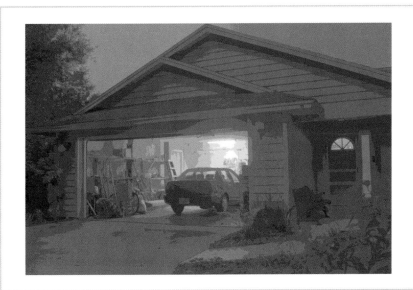

FIGURE 7.44 *This image is segmented into 10 bins, and then encoded with a separate gray level per bin.*

the adaptation level image. This image should not contain sharp discontinuities, in that such discontinuities would lead to artifacts in the final tone-mapped result. By choosing more layers, each created with a histogram with a different spacing of bins, a smoother result is obtained. Hence, the total number of layers is an important parameter, trading computation time for visual quality. The number of layers required to minimize artifacts depends on the composition of the image and on its dynamic range. The bin size B_n is determined by the total number of layers N, the current layer number n, and two further user parameters that limit the minimum and maximum bin size (B_{min} and B_{max}), as follows.

$$B_n = B_{min} + (B_{max} - B_{min})\frac{n}{N-1}$$

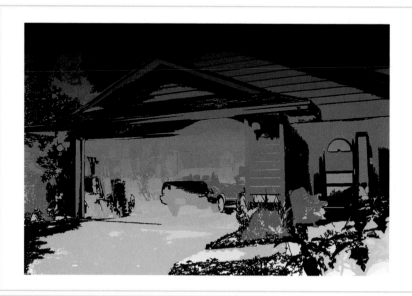

FIGURE 7.45 *This image is segmented into 10 bins, grouped, and then encoded with a separate gray level per group.*

The minimum and maximum bin size are by default set to 0.5 and 1.0, respectively. Given the bin size B_n for the current layer, each pixel may be categorized as belonging to bin b, as follows.

$$b(x, y) = \frac{D(x, y) - D_{\min}}{B_n}$$

An example is shown in Figure 7.44, where each gray level indicates a separate bin. Once each pixel is labeled with its bin number b, pixels may be grouped. An image after grouping is shown in Figure 7.45. During the grouping process, the average density of the group is determined and stored. The grouping makes use of a recursive flood-fill algorithm. A potential problem with this approach is that if

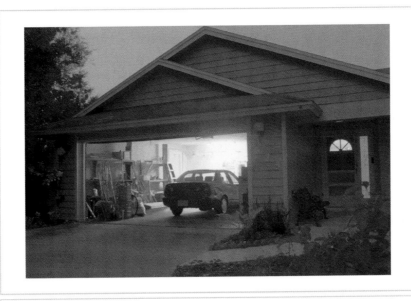

FIGURE 7.46 *Layer averaging demonstrated with a total of 10 layers.*

large areas are filled recursively the number of recursive calls may cause the system to run out of stack space. The flood-fill algorithm also keeps track of how many pixels are added to a group. After each group is filled, the average density of the group is computed.

The assimilation process merges small groups with larger ones. For details, we refer to the original paper [150]. For the images shown in this section, we have omitted this step. It is possible that for certain image compositions the assimilation step produces an improved estimate of local adaptation levels, but we have found that for the test images used here (in combination with the sigmoidal compression function we used) the results without the assimilation step are very good.

In our implementation, the average density of a group is used in the layer-averaging process. Because for each pixel the group number is known, the average

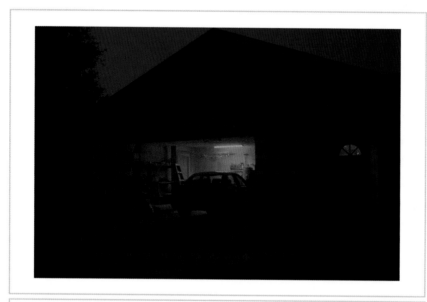

FIGURE 7.47 *Final result of tone mapping with Yee and Pattanaik's method for deriving local adaptation levels. This image was created with layer averaging over 10 layers to allow comparison with Figure 7.46.*

density assigned to each pixel is found by computing the following.

$$D_{n,\mathrm{av}}(x, y) = \texttt{group_list[group[y][x]].lum_av}$$

The previous steps are repeated for all layer numbers $0, \ldots, N$, and the results are averaged, as follows.

$$L_{\mathrm{a}}(x, y) = \exp\left(\frac{1}{N} \sum_{n=0}^{N-1} D_{n,\mathrm{av}}(x, y) \right)$$

FIGURE 7.48 *Image tone mapped with a global tone-reproduction operator (left), and with a replacement of the global adaptation level for local adaptation levels based on segmentation (right).*

The resulting adaptation levels are shown in Figure 7.46. The final result for a total of 10 layers is shown in Figure 7.47. For this image, 10 layers are not quite sufficient for an artifact-free result. Rather, this choice allows a direct comparison between Figures 7.46 and 7.47.

To demonstrate the effect of this approach in deriving the local adaptation luminance for each pixel, we adapted Reinhard and Devlin's photoreceptor-based algorithm to accept the previously cited local averages. Figure 7.48 shows the result of this operator with a global adaptation level (left) and locally computed adaptation levels obtained with the previous segmentation procedure (right).

The effect of varying the number of layers on the quality of the results is shown in Figure 7.49, where the number of layers was varied between 5 and 30. It is clear that the smoothing effect of averaging multiple layers is important in avoiding visual artifacts. The number of layers required varies with the dynamic range of the image, as well as the composition of the image. For this particular example, 30 layers are sufficient.

In summary, Yee and Pattanaik propose to segment the image into regions and compute an adaptation level for each region. By smoothing the results — accomplished by repeating the segmentation for different histogram bin sizes — local

FIGURE 7.49 *The number of layers computed with Yee and Pattanaik's segmentation approach is varied between 5 and 30 (with increments of five layers) in this image sequence. If this number is too small, artifacts occur. For this example, artifacts are removed completely when 30 layers are used.*

adaptation levels are computed suitable for steering local tone-reproduction operators. The usefulness of this approach is demonstrated in this section by augmenting the photoreceptor-based operator with these local adaptation levels.

7.4 SUMMARY

Tone-reproduction operators may reduce the dynamic range of images by applying the same function to all pixels, or they may compress pixels based on their value and the values of a local neighborhood of pixels. The former category is computationally efficient and generally suitable for medium-dynamic-range images.

Extra compression may be achieved by making the compressive function dependent on neighboring pixels. This may be achieved by dividing the input image by a blurred version of the image, in which case the amount of blur to apply should be large to avoid haloing artifacts. A blurred version of the image may also be seen as an adaptation level. Then it can be used as the semisaturation constant in a sigmoidal (or S-shaped) function. In this case, artifacts are minimized by choosing a small filter kernel — typically only a few pixels wide. Small filter kernels have the added advantage of low computational cost.

In either case, artifacts may be minimized by using filter kernels that do not cross sharp image contrasts. Edge-preserving smoothing operators such as the bilateral filter, as well as the scale selection mechanism employed by the photographic operator, are examples of techniques that avoid blurring across stark contrasts and therefore show fewer artifacts than operators that blur each pixel by the same amount.

Frequency Domain and Gradient Domain Tone Reproduction

08

In addition to local and global operators, there are two other classes of operators that work in a fundamentally different way. First, it may be possible under favorable conditions to separate illuminance from surface reflectance. By compressing only the illuminance component, an image may be successfully reduced in dynamic range. Second, we may exploit the fact that an image area with a high dynamic range tends to exhibit large gradients between neighboring pixels. This leads to a solution whereby the image is differentiated. Then the gradients are manipulated before the result is integrated into a compressed image.

Frequency-dependent operators are interesting from a historical perspective as well as for the observations about image structure they afford. These algorithms may therefore help us better understand the challenges we face when preparing HDR images for display. The following also explores gradient domain operators, in that they are algorithmically related to frequency domain operators.

8.1 FREQUENCY DOMAIN OPERATORS

Tone reproduction and dynamic range reduction are generally thought of as fairly recent developments. The problem was introduced to the field of lighting design in 1984 [186], and to the computer graphics community in 1993 [130,131]. However, HDR images and the problem of dynamic-range reduction are as old as the field of photography, for which the printing process may be seen as a tone-mapping technique. The problem also surfaced again with the invention of digital images. The

first digital images were scanned with a bit depth of 12 bits, but could only be displayed with a bit depth of 8 bits. As a result, the first digital images had to be tone mapped prior to display. To our knowledge, the first digital tone-reproduction operator was published in 1968 by Oppenheim and colleagues [91].

Although this operator appears to be largely forgotten, the work itself contains several key ideas (including homomorphic filtering) that have found their way into numerous other tone-reproduction operators. In addition, the resulting tone-reproduction operator produces visually appealing output for a variety of images and perhaps deserves more attention than it currently receives.

Oppenheim's operator is a frequency-dependent compressor, in which low frequencies are attenuated more than higher frequencies. This approach was recently also taken by a technique called *bilateral filtering* [23] (Section 8.1.2). This term refers to an edge-preserving smoothing technique that forms the basis for various image-processing tasks, including tone reproduction. The bilateral filtering technique is used to separate an image into a base layer and a detail layer. The base layer tends to be low frequency and HDR, whereas the detail layer is high frequency and LDR. The tone-reproduction operator then proceeds by compressing the base layer before recombining it with the detail layer. At the same time, the output of the bilateral filter may be seen as providing a local adaptation value for each pixel, and therefore classification of this algorithm as a local operator would have been equally valid.

A similar separation into base and detail layers may be achieved with the trilateral filter [10], which is an extension of the bilateral filter. The difference between this and the bilateral filter lies in the technique used to separate the image into two layers.

All three techniques, however, apply a compression scheme that is frequency dependent, and thus they are grouped in this chapter. In the following subsections, each of these techniques is presented in more detail.

8.1.1 OPPENHEIM FREQUENCY-BASED OPERATOR

Under simplified assumptions, such as a scene consisting of diffuse objects only and no directly visible light sources, image formation may be thought of as the product of illuminance and reflectance. As indicated in Section 7.1.3, the illuminance component is then HDR, whereas the reflectance component is not. It would

therefore be advantageous if we could separate the two components, and perform dynamic-range compression on the illuminance component only.

This approach implicitly assumes that the surfaces in a scene are diffuse. This is to an approximation true for many objects, but the method ignores high-frequency HDR phenomena such as specular reflections, caustics, and directly visible light sources. We would therefore not recommend this approach for images depicting these types of lighting.

For the remaining class of images, separation of reflectance and illuminance is to some degree possible by observing that illumination varies slowly over the image, whereas reflection is sometimes static and sometimes dynamic [91]. This is because objects tend to have well-defined edges and vary in size and texture. As such, partially independent processing of illuminance and reflectance is possible in the frequency domain.

Oppenheim et al. therefore suggest applying a whitening filter to the density representation of an image, which attenuates low frequencies while preserving higher frequencies. This is based on the observation that density representations of images tend to show a sharp peak in the low frequencies, with a plateau for medium and high frequencies.

As an aside, whitening is the process in which the amplitude of the Fourier representation is altered such that all frequencies carry an equal amount of energy. This is generally achieved by amplifying higher frequencies. The opposite approach, in which higher frequencies are attenuated, has the effect of blurring the image. These two effects are demonstrated in Figure 8.1.

Frequency-sensitive attenuation of an image thus starts by taking the logarithm of each pixel to compute densities. Then the FFT is computed on the density representation so that low frequencies may be attenuated more than high frequencies. The inverse Fourier transform is then applied to return to a density representation. In turn, the density image is exponentiated to yield a displayable image. For a Fourier-transformed density image, we experimented with the following attenuation function.

$$s(f) = (1 - c) + c\frac{kf}{1 + kf}$$

Both amplitude and phase spectra are multiplied by this scaling, which depends on frequency f and takes two user parameters c and k. The user parameter c controls

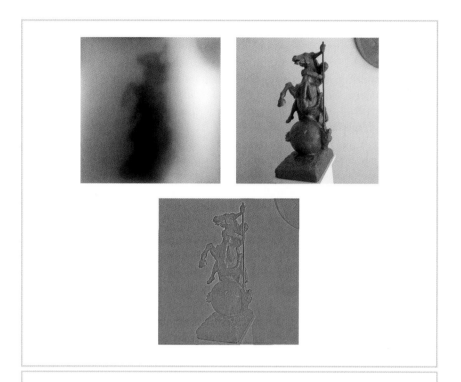

FIGURE 8.1 *The image in the middle was blurred by attenuating higher frequencies (top left) and whitened by amplifying higher frequencies (bottom). (Albin Polasek (1879–1965) Victory of Moral Law, 1957, Bronze. Courtesy of the Albin Polasek Museum and Sculpture Gardens, Winter Park, FL.)*

the maximum amount of attenuation applied to the zero-frequency DC (direct current) component, whereas the k user parameter determines how rapidly the slope reaches the plateau of 1.

A reasonable default value for c is 0.5, as recommended by Oppenheim et al. [91], which generally lies between 0 and 1. The scaling functions $s(f)$ spanned

FIGURE 8.2 To demonstrate Oppenheim's operator, the effect of the parameter choice of c on the scaling function $s(f)$ is shown.

by different choices of c are plotted in Figure 8.2. An HDR image compressed with different values for c is shown in Figure 8.3.

The k parameter could be initialized to 0.01, with a sensible range for this parameter being $[0.001, 0.02]$. Its impact on the shape of the scaling function $s(f)$ is shown in Figure 8.4. Images compressed with different values of k are presented in Figure 8.5. For smaller values of k, the plateau at which no attenuation is applied occurs for higher frequencies and thus the image is compressed more. The higher the value of k the sooner the plateau is reached, and less dynamic-range reduction is achieved.

In summary, Oppenheim et al. were the first to address the dynamic-range reduction problem. They proposed to attenuate low frequencies in the density (log)

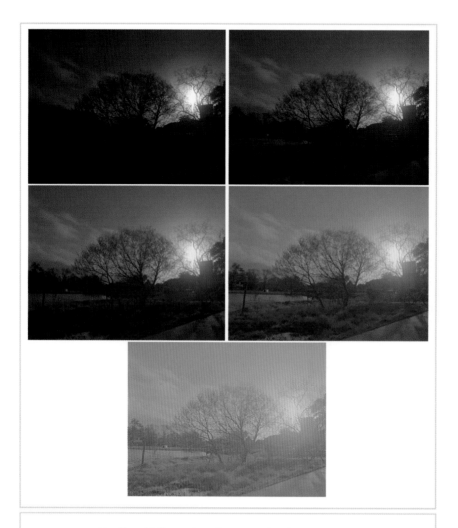

FIGURE 8.3 The effect of different values of c in Oppenheim's operator. In reading order, c is given values of 0.1, 0.3, 0.5, 0.7, and 0.9.

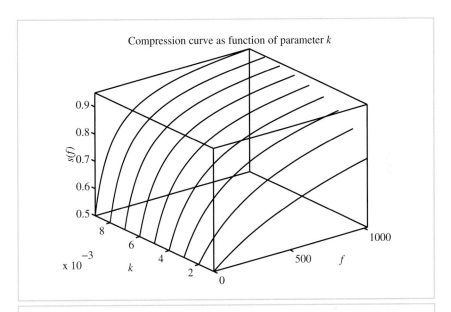

FIGURE 8.4 *Effect of the parameter choice of* k *on the scaling function* $s(f)$ *in Oppenheim's operator.*

domain, while preserving higher frequencies. This type of processing is called homomorphic filtering, which affords partially independent processing of illuminance and reflectance. They observed that reflectance is typically high frequency and LDR, whereas illuminance produces slow gradients within an arbitrary HDR. For images depicting sharp shadow boundaries, participating media, specular highlights, or directly visible light sources, this separation may not always be performed cleanly and the method may therefore not always yield satisfactory results.

Aspects of this algorithm — including homomorphic filtering (Section 7.1.3), separation of the image into illuminance and reflectance, and the concept of tone reproduction — were first introduced in Oppenheim's work. With a suitable choice

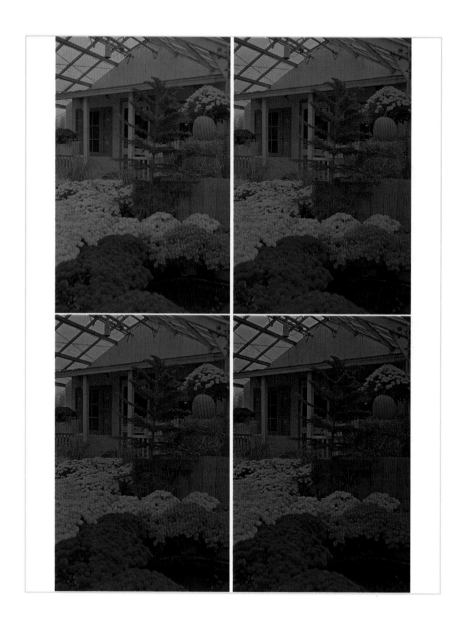

FIGURE 8.5 *The effect of different values of k in Oppenheim's operator. In reading order, k is increased from 0.002 to 0.004, 0.008, and 0.016.*

of the parameters c and k (introduced by us), this algorithm produces reasonable output, despite the theoretical restrictions mentioned previously.

8.1.2 DURAND BILATERAL FILTERING

The idea that an image may be separated into a high-frequency component that contains only LDR information and a low-frequency component with an HDR is explicitly exploited by Oppenheim's operator by attenuating low frequencies in the Fourier domain. Separation of an image into separate components whereby only one of the components needs to be compressed may also be achieved by applying an edge-preserving smoothing operator.

Durand and Dorsey introduced the bilateral filter to the computer graphics community and showed how it may be used to help solve the tone-reproduction problem [23]. Bilateral filtering is an edge-preserving smoothing operator that effectively blurs an image but keeps sharp edges intact. An example is shown in Figure 8.6, in which the smoothed image is shown on the right. Edges in this image are preserved (compare with the unprocessed image on the left), whereas interior regions have reduced detail. This section introduces a tone-reproduction operator that uses bilateral filtering and goes by the same name.

Blurring an image is usually achieved by convolving the image with a Gaussian filter kernel. The bilateral filter extends this idea by reducing the weight of the Gaussian kernel if the density difference is too large (see Equation 7.7). A second Gaussian is applied to density differences. Following Oppenheim, this method operates on a density image, rather than on linear values.

The result of this computation, as seen in Figure 8.6, is to some extent analogous to the illuminance component as discussed by Oppenheim et al. [91]. From the input image and this illuminance image, the reflectance image may be reconstructed by dividing the input and illuminance image. The smoothed image is known as the

FIGURE 8.6 *The image on the left was smoothed with a bilateral filter, resulting in the image on the right.*

base layer, whereas the result of this division is called the detail layer. Note that the base and detail layers do not necessarily split the image into an illuminance and reflectance component. This method does not make the implicit assumption that the scene depicted is predominantly diffuse.

Examples of an HDR input image, an HDR base layer, and an LDR detail layer are shown in Figure 8.7. In this figure, the bilateral filter is applied to the luminance channel only. To reconstruct the base layer in color, we replaced the luminance channel of the image (in Yxy color space) with this output, exponentiated the result to yield a linear image, and converted to RGB. The detail layer was reconstructed in a similar manner.

After the bilateral filter is applied to construct base and detail layers in the logarithmic domain, the dynamic range may be reduced by scaling the base layer to a user-specified contrast. The two layers are then recombined and the result is exponentiated and converted to RGB to produce the final displayable result.

The amount of compression applied to the base layer is user specified, but Durand and Dorsey note that a target dynamic range of about 5 log units suffices for

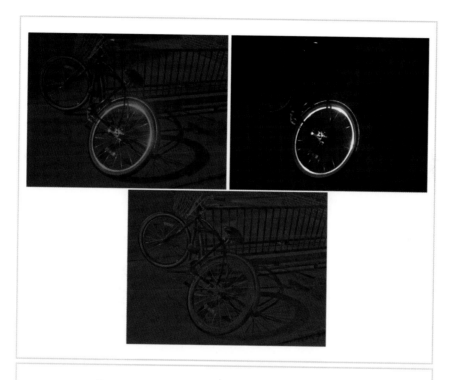

FIGURE 8.7 *HDR image tone mapped with bilateral filtering (left). The corresponding base layer and detail layers are shown in the right-hand and bottom images.*

many images.[1] For images that show light sources directly, this value may be adjusted. The effect of this parameter is shown in Figure 8.8, in which the contrast of the base layer was varied between 2 log units and 7 log units.

Bilateral filtering may be implemented directly in image space, but the convolution with a spatial Gaussian modulated by a Gaussian in density differences is rel-

. .

1 We use the natural logarithm in this case.

FIGURE 8.8 Bilateral filtering results with varying amounts of compression applied to the base layer. The dynamic range of the base layer was set between 2 log units (top left-hand image) and 7 log units (bottom right-hand image).

atively expensive to compute. In addition, the second Gaussian makes this method unsuitable for execution in the Fourier domain. Durand and Dorsey show how these

disadvantages may be overcome by splitting the density differences into a number of segments [23]. The results are then recombined, yielding an approximate solution that in practice is indistinguishable from accurate spatial processing. The computation is given by the following.

$$D_j^{\text{smooth}}(x, y) = \frac{1}{k_j(x, y)} \sum_u \sum_v b_j(x, y, u, v) \, D(x - u, y - v)$$

$$k_j(x, y) = \sum_u \sum_v b_j(x, y, u, v)$$

$$b_j(x, y, u, v) = f\left(\sqrt{(x - u)^2 + (y - v)^2}\right) g\left(D(x - u, y - v) - D_j\right)$$

Here, the values D_j form a quantized set of possible values for pixel (x, y). The final output for this pixel is a linear combination of the output of the two smoothed values D_j^{smooth} and D_{j+1}^{smooth}. These two values are chosen such that D_j and D_{j+1} are the closest two values to the input density D of pixel (x, y).

For each segment j, the previous equation may be executed in the Fourier domain, thus gaining speedup. The number of segments depends on the dynamic range of the input image, as well as the choice of standard deviation for the Gaussian $g()$, which operates on density differences. A suitable choice for this standard deviation is about 0.4. The computation time of the bilateral filter depends on the number of segments. There is therefore a trade-off between computation time and visual quality, which may be chosen by specifying this standard deviation.

We have experimented with different values and show the results in Figure 8.9. For this particular image, the choice of standard deviation has a relatively small effect on its visual appearance. However, this parameter directly influences the number of segments generated, and thus affects the computation time. For this image, the largest standard deviation we chose was 8 log units, resulting in the creation of two segments. For values close to the default of 0.4, the number of segments is much higher due to the image's high dynamic range. This image was split into 19 segments for a standard deviation of 0.5, and into 38 segments for a standard deviation of 0.25. The computation times recorded for these images are graphed in Figure 8.10.

This computation time is substantially higher than those reported by Durand and Dorsey [23], most likely because the dynamic range of this image is higher

than many of their examples. In this chapter, we use a standard deviation of 0.4 as recommended in the original paper, but note that discrepancies in reported computation times may be due to the choice of images.

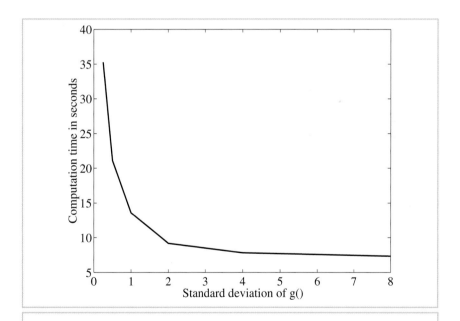

FIGURE 8.10 Computation time of Durand and Dorsey's bilateral filter as a function of the standard deviation of the Gaussian filter.

Further, Durand and Dorsey observed that bilateral filtering aims at low-pass filtering, and thus for most of the computations the full resolution of the input image is not required. It is therefore possible to sample the image using nearest-neighbor downsampling, perform bilateral filtering, and then upsample the results to the full resolution. This significantly reduces the computational cost of the algorithm for downsampling factors of up to 10 to 25. Higher factors will not yield a further reduction in computation time, because upsampling and linear interpolation will then start to dominate the computation. The visual difference between no downsampling and downsampling within this range is negligible. We therefore downsampled all results in this section with a factor of 16.

In summary, bilateral filtering is a worthwhile technique that achieves a hands-off approach to tone reproduction. The method is able to smooth an image without blurring across sharp edges. This makes the method robust against outliers and other anomalies. The method splits a density image into an HDR and an LDR layer. The HDR layer is then compressed and recombined with the other layer. The result is exponentiated to form an LDR image. Various techniques are available to speed up the process.

8.1.3 CHOUDHURY TRILATERAL FILTERING

Although the bilateral filter has attractive features for edge-preserving filtering, Choudhury and Tumblin note that this filter also has certain drawbacks. In particular, the filter smooths across sharp changes in the gradients of the image, and the filter poorly smooths high-gradient and high-curvature regions [10].

The trilateral filter aims to overcome these limitations by extending the bilateral filter. In fact, two modified versions of the bilateral filter are applied in succession. The algorithm starts by computing a density image from a luminance image, whereupon image gradients are computed. These gradients are then smoothed and used as an indicator of the amount by which the bilateral filter should be tilted to adapt to the local region. The smoothing itself is achieved through bilateral filtering. Figure 8.11 shows images of the various steps involved in the algorithm.

FIGURE 8.11 *Image gradients and smoothed image gradients (top row) for x and y directions. The tilting angle A_θ is shown as the first image of the second row, followed by the output of the trilateral filter, which may be viewed as the base layer. The input density image and the base layer are then subtracted to produce the detail layer (third image on the second row). Compression of the base layer and recombination with the detail layer yields the final tone-mapped result (last image, second row).*

With the filter kernel given by $b(x, y, u, v)$, the bilaterally smoothed tilting vector A may be computed for each pixel as follows.

$$A(x, y) = \frac{1}{w(x, y)} \sum_u \sum_v b(x, y, u, v) \nabla D_{in}(x - u, y - v)$$

$$w(x, y) = \sum_u \sum_v b(x, y, u, v)$$

$$b(x, y, u, v) = f\left(\sqrt{(x - u)^2 + (y - v)^2}\right)$$
$$\times g\left(\|\nabla D_{in}(x - u, y - v) - \nabla D_{in}(x, y)\|\right)$$

The filter output is normalized by the weight factor w. The gradients of the input are computed using forward differences, as follows.

$$\nabla D_{in}(m, n) \approx \left(D_{in}(m + 1, n) - D_{in}(m, n), D_{in}(m, n + 1) - D_{in}(m, n)\right)$$

If we were to apply a bilateral filter to the input image after tilting the filter by $A(x, y)$, its Gaussian constituents $f()$ and $g()$ would no longer be orthogonal. Therefore, rather than computing a spatial weight $s()$ for neighboring densities $D(x - u, y - v)$ by measuring the spatial distance between (x, y) and $(x - u, y - v)$, this distance is now measured through a plane of density values with orientation $P(x - u, y - v)$. This orientation is a scalar value that may be computed as follows.

$$P(x - u, y - v) = D_{in}(x, y) + A(x, y) \cdot (u, v)^T$$

Before computing trilateral output values, $P(x - u, y - v)$ is subtracted from the input density values to compute a local detail signal $D_\Delta(x - u, y - v)$, as follows.

$$D_\Delta(x - u, y - v) = D_{in}(x - u, y - v) - P(x - u, y - v)$$

The output of the trilateral filter $D^{smooth}(x, y)$ is then obtained as follows.

$$D^{smooth}(x, y) = D_{in}(x, y) + \frac{1}{w_\Delta(x, y)} \sum_u \sum_v b(x, y, u, v) D_\Delta(x - u, y - v)$$

$$w_\Delta(x, y) = \sum_u \sum_v n(x, y, u, v)$$

$$b(x, y, u, v) = f\left(\sqrt{(x-u)^2 + (y-v)^2}\right) g\left(D_\Delta(x-u, y-v)\right)\delta_A(x-u, y-v)$$

By tilting the trilateral filter it is possible to smooth more accurately in high-gradient regions, but this comes at the cost of a potential for extending the filter window beyond local boundaries into regions of dissimilar gradients. This may cause undesirable blurring across sharp ridges and corners where the bilaterally smoothed gradient A changes abruptly.

This problem is solved by the binary function δ_A introduced in the previous equation. This function exploits a feature of the functional shape of the smoothed gradient field A to limit the contribution of pixel $(x-u, y-v)$ if it lies across a sharp edge. A sharp edge is present if there is a large jump in the magnitude of A between (x, y) and $(x-u, y-v)$. Thus, δ_A is the Kronecker delta function, which is 1 if the gradient step is below a specified threshold R, and 0 if the jump in gradient magnitude is too large. This is represented as follows.

$$\delta_A(x-u, y-v) = \begin{cases} 1 & \text{if } \|A(x-u, y-v) - A(x, y)\| < R \\ 0 & \text{otherwise} \end{cases}$$

A computationally efficient way of approximating the search for gradients in a local neighborhood for a pixel (x, y) is to precompute a stack of minimum and maximum gradients at different spatial resolutions. We refer to the original paper on trilateral filtering for additional information [10].

Although the method has seven internal parameters, only one needs to be specified by the user. All other parameters are derived from this single user parameter. The user parameter $\sigma_{c,\Theta}$ is the neighborhood size of the bilateral gradient-smoothing filter, specified in pixels. The influence of this parameter on the various stages of processing is shown in Figure 8.12.

For small kernel sizes, too much detail ends up in the base layer, which is subsequently compressed. The consequence is that these details are absent from the final tone-mapped image. For larger values of $\sigma_{c,\Theta}$, the details are separated more sensibly from the HDR component and thus detail is preserved in the tone-mapped images. This is shown in the rightmost column in Figure 8.12, where $\sigma_{c,\Theta}$ is set

FIGURE 8.12 *For three different values of* σ *(3, 13, and 21 pixels), we show the base layer (top), the detail layer (middle), and the tone-mapped result (bottom).*

to 21. This value is recommended for practical use. Larger values have an adverse effect on the computation time without creating better images.

For the purpose of comparison, Figure 8.13 shows an image tone mapped with both bilateral and trilateral filters. With comparable parameter choices, the overall impression of the two images is similar, although several differences between the two images exist. In particular, the trilateral filter affords a better visualization of

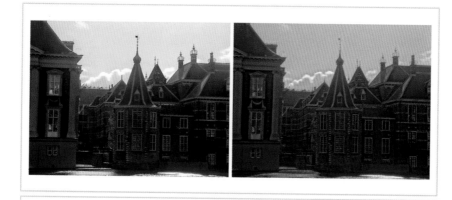

FIGURE 8.13 *Bilateral (left) and trilateral filters (right) applied to the same image with comparable parameter settings.*

the clouds. On the other hand, the tree in the lower right-hand corner is better preserved by the bilateral filter.

In summary, the trilateral filter is a further development over the bilateral filter. The filter smooths the image while preserving edges. Good results are achieved by tilting the filter kernel dependent on the local gradient information in an image. Like Oppenheim's method and Durand and Dorsey's bilateral filtering approach, Choudhury and Tumblin's trilateral filter is used to separate a density image into an LDR high-frequency image, and an HDR low-frequency image. The latter is compressed and recombined with the former to produce a tone-mapped density image. This result is then exponentiated to compute a displayable image.

8.2 GRADIENT DOMAIN OPERATORS

High-frequency components in an image cause rapid changes from one pixel to the next. On the other hand, low-frequency features cause the differences between neighboring pixels to be relatively small. It is therefore possible to partially distinguish between illuminance and reflectance in a different way by considering the

gradients in the image. Under the assumption of diffusely reflecting scenes, this separation may be reasonably successful, as shown by Horn's lightness computation (discussed in the following section).

Although such separation depends on thresholding, tone reproduction does not necessarily require separation of illuminance and reflectance. In addition, HDR imagery frequently depicts scenes that deviate significantly from the assumption of diffuse reflection. Fattal et al. have shown that image gradients may be attenuated rather than thresholded, leading to a capable tone-reproduction operator (discussed in Section 8.2.2).

8.2.1 HORN LIGHTNESS COMPUTATION

The first to explore the idea of separating reflectance from illuminance on the basis of the gradient magnitude was Berthold Horn [53]. His work outlines a computational model of human lightness perception, that is a perceptual quantity that correlates with surface reflectance. Like Stockham and colleagues [91,123], this work assumes that each pixel of an image is formed as the product of illumination and surface reflectance, as follows.

$$L_v(x, y) = E_v(x, y)r(x, y)$$

Here, $L_v(x, y)$ is the pixel's luminance and $E_v(x, y)$ and $r(x, y)$ are illuminance and reflectance components, respectively. In the log domain, a density image would represent the same information, as follows.

$$D(x, y) = \log(L_v(x, y))$$
$$= \log(E_v(x, y)) + \log(r(x, y))$$

Taking the derivative of $D(x, y)$ gives us the gradient, which is a 2-vector of partial derivatives in the horizontal and vertical directions. The gradient field of an image may be approximated using forward differences, as follows.

$$\nabla G(x, y) = \big(G_x(x, y), G_y(x, y)\big)$$
$$= \big(D(x + 1, y) - D(x, y), D(x, y + 1) - D(x, y)\big)$$

Note that differences in the log domain correspond to ratios in linear space. By computing a gradient field of a density image we are effectively computing contrast ratios.

Edges in an image will produce sharp pulses in the gradient field, whereas the spatial variation of illumination will produce only small gradient values. To separate reflectance from illuminance, it is now possible to threshold the gradient and discard any small gradients, as follows.

$$\nabla G(x, y) = 0 \quad \text{iff} \quad \sqrt{G_x(x, y)^2 + G_y(x, y)^2} < t$$

Integration of the remaining gradients yields an image that represents lightness. Integration of a discrete image is straightforward in one dimension, but amounts to solving a partial differential equation in two dimensions. The particular form of this equation is as follows.

$$\nabla^2 D(x, y) = \operatorname{div} G(x, y)$$

This is Poisson's equation with ∇^2 the Laplacian operator and $\operatorname{div} G(x, y)$ the divergence of $G(x, y)$. The Laplacian and divergence may be approximated in two dimensions using a differencing scheme, as follows.

$$\nabla^2 D(x, y) \approx D(x + 1, y) + D(x - 1, y) + D(x, y + 1)$$
$$+ D(x, y - 1) - 4D(x, y)$$
$$\operatorname{div} G(x, y) \approx G_x(x, y) - G_x(x - 1, y) + G_y(x, y) - G_y(x, y - 1)$$

The Poisson equation cannot be solved analytically, but must be approximated numerically. The method of choice is the full multigrid method, for which off-the-shelf routines are available [101]. Finally, the resulting density image $D(x, y)$ is exponentiated to produce the final image $L_d(x, y)$.

The success of separating illuminance from reflectance in this manner depends on the choice of threshold value t. Setting the threshold too low will cause the resulting image to contain both the reflectance component and some residual illuminance. If the threshold is chosen too high, the integrated result will only partially represent reflectance.

FIGURE 8.14 *A mini-world of Mondrian (from [88]).*

It is also important to note that this method assumes that no light sources are directly visible in the image. Horn presented his work in the context of Land's retinex theory, which was tested with mini-worlds of Mondrian [69].[2] In such worlds, scenes are flat areas divided into subregions of uniform matte color (see Figure 8.14). The lighting of such worlds creates smooth shading variations within each panel, but sharp gradient jumps between regions. Thus, the observation that reflectance causes sharp spikes in the gradient whereas illuminance is smoothly varying holds for this type of idealized scene.

For practical scenes that are generally more complicated, this assumption may not hold. In particular, if there are light sources directly visible in the image one

. .

2 Mini-worlds of Mondriaan are inspired by the neo-plasticist painting style pioneered by famous Dutch artist Piet Mondri-
 aan. Over time, the spelling has become anglicized so that mini-worlds of Mondriaan are now more commonly known as
 mini-worlds of Mondrian.

may expect the illuminance component to also exhibit large gradients, causing this approach to fail to successfully separate illuminance and reflectance. Depth discontinuities, specular highlights, and the presence of fluorescent materials may also cause the separation of reflectance from illuminance to be incomplete. Horn concludes that the method may be reasonable for the computation of lightness, but not for computing reflectance when applied to general images.

In Figure 8.15 the output of this approach is shown for different threshold values t. Small gradients are indeed removed, whereas dependent on the choice of threshold value reflectance edges are reasonably well respected. The images produced by this technique bear a resemblance to those created by bilateral filtering. In particular, compare the results of Figure 8.15 with Figure 8.6. Both techniques blur images without blurring across sharp edges. We therefore speculate that Horn's lightness computations may be viewed as an early example of an edge-preserving smoothing operator.

For the purpose of demonstration, Figure 8.15 shows an LDR image because it is close in nature to a mini-world of Mondrian. HDR images do not tend to adhere to the restrictions imposed by the mini-worlds of Mondriaan. The direct application of the previous thresholding technique is therefore not practical. On the other hand, large gradients in HDR images are correlated with illuminance variations. We therefore applied the same thresholding technique to an HDR image, although now we remove gradients that are larger than the threshold t, as follows.

$$\nabla G(x, y) = 0 \qquad \text{iff} \quad \sqrt{G_x(x, y)^2 + G_y(x, y)^2} > t$$

Results of this new thresholding scheme are shown in Figure 8.16. It is clear that this thresholding scheme is a fairly crude method of bringing an HDR image within a displayable range. It indicates that compressing the gradient field in some fashion may be a viable approach, although perhaps not using simple thresholding.

Although Horn was largely interested in computational models of human lightness perception, we have shown that a small modification could make the technique suitable for HDR compression. Thresholding may be too crude for practical purposes, and the appropriate selection of a suitable threshold would be a matter of trial and error. On the other hand, modifying the gradient field of an image and then integrating the result does present an opportunity for effective dynamic

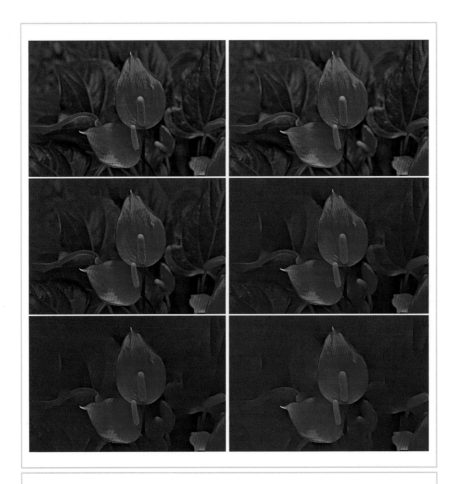

FIGURE 8.15 Horn's lightness computation for threshold values of $t = 0.0$ (top left) through $t = 0.1$ in increments of 0.02. The original photograph is shown in the top left.

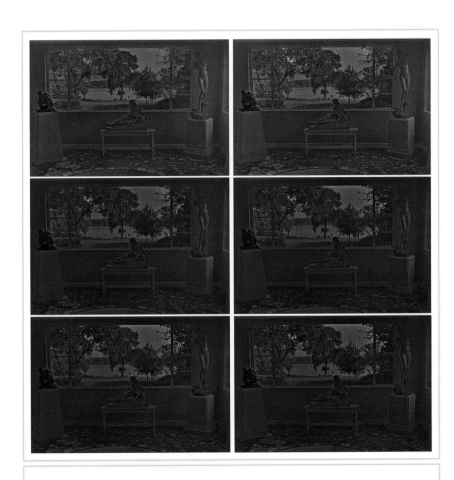

FIGURE 8.16 New thresholding scheme applied to Horn's lightness computation using threshold values of $t = 0.25$ (top left) through $t = 1.50$ in increments of 0.25. (Albin Polasek (1879–1965) Mother Crying Over the World, 1942, Bronze; Albin Polasek (1879–1965) Awakening Spring, 1926, Plaster; Albin Polasek (1879–1965) Unfettered, 1924, Plaster. Courtesy of the Albin Polasek Museum and Sculpture Gardens, Winter Park, FL.)

range reduction. This approach is taken by Fattal's gradient domain compression algorithm, discussed in the following section.

8.2.2 FATTAL GRADIENT DOMAIN COMPRESSION

Fattal et al. presented an alternative compression algorithm that achieves HDR reduction by applying a compressive function to the gradient field [32]. Following Horn, they compute the gradient field of a density image, manipulate these gradients, and then integrate by solving a Poisson equation.

However, rather than thresholding the gradient field their compressive function is more sophisticated. Fattal et al. observe that any drastic change in luminance across an HDR image gives rise to luminance gradients with a large magnitude. On the other hand, fine details (such as texture) correspond to much smaller gradients. The proposed solution should therefore identify gradients at various spatial scales and attenuate their magnitudes. By making the approach progressive (i.e., larger gradients are attenuated more than smaller gradients), fine details may be preserved while compressing large luminance gradients. After computing a density image $D(x, y) = \log(L(x, y))$, the method proceeds by computing the gradient field $\nabla G(x, y)$, as follows.

$$\nabla G(x, y) = \big(D(x + 1, y) - D(x, y), D(x, y + 1) - D(x, y)\big)$$

This gradient field is then attenuated by multiplying each gradient with a compressive function $\Phi(x, y)$, resulting in a compressed gradient field $\nabla G'(x, y)$, as follows.

$$\nabla G'(x, y) = \nabla G(x, y)\Phi(x, y)$$

As in Horn's approach, a compressed density image $D'(x, y)$ is constructed by solving the Poisson equation, as follows.

$$\nabla^2 D'(x, y) = \operatorname{div} G'(x, y)$$

The rationale for solving this partial differential equation is that we seek a density image $D'(x, y)$ with a gradient that approximates $G'(x, y)$ as closely as possible. In

the least squares sense, this conforms to minimizing the following integral.

$$\iint \|\nabla D'(x, y) - G(x, y)\|^2 dxdy$$

$$= \iint \left(\frac{\delta D'(x, y)}{\delta x} - G_x(x, y)\right)^2 + \left(\frac{\delta D'(x, y)}{\delta y} - G_y(x, y)\right)^2 dxdy$$

According to the variational principle, $D'(x, y)$ must satisfy the Euler–Lagrange equation [101], yielding

$$2\left(\frac{\delta^2 D'(x, y)}{\delta x^2} - \frac{\delta G_x(x, y)}{\delta x}\right) + 2\left(\frac{\delta^2 D'(x, y)}{\delta y^2} - \frac{\delta G_y(x, y)}{\delta y}\right) = 0$$

Rearranging terms produces this Poisson equation, which may be solved using the full multigrid method [101]. Exponentiating the compressed density image then produces the tone-mapped image $L_d(x, y)$, as follows.

$$L_d(x, y) = \exp(D'(x, y))$$

To a large extent the choice of attenuation function will determine the visual quality of the result. In the previous section, a very simple example is shown by setting large gradients to zero. This produces compressed images, but at the cost of visual quality. Fattal et al. follow a different approach and only attenuate large gradients.

 Their attenuation function is based on the observation that edges exist at multiple scales [148]. To detect significant ratios, a multiresolution edge-detection scheme is employed. Rather than attenuate a significant gradient at the resolution where it is detected, the attenuation is propagated to the full resolution gradient field before being applied. This scheme avoids haloing artifacts.

 First, a Gaussian pyramid $D_0, D_1 \ldots D_d$ is constructed from the density image. The number of levels d is chosen such that at this coarsest level the resolution of the image is at least 32 by 32. At each level s, a gradient field $\nabla G_s(x, y)$ is computed using central differences, as follows.

$$\nabla G_s(x, y) = \left(\frac{D_s(x + 1, y) - D_s(x - 1, y)}{2^{s+1}}, \frac{D_s(x, y + 1) - D_s(x, y - 1)}{2^{s+1}}\right)$$

At each level and for each pixel, a scale factor may be computed based on the magnitude of the gradient, as follows.

$$\phi_s(x, y) = \frac{\alpha}{\|\nabla G_s(x, y)\|} \left(\frac{\|\nabla G_s(x, y)\|}{\alpha} \right)^{\beta}$$

This scale factor features two user-defined parameters α and β. Gradients larger than α are attenuated provided that $\beta < 1$, whereas smaller gradients are not attenuated and in fact may even be somewhat amplified. A reasonable value for α is 0.1 times the average gradient magnitude. Fattal et al. suggest setting user parameter β between 0.8 and 0.9, although we have found that larger values (up to about 0.96) are sometimes required to produce a reasonable image. The attenuation function $\Phi(x, y)$ can now be constructed by considering the coarsest level first and then propagating partial values in top-down fashion, as follows.

$$\Phi_d(x, y) = \phi_d(x, y)$$
$$\Phi_s(x, y) = U(\Phi_{s+1}(x, y))\phi_s(x, y)$$
$$\Phi(x, y) = \Phi_0(x, y)$$

Here, $\Phi_s(x, y)$ is the partially accumulated scale factor at level s, and $U()$ is an upsampling operator with linear interpolation. For one image, the two parameters α and β were varied to create the tableau of images shown in Figure 8.17. For smaller values of β, more details are visible in the tone-mapped image. A similar effect occurs for decreasing values of α. Both parameters afford a trade-off between the amount of compression applied to the image and the amount of detail visible. In our opinion, choosing values that are too small for either α or β produces images that contain too much detail to appear natural.

FIGURE 8.17 *Fattal's gradient domain compression. The user parameters α and β were varied: from left to right α is given values of 0.10, 0.25, and 0.40. From top to bottom, β is 0.85, 0.89, and 0.95.*

FIGURE 8.18 *Clamping in Fattal's gradient domain compression. Top row: clamping 0.1, 1, and 10% of the dark pixels. Bottom row: clamping 0.1, 1, and 10% of the light pixels.*

This approach may benefit somewhat from clamping, a technique whereby a percentage of the smallest and largest pixel intensities is removed and the remain-

ing range of intensities is scaled to fit the display range. Figure 8.18 shows the effect of varying the percentage of dark pixels that are clamped (top row) and separately varying the percentage of light pixels that are clamped (bottom row). The effect of clamping dark pixels is fairly subtle, but dramatic effects may be achieved by clamping a percentage of light pixels. In general, if a tone-mapped image appears too gray it may be helpful to apply some clamping at the light end. This removes outliers that would cause the average luminance to drop too much after normalization.

In summary, Fattal's gradient domain compression technique attenuates gradients, but does so in a gentler manner than simply thresholding. The two user parameters provide a trade-off between the amount of compression and the amount of detail available in the image. Too much compression has the visual effect of exaggerated small details. The technique is similar in spirit to Horn's lightness computations and is the only recent example of a tone-reproduction operator working on gradient fields.

8.3 PERFORMANCE

For many applications the speed of operation is important. For most tone-reproduction operators, performance is simply a function of the size of the image. In this section we report results obtained on an Apple iBook G3 running at 800 MHz using images with 1,600 by 1,200 pixels.

We show the timing required to execute each tone-mapping operator, but exclude the time it takes to read the image from disk or write the result to file. We also routinely normalize the result of the tone-reproduction operators and apply gamma correction. None of these operations is included in the timing results.

All timing results are summarized in Table 8.1. This table should be interpreted with the following caveats. The timing given for Miller's operator is a rough average of the timings shown in Figure 8.19. The timing for the bilateral filter is given for a downsampling factor of 16. The computation time of Chiu's spatially variant operator is representative of the algorithm explained in this chapter, but not for the full algorithm as described by Chiu et al. (in that we have omitted the iterative smoothing stage).

Operator	Time (in seconds)
GLOBAL OPERATORS	
Miller's operator	≈ 15.0
Tumblin–Rushmeier's operator	3.2
Ward's scale factor	0.96
Ferwerda's operator	1.0*
Ferschin's exponential mapping	3.0
Logarithmic mapping	3.4
Drago's logarithmic mapping	2.8
Reinhard's global photographic operator	3.7
Reinhard and Devlin's photoreceptor model	9.7
Ward's histogram adjustment	3.4
Schlick's uniform rational quantization	3.4
LOCAL OPERATORS	
Chiu's spatially variant operator	10.0
Rahman and Jobson's multiscale retinex	120.0
Johnson and Fairchild's iCAM	66.0
Ashikhmin's operator	120.0
Reinhard's local photographic operator	80.0
GRADIENT DOMAIN OPERATORS	
Horn's lightness computation	45.0
Fattal's gradient domain compression	45.5
FREQUENCY-BASED OPERATORS	
Oppenheim's operator	12.4
Durand's bilateral filtering	23.5

TABLE 8.1 *Computation time for all operators using 1,600 by 1,200 images on an Apple iBook with 512 MB RAM and a G3 processor running at 800 MHz. Note: * Ferwerda's operator does not include the algorithm to lower visual acuity in scotopic lighting conditions.*

8.3.1 LOCAL AND GLOBAL OPERATORS

In general, global operators are the fastest to execute because normally only two or three passes over the image are required. In each pass, only very simple computations are performed. For applications that require real-time operation, global operators would be the first choice.

Local operators rely on the computation of local averages for each pixel. Such local averages are often computed by convolving the image with a filter kernel. For filter kernels larger than about 3 by 3 pixels, it is faster to Fourier transform both the image and the filter kernel and perform a pairwise multiplication in the Fourier domain. The convolved image is then obtained by applying an inverse Fourier transform on the result. Whether the convolution is computed directly or by means of the Fourier transform, local operators tend to be much slower than their global counterparts.

The performance of global operators is usually dependent only on the size of the image. The exception is Miller's operator, which is also weakly dependent on the maximum display luminance. The running time as a function of maximum display luminance is plotted in Figure 8.19. In all cases, the execution time remains below about 17 seconds.

The performance of the iCAM model depends on whether the adaptation level is computed from the luminance channel only, or for all three channels independently. The former takes 44 seconds, whereas the latter takes 66 seconds.

Our implementation of the multiscale observer model requires a substantial amount of memory to store the full image pyramid. We were not able to reliably measure the execution time of this operator for the default image size of 1,600 by 1,200 because our iBook did not have sufficient memory (512 MB) to complete the computation without significant swapping.

FIGURE 8.19 *Running time of Miller's operator as function of the maximum display luminance user parameter.*

The performance of the local version of Reinhard's photographic operator is about 80 seconds. For two reasons, this constitutes a performance gain with respect to other operators that also build a Gaussian pyramid. First, this operator compresses a luminance channel, as opposed to three color channels in the multiscale observer model. In comparison with Ashikhmin's operator, the total number of levels in the Gaussian pyramid is smaller.

8.3.2 GRADIENT AND FREQUENCY DOMAIN OPERATORS

Gradient domain operators require an integration step that is both approximate and costly, though less so than techniques that build image pyramids. The numerical

integration method of choice is the full multigrid method, which dominates the computation time of this class of operators. For example, Horn's lightness computation takes about 45 seconds. We found the gradient domain operator to be very similar in performance to Horn's operator (about 45.5 seconds).

Frequency domain operators rely on FFTs to obtain a frequency-space representation. We used the public domain FFTW library [39], and for these operators the performance of the FFT transform dominates the computation time. Note that the speed of executing an FFT depends strongly on the size of the image. Any image size that has a large number of factors will be substantially faster than image sizes that have a smaller number of factors. Although the running time depends on image size, this dependency is not linear. Our results are obtained with 1,600-by-1,200 images. These numbers may be factored into $2 \times 2 \times 2 \times 2 \times 2 \times 2 \times 5 \times 5$ and $2 \times 2 \times 2 \times 2 \times 3 \times 5 \times 5$, and therefore have eight and seven factors, respectively. This yields a relatively fast computation of FFTs. On the other hand, if the image were smaller by 1 pixel in each dimension (1,599 by 1,199 pixels) the factors would be $3 \times 13 \times 41$ and 11×109. This would have a negative impact on the computation time. In general, images that are powers of 2 will be the fastest and images the size of prime numbers will be the slowest to compute. In terms of performance, it is beneficial to pad images to a power-of-2 size if a Fourier transform needs to be computed.

An alternative filtering technique is to apply a fast but approximate filter, such as that described by Burt and Adelson [8]. For filter kernels with a Gaussian shape, this may speed up the computations, but with a loss of accuracy. We have found that this approximation is useful only for larger filter kernels. For very small filter kernels, this approximation may not be accurate enough.

Oppenheim's frequency-based operator takes about 12.4 seconds. Bilateral filtering takes about 23 seconds when a downsampling factor of 16 is selected. This is somewhat slower than Oppenheim's operator, although not dramatically so. Smaller downsampling factors will cause the computation time to increase significantly. If no downsampling is used, the computation time of the same image increases to 685 seconds. The progression of computation times as a function of downsampling factors is depicted in Figure 8.20.

The computational complexity of the trilateral filter is of necessity higher than for the bilateral filter, in that its main computational cost is the double application of the bilateral filter. If the same optimizations are employed as outlined for the

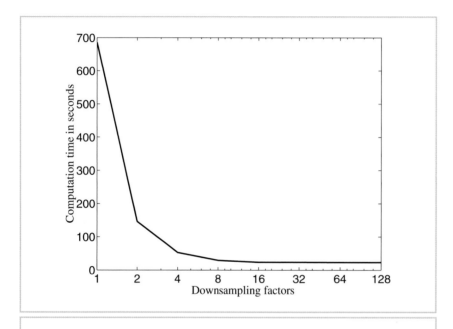

FIGURE 8.20 *Computation time (in seconds) for the bilateral filter as a function of downsampling factors.*

FIGURE 8.20 *Computation time (in seconds) for the bilateral filter as a function of downsampling factors.*

bilateral filter in Section 8.1.2, we expect the running times to be about double that of the bilateral filter. However, our implementation does not incorporate these optimizations, and we therefore recorded computation times that are substantially higher.

8.4 DISCUSSION

Tone-reproduction operators achieve dynamic-range reduction based on a small set of distinct observations. We have chosen to classify operators into four classes, two

of which are loosely based on image formation and two others operating in the spatial domain.

The underlying assumption of the first two classes is that images are formed by light being reflected from surfaces. In particular, the light intensities recorded in an image are assumed to be the product of light being reflected from a surface and the surface's ability to reflect. This led to Oppenheim's frequency-dependent attenuation. Subdivision of an image into base and detail layers may be seen as a frequency-dependent operation. The bilateral and trilateral filters, however, lift the restriction that images are assumed largely diffuse. These filters operate well for images depicting scenes containing directly visible light sources, specular reflections, and so on.

A parallel development has occurred in the class of gradient domain operators. Horn's lightness computation is aimed at disentangling illumination from reflectance by thresholding gradients. It necessarily assumes that scenes are diffuse. This restriction is lifted by Fattal et al., who attenuate large gradients but keep small gradients intact.

Various tone-reproduction operators use partial computational models of the human visual system to achieve dynamic-range reduction. A returning theme within this class of operators is the notion of adaptation luminance. Global operators often derive an adaptation level from the (log) average luminance of the image, whereas local operators compute a separate adaptation level for each pixel. Local adaptation levels are effectively weighted local averages of pixel neighborhoods. If the size of these neighborhoods is grown to include the entire image, these local operators default to global operators. It should therefore be possible to replace the global adaptation level of a global operator with a locally derived set of adaptation levels. The validity of this observation is demonstrated in Figure 8.21, in which the semisaturation constant of Reinhard and Devlin's photoreceptor model is fed with various luminance adaptation computations.

There are various ways of computing local adaptation luminances. The use of a stack of Gaussian-blurred images may be closest to the actual working of the human visual system, and with a carefully designed scale selection mechanism (such as shown by Reinhard et al.'s photographic operator, as well as Ashikhmin's operator), local adaptation levels may be computed that minimize haloing artifacts. Alternatively, edge-preserving smoothing filters may be used to derive local adapta-

FIGURE 8.21 *Global photoreceptor model (top left) and global photoreceptor model with the light adaptation parameter set to 0 (top right), followed by local versions in which adapting luminances are computed with Durand's bilateral filter (bottom left) and Pattanaik's gain control operator (bottom right)* [23,96].

tion luminances. Examples of such filters are the bilateral and trilateral filters, as well as the low-curvature image simplifier [132] and the mean shift algorithm [13].

The human visual system adapts over a period of time to novel lighting conditions. This is evident when entering a dark tunnel from bright daylight. It takes a short period of time before all details inside the tunnel become visible. Such time-

dependent behavior may also be included in tone-reproduction operators [22,35, 43,95,112].

Finally, we would like to stress the fact that each of these operators has its own strengths and weaknesses. Computational complexity, presence or absence of artifacts, and ability to deal with extreme HDR images should all be considered. We believe that there is no single operator that will be the best choice for all tasks, or even for all images.

For instance, in photography the purpose of tone reproduction may be to produce an image that appears as beautiful as possible. It may not be necessary to show every last detail in the captured image to achieve this goal. In addition, for this type of application a fully automatic operator may be less desirable than one that provides intuitive user parameters that allow the final result to be steered in the direction the photographer has in mind.

On the other hand, the task may be to visualize data, for instance if the HDR data is the result of a scientific simulation. In such cases it may be more important to visualize all important details than to produce an appealing image. It may be undesirable to have user parameters in this case.

For video and film, tone reproduction should produce consistent results between consecutive frames. In addition, tone reproduction could conceivably be used creatively to steer the mood of the scene, and thus help convey a story.

Thus, appropriate tone-reproduction operators should be matched to the task at hand. The current state of affairs is that we do not know how to match an operator to a given task. Selection of tone-reproduction operators is usually a matter of taste, as well as public availability of source code. We hope to alleviate the latter problem by having made the source code of all of our implementations available on the companion DVD-ROM.

Image-based Lighting

09

9.1 INTRODUCTION

The previous chapters in this book have described numerous properties and advantages of HDR imagery. A major advantage is that HDR pixel values can cover the full range of light in a scene and can be stored as calibrated linear-response measurements of incident illumination. Earlier chapters have described how these images are useful for improved image processing, and for determining how a human observer might perceive a real-world scene, even if shown on an LDR display.

This chapter describes how HDR images can be used as sources of illumination for computer-generated objects and scenes. Because HDR images record the full range of light arriving at a point in space, they contain information about the shape, color, and intensity of direct light sources, as well as the color and distribution of the indirect light from surfaces in the rest of the scene. Using suitable rendering algorithms, we can use HDR images to accurately simulate how objects and environments would look if they were illuminated by light from the real world. This process of using images as light sources is called *image-based lighting* (IBL). In that IBL generally involves the use of HDR images, both the IBL process and the HDR

images used for IBL are sometimes referred to as HDRI for high-dynamic-range imagery.

Figure 9.1 compares a simple scene illuminated by a traditional computer graphics light source (a) to its appearance as illuminated by three different image-based lighting environments (b through d). The scene's geometry consists of simple shapes and materials such as plastic, metal, and glass. In all of these images, the

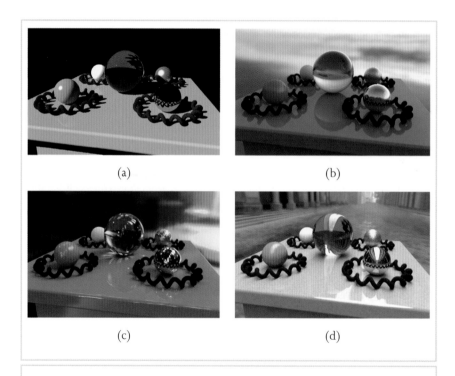

(a) (b)

(c) (d)

FIGURE 9.1 *Scene illuminated with (a) a traditional point light source. Scene illuminated with (b–d) HDR image-based lighting environments, including (b) sunset on a beach, (c) inside a cathedral with stained-glass windows, and (d) outside on a cloudy day.*

lighting is being simulated using the RADIANCE global illumination system [205]. Without IBL (a), the illumination is harsh and simplistic, and the scene appears noticeably computer generated. With IBL (b through d), the scene's level of realism and visual interest are increased — the shadows, reflections, and shading all exhibit complexities and subtleties that are realistic and internally consistent. In each rendering, a view of the captured environment appears in the background behind the objects. As another benefit of IBL, the objects appear to actually belong within the scenes that are lighting them.

In addition to HDR photography, IBL leverages two other important processes. One of them is omnidirectional photography, the process of capturing images that see in all directions from a particular point in space. HDR images used for IBL generally need to be omnidirectional, because light coming from every direction typically contributes to the appearance of real-world objects. This chapter describes some common methods of acquiring omnidirectional HDR images, known as *light probe images* or *HDR environment maps*, which can be used as HDR image-based lighting environments.

The other key technology for IBL is *global illumination*: rendering algorithms that simulate how light travels from light sources, reflects between surfaces, and produces the appearance of the computer-generated objects in renderings. Global illumination algorithms simulate the interreflection of light between diffuse surfaces, known as *radiosity* [170], and can more generally be built on the machinery of *ray tracing* [206] to simulate light transport within general scenes according to the *rendering equation* [175]. This chapter describes how such algorithms operate and demonstrates how they can be used to illuminate computer-generated scenes and objects with light captured in light probe images.

An important application of IBL is in the area of motion picture visual effects, where a common effect is to add computer-generated objects, creatures, and actors into filmed imagery as if they were really there when the scene was photographed. A key part of this problem is to match the light on the CG elements to be plausibly consistent with the light present within the environment. With IBL techniques, the real illumination can be captured at the location the CG object needs to be placed, and then used to light the CG element so that it has the same shading, shadows, and highlights as if it were really in the scene. Using this lighting as a starting point, visual effects artists can augment and sculpt the image-based lighting to achieve effects that are both dramatic and realistic.

Within the scope of IBL, there are several variants and extensions that increase the range of application of the technique. When implemented naïvely in global illumination software, IBL renderings can be computationally expensive for scenes with concentrated light sources. This chapter presents both user-guided and automatic techniques for *importance sampling* that make IBL calculations more efficient. In addition, various approximations of IBL can produce convincing results for many materials and environments, especially under appropriate artistic guidance. One is *environment mapping*, a precursor to IBL that yields extremely efficient and often convincing renderings by directly mapping images of an environment onto object surfaces. Another technique, *ambient occlusion*, uses some of IBL's machinery to approximate an object's self-shadowing so that it can be quickly applied to different lighting environments. To begin, we will start with a detailed example of IBL in a relatively basic form.

9.2 BASIC IMAGE-BASED LIGHTING

This section describes image-based lighting in both theoretical and practical terms using the example of *Rendering with Natural Light* (RNL), an IBL animation shown at the SIGGRAPH 98 Electronic Theater. The RNL scene is a still life of computer-generated spheres on a pedestal, and is illuminated by light captured in the Eucalyptus grove at the University of California at Berkeley. The animation was modeled, rendered, and illuminated using the RADIANCE lighting simulation system [205], and the necessary scene files and images for creating the animation are included on the companion DVD-ROM. The animation was created via the following steps:

1 Acquire and assemble the light probe image.
2 Model the geometry and reflectance of the scene.
3 Map the light probe to an emissive surface surrounding the scene.
4 Render the scene as illuminated by the IBL environment.
5 Postprocess and tone map the renderings.

9.2.1 ACQUIRE AND ASSEMBLE THE LIGHT PROBE

The lighting environment for RNL was acquired in the late afternoon using a three-inch chrome bearing and a digital camera. The mirrored ball and a digital video

camera were placed on tripods about 4 feet from each other and 3.5 feet off the ground.[1] The digital video camera was zoomed until the sphere filled the frame, and the focus was set so that the reflected image was sharp. The camera's aperture was narrowed to f/8 to allow for sufficient depth of field, and an HDR image series was acquired with shutter speeds varying from $\frac{1}{4}$ second to $\frac{1}{10,000}$ second, spaced one stop apart. To cover the scene with better sampling, a second series was acquired after having moved the camera 90 degrees around to see the ball from the side (see Section 9.3.1). The process took only a few minutes and the resulting image series can be seen in Figures 9.2(a) and 9.2(c).

Mirrored spheres reflect nearly the entire environment they are in — not, as sometimes assumed, just the hemisphere looking back in the direction of the camera. This follows from the basic mirror formula that the angle of incidence is equal to the angle of reflection: rays near the outer edge of a sphere's image have an angle of reflection toward the camera that nears 90 degrees, and thus their angle of incidence also nears 90 degrees. Thus, the ray's angle of incidence relative to the camera nears 180 degrees, meaning that the rays originate from nearly the opposite side of the sphere relative to the camera.

Each image series of the sphere was converted into an HDR image using the HDR image assembly algorithm in Debevec and Malik [164] (Chapter 4), and the images were saved in RADIANCE's native HDR image format (Chapter 3). The algorithm derived the response curve of the video camera and produced HDR images where the pixel values were proportional to the light values reflected by the mirrored sphere. The total dynamic range of the scene was approximately 5,000:1, measuring from the dark shadows beneath the bushes to the bright blue of the sky and the thin white clouds lit from behind by the sun. As another measure of the range, the brightest pixel values in the sky and cloud regions were some 150 times the average level of light in the scene. The two views of the sphere were combined (using techniques presented in Section 9.3.1) and mapped into the angular map space (described in Section 9.4.2) to become the light probe image seen in Figure 9.2(b).

. .

1 Many tripods allow the center pole (the vertical pole the tripod head is attached to) to be removed from the legs and reinserted upside-down, leaving the end of the pole pointing up and able to accommodate a mirrored sphere.

(a) (b) (c)

FIGURE 9.2 *The two HDRI series (a and c) used to capture the illumination in the Eucalyptus grove for RNL, and the resulting combined light probe image (b), converted into the Angular Map format.*

9.2.2 MODEL THE GEOMETRY AND REFLECTANCE OF THE SCENE

The RNL scene's spheres, stands, and pedestal were modeled using RADIANCE's standard scene primitives and generators. Each sphere was given a different material property with different colors of glass, metal, and plastic. The pedestal itself was

texture mapped with a polished marble texture. The scene specification files are included on the companion DVD-ROM as `rnl_scene.rad` and `gensup.sh`.

9.2.3 MAP THE LIGHT PROBE TO AN EMISSIVE SURFACE SURROUNDING THE SCENE

In IBL, the scene is surrounded (either conceptually or literally) by a surface that the light probe image is mapped onto. In the simplest case, this surface is an infinite sphere. The RNL animation used a large but finite inward-pointing cube, positioned so that the bottom of the pedestal sat centered on the bottom of the cube (Figure 9.3). The light probe image was mapped onto the inner surfaces of

FIGURE 9.3 *The RNL pedestal is seen within the large surrounding box, texture mapped with the Eucalyptus Grove light probe image.*

the cube so that from the perspective of the top of the pedestal the light from the environment would come from substantially the same directions as it would have in the forest. The RADIANCE shading language was sufficiently general to allow this mapping to be specified in a straightforward manner. When a ray hits a surface, it reports the 3D point of intersection $P = (P_x, P_y, P_z)$ to user-supplied equations that compute the texture map coordinate for that point of the surface. In the RNL scene, the top of the pedestal was at the origin, and thus the direction vector into the probe was simply the vector pointing toward P. From this direction, the (u, v) coordinates for the corresponding pixel in the light probe image are computed using the angular map equations in Section 9.4.2. These calculations are specified in the file angmap.cal included on the companion DVD-ROM.

In IBL, the surface surrounding the scene is specified to be *emissive*, so that its texture is treated as a map of light emanating from the surface rather than a map of surface reflectance. In RADIANCE this is done by assigning this environment the *glow* material, which tells the renderer that once a ray hits this surface the radiance along the ray should be taken directly as the HDR color in the image, rather than the product of the texture color and the illumination incident upon it. When the environment surface is viewed directly (as in most of Figure 9.3), it appears as an image-based rendering with the same pixel colors as in the original light probe image.

9.2.4 RENDER THE SCENE AS ILLUMINATED BY THE IBL ENVIRONMENT

With the scene modeled and the light probe image mapped onto the surrounding surface, RADIANCE was ready to create the renderings using IBL. Appropriate rendering parameters were chosen for the number of rays to be used per pixel, and a camera path was animated to move around and within the scene. RADIANCE simulated how the objects would look as if illuminated by the light from the environment surrounding them. Some renderings from the resulting image sequence are shown in Figure 9.4. This lighting process is explained in further detail in Section 9.5.

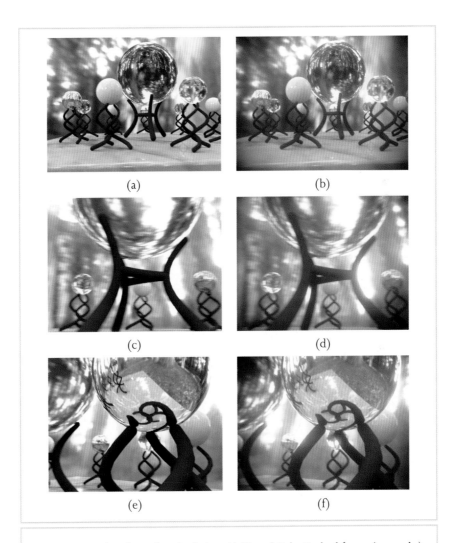

(a) (b)

(c) (d)

(e) (f)

FIGURE 9.4 Three frames from *Rendering with Natural Light*. Rendered frames (a, c, and e) before postprocessing. After postprocessing (b, d, and f) as described in Section 9.2.5.

9.2.5 POSTPROCESS THE RENDERINGS

A final step in creating an IBL rendering or animation is to choose how to tone map the images for display. RADIANCE and many recent rendering systems can output their renderings as HDR image files. Because of this, the RNL renderings exhibited the full dynamic range of the original lighting environment, including the very bright areas seen in the sky and in the specular reflections of the glossy spheres. Because the renderings exhibit a greater dynamic range than can be shown on typical displays, some form of tone mapping is needed to produce the final displayable images. The most straightforward method of tone mapping is to pick a visually pleasing exposure factor for the image, truncate the bright regions to the maximum "white" value of the display, and apply any needed compensation for the response curve of the display (most commonly, applying a gamma-correction function). With this technique, values below the white point are reproduced accurately, but everything above the white point is clipped.

Chapters 6, 7, and 8 discussed several tone-reproduction operators that reduce the dynamic range of an image in a natural way to fall within the range of the display, any of which could be used for postprocessing IBL images. Another approach to postprocessing HDR images is to simulate some of the optical imperfections of a real camera system that communicate the full dynamic range of bright regions through blooming and vignetting effects. Such operators often work well in conjunction with IBL rendering because, like IBL, they are designed to simulate the appearance of photographic imagery.

Let's first examine how a blurring operator can communicate the full dynamic range of a scene even on an LDR display. The top of Figure 9.5 shows two bright square regions in an image. In the HDR image file, the right-hand square is six times brighter than the left (as seen in the graph below the squares). However, because the maximum "white" point of the display is below the brightness of the dimmer square the displayed squares appear to be the same intensity. If we apply a Gaussian blur convolution to the HDR pixel values, the blurred squares appear very different, even when clipped to the display's white point. The dim blurred square now falls considerably below the white point, whereas the middle of the bright blurred square still exceeds the range of the display. The brighter region also appears larger, even though the regions were originally the same size and are filtered with the same amount of blur. This effect is called *blooming*.

(a) Before blur (b) After blur

FIGURE 9.5 *Two bright image squares (a) with pixel values 1.5 and 6 are shown on a display with a white point of 1. Because of clipping, the squares appear the same. A graph of pixel intensity for a scan line passing through the centers of the squares is shown below, with "white" indicated by the dotted line. After applying a Gaussian blur (b), the blurred squares are very different in appearance, even though they are still clipped to the display white point.*

Similar blooming effects are seen frequently in real photographs, in which blur can be caused by any number of factors, including camera motion, subject motion, image defocus, "soft focus" filters placed in front of the lens, dust and coatings on lens surfaces, and scattering of light within the air and image sensor. Figure 9.6(a) shows an image acquired in HDR taken inside Stanford's Memorial church. When a clipped LDR version of the image is blurred horizontally (Figure 9.6(b)), the bright stained-glass windows become noticeably darker. When the HDR version of the image is blurred with the same filter (Figure 9.6(c)), the windows appear as vibrant bright streaks, even when clipped to the white point of the display. In addition to

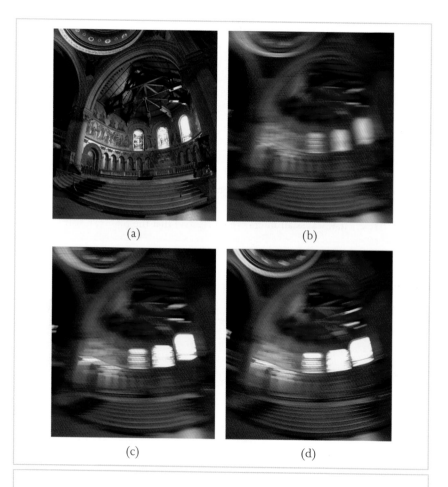

(a) (b)

(c) (d)

FIGURE 9.6 *An HDR scene inside a church with bright stained-glass windows. (b) Horizontally blurring the clipped LDR image gives the effect of image motion, but it noticeably darkens the appearance of the stained-glass windows. (c) Blurring an HDR image of the scene produces bright and well-defined streaks from the windows. (d) Real motion blur obtained by rotating camera during the exposure validates the HDR blurring simulated in image* **c.**

the HDR image series, the photographer also acquired a motion-blurred version of the church interior by rotating the camera on the tripod during a half-second exposure (Figure 9.6(d)). The bright streaks in this real blurred image (though not perfectly horizontal) are very similar to the streaks computed by the HDR blurring process seen in Figure 9.6(c), and dissimilar to the LDR blur seen in Figure 9.6(d).

The renderings for *Rendering with Natural Light* were postprocessed using a summation of differently blurred versions of the renderings produced by RADIANCE. Each final image used in the film was a weighted average of several differently blurred versions of the image. All of the blur functions used in RNL were Gaussian filters, and their particular mixture is illustrated in Figure 9.7.

With the right techniques, such blurring processes can be performed very efficiently, even though convolving images with wide filters is normally computationally expensive. First, Gaussian filters are *separable*, so that the filter can be performed

$$I' \quad = \quad \tfrac{3}{4}\mathrm{Blur}(I,1) \quad + \quad \tfrac{1}{10}\mathrm{Blur}(I,15)$$

$$+ \quad \tfrac{1}{10}\mathrm{Blur}(I,50) \quad + \quad \tfrac{1}{20}\mathrm{Blur}(I,150)$$

FIGURE 9.7 *The mix of blur filters used to postprocess the RNL frames. Blur(I, σ) indicates a Gaussian blur with a standard deviation of σ pixels.*

as a 1D Gaussian blur in x followed by a 1D Gaussian blur in y. Second, a Gaussian blur can be closely approximated as several successive box blurs. Finally, the wider blurs can be closely approximated by applying correspondingly narrower blurring filters to a low-resolution version of the image, and then up-sampling the small blurred version. With these enhancements, efficient implementations of such techniques can be achieved on modern GPUs [187], and considerably more elaborate lens flare effects can be performed in real time [176].

Postprocessed frames from RNL can be seen in the right-hand column of Figure 9.4. Because the final postprocessed images are 75% composed of the original renderings with just a slight blur applied, the original image detail is still evident. However, because of the other blurred versions added, the bright parts of the environment and their specular reflections tend to bloom in the final renderings. Often, as in Figure 9.7, the bloom from bright spots in the environment appears to "wrap" around objects in the foreground. This is a surprisingly natural effect that helps the rendered objects appear to belong within the rest of the scene.

As mentioned previously, this postprocessing of HDR imagery is a form of tone mapping, the effects of which are similar to the results produced by using "soft focus," "mist," and "fog" filters on real camera lenses. The effects are also similar to the effects of the optical imperfections of the human eye. A detailed model of the particular glare and bloom effects produced in the human eye is constructed and simulated by Spencer et al. [198]. In addition, a basic model of human eye glare was used in conjunction with a tone-reproduction operator by Larson et al. [180].

A final subtle effect applied to the renderings in RNL is *vignetting*. Vignetting is the process of gently darkening the pixel values of an image toward its corners, which occurs naturally in many camera lenses (particularly at wide apertures) and is sometimes intentionally exaggerated with an additional mask or iris for photographic effect. Applying this effect to an HDR image before tone mapping the pixel values can also help communicate a greater sense of the range of light in a scene, particularly in animations. With this effect, as a bright region moves from the center of the field of view to the edge, the pixels around it dim. However, its particularly bright pixels will still reach the white point of the display. Thus, different exposures of the scene are revealed in a natural manner simply through camera motion. The effect is easily achieved by multiplying an image by a brightness falloff image such as in Figure 9.8(a). Figures 9.8(b) and 9.8(c) show a rendering from RNL before and after vignetting.

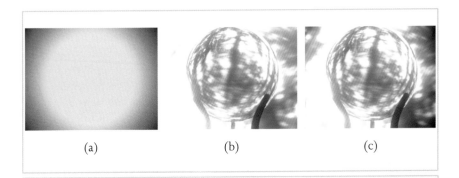

(a) (b) (c)

FIGURE 9.8 *Via the brightness fall-off function shown in image (a), a frame from the RNL animation is seen (b) before and (c) after vignetting. In this image, this operation darkens the right-side image corners, reveals detail in the slightly overexposed upper left corner, and has little effect on the extremely bright lower left corner. In motion, this vignetting effect helps communicate the HDR environment on an LDR display.*

As an early IBL example, RNL differed from most CG animations in that designing the lighting in the scene was a matter of choosing real light from a real location rather than constructing the light as an arrangement of computer-generated light sources. Using global illumination to simulate the image-based lighting naturally produced shading, highlights, refractions, and shadows that were consistent with one another and with the environment surrounding the scene. With traditional CG lighting, such an appearance would have been difficult to achieve.

9.3 CAPTURING LIGHT PROBE IMAGES

Moving on from our basic example, the next few sections present the key stages of IBL with greater generality and detail, beginning with the process of lighting capture. Capturing the incident illumination at a point in space requires taking an image with two properties. First, it must see in all directions, in that light coming

from anywhere can affect the appearance of an object. Second, it must capture the full dynamic range of the light within the scene, from the brightest concentrated light sources to the dimmer but larger areas of indirect illumination from other surfaces in the scene. In many cases, the standard HDR photography techniques presented in Chapter 4 satisfy this second requirement. Thus, the remaining challenge is to acquire images that see in all directions, a process known as panoramic (or omnidirectional) photography. There are several methods of recording images that see in all directions, each with advantages and disadvantages. In this section, we describe some of the most common techniques, which include using mirrored spheres, tiled photographs, fish-eye lenses, and scanning panoramic cameras. This section concludes with a discussion of how to capture light probe images that include a direct view of the sun, which is usually too bright to record with standard HDR image capture techniques.

9.3.1 PHOTOGRAPHING A MIRRORED SPHERE

The technique used to capture the *Rendering with Natural Light* light probe was to photograph a mirrored sphere placed in the scene where it is desired to capture the illumination. Using mirrored spheres to obtain omnidirectional reflections of an environment was first used for *environment mapping* [186,207,171] (described in Section 9.8.1), where such images are directly texture mapped onto surfaces of objects. The main benefit of photographing a mirrored sphere is that it reflects very nearly the entire environment in a single view. Aside from needing two tripods (one for the sphere and one for the camera), capturing a light probe image with this technique can be fast and convenient. Mirrored spheres are inexpensively available as 2- to 4-inch diameter chrome ball bearings (available from the McMaster–Carr catalog, *www.mcmaster.com*), 6- to 12-inch mirrored glass lawn ornaments (available from Baker's Lawn Ornaments, *www.bakerslawnorn.com*), and Chinese meditation balls (1.5 to 3 inches). Dubé juggling equipment (*www.dube.com*) sells polished hollow chrome spheres from 2-1/6 to 2-7/8 inches in diameter. Professionally manufactured mirrored surfaces with better optical properties are discussed at the end of this section.

There are several factors that should be considered when acquiring light probe images with a mirrored sphere. These are discussed in the sections that follow.

Framing and Focus First, it is desirable to have the sphere be relatively far from the camera to minimize the size of the camera's reflection and to keep the view nearly orthographic. To have the sphere be relatively large in the frame, it is necessary to use a long-focal-length lens. Many long lenses have difficulty focusing closely on small objects, and thus it may be necessary to use a +1 diopter close-up filter (available from a professional photography store) on the lens to bring the sphere into focus. The image of the sphere usually has a shallow depth of field, especially when a close-up filter is used, and thus it is often necessary to use an aperture of f/8 or smaller to bring the full image into focus.

Blind Spots There are several regions in a scene that are usually not captured well by a mirrored sphere. One is the region in front of the sphere, which reflects the camera and often the photographer. Another is the region directly behind the sphere, which is reflected by a thin area around the sphere's edge. The last is a strip of area from straight down and connecting to the area straight back, which usually reflects whatever supports the sphere. For lighting capture, these effects are easily minimized by orienting the camera so that no photometrically interesting areas of the scene (e.g., bright light sources) fall within these regions. However, it is sometimes desirable to obtain clear images of all directions in the environment, for example when the light probe image itself will be seen in the background of the scene. To do this, one can take two HDR images of the mirrored sphere, with the second rotated 90 degrees around from the first. In this way, the poorly represented forward and backward directions of one sphere correspond to the well-imaged left and right directions of the other, and vice versa. The two images taken for the RNL light probe are shown in Figure 9.9. Each image slightly crops the top and bottom of the sphere, which was done intentionally to leverage the fact that these areas belong to the rear half of the environment that appears in the other sphere image. Using an HDR image-editing program such as HDR Shop [202], these two images can be combined into a single view of the entire environment that represents all directions well except straight down. If needed, this final area could be filled in from a photograph of the ground or through manual image editing.

Calibrating Sphere Reflectivity It is important to account for the fact that mirrored spheres are generally not optically perfect reflectors. Though the effect is often unnoticed, ball bearings typically reflect only a bit more than half of the light hitting

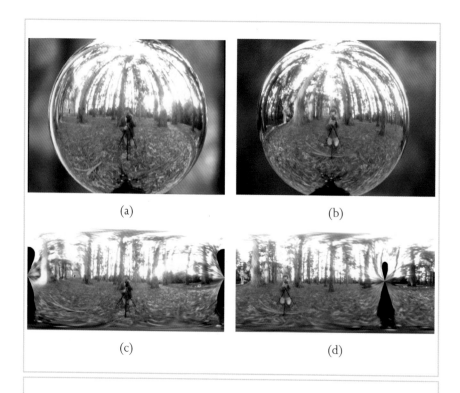

FIGURE 9.9 *Acquiring a light probe with a mirrored sphere. (a) and (b) show two images of the sphere, taken 90 degrees apart. (c) and (d) show the mirrored sphere images transformed into latitude-longitude mappings. In (d), the mapping has been rotated 90 degrees to the left to line up with the mapping of (c). The black teardrop shapes correspond to the cropped regions at the top and bottom of each sphere, and the pinched area between each pair of drops corresponds to the poorly sampled region near the outer edge of the sphere image. Each sphere yields good image data where the other one has artifacts, and combining the best regions of each can produce a relatively seamless light probe image, as in Figure 9.2.*

them. In some IBL applications, the lighting is captured using a mirrored sphere, and the background image of the scene is photographed directly. To correct the sphere image so that it is photometrically consistent with the background, we need to measure the reflectivity of the sphere. This can be done using a setup such as that shown in Figure 9.10. In this single photograph, taken with a radiometrically calibrated camera, the indicated patch of diffuse paper is reflected in the ball. We can thus divide the average pixel value of the patch in the reflection by the average pixel value in the direct view to obtain the sphere's percent reflectivity in each of the red, green, and blue channels. A typical result would be $(0.632, 0.647, 0.653)$. Often, these three numbers will be slightly different, indicating that the sphere tints the incident light. The light probe image can be corrected to match the background by dividing its channels by each of these numbers.

FIGURE 9.10 *The reflectivity of a mirrored sphere can be determined by placing the sphere near an easy-to-identify part of a diffuse surface, and comparing its brightness seen directly to its appearance as reflected in the sphere. In this case, the sphere is 59% reflective.*

Nonspecular Reflectance Mirrored spheres usually exhibit a faint diffuse or rough specular component due to microscopic scratches and deposits on their surface. It is best to keep the spheres in cloth bags to minimize such scratching, as well as to keep them dry so that the surface does not oxidize. A slight rough specular component usually makes little difference in how light probe images illuminate CG objects, but when viewed directly the reflected image may lack contrast in dark regions and exhibit bright flares around the light sources. If an application requires a near-perfectly shiny mirrored surface, one can have a glass or metal sphere or hemisphere specially coated with a thin layer of aluminum by an optical coating company (only half a sphere can be photographed at once, and thus in practice a hemisphere can also be used as a light probe). Such coated optics yield extremely clear specular reflections and can be up to 91% reflective. Some experiments in capturing the sky using such optics can be found in Stumpfel [199].

Polarized Reflectance Mirrored spheres behave somewhat unexpectedly with respect to polarization. Light that reflects from a sphere at angles next to the outer rim becomes polarized, an effect characterized by Fresnel's equations [168]. Camera sensors generally record light irrespective of polarization, so this itself is not a problem.[2] However, for the same reasons, polarized light reflecting from a mirrored sphere can appear either too bright or too dim compared to being viewed directly. This is a significant effect in outdoor environments, where the scattered blue light of the sky is significantly polarized. This problem can be substantially avoided by using highly reflective mirror coatings (as discussed previously).

Image Resolution It can be difficult to obtain a particularly high-resolution image of an environment as reflected in a mirrored sphere, because only one image is used to cover a fully spherical field of view. For lighting CG objects, the need for highly detailed light probe images is not great: only large and very shiny objects reflect light in a way that fine detail in an environment can be noticed. However, for forming virtual backgrounds behind CG objects it is often desirable to have higher-resolution imagery. In the RNL animation, the low resolution of the light probe image used

2 Whereas sensors tend to detect different polarization directions equally, wide-angle lenses can respond differently according to polarization for regions away from the center of the image.

for the background produced the reasonably natural appearance of a shallow depth of field, even though no depth of field effects were simulated.

Photographing a mirrored sphere is an example of a *catadioptric* imaging system in that it involves both a lens and a reflective surface. In addition to mirrored spheres, other shapes can be used that yield different characteristics of resolution, depth of field, and field of view. One example of a well-engineered omnidirectional video camera covering slightly over a hemispherical field of view is presented in Nayer [188]. Nonetheless, for capturing illumination wherein capturing the full sphere is more important than high image resolution, mirrored spheres are often the most easily available and convenient method.

9.3.2 TILED PHOTOGRAPHS

Omnidirectional images can also be captured by taking a multitude of photographs looking in different directions and "stitching" them together — a process made familiar by QuickTime VR panoramas [156]. This technique can be used to assemble remarkably high-resolution omnidirectional images using a standard camera and lens. Unfortunately, the most commonly acquired panoramas see all the way around the horizon but only with a limited vertical field of view. For capturing lighting, it is important to capture imagery looking in *all* directions, particularly upward, because this is often where much of the light comes from. Images taken to form an omnidirectional image will align much better if the camera is mounted on a nodal rotation bracket, which can eliminate viewpoint parallax between the various views of the scene. Such brackets are available commercially from companies such as Kaidan (*www.kaidan.com*). Some models allow the camera to rotate around its nodal center for both the horizontal and vertical axes.

Figure 9.11 shows tone-mapped versions of the source HDR images for the "Uffizi Gallery" light probe image [160], which was acquired as an HDR tiled panorama. These images were aligned by marking pairs of corresponding points between the original images and then solving for the best 3D rotation of each image to minimize the distance between the marked points. The images were then blended across their edges to produce the final full-view latitude-longitude mapping. This image was used as the virtual set and lighting environment for the middle sequence of the animation *Fiat Lux*.

FIGURE 9.11 (a) The Uffizi light probe was created from an HDR panorama with two rows of nine HDR images. (b) The assembled light probe in latitude-longitude format. (c) Synthetic objects added to the scene, using the light probe as both the virtual background and the lighting environment.

A more automatic algorithm for assembling such full-view panoramas is described in [201], and commercial image-stitching products such as QuickTime VR (*www.apple.com/quicktime/qtvr/*) and Realviz Stitcher (*www.realviz.com*) allow one to interactively align images taken in different directions to produce full-view panoramas in various image formats. Unfortunately, at the time of writing no commercial products natively support stitching HDR images. Digital photographer Greg Downing (*www.gregdowning.com*) has described a process [166] for stitching each set of equivalent exposures across the set of HDR images into its own panorama, and then assembling this series of LDR panoramas into a complete light probe image. The key is to apply the same alignment to every one of the exposure sets: if each set were aligned separately, there would be little chance of the final stitched panoramas aligning well enough to be assembled into an HDR image. To solve this problem, Downing uses Realviz Stitcher to align the exposure level set with the most image detail and saves the alignment parameters in a way that they can be applied identically to each exposure level across the set of views. These differently exposed LDR panoramas can then be properly assembled into an HDR panorama.

9.3.3 FISH-EYE LENSES

Fish-eye lenses are available for most single-lens reflex cameras and are capable of capturing 180 degrees or more of an environment in a single view. As a result, they can cover the full view of an environment in as few as two images. In Greene [171], a fish-eye photograph of the sky was used to create the upper half of a cube map used as an environment map. Although fish-eye lens images are typically not as sharp as regular photographs, light probe images obtained using fish-eye lenses are usually of higher resolution than those obtained by photographing mirrored spheres. A challenge in using fish-eye lenses is that not all 35-mm digital cameras capture the full field of view of a 35-mm film camera due to having a smaller image sensor. In this case, the top and bottom of the circular fish-eye image are usually cropped off. This can require taking additional views of the scene to cover the full environment. Fortunately, recently available digital cameras, such as the Canon EOS 1Ds and the Kodak DCS 14n, have image sensor chips that are the same size as 35-mm film (and no such cropping occurs).

Fish-eye lenses can exhibit particularly significant radial intensity fall-off, also known as *vignetting*. As with other lenses, the amount of falloff tends to increase with

the size of the aperture being used. For the Sigma 8-mm fish-eye lens, the amount of falloff from the center to the corners of the image is more than 50% at its widest aperture of f/4. The falloff curves can be calibrated by taking a series of photographs of a constant intensity source at different camera rotations and fitting a function to the observed image brightness data. This surface can be used to render an image of the *flat-field response* of the camera. With this image, any HDR image obtained with the camera can be made radiometrically consistent across its pixels by dividing by the image of the flat-field response. An example of this process is described in more detail in [200].

9.3.4 SCANNING PANORAMIC CAMERAS

Scanning panoramic cameras are capable of capturing particularly high-resolution omnidirectional HDR images. These cameras use narrow image sensors that are typically 3 pixels wide and several thousand pixels tall. The three columns of pixels are filtered by red, green, and blue filters, allowing the camera to sense color. A precise motor rotates the camera by 360 degrees over the course of a few seconds to a few minutes, capturing a vertical column of the panoramic image many times per second. When a fish-eye lens is used, the full 180-degree vertical field of view can be captured from straight up to straight down. Two cameras based on this process are made by Panoscan and Spheron VR (Figure 9.12).

Trilinear image sensors, having far fewer pixels than area sensors, can be designed with more attention given to capturing a wide dynamic range in each exposure. Nonetheless, for IBL applications in which it is important to capture the full range of light, including direct views of concentrated light sources, taking multiple exposures is usually still necessary. The Panoscan camera's motor is able to precisely rewind and repeat its rotation, allowing multiple exposures to be taken and assembled into an HDR image without difficulty. The Spheron VR camera (see also Section 4.9.4) can be ordered with a special HDR feature in which the image sensor rapidly captures an HDR series of exposures for each column of pixels as the camera head rotates. These differently exposed readings of each pixel column can be assembled into HDR images from just one rotation of the camera.

For these cameras, the speed of scanning is limited by the amount of light in the scene. Suppose that at the chosen f-stop and ISO setting it takes $\frac{1}{125}$ of a second to obtain a proper exposure of the shadows and midtones of a scene. If the

(a)

(b)

FIGURE 9.12 (a) *The Spheron scanning panoramic camera.* (b) *A tone-mapped version of a high-resolution omnidirectional HDR image taken with the camera. Panorama courtesy of Ted Chavalas of Panoscan, Inc.*

image being acquired is 12,000 pixels wide, the camera must take at least 96 seconds to scan the full panorama. Fortunately, shooting the rest of the HDR image series to capture highlights and light sources takes considerably less time because

each shutter speed is shorter, typically at most one-fourth the length for each additional exposure. Although capturing lighting with scanning panoramic cameras is not instantaneous, the resulting lighting environments can have extremely detailed resolution. The high resolution also enables using these images as background plates or to create image-based models for 3D virtual sets.

9.3.5 CAPTURING ENVIRONMENTS WITH VERY BRIGHT SOURCES

For image-based lighting, it is important that the acquired light probe images cover the full dynamic range of light in the scene up to and including light sources. If 99.99% of a light probe image is recorded properly but 0.01% of the pixel values are saturated, the light captured could still be very inaccurate depending on how bright the saturated pixels really should have been. Concentrated light sources are often significantly brighter than the average colors within a scene. In a room lit by a bare light bulb, the light seen reflecting from tens of square meters of ceiling, floor, and walls originates from just a few square millimeters of light bulb filament. Because of such ratios, light sources are often thousands, and occasionally millions, of times brighter than the rest of the scene.

In many cases, the full dynamic range of scenes with directly visible light sources can still be recovered using standard HDR photography techniques, in that camera shutter speeds can usually be varied down to $\frac{1}{4000}$ of a second or shorter, and small apertures can be used as well. Furthermore, modern lighting design usually avoids having extremely concentrated lights (such as bare filaments) in a scene, preferring to use globes and diffusers to more comfortably spread the illumination over a wider area. However, for outdoor scenes the sun is a light source that is both very bright and very concentrated. When the sun is out, its brightness can rarely be recorded using a typical camera even using the shortest shutter speed, the smallest aperture, and the lowest sensor gain settings. The sun's brightness often exceeds that of the sky and clouds by a factor of fifty thousand, which is difficult to cover using varying shutter speeds alone.

Stumpfel et al. [200] presented a technique for capturing light from the sky up to and including the sun. To image the sky, the authors used a Canon EOS 1Ds digital camera with a Sigma 8-mm fish-eye lens facing upward on the roof of an

office building (Figure 9.13(a)). The lens glare caused by the sun was minor, which was verified by photographing a clear sky twice and blocking the sun in one of the images. For nearly the entire field of view, the pixel values in the sky were within a few percent points of each other in both images.

As expected, the sun was far too bright to record even using the camera's shortest shutter speed of $\frac{1}{8000}$ of a second at f/16, a relatively small aperture.[3] The authors thus placed a Kodak Wratten 3.0 neutral density (ND) filter on the back of the lens to uniformly reduce the light incident on the sensor by a factor of one thousand.[4] ND filters are often not perfectly neutral, giving images taken though them a significant color cast. The authors calibrated the transmission of the filter by taking HDR images of a scene with and without the filter, and divided the two images to determine the filter's transmission in the red, green, and blue color channels. All images subsequently taken through the filter were scaled by the inverse of these transmission ratios.

Having the 3.0 ND filter on the lens made it possible to image the sun at $\frac{1}{8000}$ of a second at f/16 without saturating the sensor (see Figure 9.13(a)), but it made the sky and clouds require an undesirably long exposure time of 15 seconds. To solve this problem, the authors used a laptop computer to control the camera so that both the shutter speed and the aperture could be varied during each HDR image sequence. Thus, the series began at f/4 with exposures of 1, $\frac{1}{4}$, and $\frac{1}{32}$ second and then switched to f/16 with exposures of $\frac{1}{16}$, $\frac{1}{125}$, $\frac{1}{1000}$, and $\frac{1}{8000}$ of a second. Images from such a sequence are seen in Figures 9.13(b) through 9.13(h). For pre-sunrise and post-sunset images, the f/16 images were omitted and an additional exposure of 4 seconds at f/4 was added to capture the dimmer sky of dawn and dusk.

Creating HDR images using images taken with different apertures is slightly more complicated than usual. Because different apertures yield different amounts of lens vignetting, each image needs to be corrected for its aperture's flat-field response (see Section 9.3.3) before the HDR assembly takes place. In addition, whereas the actual exposure ratios of different camera shutter speeds typically follow the expected geometric progression ($\frac{1}{30}$ second is usually precisely half the exposure of

. .

3 The authors observed unacceptably pronounced star patterns around the sun at the smaller apertures of f/22 and f/32 due to diffraction of light from the blades of the iris.

4 Because the fish-eye lens has such a wide-angle view, filters are placed on the back of the lens using a small mounting bracket rather than on the front.

(a) Setup (b) 1 sec., f/4

(c) $\frac{1}{4}$ sec., f/4 (d) $\frac{1}{32}$ sec., f/4

FIGURE 9.13 (a) *A computer-controlled camera with a fish-eye lens placed on a roof to capture HDR images of the sky. A color-corrected HDR image series (b through h) of a sunny sky taken using varying shutter speed, aperture, and a 3.0 neutral density filter. The inset of each frame shows a small area around the sun, with saturated pixels shown in pink. Only the least exposed image (h) accurately records the sun's intensity without sensor saturation.*

$\frac{1}{15}$ second; $\frac{1}{15}$ second is usually precisely half the exposure of $\frac{1}{8}$ second), aperture transmission ratios are less exact. In theory, images taken at f/4 should receive sixteen times the exposure of images taken at f/16, but generally do not.

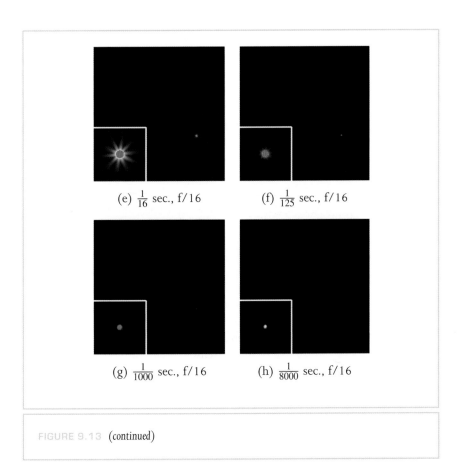

(e) $\frac{1}{16}$ sec., f/16 (f) $\frac{1}{125}$ sec., f/16

(g) $\frac{1}{1000}$ sec., f/16 (h) $\frac{1}{8000}$ sec., f/16

FIGURE 9.13 (*continued*)

To test this, the authors took images of a constant intensity light source at both f/4 and f/16 and compared the pixel value ratios at the center of the image, measuring a factor of 16.63 rather than 16, and compensated for this ratio accordingly.

When the sun was obscured by clouds or was low in the sky, the images with the shortest exposure times were not required to cover the full dynamic range.

The authors discovered they could adaptively shoot the HDR image sequence by programming the laptop computer to analyze each image in the series after it was taken. If one of the images in the series was found to have no saturated pixels, no additional photographs were taken.

Indirectly Deriving Sun Intensity from a Diffuse Sphere Rather than using specialized HDR photography to directly capture the sun's intensity, we can estimate the sun's intensity based on the appearance of a diffuse object within the scene. In particular, we can use a mirrored sphere to image the ground, sky, and clouds and a diffuse sphere to indirectly measure the intensity of the sun. Such an image pair is shown in Figure 9.14.

The mirrored sphere contains accurate pixel values for the entire sky and surrounding environment, except for the region of sensor saturation near the sun. Because of this, the clipped light probe will not accurately illuminate a synthetic object as it would really appear in the real environment; it would be missing the light from the sun. We can quantify the missing light from the sun region by comparing the real and synthetic diffuse sphere images.

To perform this comparison, we need to adjust the images to account for each sphere's reflectivity. For the diffuse sphere, a gray color can be preferable to white because it is less likely to saturate the image sensor when exposed according to the average light in the environment. The paint's reflectivity can be measured by painting a flat surface with the same paint and photographing this sample (with a radiometrically calibrated camera) in the same lighting and orientation as a flat surface of known reflectance. Specialized *reflectance standards* satisfying this requirement are available from optical supply companies. These reflect nearly 99% of the incident light — almost perfectly white. More economical reflectance standards are the neutral-toned squares of a Gretag–MacBeth ColorChecker chart (*www.gretagmacbeth.com*), whose reflectivities are indicated on the back of the chart. Let us call the reflectivity of our standard $\rho_{standard}$, the pixel color of the standard in our image $L_{standard}$, and the pixel color of the paint sample used for the diffuse sphere L_{paint}. Then the reflectivity ρ_{paint} of the paint is simply:

$$\rho_{paint} = \rho_{standard} \frac{L_{paint}}{L_{standard}}.$$

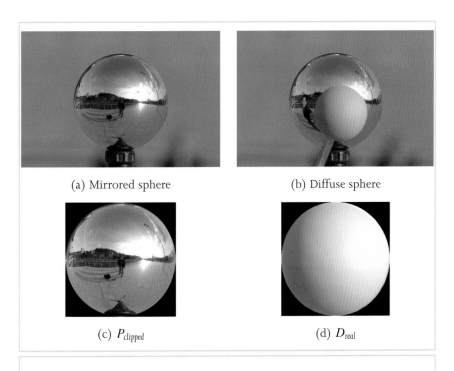

(a) Mirrored sphere

(b) Diffuse sphere

(c) P_{clipped}

(d) D_{real}

FIGURE 9.14 *(a) A mirrored sphere photographed as a single LDR exposure with direct sunlight. The bright sun becomes a saturated region of pixels clipped to white. (b) A gray diffuse sphere photographed in the same illumination, held several inches in front of the mirrored sphere. (c) The cropped, reflectance-calibrated, and clipped mirrored sphere image P_{clipped}. (d) The cropped and reflectance-calibrated image of the diffuse sphere D_{real}.*

For the diffuse paint used to paint the sphere in Figure 9.14(b), the reflectivity was measured to be (0.320, 0.333, 0.346) in the red, green, and blue channels, indicating that the chosen paint is very slightly bluish. Dividing the pixel values of the diffuse sphere by its reflectivity yields the appearance of the diffuse sphere as if it were 100% reflective, or perfectly white; we call this image D_{real} (see Figure 9.14(d)).

Likewise, the image of the mirrored sphere should be divided by the mirrored sphere's reflectivity as described in Section 9.3.1 and Figure 9.10 to produce the image that would have been obtained from a perfectly reflective mirrored sphere.

With both sphere images calibrated, we can use IBL to light a synthetic white sphere with the clipped lighting environment image, which we call D_{clipped} in Figure 9.15. As expected, this synthetic sphere appears darker than the real sphere in the actual lighting environment D_{real}. If we subtract D_{clipped} from D_{real}, we obtain an image of the missing reflected light from the sun region (which we call D_{sun}). This operation leverages the additive property of light, described in detail in Section 9.9.

From the previous section we know that the sun is a 0.53-degree disk in the sky. To properly add such a source to P_{clipped}, it should be placed in the right direction and assigned the correct radiant intensity. The direction of the sun can usually be estimated from the clipped light probe image as the center of the saturated region in the image. The pixel coordinates (u, v) in this image can be converted to a direction vector (D_x, D_y, D_z) using the ideal sphere-mapping formula discussed in Section 9.4.1. If the saturated region is too large to locate the sun with sufficient precision, it is helpful to have at least one additional photograph of the mirrored

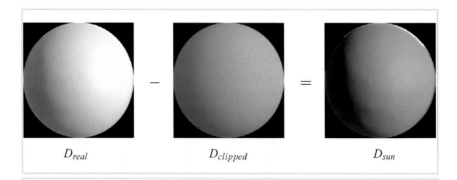

D_{real} $D_{clipped}$ D_{sun}

FIGURE 9.15 The calibrated image of the real diffuse sphere D_{real}, minus the image of a synthetic diffuse sphere lit by the clipped IBL environment D_{clipped}, yields an image of the missing light from the sun D_{sun}.

sphere taken with a shorter exposure time, or a photograph of a black plastic sphere in which the sun's position can be discerned more accurately. In this example, the sun's direction vector was measured as $(0.748, 0.199, 0.633)$ based on its position in the mirrored sphere image.

To determine the sun's radiance, we know that if the sun alone were to illuminate a white diffuse sphere the sphere should appear similar to D_{sun}. We begin by creating a sun disk with direction $(0.748, 0.199, 0.633)$, an angular extent of 0.53 degrees diameter, and an experimental radiance value of $L_{suntest} = 46,700$. The specification for such a light source in a rendering file might look as follows.

```
light sun directional {
    direction 0.748   0.199   0.633
    angle 0.5323
    color 46700 46700 46700
}
```

The value 46,700 is chosen for convenience to be the radiant intensity of a 0.53 degrees diameter infinite light source that illuminates a diffuse white sphere such that its brightest spot (pointing toward the source) has a radiance of 1. Lighting a white sphere with this source produces the image $D_{suntest}$ seen in Figure 9.16.

From the equation shown in Figure 9.16, we can solve for the unknown color α that best scales $D_{suntest}$ to match D_{sun}. This is easily accomplished by dividing the average pixel values of the two images: $\alpha = avg(D_{sun})/avg(D_{suntest})$. Then, we can compute the correct radiant intensity of the sun as $L_{sun} = \alpha L_{suntest}$. For this example, applying this procedure to each color channel yields $\alpha = (1.166, 0.973, 0.701)$, which produces $L_{sun} = (54500, 45400, 32700)$. Replacing the $L_{suntest}$ value in the directional light specification file with this new L_{sun} value produces a directional light that models the missing sunlight in the clipped light probe image.

We can validate the accuracy of this procedure by lighting a diffuse sphere with the combined illumination from the clipped probe $P_{clipped}$ and the reconstructed sun. Figures 9.17(a) and (b) show a comparison between the real diffuse sphere D_{real} and a synthetic diffuse sphere illuminated by the recovered environment. Subtracting (a) from (b) (shown in Figure 9.17(c)) allows us to visually and quantitatively verify the accuracy of the lighting reconstruction. The difference image is nearly black, which indicates a close match. In this case, the root mean squared intensity

FIGURE 9.16 Lighting a white sphere (D_{suntest}) from the direction of the sun with an experimental radiant intensity L_{suntest} sets up an equation to determine the missing light from the sun.

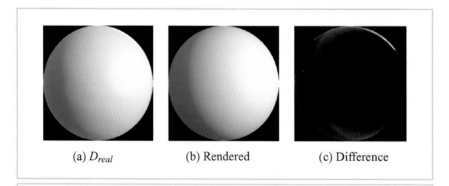

FIGURE 9.17 (a) The calibrated diffuse sphere D_{real} in the lighting environment. (b) A rendered diffuse sphere, illuminated by the incomplete probe P_{clipped} and the recovered sun. (c) The difference between the two. The nearly black image indicates that the lighting environment was recovered accurately.

difference between the real and simulated spheres is less than 2%, indicating a close numeric match as well. The area of greatest error is in the lower left of the difference image, which is a dim beige color instead of black due to unintended bounced light on the real sphere from the person's hand holding the sphere.

At this point, the complete lighting environment is still divided into two pieces: the clipped IBL environment and the directional sun source. To unify them, the sun disk could be rasterized into a mirror reflection image space and then added to the clipped IBL environment. However, as we will see in Section 9.6.1, it can be a great benefit to the rendering process if concentrated lights such as the sun are simulated as direct light sources rather than as part of the IBL environment (because of the sampling problem). Figure 9.38(e) later in this chapter shows a rendering of a collection of CG objects illuminated by the combination of the separate clipped probe and the direct sun source. The appearance of the objects is realistic and consistent with their environment. The rendering makes use of an additional technique (described in Section 9.7) to have the objects cast shadows onto the scene as well.

Images with concentrated light sources such as the sun not only require additional care to acquire but also pose computational challenges for image-based lighting algorithms. Section 9.6 describes why these challenges occur and how they can be solved through importance sampling techniques. Before beginning that topic, we will describe some of the omnidirectional image-mapping formats commonly used to store light probe images.

9.4 OMNIDIRECTIONAL IMAGE MAPPINGS

Once a light probe image is captured, it needs to be stored in an image file using an omnidirectional image mapping. This section describes four of the most commonly used image mappings and provides formulas to determine the appropriate (u, v) coordinates in the image corresponding to a unit direction in the world $D = (D_x, D_y, D_z)$, and vice versa. These formulas all assume a right-handed coordinate system in which $(0, 0, -1)$ is forward, $(1, 0, 0)$ is right, and $(0, 1, 0)$ is up.

This section also discusses some of the advantages and disadvantages of each format. These considerations include the complexity of the mapping equations, how much distortion the mapping introduces, and whether the mapping has special features that facilitate computing properties of the image or using it with specific

rendering algorithms. The mappings this section presents are the *ideal mirrored sphere*, the *angular map*, *latitude-longitude*, and the *cube map*.

9.4.1 IDEAL MIRRORED SPHERE

For the ideal mirrored sphere we use a circle within the square image domain of $u \in [0, 1]$, $v \in [0, 1]$. The mapping equation for world to image is as follows.

$$r = \frac{\sin(\frac{1}{2} \arccos(-D_z))}{2\sqrt{D_x{}^2 + D_y{}^2}}$$

$$(u, v) = \left(\frac{1}{2} + r D_x , \; \frac{1}{2} - r D_y \right)$$

The mapping equation for image to world is as follows.

$$r = \sqrt{(2u - 1)^2 + (2v - 1)^2}$$

$$(\theta, \phi) = (\text{atan2}(2u - 1, -2v + 1), 2 \arcsin(r))$$

$$(D_x, D_y, D_z) = (\sin \phi \cos \theta, \sin \phi \sin \theta, -\cos \phi)$$

The ideal mirrored sphere mapping (Figure 9.18(a)) is how the world looks when reflected in a mirrored sphere, assuming an orthographic camera and a world that is distant relative to the sphere's diameter. In practice, real spheres exhibit a mapping similar to this ideal one as long as the sphere is small relative to its distance to the camera and to the objects in the environment. Of course, the reflection in a sphere is actually a mirror image of the environment, and thus the image should be flipped in order to be consistent with directions in the world.

 Like all mappings in this section, the ideal mirrored sphere reflects all directions of the environment. Straight forward — that is, $D = (0, 0, -1)$ — appears in the center of the image. Straight right, $D = (1, 0, 0)$, appears $\frac{\sqrt{2}}{2}$ of the way from the center to the right-hand edge of the image. Straight up appears $\frac{\sqrt{2}}{2}$ of the way from the center to the top of the image. Straight back is the one direction that

<div align="center">(a) (b)</div>

FIGURE 9.18 (a) *The ideal mirrored sphere mapping.* (b) *the angular map mapping. The mappings appear similar, but devote different amounts of image area to the front versus the back half of the environment.*

does not cleanly map to a particular image coordinate, and corresponds to the outer circumference of the circle's edge.

From these coordinates, we see that the front half of the environment is contained within a disk that is $\frac{\sqrt{2}}{2}$ of the diameter of the full image. This makes the area taken up by the front half of the environment precisely equal to the area taken up by the back half of the environment. This property generalizes in that any two regions of equal solid angle in the scene will map to the same amount of area in the image. One use of this equal-area property is to calculate the average illumination color in a light probe (the average pixel value within the image circle is the average value in the environment). If the image has a black background behind

the circular image, the average value in the scene is $\frac{4}{\pi}$ of the average of the entire square.

A significant disadvantage with the mirrored sphere mapping is that the back half of the environment becomes significantly stretched in one direction and squeezed in the other. This problem increases in significance toward the outer edge of the circle, becoming extreme at the edge. This can lead to the same problem we saw with mirrored sphere light probe images, in that the regions around the edge are poorly sampled in the radial direction. Because of this, the mirrored sphere format is not a preferred format for storing omnidirectional images, and the angular map format is frequently used instead.

9.4.2 ANGULAR MAP

For the angular map we also use a circle within the square image domain of $u \in [0, 1]$, $v \in [0, 1]$. The mapping equation for world to image is as follows.

$$r = \frac{\arccos(-D_z)}{2\pi\sqrt{D_x{}^2 + D_y{}^2}}$$

$$(u, v) = \left(\frac{1}{2} - rD_y, \frac{1}{2} + rD_x\right)$$

The equation for image to world is as follows.

$$(\theta, \phi) = \left(\text{atan2}(-2v + 1, 2u - 1), \phi = \pi\sqrt{(2u - 1)^2 + (2v - 1)^2}\right)$$

$$(D_x, D_y, D_z) = (\sin\phi\cos\theta, \sin\phi\sin\theta, -\cos\phi)$$

The angular map format (Figure 9.18(b)) is similar in appearance to the mirrored sphere mapping, but it samples the directions in a manner that avoids undersampling the regions around the edges. In this mapping, the distance of a point from the center of the image is directly proportional to the angle between straight ahead and its direction in the world. In this way, straight forward appears at the center of the image, and straight right and straight up appear halfway to the edge of the image. Regions that map near the edge of the sphere are sampled with at least

as many pixels per degree in any direction as the center of the image. Because of
this property, many light probe images (including those in the Light Probe Image
Gallery [160]) are available in this format. Unlike the mirrored sphere mapping,
the angular map is not equal area, and does not translate solid angle proportion-
ately into image area. Areas near the edge become stretched in the direction tangent
to the circumference but are neither stretched nor squeezed in the perpendicular
direction, making them overrepresented in the mapping.

Because the mirrored sphere and angular map mappings appear similar, some-
times an angular map image is loaded into a rendering program as if it were a
mirrored sphere image, and vice versa. The result is that the environment becomes
distorted, and straight vertical lines appear curved. One way to tell which mapping
such an image is in is to convert it to the latitude-longitude format (in which ver-
tical lines should be straight) or the cube map format, in which all straight lines
should be straight except at face boundaries.

9.4.3 LATITUDE-LONGITUDE

For the latitude-longitude mapping we use a rectangular image domain of $u \in$
$[0, 2]$, $v \in [0, 1]$. The mapping equation for world to image is as follows.

$$(u, v) = \left(1 + \frac{1}{\pi} \operatorname{atan} 2(D_x, -D_z), \frac{1}{\pi} \arccos D_y\right)$$

The equation for image to world is as follows.

$$(\theta, \phi) = (\pi(u - 1), \pi v)$$

$$(D_x, D_y, D_z) = (\sin\phi \sin\theta, \cos\phi, -\sin\phi \cos\theta)$$

The latitude-longitude mapping (Figure 9.19(a)) maps a direction's azimuth to the
horizontal coordinate and its elevation to the vertical coordinate of the image. This
is known to cartographers as an *equirectangular mapping*. Unlike the previous two map-
pings, it flattens the sphere into a rectangular area. The top edge of the image cor-
responds to straight up, and the bottom edge of the image is straight down. The
format most naturally has a 2:1 aspect ratio (360 degrees by 180 degrees), as this in-
troduces the least distortion for regions near the horizon. The areas toward straight

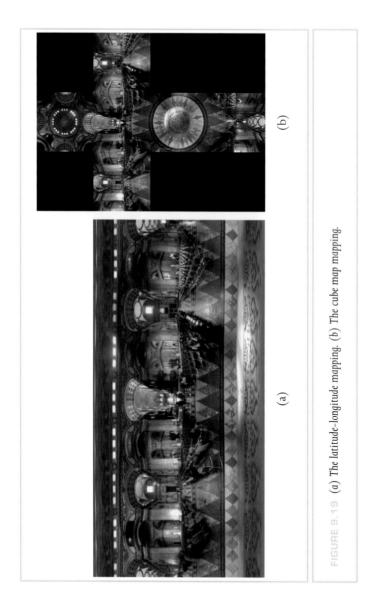

(a)

(b)

FIGURE 9.19 *(a) The latitude–longitude mapping. (b) The cube map mapping.*

up and straight down are sampled equivalently with the regions near the horizon in the vertical direction, and are progressively more oversampled toward the top and bottom edges.

The latitude-longitude mapping is convenient because it is rectangular and has no seams (other than at the poles), and because the mapping formulas are simple and intuitive. Although straight lines generally become curved in this format, vertical lines in the scene map to straight vertical lines in the mapping. Another useful property is that in this format the lighting environment can be rotated around the y axis simply by translating the image horizontally. The mapping is not equal area (the percentage any particular area is overrepresented is inversely proportional to the cosine of the latitude ϕ). Thus, to find the average pixel value in a light probe image in this format one can multiply the image by the vertical cosine falloff function $\cos \phi$ and compute the average value of these modified pixels.

9.4.4 CUBE MAP

For the cube map we use a rectangular image domain of $u \in [0, 3]$, $v \in [0, 4]$. The cube map formulas require branching to determine which face of the cube corresponds to each direction vector or image coordinate. Thus, they are presented as pseudocode. The code for world to image is as follows.

```
if ((Dz<0) && (Dz<=-abs(Dx))
           && (Dz<=-abs(Dy))) // forward
   u = 1.5 - 0.5 * Dx / Dz;
   v = 1.5 + 0.5 * Dy / Dz;
else if ((Dz>=0) && (Dz>=abs(Dx))
                  && (Dz>=abs(Dy))) // backward
   u = 1.5 + 0.5 * Dx / Dz;
   v = 3.5 + 0.5 * Dy / Dz;
else if ((Dy<=0) && (Dy<=-abs(Dx))
                  && (Dy<=-abs(Dz))) // down
   u = 1.5 - 0.5 * Dx / Dy;
   v = 2.5 - 0.5 * Dz / Dy;
else if ((Dy>=0) && (Dy>=abs(Dx))
                  && (Dy>=abs(Dz))) // up
```

```
  u = 1.5 + 0.5 * Dx / Dy;
  v = 0.5 - 0.5 * Dz / Dy;
else if ((Dx<=0) && (Dx<=-abs(Dy))
                 && (Dx<=-abs(Dz))) // left
  u = 0.5 + 0.5 * Dz / Dx;
  v = 1.5 + 0.5 * Dy / Dx;
else if ((Dx>=0) && (Dx>=abs(Dy))
                 && (Dx>=abs(Dz))) // right
  u = 2.5 + 0.5 * Dz / Dx;
  v = 1.5 - 0.5 * Dy / Dx;
```

The code for image to world is as follows.

```
if u>=1 and u<2 and v<1 // up
  Vx = (u - 1.5) * 2
  Vy = 1.0
  Vz = (v - 0.5) * -2
else if u<1 and v>=1 and v<2 // left
  Vx = -1.0
  Vy = (v - 1.5) * -2
  Vz = (u - 0.5) * -2
else if u>=1 and u<2 and v>=1 and v<2 // forward
  Vx = (u - 1.5) * 2
  Vy = (v - 1.5) * -2
  Vz = -1.0
else if u>=2 and v>=1 and v<2 // right
  Vx = 1.0
  Vy = (v - 1.5) * -2
  Vz = (u - 2.5) * 2
else if u>=1 and u<2 and v>=2 and v<3 // down
  Vx = (u - 1.5) * 2
  Vy = -1.0
  Vz = (v - 2.5) * 2
else if u>=1 and u<2 and v>=3 // backward
  Vx = (u - 1.5) * 2
  Vy = (v - 3.5) * 2
```

```
Vz = 1.0

normalize = 1 / sqrt(Vx * Vx + Vy * Vy + Vz * Vz)

Dx = normalize * Vx
Dy = normalize * Vy
Dz = normalize * Vz
```

In the cube map format (Figure 9.19(b)) the scene is represented as six square perspective views, each with a 90-degree field of view, which is equivalent to projecting the environment onto a cube and then unfolding it. The six squares are most naturally unfolded into a horizontal or vertical cross shape but can also be packed into a 3 × 2 or 6 × 1 rectangle to conserve image space. The mapping is not equal area (areas in the corners of the cube faces take up significantly more image area per solid angle than the areas in the center of each face). However, unlike the angular map and latitude-longitude mappings, this relative stretching is bounded: angular areas that map to the cube's corners are overrepresented by a factor of up to $3\sqrt{3}$ in area relative to regions in the center.

This mapping requires six different formulas to convert between world directions and image coordinates, depending on which face of the cube the pixel falls within. Although the equations include branching, they can be more efficient to evaluate than the other mappings (which involve transcendental functions such as *asin* and *atan*2). This image format is sometimes the most convenient for editing the light probe image, because straight lines in the environment remain straight in the image (although there are generally directional discontinuities at face boundaries). For showing a light probe image in the background of a real-time rendering application, the image mapping is straightforward to texture map onto a surrounding cubical surface.

9.5 HOW A GLOBAL ILLUMINATION RENDERER COMPUTES IBL IMAGES

Returning to the rendering process, it is instructive to look at how a global illumination algorithm computes IBL images such as those seen in Figure 9.4. In general, the algorithm needs to estimate how much light arrives from the lighting environment

and the rest of the scene at each surface point, which in large part is a matter of visibility: light from the visible parts of the environment must be summed, and light that is blocked by other parts of the scene must instead be replaced by an estimate of the light reflecting from those surfaces. This measure of incident illumination, multiplied by the reflectance of the surface itself, becomes the color rendered at a particular pixel in the image.

The RNL animation was rendered with RADIANCE [205], which like most modern global illumination systems is based on ray tracing. The image is rendered one pixel at a time, and for each pixel the renderer needs to determine the RGB color L to display for that pixel. In our case, L is an HDR RGB pixel value, with its three components proportional to the amount of red, green, and blue radiance arriving toward the camera in the direction corresponding to the pixel. For each pixel, a ray R is traced from the camera C (Figure 9.20(a)) until it hits a surface in the scene at a 3D point P. L is then computed as a function of the reflectance properties of the surface at P and the incident light arriving at P. This section lists the different types of surfaces R can hit and how the rendering system then computes their appearance as lit by the scene. We will see that the most costly part of the process is computing how light reflects from diffuse surfaces. Later in this chapter, we will see how understanding this rendering process can motivate techniques for increasing the rendering efficiency.

Case 1: R Hits the IBL Environment If the ray strikes the emissive surface surrounding the scene at point P (Figure 9.20(a)), the pixel color L in the rendering is computed as the color from the light probe image that was texture mapped onto the surface at P. In RNL, this could be a green color from the leaves of the trees, a bright blue color from the sky, or a brown color from the ground below, depending on which pixel and where the camera is looking. The HDR range of the surrounding environment is transferred to the resulting HDR renderings.

In this case, the renderer does not take into consideration how the surface at point P is being illuminated, because the surface is specified to be emissive rather than reflective. This is not exactly how light behaves in the real world, in that most objects placed in a scene have at least a minute effect on the light arriving at all other surfaces in the scene. In RNL, however, the only place where this might be noticeable is on the ground close to the pedestal, which might receive less light

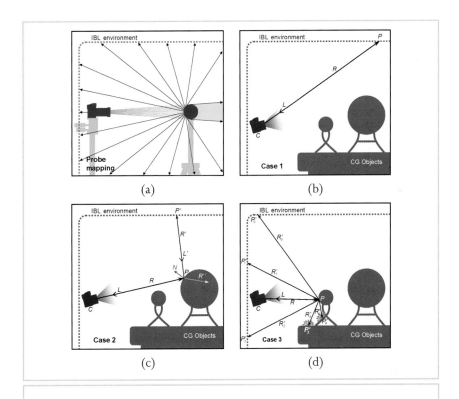

FIGURE 9.20 **Probe mapping:** *A mirrored sphere reflects the entire surrounding environment* *except for the light blue area obscured by the ball. The ideal mirrored sphere mapping (see Sec-* *tion 9.4.1) maps a light probe image onto an IBL environment surface.* **Case 1:** *A ray* R *sent* *from the virtual camera* C *hits the IBL environment surface at* P. *The HDR value* L *on the* *surface is copied to the image pixel.* **Case 2:** R *hits a specular surface of a CG object. The reflected* *ray* R' *is traced, in this case striking the IBL environment at* P' *with an HDR value of* L'. L' *is multiplied by the object's specular color to determine the final pixel value* L. *(For a translucent* *surface, a refracted ray* R'' *is also traced.)* **Case 3:** R *hits a diffuse surface at* P. *A multitude of* *rays* R'_i *are traced into the scene to determine the irradiance* E *at* P *as a weighted average of the* *incident light values* L'_i *from points* P'_i. E *is multiplied by the diffuse object color to determine* *the final pixel value* L.

from the environment due to shadowing from the pedestal. Because this area was not seen in the RNL animation, the effect did not need to be simulated.

Case 2: R **Hits a Mirror–like Specular Surface** A mirror-like specular surface having no roughness shows a clear image of the scene around it. In RNL, the glass, plastic, and metallic spheres have mirror-like specular components. When the ray R hits such a surface at a point P (Figure 9.20(b)), the renderer reflects the ray about P's surface normal N and follows this reflected ray R' into the scene until it strikes a new surface at point P'. It then recursively computes the color L' of the light coming from P' along R' toward P in precisely the same way it computes the light coming from a point P along R toward the camera. For example, if R' strikes the emissive surface surrounding the scene at P', the renderer retrieves the appropriate pixel color L' from the surrounding light probe image (an instance of Case 1). The recursion depth for computing bounces of light is usually limited to a user-defined number, such as six bounces for specular reflections and two bounces for diffuse reflections.

The incident light L' along the reflected ray is then used to produce the specular component of the resulting light L reflecting from the surface. For metals, this light is multiplied by the metallic color of the surface. For example, a gold material might have a metallic color of (0.8, 0.6, 0.3). Because these color components are less than 1, the metallic reflection will reveal some of the detail in the reflected HDR environment not seen directly.

For glass-like materials, the mirror-like specular component is fainter, typically in the range of 4 to 8% (though at grazing angles it becomes greater due to Fresnel reflection), depending on the index of refraction of the material. Thus, the light L' is multiplied by a small value to create the specular component of the color L in the image. In the case of RNL, this makes the bright sky detail particularly evident in the reflections seen in the top of the large glass ball (as in Figure 9.4(a)). For glass-like materials, a second refracted ray R'' is also traced through the translucent surface, and the light L'' arriving along this ray is added to the total light L reflected toward the camera.

For plastic materials, there is both a specular component and a diffuse component to the reflection. For such materials the specular component is computed in the same way as the specular component of glass-like materials and is added to the diffuse component, which is computed as described in material following.

Case 3: R **Hits a Diffuse Surface** Diffuse surfaces reflect light equally in all directions, and light arriving from every direction in the upper hemisphere of the surface contributes to the reflected light. Because of this, computing the light reflecting from diffuse surfaces can be computationally expensive. The total amount of light arriving at a surface point P is called its *irradiance*, denoted by E, which is a weighted integral of all colors L_i' arriving along all rays R_i' (Figure 9.20(c)). The contribution of each ray R_i' is weighted by the cosine of the angle θ_i between it and the surface normal N, because light arriving from oblique angles provides less illumination per unit area. If we denote $L'(P, \omega)$ to be the function representing the incident light arriving at P from the angular direction ω in P's upper hemisphere Ω, E can be written as

$$E(P, N) = \int_\Omega L'(P, \omega) \cos\theta \, d\omega.$$

Unfortunately, E cannot be computed analytically, because it is dependent on not just the point's view of the environment but also on how this light is occluded and reflected by all other surfaces in the scene visible to the point. To estimate E, the renderer takes a weighted average of the light colors L_i' arriving from a multitude of rays R_i' sent out from P to sample the incident illumination. When a ray R_i' strikes the surface surrounding the scene, it adds the corresponding pixel color L_i' from the lighting environment to the sum, weighted by the cosine of the angle between N and R_i'. When a ray R_i' strikes another part of the scene P_i', the renderer recursively computes the color of light L_i' reflected from P_i' toward P and adds this to the sum as well, again weighted by $\cos\theta$. Finally, E is estimated as this sum divided by the total number of rays sent out, as follows.

$$E(P, N) \approx \frac{1}{k} \sum_{i=0}^{k-1} L_i' \cos\theta_i$$

The accuracy of the estimate of E increases with the number of rays k sent out from P. Once E is computed, the final light L drawn for the pixel is the surface's diffuse color (called its *albedo*, often denoted by ρ) multiplied by the irradiance E.

Computing the integral of the incident illumination on an object's surface performs a blurring process on the HDR light probe image that is similar to the blurring

we have seen in Section 9.2.5. HDR pixels in the image are averaged together according to a filter, in this case a blur over the upper hemisphere. Just as before, this process makes the effect of HDR pixel values in an environment visible in the much lower dynamic range values reflecting from diffuse surfaces. Clipping the lighting environment to a display's white point before computing the lighting integral would significantly change the values of the computed irradiance.

Because many rays must be traced, the process of sampling the light arriving from the rest of the scene at a point can be computationally intensive. When rays are sent out at random, the number of rays needed to estimate the incident illumination to a given expected accuracy is proportional to the variance of the illumination within the scene. To conserve computation, some renderers (such as RADIANCE) can compute E for a subset of the points P in the scene, and for other points interpolate the irradiance from nearby samples — a process known as *irradiance caching*. Furthermore, irradiance samples computed for one frame of an animation can be reused to render subsequent frames, as long as the scene remains static. Both of these features were used to reduce the rendering time for the RNL animation by a factor of several thousand.

9.5.1 SAMPLING OTHER SURFACE REFLECTANCE TYPES

In RNL, all of the surfaces had either a mirror-like specular component or completely diffuse reflectance, or a combination of the two. Other common material types include rough specular reflections and more general bidirectional reflectance distribution functions (BRDFs) [190] that exhibit behaviors such as retroreflection and anisotropy. For such surfaces, the incident illumination needs to be sampled according to these more general distributions. For example, in the case of rough specular surfaces the rendering system needs to send out a multitude of rays in the general direction of the reflected angle R' with a distribution whose spread varies with the specular roughness parameter. Several BRDF models (such as Lafortune et al. [178] and Ashikhmin and Shirley [153]) have associated sampling algorithms that generate reflected ray directions in a distribution that matches the relative contribution of incident light directions for any particular viewing direction. Having such *importance sampling* functions is very help-

ful for computing renderings efficiently, as the alternative is to send out significantly more rays with a uniform distribution and weight the incident light arriving along each ray according to the BRDF. When the number of rays is limited, this can lead to noisy renderings in comparison to sampling in a distribution that matches the BRDF. Figure 9.21 shows an example of this difference from Lawrence et al. [181].

In general, using more samples produces higher-quality renderings with more accurate lighting and less visible noise. We have just seen that for different types of materials renderings are created most efficiently when samples are chosen according to a distribution that matches the relative importance of each ray to the final appearance of each pixel. Not surprisingly, the importance of different ray direc-

(a) (b)

FIGURE 9.21 IBL renderings of a pot from [181] computed with 75 rays per pixel to sample the incident illumination for a vase with a rough specular BRDF. (a) Noisy results obtained by using uniform sampling and modulating by the BRDF. (b) A result with less noise obtained by sampling with a distribution based on a factored representation of the BRDF.

tions depends on not only the BRDF of the material but on the distribution of the incident illumination in the environment. To render images as efficiently as possible, it becomes important to account for the distribution of the incident illumination in the sampling process, particularly for IBL environments with bright concentrated light sources. The next section presents this problem and describes solutions for sampling incident illumination efficiently.

9.6 SAMPLING INCIDENT ILLUMINATION EFFICIENTLY

We have just seen that the speed at which images can be computed using IBL as described in the previous section depends on the number of rays that need to be traced. The bulk of these rays are traced to estimate the illumination falling upon diffuse surfaces through sampling. The light falling on a surface (i.e., its irradiance E) is the average value of the radiance arriving along all light rays striking the surface, weighted by the cosine of the angle each ray makes with the surface normal. Because averaging together the light from every possible ray is impractical, global illumination algorithms estimate the average color using just a finite sampling of rays. This works very well when the lighting environment is generally uniform in color. In this case the average radiance from any small set of rays will be close to the average from all of the rays because no particular ray strays far from the average value to begin with. However, when lighting environments have some directions that are much brighter than the average color, it is possible for the average of just a sampling of the rays to differ greatly from the true average.

When ray directions are chosen at random, the number of rays needed to accurately sample the illumination is proportional to the variance in the light probe image. Lighting environments that have low variance (such as cloudy skies) can be sampled accurately with just tens of rays per irradiance calculation. Environments with greater variance, such as scenes with concentrated light sources, can require hundreds or thousands of rays per irradiance calculation when rays are sent out at random. The Eucalyptus Grove light probe, which featured bright backlit clouds in the direction of the setting sun, required over 1,000 rays per irradiance calculation, making rendering RNL computationally expensive. In this section, we describe this sampling problem in detail and present several sampling techniques that mitigate the difficulties.

FIGURE 9.22 *A laser-scanned 3D model of the Parthenon illuminated by a uniformly white lighting environment, giving the appearance of a dense cloudy day.*

Figure 9.22 shows a virtual model of the Parthenon rendered with IBL using a synthetic lighting environment of a completely white sky.[5] This environment, being all the same color, has zero variance, and a high-quality rendering could be computed using the Arnold global illumination rendering system [167] using a relatively modest 81 rays to sample the incident light at each pixel. The only source of illumination variance at each surface point is due to visibility: some directions see out to the sky, whereas others see indirect light from the other surfaces in the scene. Because the color of the indirect light from these other surfaces is also low in variance and not radically different from the light arriving from the sky, the

- -

5 The virtual Parthenon model was created by laser scanning the monument and using an inverse global illumination process leveraging image-based lighting to solve for its surface colors and reflectance properties from photographs, as described in Debevec et al. [163].

FIGURE 9.23 *A light probe image of a sunny sky, taken with a fish-eye lens. Pixels on the sun disk (much smaller than the saturated region seen here) are on the order of 100,000 times brighter than the average color of the rest of the sky.*

total variance remains modest and the illumination is accurately sampled using a relatively small number of rays.

In contrast to the perfectly even sky, Figure 9.23 shows a clear sky with a directly visible sun, acquired using the technique in Stumpfel et al. [200]. The half-degree disk of the sun contains over half the sky's illumination but takes up only one hundred thousandth of the sky's area, giving the sunny sky a very high variance. If we use such a high-variance environment to illuminate the Parthenon model, we obtain the noisy rendering seen in Figure 9.24. For most of the pixels, none of the 81 rays sent out to sample the illumination hit the small disk of the sun, and thus they appear only to be lit by the light from the sky and clouds. For the pixels where one of the rays did hit the sun, the sun's contribution is greatly overestimated, because the sun is counted as $\frac{1}{81}$ of the lighting environment rather than one hundred

FIGURE 9.24 The virtual Parthenon rendered using the sunny sky light probe in Figure 9.23 with 81 lighting samples per pixel. The appearance is speckled because 81 samples distributed randomly throughout the sky are not enough to accurately sample the small disk of the sun.

thousandth. These pixels are far brighter than what can be shown in an LDR image, and their intensity is better revealed by blurring the image somewhat (as in Figure 9.25). On average, this image shows the correct lighting, but the appearance is strange because the light from the sun has been squeezed into a random scattering of overly bright pixels.

The noisy Parthenon rendering shows what is known as the *sampling problem*. For lighting environments with concentrated sources, a very large number of rays needs to be sent in order to avoid noisy renderings. For the sunny sky, hundreds of thousands of rays would need to be sent to reliably sample the small sun and the large sky, which is computationally impractical. Fortunately, the number of rays can be

FIGURE 9.25 *A Gaussian blurred version of Figure 9.24, showing more clearly the amount of reflected sun energy contained in just a few of the image pixels.*

reduced to a manageable number using several techniques. In each technique, the key idea is to give the rendering algorithm *a priori* information about how to sample the illumination environment efficiently. These techniques (described in material following) include *light source identification*, *light source constellations*, and *importance sampling*.

9.6.1 IDENTIFYING LIGHT SOURCES

The ray sampling machinery implemented in traditional global illumination algorithms typically only samples the indirect lighting within a scene. Concentrated light sources are assumed to be explicitly modeled and taken into account in the direct lighting calculation in which rays are sent to these lights explicitly. In image-

based lighting, both direct and indirect sources are effectively treated as indirect illumination, which strains the effectiveness of this sampling machinery.

Many IBL environments can be partitioned into two types of areas: small concentrated light sources and large areas of indirect illumination. These types of environments fare poorly with simplistic sampling algorithms, in that much of the illumination is concentrated in small regions that are easily missed by randomly sampled rays. One method of avoiding this problem is to identify these small concentrated light regions and convert them into traditional area light sources. These new area light sources should have the same shape, direction, color, and intensity as seen in the original image, and the corresponding bright regions in the image-based lighting environment must be removed from consideration in the sampled lighting computation. This yields the type of scene that traditional global illumination algorithms are designed to sample effectively.

For the sunny sky light probe, this process is straightforward. The direction of the sun can be determined as the centroid of the brightest pixels in the image, converted to a world direction vector using the angular mapping formula in Section 9.4.2. As mentioned earlier in this chapter, the size and shape of the sun is known to be a disk whose diameter subtends 0.53 degrees of the sky. The color and intensity of the sun can be obtained from the light probe image as the average RGB pixel value of the region covered by the sun disk. In a typical rendering system a specification for such a light source might look as follows.

```
light sun directional {
    direction -0.711743 -0.580805 -0.395078
    angle 0.532300
    color 10960000 10280000 866000
}
```

Figure 9.26 shows a global illumination rendering of the Parthenon illuminated just by the sun light source. For each pixel, the renderer explicitly sends at least one ray toward the disk of the sun to sample the sun's light because the sun is a direct light source known *a priori* to the renderer. Thus, the rendering has no noise problems, as in Figure 9.24. Although the rest of the sky is black, the renderer still sends additional randomly fired rays from each surface to estimate the indirect illumination arriving from other surfaces in the scene. These effects are most significant in the case of shadowed surfaces that are visible to sunlit surfaces, such as the left sides of

FIGURE 9.26 *The Parthenon illuminated only by the sun, simulated as a direct light source.*

the front columns. Because the blue skylight scattered by the atmosphere is not being simulated, the rendering shows how the Parthenon might look if it were located on the moon and illuminated by a somewhat yellowish sun.

The rest of the sky's illumination can be simulated using an image-based lighting process, but we first need to make sure that the light from the sun is no longer considered to be part of the image-based lighting environment. In some rendering systems, it is sufficient to place the new direct light source in front of the IBL environment surface and it will occlude the image-based version of the source from being hit by indirect sample rays. In others, the corresponding image region should be set to black in order to prevent it from being part of the image-based illumination. If we remove the sun from the sky and use the remainder of the image as an IBL environment, we obtain the rendering seen in Figure 9.27. This rendering,

FIGURE 9.27 *The Parthenon illuminated only by the sky and clouds, with 81 samples per pixel.*

although it lacks sunlight, is still a realistic one. It shows the scene approximately as if a cloud had passed in front of the sun.

In practice, it is sometimes necessary to delete a somewhat larger area around the light source from the IBL environment, because some light sources have significantly bright regions immediately near them. These regions on their own can contribute to the appearance of noise in renderings. Sometimes, these regions are due to glare effects from imperfect camera optics. In the case of the sun, forward scattering effects in the atmosphere creates a bright circumsolar region around the sun. Because of both of these effects, to create the sky used for Figure 9.27 a region covering the circumsolar area was removed from the light probe image, and this additional light energy was added to the sun intensity used to render Figure 9.26.

FIGURE 9.28 *An efficient noise-free rendering of the Parthenon made using IBL for the sky and clouds and a direct light source for the sun, with 81 samples per pixel.*

As a result, the edges of shadows in the sun rendering are slightly sharper than they should be, but the effect is a very subtle one.

Finally, we can light the scene with the sun and sky by simultaneously including the IBL environment for the sky and clouds and the direct light source for the sun in the same rendering, as seen in Figure 9.28. (We could also just add the images from Figures 9.26 and 9.27 together.) This final rendering shows the combined illumination from the sun and the rest of the sky, computed with a relatively modest 81 sample rays per pixel.

Identifying light sources can also be performed for more complex lighting environments. The SIGGRAPH 99 Electronic Theater animation *Fiat Lux* used an IBL environment created from HDR images acquired in St. Peter's Basilica. It was ren-

dered with the RADIANCE lighting simulation system. The images were assembled into HDR panoramas and projected onto the walls of a basic 3D model of the Basilica's interior, seen in Figure 9.29(b). The illumination within the Basilica consisted of indirect light from the walls and ceiling, as well as concentrated illumination from the windows and the incandescent lights in the vaulting. To create renderings efficiently, each of the concentrated area lights' sources was identified by drawing a polygon around the source in the panoramic image, as seen in Figure 9.29(a). A simple program computed the average HDR pixel value of the region covered by each light source, and created an area light source set to this value for its radiance. Just like the panoramic image, the vertices of the identified light sources were projected onto the walls of the virtual Basilica model, placing the lights at their proper 3D locations within the scene. Thus, the image-based illumination changed throughout the virtual scene, as the directional light depended on each object's 3D location relative to the light sources.

Two other details of the procedure used in *Fiat Lux* are worth mentioning. First, the light sources were placed a small distance in front of the walls of the Basilica, so that rays fired out from the surfaces would have no chance of hitting the bright regions behind the lights without having to set these regions to black. Second, the lights were specified to be "illum" light sources, a special RADIANCE light source type that is invisible to rays coming directly from the camera or from mirror-like reflections. As a result, the lights and windows appeared with their proper image-based detail when viewed directly and when seen in the reflections of the synthetic objects, even though they had been covered up by direct light sources. Figure 9.30(a) shows a frame from *Fiat Lux* in which a variety of virtual objects have been placed within the Basilica using IBL with identified light sources. Because "illum" sources were used, the motion-blurred reflections in Figure 9.30(b) reflect the original image-based light sources.

Identifying light sources dramatically reduces the number of rays needed to create noise-free renderings of a scene, and it maintains the realism and accuracy of image-based lighting. Having the concentrated sources converted to individual CG lights is also useful for art direction, as these light sources can be readily repositioned and changed in their color and brightness. These light sources can also be used in a rendering system that does not support global illumination, yielding at least an approximate version of the IBL environment. For some applications, however, it is desirable to have a fully automatic method of processing an IBL en-

(a)

(b)

(c)

FIGURE 9.29 (a) Identified light sources from (c) corresponding to the windows and the incandescent lights in the vaulting. The HDR image and the light sources were projected onto a 3D model of the Basilica interior to form a 3D lighting environment. (b) Basic 3D geometry of the Basilica interior used as the IBL environment surface. (c) An image-based lighting environment acquired inside St. Peter's Basilica.

(a)

(b)

FIGURE 9.30 (a) *A frame from the Fiat Lux animation, showing synthetic objects inserted into the Basilica, illuminated by the HDR lighting environment using identified light sources. (b) Another frame from the animation showing HDR motion blur effects in the reflections of the spinning objects. Shadows and reflections of the objects in the floor were created using the techniques described in Section 9.7.*

vironment into a description that can be rendered efficiently. The remainder of this section presents some of these automatic sampling techniques.

9.6.2 CONVERTING A LIGHT PROBE INTO A CONSTELLATION OF LIGHT SOURCES

As we saw previously, it is possible to reduce the variance in an image-based lighting environment by converting concentrated spots of illumination into direct light sources. We can carry this idea further by turning *entire* lighting environments into constellations of light sources. These approximations can eliminate noise from renderings but can introduce aliasing in shadows and highlights when not enough light sources are used. When the light source directions are chosen with care, accurate illumination can be created using a manageable number of light sources, and these lights can be used in either traditional or global illumination rendering systems.

In general, this approach involves dividing a light probe image into a number of regions, and then creating a light source corresponding to the direction, size, color, and intensity of the total light coming from each region. Each region can be represented either by a point light source, or by an area light source corresponding to the size and/or shape of the region. Figure 9.31 shows perhaps the simplest case of approximating an IBL environment with a constellation of point light sources. A light probe taken within St. Peter's Basilica was converted to a cube map (Figure 9.31(a)), and each face of the cube map was resized to become a square of just 10 by 10 pixels, seen in Figure 9.31(a). Then, a point light source was placed in the direction corresponding to each pixel on each face of the cube, and set to the color and intensity of the corresponding pixel, yielding 600 light sources. These light sources produced a low-resolution point-sampled version of the image-based lighting environment. The technique has the attractive quality that there is no sampling noise in the renderings, as rays are always traced to the same light locations. However, the technique can introduce *aliasing*, because the finite number of lights may become visible as stair-stepped shadows and fragmented specular reflections.

Figure 9.31(b) shows the results of rendering a small scene using this constellation of light sources. For both the diffuse figure and the glossy red ball the rendering is free of noise and artifacts, though the shadows and highlights from the windows and lights are not in precisely the right locations due to the finite resolution of the

(a)

(b)

FIGURE 9.31 (a) *A light probe image taken inside St. Peter's Basilica in cube map format.* (b) *An approximation of the St. Peter's lighting using a 10×10 array of point lights for each cube face. The Buddha model is courtesy of the Stanford computer graphics laboratory.*

light source constellation. For the shiny sphere, simulating the illumination from the set of point lights makes little sense because there is a vanishingly small probability that any particular reflected ray would precisely hit one of the point lights. Instead, it makes sense to use ray tracing to reflect these rays directly into the image-based lighting environment, as described in case 2 in Section 9.5. In the rendering, the mirrored sphere is shown reflecting an illustrative image composed of spots for each point light source.

The quality of approximating an IBL environment with a finite number of lights can be significantly increased if the light sources are chosen in a manner that conforms to the distribution of the illumination within the light probe image. One strategy for this is to have each light source represent approximately the same quantity of light in the image. Taking inspiration from Heckbert's median-cut color quantization algorithm [173], we can partition a light probe image in the rectangular latitude-longitude format into 2^n regions of similar light energy as follows.

1 Add the entire light probe image to the region list as a single region.
2 For each region, subdivide along the longest dimension such that its light energy is divided evenly.
3 If the number of iterations is less than n, return to step 2.

For efficiency, calculating the total energy within regions of the image can be accelerated using summed area tables [159]. Once the regions are selected, a light source can be placed in the center of each region, or alternately at each region's energy centroid, to better approximate the spatial distribution of the light within the region. Figure 9.32 shows the Grace Cathedral lighting environment partitioned into 256 light sources, and Figure 9.33 shows a small scene rendered with 16, 64, and 256 light sources chosen in this manner. Applying this technique to our simple diffuse scene, 64 lights produce a close approximation to a well-sampled and computationally intensive global illumination solution, and the 256-light approximation is nearly indistinguishable.

A few implementation details should be mentioned. First, computing the total light energy is most naturally performed on monochrome pixel values rather than RGB colors. Such an image can be formed by adding together the color channels of the light probe image, optionally weighting them in relation to the human eye's sen-

(a)

(b)

FIGURE 9.32 (a) The Grace Cathedral light probe image subdivided into 256 regions of equal light energy using the median cut algorithm. (b) The 256 light sources chosen as the energy centroids of each region. All of the lights are approximately equal in intensity. A rendering made using these lights appears in Figure 9.33(c).

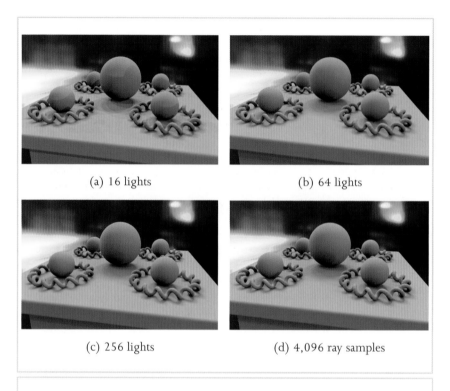

(a) 16 lights (b) 64 lights

(c) 256 lights (d) 4,096 ray samples

FIGURE 9.33 *Noise-free renderings (a through c) in the Grace Cathedral lighting environment as approximated by 16, 64, and 256 light sources chosen with the median cut algorithm. An almost noise-free Monte Carlo IBL rendering (d) needing 4,096 randomly chosen rays per pixel.*

sitivity to each color channel.[6] Partitioning decisions are made on this monochrome image, and light source colors are computed using the corresponding regions in the

. .

6 Following ITU-R BT.709, the formula used to convert RGB color to monochrome luminance is $Y = 0.2125R + 0.7154G + 0.0721B$.

original color image. Second, the latitude-longitude format overrepresents the area of regions near the poles. To compensate for this, the pixels of the probe image should first be scaled by $\cos\phi$. Additionally, determining the longest dimension of a region should also take this stretching into account. This can be approximated by multiplying a region's width by $\cos\phi$, where ϕ is taken to be the angle of inclination of the middle of the region.

Several other light source selection procedures have been proposed for approximating light probe images as constellations of light sources. In each, choosing these point light source positions is also done with a clustering algorithm.

The LightGen plug-in [158] for HDR Shop [202] takes a light probe image in latitude-longitude format and outputs a user-specified number of point light sources in a variety of 3D modeling program formats. LightGen chooses its light source positions using a K-means clustering process [184]. In this process, K light source positions are initially chosen at random. Then the pixels in the light probe image are partitioned into sets according to which light source they are closest to. For each set of pixels, the mass centroid of the set is determined such that a pixel's mass is proportional to its total intensity. Then, each of the K light sources is moved to the mass centroid of its set. The pixels are repartitioned according to the new light source directions and the process is repeated until convergence. Finally, each light source is assigned the total energy of all pixels within its set. Figure 9.34 shows results for $K = 40$ and $K = 100$ light sources for a kitchen light probe image.

LightGen tends to cluster the light sources around bright regions, but these light sources generally contain more energy than the light sources placed in dimmer regions. As a result, dimmer regions receive more samples than they do in the median cut algorithm, but more lights may be necessary to approximate the structure of shadows. For example, if the kitchen window is approximated as six bright point light sources it can be possible to observe multiple distinct shadows from the six sources rather than the expected soft shadow from an area light source.

Kollig and Keller [177] propose several improvements to LightGen's clustering technique. They begin the K-means procedure using a single randomly placed light source and then add in one more random light at a time, each time iterating the K-means clustering procedure until convergence. This process requires additional computation but performs better at placing the light sources within concentrated areas of illumination. They also discuss several procedures of reducing aliasing once

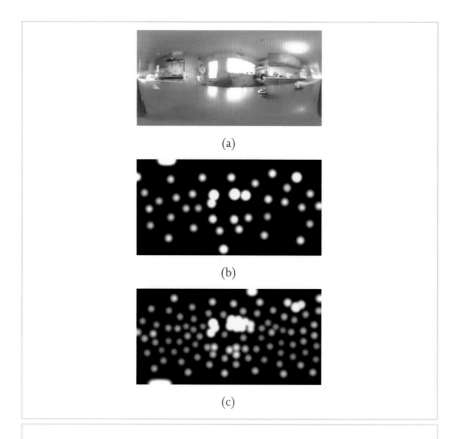

FIGURE 9.34 (a) *An IBL environment of a kitchen.* (b) *An approximation of the kitchen environment made by LightGen using* 40 *point lights.* (c) *An approximation using* 100 *point lights.*

the light source positions are chosen. One of them is to use the light source regions as a structure for *stratified sampling*. In this process, the lighting environment is sampled with K rays, with one ray chosen to fire at random into each light source region. To

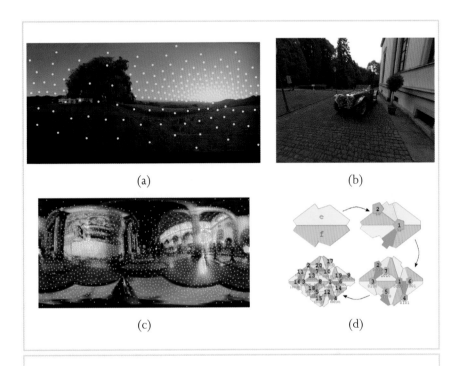

FIGURE 9.35 (a) *Lights chosen for an outdoor light probe image by the Kollig and Keller sampling algorithm. (b) An IBL rendering created using lights from the Kollig and Keller algorithm. (c) Lights chosen for the Galileo's Tomb light probe image by the Ostromoukhov et al. sampling algorithm. (d) The Penrose tiling pattern used by Ostromoukhov et al. for choosing light source positions.*

avoid problems with the remaining variance within each region, they propose using the average RGB color of each region as the color of any ray fired into the region. Lights chosen by this algorithm and a rendering using such lights are shown in Figures 9.35(a) and 9.35(b).

Ostromoukhov et al. [191] use a light source sampling pattern based on the geometric Penrose tiling to quickly generate a hierarchical sampling pattern with an appropriately spaced distribution. The technique is optimized for efficient sampling and was able to achieve sampling speeds of just a few milliseconds to generate several hundred light samples representing a lighting environment. A set of lights chosen using this pattern is shown in Figure 9.35(c), and the Penrose tiling pattern used is shown in Figure 9.35(d).

9.6.3 IMPORTANCE SAMPLING

As an alternative to converting a light probe image into light sources, one can construct a randomized sampling technique such that the rays are sent in a distribution that matches the distribution of energy in the light probe image. In the case of the sunny sky in Figure 9.23, such an algorithm would send rays toward the disk of the sun over half the time, since more than half of the light comes from the sun, rather than in proportion to the sun's tiny area within the image. This form of sampling can be performed using a mathematical technique known as *importance sampling*.

Importance sampling was introduced for the purpose of efficiently evaluating integrals using Monte Carlo techniques [185] and has since been used in a variety of ways to increase the efficiency of global illumination rendering (e.g., Veach and Guibas [204]). Because a computer's random number generator produces uniformly distributed samples, a process is needed to transform uniformly distributed numbers to follow the *probability distribution function* (PDF) corresponding to the distribution of light within the image. The process is most easily described in the context of a 1D function $f(x) : x \in [a, b]$, as seen in Figure 9.36(a). Based on a desired PDF, one computes the cumulative distribution function $g(x) = \int_a^x f(x) / \int_a^b f(x)$, as seen in Figure 9.36(b). We note that $g(x)$ increases monotonically (and thus has an inverse) because $f(x)$ is nonnegative, and that $g(x)$ ranges between 0 and 1. Using $g(x)$, we can choose samples x_i in a manner corresponding to the distribution of energy in $f(x)$ by choosing values y_i uniformly distributed in $[0, 1]$ and letting $x_i = g^{-1}(y_i)$. This process is shown graphically for four samples in Figure 9.36(b).

To see why this process works, note that each bright light source near a point x in the PDF produces a quick vertical jump in the CDF graph in the area of $g(x)$. Seen from the side, the jump produces a flat span whose length is proportional to

(a) (b)

FIGURE 9.36 *Importance sampling. (a) A plot of the brightness of a 256 × 1 pixel region (seen below) of the St. Peter's light probe image that intersects several bright windows, forming a probability distribution function (PDF). The image region is displayed below the graph using an HDR glare effect. (b) A graph of the cumulative distribution function (CDF) of the region from left to right for importance sampling. Four randomly chosen samples y_i (indicated by small horizontal arrows) are followed right until they intersect the graph (indicated by the diamonds), and are then followed down to their corresponding image pixel samples x_i.*

the amount of the scene's energy contained by the light. This flat span becomes a likely landing spot for randomly chosen samples y_i, with a likelihood proportional to the light's energy within the scene. When a sample y_i falls within the span, it produces a sample of the light source near x. In Figure 9.36(b) we see that three of the four random samples fell on spans corresponding to areas within bright light

(a) (b)

FIGURE 9.37 (a) A noisy IBL rendering in the St. Peter's lighting environment Figure 9.31(a)
using 64 randomly distributed samples per pixel. (b) A much smoother rendering using 64 samples
per pixel chosen using the importance sampling technique described in Pharr et al. [192].

sources. The sample furthest to the top right did not land on a steep slope, and thus
produced a sample in one of the dimmer areas of the image.

Extending this technique from 1D functions to 2D images is straightforward, as
one can concatenate each row of an $m \times n$ light probe image into a single $mn \times 1$
pixel vector, suggested by Agarwal et al. [152]. Pharr and Humphreys [192] pro-
pose an implementation of importance sampling for light probe images within their
Physically-Based Rendering package [193], in which importance sampling is first
used to compute which column of the image to sample (the energy of each column
x is summed to produce $f(x)$) and a sample is taken from the chosen image column
using 1D importance sampling (as described previously). Figure 9.37 compares the
results of using this sampling algorithm to using randomly distributed rays. As de-

sired, the rendering using importance sampling yields dramatically less noise than random sampling for the same number of samples.

To produce renderings that converge to the correct solution, light values chosen using importance sampling must be weighted in a manner that is inversely proportional to the degree of preference given to them. For example, sampling the sunny sky of Figure 9.23 with importance sampling would on average send over half of the rays toward the sun, as the sun contains over half the light in the image. If we weighted the radiance arriving from all sampled rays equally the surface point would be illuminated as if the sun were the size of half the entire sky.

A deficiency of these light probe sampling techniques is that they sample the lighting environment without regard to which parts of the environment are visible to a given surface point. Agarwal et al. [152] present a *structured importance sampling* approach for IBL that combines importance sampling with the conversion to light sources in order to better anticipate variable visibility to the environment. They first threshhold the image into regions of similar intensity, and use the Hochbaum–Shmoys clustering algorithm to subdivide each region a number of times proportional to both its size and its total energy. In this way, large dim regions do not become undersampled, which improves the rendering quality of shadowed areas. Likewise, small bright regions are represented with fewer samples relative to their intensity, in that their small spatial extent allows them to be accurately modeled with a relatively small number of samples. Cohen [157] constructs a piecewise-constant importance function for a light probe image, and introduces a *visibility cache* that exploits coherence in which parts of the lighting environment are visible to neighboring pixels. With this cache, significantly fewer rays are traced in directions that are occluded by the environment.

9.7 SIMULATING SHADOWS AND SCENE-OBJECT INTERREFLECTION

So far, the IBL techniques presented simulate how the light from an environment illuminates CG objects, but not how the objects in turn affect the appearance of the environment. The most notable effect to be simulated is the shadow an object casts beneath itself. However, shadows are just part of the lighting interaction that should be simulated. Real objects also reflect light back onto the scene around them.

(a)

(b)

(c)

(d)

FIGURE 9.38 *Adding synthetic objects that cast shadows. (a) A background plate taken near the location of the light probe image in Figure 9.14. It shows the radiance L of pixels in the local scene. (b) A light probe image taken within the scene. (c) A diffuse surface is added to the scene at the position of the ground and is rendered as lit by the surrounding IBL environment. The resulting pixel values on the surface produce an estimate of the irradiance E at each pixel. (d) Dividing a by c yields the lighting-independent texture map for the local scene. (e) A CG statue and four CG spheres are added on top of the local scene and illuminated by the IBL environment. The CG objects cast shadows and interreflect light with the real scene.*

For example, a red ball on the floor will make the floor around it somewhat redder. Effects such as this are often noticed only subconsciously but can contribute significantly to the realism of rendered images.

(e)

FIGURE 9.38 (continued)

The examples we have seen so far from *Rendering with Natural Light* and the Parthenon did not need to simulate shadows back into the scene. The Parthenon model was a complete environment with its own surrounding ground. In RNL, the pedestal received shadows from the objects but the pedestal itself was part of the computer-generated scene. The example we show in this section involves adding several CG objects into the photograph of a museum plaza (seen in Figure 9.38(a)) such that the objects realistically shadow and reflect light with the ground below them (see Figure 9.38(c)). In this example, the light probe image that corresponds to this background plate is the sunny lighting environment shown in Figure 9.14.

Usually, the noticeable effect a new object has on a scene is limited to a local area near the object. We call this area the *local scene*, which in the case of the scene

in Figure 9.38(a) is the ground in front of the museum. Our strategy for casting shadows on the local scene is to convert the local scene into a CG representation of its geometry and reflectance that can participate in the lighting simulation along with the CG objects. We can then use standard IBL machinery to light the objects and the local scene together by the IBL environment. The local scene model does not need to have the precise geometry and reflectance of what it represents in the real world, but it does need to satisfy two properties. First, it should have approximately the same geometry that the real scene it represents, in that the shadows reveal some of the scene structure. Second, it should have reflectance properties (e.g., texture maps) that cause it to look just like the real local scene when illuminated on its own by the IBL environment.

Modeling the geometry of the local scene can be done by surveying the scene or using photogrammetric modeling techniques (e.g., Debevec et al. [165]) or software (e.g., ImageModeler by Realviz, *www.realviz.com*). Because the geometry needed is often very simple, it can also be modeled by eye in a 3D modeling package. Similar techniques should also be used to recover the camera position, rotation, and focal length used to take the background photograph.

Obtaining the appropriate texture map for the local scene is extremely simple. We first assign the local scene a diffuse white color. We render an image of the white local scene as lit by the IBL lighting environment, as in Figure 9.38(c). We then divide the image of the real local scene (Figure 9.38(a)) in the background plate by the rendering to produce the reflectance image for the local scene (Figure 9.38(d)). Finally, we texture map the local scene with this reflectance image using camera projection (supported in most rendering systems) to project the image onto the local scene geometry. If we create a new IBL rendering of the local scene using this texture map, it will look just as it did in the original background plate. The difference is that it now participates in the lighting calculation, and thus can receive shadows and interreflect light with synthetic objects added to the scene.

Figure 9.38(e) shows the result of adding a 3D model of a sculpture and four spheres on top of the local scene geometry before computing the IBL rendering. The objects cast shadows on the ground as they reflect and refract the light of the scene. One can also notice bounced beige light near the ground of the beige sphere. The color and direction of the shadows are consistent with the real shadow cast on the ground by a post to the right of the camera's view.

The reason the reflectance-solving process works derives from the fact that the pixel color of a diffuse surface is obtained by multiplying its surface color by the color and intensity of the light arriving at the surface. This calculation was described in detail in case 3 of Section 9.5. More technically stated, the surface's radiance L is its reflectance ρ times the irradiance E at the surface. Inverting this equation, we have $\rho = L/E$. The background plate image shows the surface radiance L of each pixel of the local scene. The IBL rendering of the diffuse white version of the local scene yields an estimate of the irradiance E at every point on the local scene. Thus, dividing L by the estimate of E yields an image ρ of the surface reflectance of the local scene. By construction, assuming the local scene is convex these are the reflectance properties that make the local scene look like the background plate when lit by the IBL environment.

This process can be modified slightly for improved results when the local scene is nonconvex or non-Lambertian. For a nonconvex local scene such as a chair or a staircase, light will reflect between the local scene's surfaces. That means that our estimate of the irradiance E arriving at the local scene's surfaces should account for light from the IBL environment as well as interreflected light from the rest of the local scene. The process described earlier does this, but the indirect light is computed as if the local scene were completely white, which will usually overestimate the amount of indirect light received from the other surfaces. As a result, the local scene's reflectance will be underestimated, and the local scene texture's map will be too dark in concave areas.

The way to avoid this problem is to assume more accurate reflectance properties for the local scene before computing the irradiance image. Typical surfaces in the world reflect approximately 25% of the incident illumination, and thus assuming an initial surface reflectance of $\rho_0 = 0.25$ is a more reasonable initial guess. After rendering the local scene, we should compute the irradiance estimate E_0 as $E_0 = L_0/\rho_0$, where L_0 is the rendering generated by lighting the local scene by the IBL environment. This is another simple application of the $L = \rho E$ formula. Then the texture map values for the local scene can be computed as before, as $\rho_1 = L/E_0$.

If the local scene exhibits particularly significant self-occlusion or spatially varying coloration, the reflectance estimates can be further refined by using the computed reflectance properties ρ_1 as a new initial estimate for the same procedure. We illuminate the new local scene by the IBL environment to obtain L_1, estimate a new map of the irradiance as $E_1 = L_1/\rho_1$, and finally form a new estimate for the

local scene's per-pixel reflectance ρ_2. Typically, the process converges quickly to the solution after one or two iterations. In fact, this basic process was used to derive the surface reflectance properties of the Parthenon model seen in Figure 9.28, in which the "local scene" was the entire monument [163].

In some cases, we can simplify the surface reflectance estimation process. Often, the local scene is a flat ground plane and the IBL environment surface is distant or infinite. In this case, the irradiance E is the same across the entire surface, and can be computed as the upward-pointing direction of a diffuse convolution of the light probe image. This eliminates the need to render a complete irradiance image such as shown in Figure 9.38(c), and the local scene reflectance is simply its appearance in the background plate divided by the RGB value E.

9.7.1 DIFFERENTIAL RENDERING

The need to use camera projection to map the local scene texture onto its geometry can be avoided using the differential rendering technique described in [161]. In differential rendering, the local scene is assigned (often uniform) diffuse and specular surface reflectance properties similar to the reflectance of the local scene. These properties are chosen by hand or computed using the reflectance estimation process described previously. Then, two renderings are created: one of the local scene and the objects together (L_{obj}), and one of the local scene without the objects (L_{noobj}). For L_{obj}, an alpha channel image α is created that is 1 for the object pixels and 0 for the non-object pixels, preferably with antialiasing and transparency encoded as gray levels. If L_{noobj} and L_{obj} are the same, there is no shadowing. Where L_{obj} is darker, there are shadows, and where L_{obj} is brighter there are reflections or indirectly bounced light. To apply these photometric effects to the background plate L, we offset its pixel values by the difference between L_{obj} and L_{noobj}. Specifically, the final rendering is computed as

$$L_{final} = \alpha L_{obj} + (1 - \alpha)(L + L_{obj} - L_{noobj}).$$

In this formula, the α mask allows L_{final} to copy the appearance of the objects directly from L_{obj}, and the local scene is rendered using differential rendering.

As an alternative method, we can apply the ratio of L_{obj} and L_{noobj} to the background plate, changing the last term of the formula to $L \times L_{obj}/L_{noobj}$. If the re-

flectance properties of the local scene and the IBL environment are modeled accurately, the background plate L and the local scene lit by the IBL environment L_{noobj} would be the same. In this case, the local scene's appearance in L_{noobj} is copied to L_{final} regardless of whether the difference or the ratio formula is used. When there are inaccuracies in either the lighting or the reflectance, either formula may yield a convincing approximation to the correct result. The difference formula may provide better results for specular reflections and the ratio formula may provide better results for shadows. In either case, only differences between L_{obj} and L_{noobj} will modify the background plate, and where the objects do not affect the local scene it will look precisely as it did in the background plate.

The benefit of this technique is that the local scene does not need to be projectively texture mapped with its appearance in the background plate image. The drawback is that mirror- and glass-like CG objects will not reflect images of the original local scene. Instead, they will reflect images of the modeled local scene.

9.7.2 RENDERING INTO A NONDIFFUSE LOCAL SCENE

If the local scene is somewhat shiny, we would like the new objects to also appear in reflections in the scene. This was the case for *Fiat Lux* (Figure 9.30), where the marble floor of St. Peter's Basilica is notably specular. The problem is compounded by the fact that a shiny local scene may already have visible specularities from bright parts of the lighting environment, and these reflections should disappear when virtual objects are placed between the light sources and the observed locations of their specular reflections. Thus, the synthetic local scene needs to model the specular as well as the diffuse reflection characteristics of the real local scene. Unfortunately, estimating spatially varying diffuse and specular reflection components of a surface, even under known illumination, is usually prohibitively challenging for current reflectometry algorithms.

The easiest procedure to follow is to first manually remove visible specular reflections in the local scene using an image-editing program. In *Fiat Lux*, the notable specular reflections in the floor were from the windows, and in some cases from the lights in the vaulting. Using the edited background plate, we then solve for the local scene reflectance assuming that it is diffuse (as described previously). For the

final rendering, we add a specular component to the local scene reflectance whose intensity and roughness are selected by hand to match the appearance of the specularities seen in the local scene on the background plate. The IBL rendering will then show the new CG objects reflecting in the local scene according to the specified specular behavior, and light sources in the IBL environment will also reflect in the local scene when their light is not blocked by the CG objects. This process also provides opportunities for art direction. In *Fiat Lux*, for example, the floor of St. Peter's was chosen to have a more polished specular reflection than it really had, to increase the visual interest of its appearance in the animation.

Sometimes a local scene's specular reflectance dominates its diffuse reflectance, as would be seen for a steel or black marble floor. In these cases, it can be difficult to remove the specular reflection through image editing. In such a case, the best solution may be to model the reflectance of the local scene by eye, choosing specular intensity and roughness parameters that cause reflections of the IBL environment to match the local scene's original appearance reasonably well. If the scene is available for photography under controlled lighting, the local scene can be shaded from specular reflections and illuminated from the side to observe its diffuse component. If the reflectance of the local scene is especially complex and spatially varying, such as an ancient stone and metal inlaid mosaic, one could use a technique such as that described in McAllister [183] or Gardner et al. [169] to derive its surface reflectance parameters by analyzing a set of images taken from many incident illumination directions.

9.8 USEFUL IBL APPROXIMATIONS

Many of today's rendering programs include specific support for image-based lighting (often referred to as *HDRI*), making IBL a straightforward process to use for many computer graphics applications. However, not every production pipeline is designed to support global illumination, and real-time applications require faster rendering times than ray-traced illumination solutions typically allow. Fortunately, there are several approximate IBL techniques that allow particularly fast rendering times and that can be implemented within more traditional rendering pipelines. The sections that follow describe two of them: *environment mapping* and *ambient occlusion*. The discussion includes the advantages and disadvantages of these two approaches.

9.8.1 ENVIRONMENT MAPPING

Environment mapping [154,186,207,171] is a forerunner of image-based lighting in which an omnidirectional LDR image of an environment is directly texture mapped onto an object surface to produce the appearance of it reflecting the environment. The omnidirectional *environment map* or *reflection map* image can also be *pre-convolved* by a blurring filter to simulate the reflections from rough specular or diffuse surfaces. The environment map is mapped onto the object according to each point's surface normal, which makes the rendering process extremely fast once the appropriate reflection map images have been computed. The disadvantage is that the technique does not take into account how light is shadowed and interreflects between object surfaces, which can be an impediment to realism. For objects that are relatively shiny and convex, the errors introduced by the approximation can be insignificant. For objects with more complex geometry and reflectance properties, however, the results can be less realistic.

Environment mapping is most successful and most often used for simulating the specular reflections of an object. In this case, for each surface point the ray from the camera R is reflected about the surface normal N to determine the reflected vector R', computed as follows.

$$R' = R - 2(R \cdot N)N$$

Then, the point on the object is drawn with the pixel color of the environment image corresponding to the direction of R'. Figure 9.39(a) shows this environment mapping process applied to the scene shown in Figure 9.1.

The environment-mapped rendering gives the appearance that the objects are reflecting the environment. However, the appearance is somewhat strange because we do not see reflections of the sphere in the table (the spheres appear to float above it). We can compare this rendering to the corresponding IBL rendering of mirror-like objects in Figure 9.39(b), which exhibits appropriate interreflections. If the scene were a single convex object, however, the two renderings would be the same.

It is interesting to note that this form of environment mapping does not require that the environment map be higher in its dynamic range than the final display. Because every pixel in the rendering comes directly from the environment map, clipping the pixel values of the environment map image would be unnoticeable on

(a) (b)

FIGURE 9.39 (a) *A shiny version of the test scene rendered using environment mapping.*
(b) *A shiny version of the scene rendered with ray-tracing-based IBL, producing interreflections.*

a similarly clipped display, unless the rendering were to exhibit significant motion blur or image defocus.

Environment mapping can also be used to simulate the reflection of an environment by surfaces with non-mirror reflectance properties, by *pre-convolving* the image of the environment by various convolution filters [186,171,155,174]. This takes advantage of an effect noted by Ramamoorthi and Hanrahan [195] that a detailed environment reflected in a rough specular surface looks similar to a blurred environment reflected in a mirror-like surface. Often, a specular Phong cosine lobe [194] is used as the convolution filter.

To simulate Lambertian diffuse reflection with environment mapping, a hemispherical cosine lobe is used as the convolution filter, yielding an *irradiance environment map*. For diffuse reflection, one indexes into the irradiance environment map using the object point's surface normal direction N rather than the reflected vector R'. Convolving the image can be computationally expensive, but because irradiance images lack sharp detail a close approximation can be made by convolving a low-resolution version of as few as 32×16 pixels in latitude-longitude format. Cabral et al. [155] suggested that such a convolution could be performed efficiently on a spherical harmonic (SH) decomposition of the incident illumination, and Ramamoorthi and Hanrahan [195] noted that computing the SH reconstruction of an

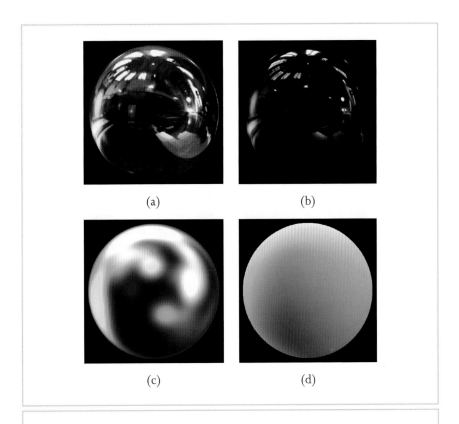

(a) (b)

(c) (d)

FIGURE 9.40 (a) HDR Grace Cathedral light probe image, in the mirrored sphere format. (b) The light probe in **a** shown with lower exposure, revealing details in the bright regions. (c) A specular convolution of **a**. (d) A diffuse convolution of **a**, showing how this lighting environment would illuminate **a** diffuse sphere. (e) An LDR environment map version of **a** with clipped pixel values. (f) The image in **e** with lower exposure, showing that the highlights have been clipped. (g) A specular convolution of **e**, showing inaccurately reduced highlight size and intensity relative to **c**. (h) A diffuse convolution of **e**, yielding an inaccurately dark and desaturated rendering compared to **d**.

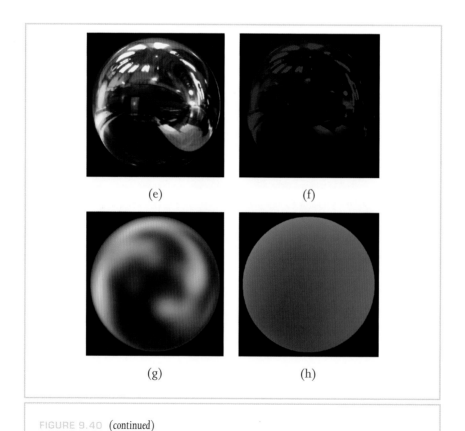

(e) (f)

(g) (h)

FIGURE 9.40 (continued)

environment using the first nine terms (orders 0, 1, and 2) of the SH decomposition approximates the diffuse convolution of any lighting environment to within 99% accuracy.[7]

7 This technique for computing an irradiance environment map can yield regions with negative pixel values when applied to an environment with concentrated light sources due to the Gibbs ringing phenomenon.

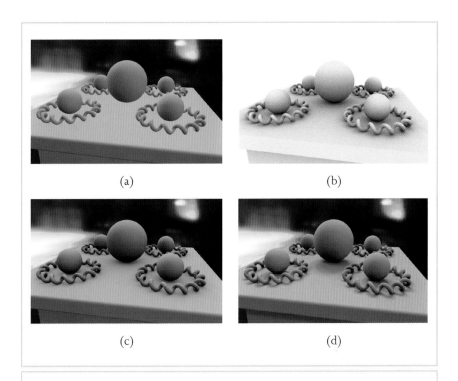

(a) (b)

(c) (d)

FIGURE 9.41 (a) *A scene environment mapped with the diffuse convolution of the Grace Cathedral environment. (b) An ambient occlusion map obtained using IBL to light the scene with a homogeneous white lighting environment. (c) The ambient occlusion map multiplied by a. (d) The scene illuminated using standard IBL from the light probe image. For this scene, the principal difference from c is in the shadow regions, which have more directional detail in d.*

Figure 9.41(a) shows a scene rendered using diffuse environment mapping. Because environment mapping does not simulate self-shadowing, the image is not as realistic a rendering of the scene as the IBL solution shown in Figure 9.41(d). However, if the scene were a single convex object the two renderings would again be the

same. In general, environment mapping produces more convincing results for spec-
ular reflection than for diffuse reflection. As a result, for objects with both specular
and diffuse reflectance components it is common for environment mapping to be
used for the specular reflection and traditional lighting for the diffuse component.
The technique of *reflection occlusion* [179] can further increase the realism of specular
environment mapping by tracing reflected rays from each surface point to deter-
mine if the environment's reflection should be omitted due to self-occlusion.

When the incident illumination is blurred by a convolution filter, it becomes
necessary that the environment map cover the full dynamic range of the incident
illumination to obtain accurate results. Figure 9.40 shows a comparison of using
an LDR environment map versus an HDR light probe image for rendering a diffuse
sphere using convolution and environment mapping.

9.8.2 AMBIENT OCCLUSION

Ambient occlusion [179] can be used to approximate image-based lighting using
a single-bounce irradiance calculation under the assumption that the IBL lighting
environment is relatively even. The technique leverages the key IBL step of firing rays
out from object surfaces to estimate the amount of light arriving from the visible
parts of the environment, but uses diffuse environment mapping to determine the
coloration of the light at the surface point. The result is an approximate but efficient
IBL process that can perform well with artistic guidance and that avoids noise from
the light sampling process.

The first step in ambient occlusion is to use an IBL-like process to render a
neutral diffuse version of the scene as illuminated by a homogeneously white il-
lumination environment. In this step, the surfaces of the scene are set to a neu-
tral diffuse reflectance so that the rendered image produces pixel values that are
proportional to a surface point's irradiance. This step can be performed using
the Monte Carlo ray-tracing process (described in Section 9.5) or by convert-
ing the white lighting environment into a constellation of light sources (Sec-
tion 9.6.2). In the latter case, the rendering can be formed by adding together
scan-line renderings of the scene lit from each lighting direction, with the shad-
ows being calculated by a shadow buffer algorithm. Usually, no additional light
bounces are simulated when computing this rendering. This estimate of the irradi-

ance from the environment at each point is called the *ambient occlusion map*, seen in Figure 9.41(b).

The next step is to multiply the ambient occlusion map by an image of the scene environment mapped with the diffuse convolution of the lighting environment, as in Figure 9.41(a). The product, seen in Figure 9.41(c), applies the self-shadowing characteristics of the ambient occlusion map to the diffuse lighting characteristics of the environment-mapped scene, yielding a rendering that is considerably more realistic. If the scene has different surface colors, this rendering can be multiplied by an image of the diffuse color of each point in the scene, which approximates having differently colored surfaces during the original rendering. If needed, specular reflections can be added using either ray tracing or specular environment mapping.

Ambient occlusion does not precisely reproduce how a scene would appear as illuminated by the light probe using standard IBL. We can see, for example, differences in comparing Figures 9.41(c) and 9.41(d). Most notably, the shadows in the ambient occlusion rendering are much softer than they appear in the standard IBL rendering. The reason is that the ambient occlusion rendering is computed as if from a completely diffuse lighting environment, whereas a standard IBL rendering computes which specific parts of the lighting environment become occluded for each part of the shadowed area. The ambient occlusion result can be improved to some extent using *bent normals* [179], where the diffuse convolution of the light probe image is mapped onto the object surfaces according to the average direction of unoccluded light, rather than the true surface normal. However, because the surface colors are still sampled from a diffuse convolution of the light probe image, the ambient occlusion rendering will lack the shading detail obtainable from sampling the light probe image directly.

Ambient occlusion most accurately approximates the correct lighting solution when the lighting environment is relatively diffuse. In this case, the homogeneous environment used to compute the occlusion is a close approximation to the environment desired to light the scene. Ambient occlusion is not designed to simulate light from environments that include concentrated light sources, as the directional detail of the environment is lost in the diffuse convolution process. For IBL environments that do have concentrated light sources, an effective way of handling them is to simulate them as direct light sources (as described in Section 9.6.1), delete

them from the IBL environment, and use a diffuse convolution of the modified IBL environment to multiply the ambient occlusion map.

Although computing ambient occlusion maps requires sending out a multitude of rays to the lighting environment, the number of rays that need to be sent is minimized because the environment has minimal variance, which alleviates the sampling problem. Also, the ambient occlusion map is solely a function of the object geometry and is independent of the lighting environment. Because of this, the technique can be used to render an object with different lighting environments while performing the ambient occlusion calculation map only once. This makes real-time implementations very fast, especially for rotating lighting environments for which performing additional diffuse convolutions is also unnecessary. In addition, the technique allows for relighting effects to be performed inside a standard compositing system. For example, the convolved light probe image can be manually edited and a relit version of the scene can be created quickly using the preexisting normals and ambient occlusion map without rerendering.

9.9 IMAGE-BASED LIGHTING FOR REAL OBJECTS AND PEOPLE

The IBL techniques described so far are useful for lighting synthetic objects and scenes. It is easy to imagine uses for a process that could illuminate *real* scenes, objects, and people with IBL environments. To do this, one could attempt to build a virtual model of the desired subject's geometry and reflectance and then illuminate the model using the IBL techniques already presented. However, creating photoreal models of the geometry and reflectance of objects (and particularly people) is a difficult process, and a more direct route would be desirable. In fact, there is a straightforward process for lighting real subjects with IBL that requires only a set of images of the subject under a variety of directional lighting conditions.

9.9.1 A TECHNIQUE FOR LIGHTING REAL SUBJECTS

The technique is based on the fact that light is *additive*, which can be described simply as follows. Suppose we have two images of a subject, one lit from the left and one

lit from the right. We can create an image of the subject lit with both lights at once simply by adding the two images together, as demonstrated by [172]. If the image pixel values are proportional to the light in the scene, this process yields exactly the right answer, with all of the correct shading, highlights, and shadows the scene would exhibit under both light sources. Furthermore, the color channels of the two images can be independently scaled before they are added, allowing one to virtually light the subject with a bright orange light to the right and a dim blue light to the left, for example.

As we have seen in Section 9.6.2, an IBL lighting environment can be simulated as a constellation of light sources surrounding the subject. If one could quickly light a person from a dense sampling of directions distributed across the entire sphere of incident illumination, it should be possible to recombine tinted and scaled versions of these images to show how the person would look in any lighting environment. The Light Stage device described by [162] (Figure 9.42) is designed to acquire precisely such a data set. The device's 250-watt halogen spotlight is mounted on a two-axis rotation mechanism such that the light can spiral from the top of the sphere to the bottom in approximately one minute. During this time, a set of digital video cameras can record the subject's appearance as illuminated by hundreds of lighting directions distributed throughout the sphere. A subsampled light stage data set of a person's face is seen in Figure 9.43(a).

Figure 9.43(c) shows the Grace Cathedral lighting environment remapped to be the same resolution and in the same longitude-latitude space as the light stage data set. For each image of the face in the data set, the remapped environment indicates the color and intensity of the light from the environment in the corresponding direction. Thus, we can multiply the red, green, and blue color channels of each light stage image by the amount of red, green, and blue light in the corresponding direction in the lighting environment to obtain a modulated image data set, as in Figure 9.43(d). Adding all of these images together then produces an image of the subject as illuminated by the complete lighting environment, as seen in Figure 9.44(a). Results obtained for three more lighting environments are shown in Figures 9.44(b) through 9.44(d).

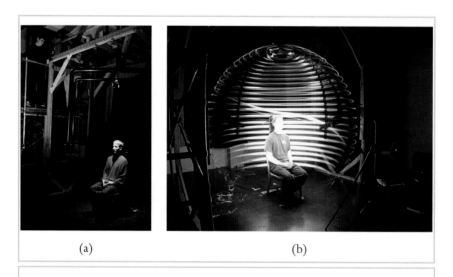

(a) (b)

FIGURE 9.42 *(a) The Light Stage 1 device for lighting a person's face from the full sphere of incident illumination directions. (b) A one-minute exposure taken during a data set acquisition. Images recorded from the right video camera are shown in Figure 9.43.*

9.9.2 RELIGHTING FROM COMPRESSED IMAGE DATA SETS

Computing the weighted sum of the light stage images is a simple computation, but it requires accessing a large amount of data to create each rendering. This process can be accelerated by performing the computation on compressed versions of the original images. In particular, if the images are compressed using an orthonormal transform such as the discrete cosine transform (DCT), the linear combination of the images can be computed directly on the basis coefficients of the compressed images [197]. The downloadable Facial Reflectance Field Demo [203] (*www.debevec.org/FaceDemo/*) uses DCT-compressed versions of light stage data sets to allow a user to interactively relight a face using either light probe images or user-controlled light sources in real time.

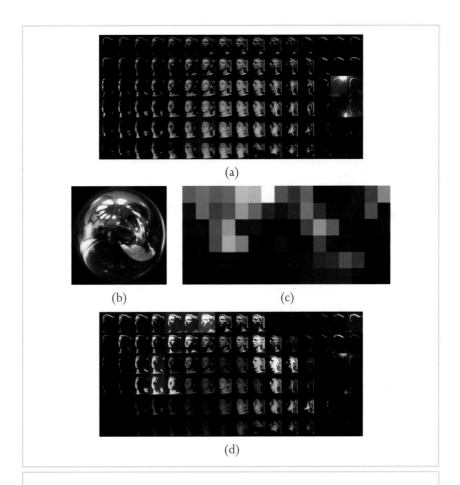

(a)

(b) (c)

(d)

FIGURE 9.43 (a) Light stage data of a face illuminated from the full sphere of lighting di-
rections. The image shows 96 images sampled from the 2,000-image data set. (b) The Grace
Cathedral light probe image. (c) The Grace probe resampled into the same longitude-latitude space
as the light stage data set. (d) Face images scaled according to the color and intensity of the
corresponding directions of illumination in the Grace light probe. Figure 9.44(a) shows the face
illuminated by the Grace probe created by summing these scaled images.

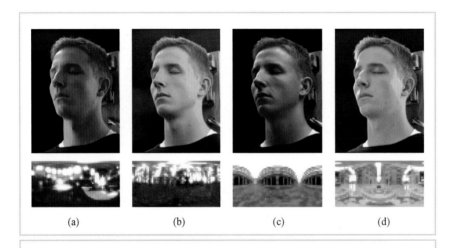

(a)	(b)	(c)	(d)

FIGURE 9.44 *Renderings of the light stage data set from Figure 9.43 as illuminated by four image-based lighting environments: (a) Grace cathedral, (b) Eucalyptus grove, (c) Uffizi gallery, and (d) St. Peter's Basilica.*

A light stage data set can be parameterized by the four dimensions of image coordinates (u, v) and lighting directions (θ, ϕ). Choosing a particular pixel (u, v) on the subject, we can create a small image (called the pixel's *reflectance function*) from the color the pixel reflects toward the camera for all incident lighting directions (θ, ϕ) (Figure 9.45). In the Facial Reflectance Field Demo, the 4D light stage data sets are actually DCT compressed in the lighting dimensions rather than the spatial dimensions, exploiting coherence in the reflectance functions rather than in the images themselves. When the DCT coefficients of the reflectance functions are quantized (as in JPEG compression), up to 90% of the data maps to zero and can be skipped in the relighting calculations, enabling real-time rendering. The process of relighting a single pixel of a light stage data set based on its reflectance function is shown in Figure 9.45.

This image-based relighting process can also be applied in the domain of computer-generated objects. One simply needs to render the object under an ar-

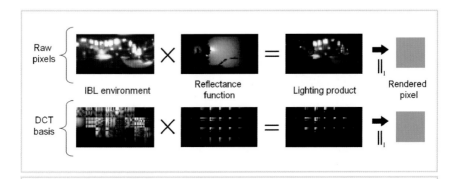

FIGURE 9.45 *Relighting a reflectance function can be performed on the original pixel values (top row) or on DCT coefficients of the illumination data.*

ray of different lighting conditions to produce a virtual light stage data set of the object. This can be useful in that the basis images can be rendered using high-quality offline lighting simulations but then recombined in real time through the relighting process, maintaining the quality of the offline renderings. In the context of CG objects, the content of a reflectance function for a surface point is its *precomputed radiance transfer*. Sloan et al. [196], Ramamoorthi and Hanrahan [195], and Ng et al. [189] have noted that the basis lighting conditions need not be rendered with point source illumination. Specifically, Sloan et al. [196] and Ramamoorthi and Hanrahan [195] use the Spherical Harmonic (SH) basis, whereas Ng et al. [189] use a wavelet basis. These techniques demonstrate varying the viewpoint of the object by mapping its radiance transfer characteristics onto a 3D geometric model of the object. Whereas these earlier techniques have been optimized for diffuse surface reflectance in low-frequency lighting environments, Liu et al. [182] use both a wavelet representation and clustered principal components analysis of PRT functions to render view-dependent reflections from glossy objects in high-frequency lighting environments, producing sharp shadows from light sources interactively. Sample renderings made using these techniques are shown in Figure 9.46. Using the GPU to perform image-based relighting on CG objects with techniques such as

(a) (b)

(c) (d)

FIGURE 9.46 Interactive IBL renderings of 3D objects using basis decompositions of the lighting environment and surface reflectance functions. (a) Max Planck model rendered in the RNL environment using precomputed radiance transfer [196] based on spherical harmonics. (b) Armadillo rendered in the Uffizi Gallery using a spherical harmonic reflection map [195]. (c) Teapot rendered into Grace Cathedral using a 2D Haar transform [189] of the lighting and reflectance, achieving detailed shadows. (d) Teapot rendered into St. Peter's Basilica using precomputed radiance transfer represented by Haar wavelets and compressed with clustered principal component analysis [182] to produce sharp shadow detail, as seen on the teapot lid.

these promises to become the standard method for using IBL in video games and other interactive rendering applications.

9.10 CONCLUSIONS

In this chapter we have seen how HDR images can be used as sources of illumination for both computer-generated and real objects and scenes through image-based lighting. Acquiring real-world lighting for IBL involves taking omnidirectional HDR images through one of several techniques, yielding a data set of the color and intensity of light arriving from every direction in the environment. This image of the incident illumination is mapped onto a surface surrounding the object, and a lighting simulation algorithm is used to compute how the object would appear as if lit by the captured illumination. With the appropriate optimizations, such images can be computed efficiently using either global illumination or traditional rendering techniques, and recent techniques have allowed IBL to happen in real time. Real objects can be illuminated by new environments by capturing how they appear under many individual lighting conditions and then recombining them according to the light in an IBL environment.

The key benefit of IBL is that it provides a missing link between light in the real world and light in the virtual world. With IBL, a ray of light can be captured by an HDR camera, reflected from a virtual surface in a rendering algorithm, and be turned back into real light by a display. The IBL process has a natural application wherever it is necessary to merge CG imagery into real scenes, in that the CG can be lit and rendered as if it were actually there. Conversely, the light stage technique allows IBL to illuminate real-world objects with the light of either virtual or real environments. In its applications so far, IBL has rendered virtual creatures into real movie locations, virtual cars onto real roads, virtual buildings under real skies, and real actors into virtually created sets. For movies, video games, architecture, and design, IBL can connect what is real with what can only be imagined.

ACKNOWLEDGEMENTS

In regard to Chapter 9, we wish to thank Andrew Jones, Chris Tchou, Andrew Gardner, Tim Hawkins, Andreas Wenger, Per Einarsson, Maya Martinez, David

Wertheimer, Bill Swartout, and Lora Chen for their help during the preparation of this chapter. The Parthenon model was created with the additional collaboration of Brian Emerson, Marc Brownlow, Philippe Martinez, Jessi Stumpfel, Marcos Fajardo, Therese Lundgren, Nathan Yun, CNR-Pisa, Alias, and Geometry Systems. Portions of the work described in this chapter have been sponsored by a National Science Foundation Graduate Research Fellowship, a MURI Initiative on 3D direct visualization from ONR and BMDO (grant FDN00014-96-1-1200), Interval Research Corporation, the University of Southern California, and the U.S. Army Research, Development, and Engineering Command (RDECOM).

Appendix A

Symbol	Description
\otimes	Convolution operator
α	A channel of $L\alpha\beta$ color space
α	The key of a scene
β	A channel of $L\alpha\beta$ color space
γ	Exponent used for gamma correction
σ	Semisaturation constant
a	Color opponent channel of $L^*a^*b^*$ color space; color opponent channel used in CIECAM02
A	CIE standard illuminant approximating incandescent light
A	Achromatic response, computed in CIECAM02
b	Color opponent channel of $L^*a^*b^*$ color space; color opponent channel used in CIECAM02
B	CIE standard illuminant approximating direct sunlight
c	Viewing condition parameter used in CIECAM02
C	CIE standard illuminant approximating indirect sunlight
C	Chroma
C_{ab}^*	Chroma, computed in $L^*a^*b^*$ color space
C_{uv}^*	Chroma, computed in $L^*u^*v^*$ color space

Symbol	Description
D	Density, computed as the log of luminance L_v
D	Degree of adaptation, used in CIECAM02
D_{55}	CIE standard illuminant with a correlated color temperature of 5503 Kelvin (K)
D_{65}	CIE standard illuminant with a correlated color temperature of 6504 Kelvin (K)
D_{75}	CIE standard illuminant with a correlated color temperature of 7504 Kelvin (K)
ΔE^* 1994	CIE color difference metric
ΔE^*_{ab}	Color difference measured in $L^*a^*b^*$ color space
ΔE^*_{uv}	Color difference measured in $L^*u^*v^*$ color space
e	Eccentricity factor, used in CIECAM02
E	CIE equal-energy illuminant
E_e	Irradiance, measured in watts per square meter
E_v	Illuminance, measured in lumens per square meter
F	Viewing condition parameter used in CIECAM02
F_2	CIE standard illuminant approximating fluorescent light
F_L	Factor modeling partial adaptation, computed using the adapting field luminance in CIECAM02
h	Hue angle as used in CIECAM02
h_{ab}	Hue, computed in $L^*a^*b^*$ color space
h_{uv}	Hue, computed in $L^*u^*v^*$ color space
H	Appearance correlate for hue
I	Catch-all symbol used to indicate an arbitrary value
I_e	Radiant intensity, measured in watts per steradian
I_v	Luminous intensity, measured in lumens per steradian or candela

Symbol	Description
J	Appearance correlate for lightness
L	Luminance
L_a	Adapting field luminance
L_D	Display luminance
L_e	Radiance, measured in watts per steradian per square meter
L_v	Luminance, measured in candela per square meter
L_W	World or scene luminance (also Y_W)
$L\alpha\beta$	Color opponent space
LMS	Color space approximating the output of cone photoreceptors
$L^*a^*b^*$	CIE color space, also known as CIELAB
$L^*u^*v^*$	CIE color space, also known as CIELUV
M	Appearance correlate for colorfulness
$M_{Bradford}$	Bradford chromatic adaptation transform
M_{CAT02}	CAT02 chromatic adaptation transform
M_e	Radiant exitance, measured in watts per square meter
M_H	Hunt–Pointer–Estevez transformation matrix
$M_{von\ Kries}$	von Kries chromatic adaptation transform
M_v	Luminous exitance, measure in lumen per square meter
N_c	Viewing condition parameter used in CIECAM02
P_e	Radiant power, measured in watts (W) or joules per second
P_v	Luminous power, measured in lumen (lm)
Q	Appearance correlate for brightness
Q_e	Radiant energy, measured in joules (J)
Q_v	Luminous energy, measured in lumens per second
r	Surface reflectance

Symbol	Description
R	Photoreceptor response
RGB	A generic red, green, and blue color space
$R_D G_D B_D$	Red, green, and blue values scaled within the displayable range
$R_W G_W B_W$	Red, green, and blue values referring to a world or scene color
s	Saturation parameter
s	Appearance correlate for saturation
s_{uv}	Saturation, computed in $L^*u^*v^*$ color space
t	Magnitude factor, used in CIECAM02
T	Correlated color temperature, measured in Kelvin (K)
$V(\lambda)$	CIE photopic luminous efficiency curve
XYZ	CIE-defined standard tristimulus values
xyz	Normalized XYZ tristimulus values
Y	Y component of an XYZ tristimulus value, indicating CIE luminance
Y_W	World or scene luminance (also L_w)
Y_b	Relative background luminance
$Y C_B C_R$	Color opponent space used for the JPEG file format

References

[1] E. H. Adelson. "Saturation and Adaptation in the Rod System," *Vision Research*, 22:1299–1312, 1982.

[2] Adobe. Tiff 6.0 specification, 1992, *http://partners.adobe.com/asn/tech/tiff/specification.jsp*.

[3] Adobe. Digital negative (DNG), 2004, *www.adobe.com/products/dng/main.html*.

[4] A. O. Akyuz, E. Reinhard, and S. Pattanaik. "Color Appearance Models and Dynamic Range Reduction," in *First ACM Symposium on Applied Perception in Graphics and Visualization (APGV)*, pp. 166, New York: ACM, 2004.

[5] S. Mann and R. W. Picard. "Being Undigital with Digital Cameras: Extending Dynamic Range by Combining Differently Exposed Pictures," in *IS&T's 48th Annual Conference*, Washington, DC: Society for Imaging Science and Technology, May 1995.

[6] M. Ashikhmin. "A Tone Mapping Algorithm for High Contrast Images," in *Proceedings of 13th Eurographics Workshop on Rendering*, pp. 145–155, Pisa, Italy: Eurographics Association, 2002.

[7] K. Barnard. "Practical Colour Constancy," Ph.D. thesis, Simon Fraser University, School of Computing, 1999.

[8] P. J. Burt and E. H. Adelson. "A Multiresolution Spline with Application to Image Mosaics," *ACM Transactions on Graphics*, 2(4):217–236, 1983.

[9] K. Chiu, M. Herf, P. Shirley, S. Swamy, C. Wang, and K. Zimmerman. "Spatially Nonuniform Scaling Functions for High Contrast Images," in *Proceedings of Graphics Interface '93*, pp. 245–253, Toronto, May 1993.

[10] P. Choudhury and J. Tumblin. "The Trilateral Filter for High Contrast Images and Meshes," in *Proceedings of the Eurographics Symposium on Rendering*, pp. 186–196, 2003.

[11] CIE. "An Analytic Model for Describing the Influence of Lighting Parameters upon Visual Performance: Vol 1, Technical Foundations," Technical report, CIE Pub. 19/2.1 Technical committee 3.1, 1981.

[12] CIE. "The CIE 1997 Interim Colour Appearance Model (Simple Version)," CIECAM97s. Technical report, CIE Pub. 131, Vienna, 1998.

[13] D. Comaniciu and P. Meer. "Mean Shift: A Robust Approach Toward Feature Space Analysis," in *IEEE Transactions on Pattern Analysis and Machine Intelligence*, 24(5):603–619, Los Alamitos: IEEE Computer Society, 2002.

[14] R. W. Corrigan, B. R. Lang, D. A. LeHoty, and P. A. Alioshin. "An Alternative Architecture for High Performance Display," in 141st *SMPTE Technical Conference and Exhibition*, New York: SMPTE, November 1999.

[15] S. Daly. "The Visible Difference Predictor: An Algorithm for the Assessment of Image Fidelity," in A. B. Watson (ed.), *Digital Images and Human Vision*, pp. 179–206, Cambridge, MA: MIT Press, 1993.

[16] H. J. A. Dartnall, J. K. Bowmaker, and J. D. Mollon. "Human Visual Pigments: Microspectrophotometric Results from the Eyes of Seven Persons," in *Proceedings of the Royal Society of London B*, 220:115–130, London: The Royal Society, 1983.

[17] P. E. Debevec. "Rendering Synthetic Objects into Real Scenes: Bridging Traditional and Image-based Graphics with Illumination and High Dy-

namic Range Photography," in *SIGGRAPH 98 Conference Proceedings*, Annual Conference Series, pp. 45–50, ACM SIGGRAPH, 1998.

[18] P. E. Debevec and J. Malik. "Recovering High Dynamic Range Radiance Maps from Photographs," in *SIGGRAPH 97 Conference Proceedings*, Annual Conference Series, pp. 369–378, ACM SIGGRAPH, August 1997.

[19] J. E. Dowling. *The Retina: An Approachable Part of the Brain*. Cambridge, MA: Belknap Press, 1987.

[20] F. Drago, W. L. Martens, K. Myszkowski, and H-P. Seidel. "Perceptual Evaluation of Tone Mapping Operators with Regard to Similarity and Preference," Technical Report MPI-I-2002-4-002, Max Plank Institut für Informatik, 2002.

[21] F. Drago, K. Myszkowski, T. Annen, and N. Chiba. "Adaptive Logarithmic Mapping for Displaying High Contrast Scenes," *Computer Graphics Forum*, 22(3), 2003.

[22] F. Durand and J. Dorsey. "Interactive Tone Mapping," in *Proceedings of the 11th Eurographics Workshop on Rendering*, pp. 219–230, Brno: Eurographics Association, 2000.

[23] F. Durand and J. Dorsey. "Fast Bilateral Filtering for the Display of High-dynamic-range Images," *ACM Transactions on Graphics*, 21(3):257–266, 2002.

[24] P. Dutré, P. Bekaert, and K. Bala. *Advanced Global Illumination*. Natick, MA: A. K. Peters, 2003.

[25] Eastman Kodak Company. Applied science fiction web site, *www.asf.com/products/FPS/fpsfaqs.shtml*, July 2004.

[26] S. R. Ellis, W. S. Kim, M. Tyler, M. W. McGreevy, and L. Stark. "Visual Enhancements for Perspective Displays: Perspective Parameters," in *Proceedings*

of the IEEE International Conf. on Systems, Man and Cybernetics, New York: IEEE SMC Society, 1985.

[27] M. D. Fairchild. *Color Appearance Models* (2nd ed.), West Sussex, England: John Wiley and Sons, 2005.

[28] M. D. Fairchild. "Revision of CIECAM97s for Practical Applications," *Color Research and Application*, 26:418–427, 2001.

[29] M. D. Fairchild and G. M. Johnson. "The iCAM Framework for Image Appearance, Image Differences, and Image Quality," *Journal of Electronic Imaging*, 13:126–138, 2004.

[30] M. D. Fairchild and G. M. Johnson. "Meet iCAM: An Image Color Appearance Model," in *IS&T/SID 10th Color Imaging Conference*, pp. 33–38, Scottsdale: IS&T, 2002.

[31] M. D. Fairchild, G. M. Johnson, J. Kuang, and H. Yamaguchi. "Image Appearance Modelling and High-dynamic-range Image Rendering," in *First ACM Symposium on Applied Perception in Graphics and Visualization (APGV)*, p. 159, New York: ACM, 2004.

[32] R. Fattal, D. Lischinski, and M. Werman. "Gradient Domain High Dynamic Range Compression," *ACM Transactions on Graphics*, 21(3):249–256, 2002.

[33] P. Ferschin, I. Tastl, and W. Purgathofer. "A Comparison of Techniques for the Transformation of Radiosity Values to Monitor Colors," in *First IEEE International Conference on Image Processing*, pp. 13–16, Piscataway: IEEE Signal Processing Society, 1994.

[34] J. A. Ferwerda. "Elements of Early Vision for Computer Graphics," *IEEE Computer Graphics and Applications*, 21(5):22–33, 2001.

[35] J. A. Ferwerda, S. Pattanaik, P. Shirley, and D. P. Greenberg. "A Model of Visual Adaptation for Realistic Image Synthesis," in *SIGGRAPH 96 Conference Proceedings*, pp. 249–258, ACM SIGGRAPH, August 1996.

[36] G. D. Finlayson and S. Süsstrunk. "Color Ratios and Chromatic Adaptation," in *Proceedings of IS&T CGIV*, pp. 7–10, Poitiers, France: IS&T, 2002.

[37] J. Foley, A. van Dam, S. Feiner, and J. Hughes. *Computer Graphics, Principles and Practice* (2nd ed.), Reading, MA: Addison-Wesley, 1990.

[38] J. Forrester, A. Dick, P. McMenamin, and W. Lee. *The Eye: Basic Sciences in Practice*. London: W. B. Saunders, 2001.

[39] M. Frigo and S. G. Johnson. "FFTW: An Adaptive Software Architecture for the FFT," in *ICASSP Conference Proceedings*, Vol. 3, pp. 1381–1384, Seattle: IEEE, 1998.

[40] A. Gardner, C. Tchou, T. Hawkins, and P. Debevec. "Linear Light Source Reflectometry," *ACM Trans. on Graphics*, 22(3):749–758, 2003.

[41] W. S. Geisler. "Effects of Bleaching and Backgrounds on the Flash Response of the Cone System," *Journal of Physiology*, 312:413–434, 1981.

[42] A. S. Glassner. *Principles of Digital Image Synthesis*. San Francisco: Morgan Kaufmann, 1995.

[43] N. Goodnight, R. Wang, C. Woolley, and G. Humphreys. "Interactive Time-dependent Tone Mapping Using Programmable Graphics Hardware," in *Proceedings of the 13th Eurographics Workshop on Rendering*, pp. 26–37, Pisa: Eurographics Association, 2003.

[44] N. Graham. *Visual Pattern Analyzer*. New York: Oxford University Press, 1989.

[45] N. Graham and D. C. Hood. "Modeling the Dynamics of Light Adaptation: The Merging of Two Traditions," *Vision Research*, 32:1373–1393, 1992.

[46] N. Greene and P. S. Heckbert. "Creating Raster Omnimax Images from Multiple Perspective View Using the Elliptical Weighted Average Filter," *IEEE Computer Graphics and Applications*, 6(6):21–27, June 1986.

[47] R. Hall. *Illumination and Color in Computer Generated Imagery*. New York: Springer-Verlag, 1989.

[48] E. Hecht. *Optics* (2nd ed.), Reading, MA: Addison-Wesley, 1987.

[49] M. Hogan, J. Alvarado, and J. Weddell. *Histology of the Human Eye*. Philadelphia: W. B. Saunders, 1971.

[50] D. C. Hood and M. A. Finkelstein. "Comparison of Changes in Sensitivity and Sensation: Implications for the Response-intensity Function of the Human Photopic System," *Journal of Experimental Psychology: Human Perceptual Performance*, 5:391–405, 1979.

[51] D. C. Hood and M. A. Finkelstein. "Sensitivity to Light," in K. R. Boff, L. R. Kaufman, and J. P. Thomas (eds.), *Handbook of Perception and Human Performance*, New York: Wiley, 1986.

[52] D. C. Hood, M. A. Finkelstein, and E. Buckingham. "Psychophysical Tests of Models of the Response Function," *Vision Research*, 19:401–406, 1979.

[53] B. K. P. Horn. "Determining Lightness from an Image," *CVGIP*, 3:277–299, 1974.

[54] R. W. G. Hunt and M. R. Luo. "The Structure of the CIECAM97 Colour Appearance Model (CIECAM97s)," in *CIE Expert Symposium '97*, Scottsdale: CIE, 1997.

[55] R. W. G. Hunt. *The Reproduction of Colour*, West Sussex, England: John Wiley and Sons, 2004.

[56] IEC. "Extended RGB Colour Space — scRGB, Multimedia Systems, and Equipment: Colour Measurement and Management, Part 2-2, Colour Management," Technical Report 61966-2-2, IEC, 2003.

[57] ITU (International Telecommunication Union), Geneva. *ITU-R Recommendation BT.709, Basic Parameter Values for the HDTV Standard for the Studio and for International Programme Exchange*, 1990. (Formerly CCIR Rec. 709.)

[58] H. W. Jensen. *Realistic Image Synthesis Using Photon Mapping*. Natick, MA: A. K. Peters, 2001.

[59] D. J. Jobson, Z. Rahman, and G. A. Woodell. "Retinex Image Processing: Improved Fidelity to Direct Visual Observation," in *Proceedings of the IS&T Fourth Color Imaging Conference: Color Science, Systems, and Applications*, Vol. 4, pp. 124–125, Scottsdale: IS&T, 1995.

[60] G. M. Johnson. "Cares and Concerns of CIE TC8-08: Spatial Appearance Modeling and HDR Imaging," in *SPIE/IS&T Electronic Imaging Conference*, San Jose: IS&T, 2005.

[61] G. M. Johnson and M. D. Fairchild. "Rendering HDR Images," in *IS&T/SID 11th Color Imaging Conference*, pp. 36–41, Scottsdale: IS&T, 2003.

[62] F. Kainz, R. Bogart, and D. Hess. "The OpenEXR Image File Format," in *SIGGRAPH Technical Sketches*, 2003. See also *www.openexr.com*.

[63] S. B. Kang, M. Uyttendaele, S. Winder, and R. Szeliski. "High Dynamic Range Video," *ACM Transactions on Graphics*, 22(3), 2003.

[64] N. Katoh and K. Nakabayashi. "Applying Mixed Adaptation to Various Chromatic Adaptation Transformation (CAT) Models," in *IS&T PICS Conference*, pp. 299–305, Montreal: IS&T, 2001.

[65] J. Kleinschmidt and J. E. Dowling. "Intracellular Recordings from Gecko Photoreceptors During Light and Dark Adaptation," *Journal of General Physiology*, 66:617–648, 1975.

[66] C. Kolb, D. Mitchell, and P. Hanrahan. "A Realistic Camera Model for Computer Graphics," in *Proceedings of the 22nd Annual Conference on Computer Graphics and Interactive Techniques*, pp. 317–324, 1995.

[67] G. Krawczyk, R. Mantiuk, K. Myszkowski, and H-P. Seidel. "Lightness Perception Inspired Tone Mapping," in *First ACM Symposium on Applied Perception in Graphics and Visualization (APGV)*, p. 172, New York: ACM, 2004.

[68] J. Kuang, H. Yamaguchi, G. M. Johnson, and M. D. Fairchild. "Testing HDR Image Rendering Algorithms," in *Proceedings of IS&T/SID 12th Color Imaging Conference*, Scottsdale: IS&T, 2004.

[69] E. H. Land and J. J. McCann. "Lightness and Retinex Theory," *Journal of the Optical Society of America*, 63(1):1–11, 1971.

[70] G. W. Larson. "LogLuv Encoding for Full-gamut, High Dynamic Range Images," *Journal of Graphics Tools*, 3(1):15–31, 1998.

[71] G. W. Larson. "Overcoming Gamut and Dynamic Range Limitations in Digital Images," in *Proceedings of the IS&T 6th Color Imaging Conference*, Scottsdale: IS&T, 1998.

[72] P. Ledda, A. Chalmers, and H. Seetzen. "HDR Displays: A Validation Against Reality," in *International Conference on Systems, Man and Cybernetics*, The Hague, The Netherlands: IEEE, October 2004.

[73] P. Ledda, A. Chalmers, and H. Seetzen. "A Psychological Validation of Tonemapping Operators Using a High Dynamic Range Display," in *First ACM Symposium on Applied Perception in Graphics and Visualization (APGV)*, p. 159, New York: ACM, 2004.

[74] C. Li, M. R. Luo, R. W. G. Hunt, N. Moroney, M. D. Fairchild, and T. New-man. "The Performance of CIECAM02," in *IS&T/SID 10th Color Imaging Conference*, pp. 28–32, Scottsdale: IS&T, November 2002.

[75] T. M. Lillesand, R. W. Kiefer, and J. W. Chipman. *Remote Sensing and Image Interpretation* (5th ed.), New York: John Wiley and Sons, 2003.

[76] Bruce Lindbloom, *www.brucelindbloom.com*.

[77] B. D. Lucas and T. Kanade. "An Iterative Image Registration Technique with an Application in Stereo Vision," in *Seventh International Joint Conference on Artificial Intelligence (IJCAI-81)*, pp. 674–679, 1981.

[78] R. Mantiuk, G. Krawczyk, K. Myszkowski, and H-P. Seidel. "Perception-motivated High Dynamic Range Video Encoding," *ACM Transactions on Graphics*, 23(3), 2004.

[79] W. R. Mark, R. S. Glanville, K. Akeley, and M. J. Kilgard. "Cg: A System for Programming Graphics Hardware in a C-like Language," *ACM Transactions on Graphics*, 22(3):896–907, 2003.

[80] R. McDonald and K. J. Smith. "CIE94: A New Colour-difference Formula," *Journal for the Society of Dyers and Colourists*, 11:376–379, December 1995.

[81] N. J. Miller, P. Y. Ngai, and D. D. Miller. "The Application of Computer Graphics in Lighting Design," *Journal of the IES*, 14:6–26, October 1984.

[82] T. Mitsunaga and S. K. Nayar. "Radiometric Self Calibration," in *Proceedings of IEEE Conference on Computer Vision and Pattern Recognition*, Fort Collins, CO: IEEE, June 1999.

[83] P. Moon and D. E. Spencer. "Visual Data Applied to Lighting Design," *Journal of the Optical Society of America*, 34(10):605–617, 1944.

[84] N. Moroney, M. D. Fairchild, R. W. G. Hunt, C. J. Li, M. R. Luo, and T. New-man. "The CIECAM02 Color Appearance Model," in IS&T 10th Color Imaging Conference, pp. 23–27, Scottsdale: IS&T, 2002.

[85] N. Moroney. "Usage Guidelines for CIECAM97s," in Proceedings of the Conference on Image Processing, Image Quality, Image Capture Systems (PICS-00), pp. 164–168, Springfield: IS&T, 2000.

[86] N. Moroney and I. Tastl. "A Comparison of Retinex and iCAM for Scene Rendering," Journal of Electronic Imaging, 13(1), 2004.

[87] K. I. Naka and W. A. H. Rushton. "S-potentials from Luminosity Units in the Retina of Fish (Cyprinidae)," Journal of Physiology, 185:587–599, 1966.

[88] S. K. Nayar and R. M. Bolle. "Reflectance-based Object Recognition," Technical Report CUCS-055-92, Columbia University, 1992.

[89] S. G. de Groot and J. W. Gebhard. "Pupil Size as Determined by Adapting Luminance," Journal of the Optical Society of America, 42:492–495, 1952.

[90] J. von Kries. "Chromatic Adaptation," in D. L. MacAdam (ed.), Sources of Color Science, pp. 120–126, Cambridge, MA: MIT Press, 1902/1970.

[91] A. V. Oppenheim, R. Schafer, and T. Stockham. "Nonlinear Filtering of Multiplied and Convolved Signals," in Proceedings of the IEEE, 56(8):1264–1291, 1968.

[92] S. E. Palmer. Vision Science: Photons to Phenomenology. Cambridge, MA: MIT Press, 1999.

[93] D. Pascale. "A Review of RGB Color Spaces," Technical Report, The Babel-Color Company, 2003.

[94] S. N. Pattanaik, J. A. Ferwerda, M. D. Fairchild, and D. P. Greenberg. "A Multiscale Model of Adaptation and Spatial Vision for Realistic Im-

age Display," in *SIGGRAPH 98 Conference Proceedings*, pp. 287–298, ACM SIG-GRAPH, July 1998.

[95] S. N. Pattanaik, J. Tumblin, H. Yee, and D. P. Greenberg. "Time-dependent Visual Adaptation for Fast Realistic Display," in *SIGGRAPH 2000 Conference Proceedings*, pp. 47–54, ACM SIGGRAPH, July 2000.

[96] S. N. Pattanaik and H. Yee. "Adaptive Gain Control for High Dynamic Range Image Display," in *Proceedings of Spring Conference in Computer Graphics (SCCG2002)*, pp. 24–27, Budmerice, Slovak Republic, 2002.

[97] A. Payne, W. DeGroot, R. Monteverde, and D. Amm. "Enabling High Data-rate Imaging Applications with Grating Light Valve Technology," in *Photonics West 2004 — Micromachining and Microfabrication Symposium*, San Jose, CA: SPIE, January 2004.

[98] E. Peli. "Contrast in Complex Images," *Journal of the Optical Society of America A*, 7(10):2032–2040, October 1990.

[99] K. Perlin and E. M. Hoffert. "Hypertexture," *Computer Graphics*, 23(3):253–262, July 1989.

[100] C. Poynton. *Digital Video and HDTV: Algorithms and Interfaces*. Boston: Elsevier/Morgan Kaufmann Publishers, 2003.

[101] W. H. Press, S. A. Teukolsky, W. T. Vetterling, and B. P. Flannery. *Numerical Recipes in C: The Art of Scientific Computing* (2nd ed.), New York: Cambridge University Press, 1992.

[102] Z. Rahman, D. J. Jobson, and G. A. Woodell. "A Multiscale Retinex for Color Rendition and Dynamic Range Compression," in *SPIE Proceedings: Applications of Digital Image Processing XIX*, Vol. 2847, Denver, CO: SPIE, 1996.

[103] Z. Rahman, G. A. Woodell, and D. J. Jobson. "A Comparison of the Multiscale Retinex with Other Image Enhancement Techniques," in *IS&T's* 50th

Annual Conference: A Celebration of All Imaging, Vol. 50, pp. 426–431, Cambridge, MA: IS&T, 1997.

[104] M. S. Rea and I. G. Jeffrey. "A New Luminance and Image Analysis System for Lighting and Vision: Equipment and Calibration," *Journal of the Illuminating Engineering Society*, 9(1):64–72, 1990.

[105] M. S. Rea (ed.). *The IESNA Lighting Handbook: Reference and Application.* New York: The Illuminating Engineering Society of North America, 2000.

[106] E. Reinhard. "Parameter Estimation for Photographic Tone Reproduction," *Journal of Graphics Tools*, 7(1):45–51, 2003.

[107] E. Reinhard, M. Ashikhmin, B. Gooch, and P. Shirley. "Color Transfer Between Images," *IEEE Computer Graphics and Applications*, 21:34–41, September/October 2001.

[108] E. Reinhard and K. Devlin. "Dynamic Range Reduction Inspired by Photoreceptor Physiology," *IEEE Transactions on Visualization and Computer Graphics*, 11(1):13–24, January/February 2005.

[109] E. Reinhard, M. Stark, P. Shirley, and J. Ferwerda. "Photographic Tone Reproduction for Digital Images," *ACM Transactions on Graphics*, 21(3):267–276, 2002.

[110] D. L. Ruderman, T. W. Cronin, and C-C. Chiao. "Statistics of Cone Responses to Natural Images: Implications for Visual Coding," *Journal of the Optical Society of America A*, 15(8):2036–2045, 1998.

[111] W. A. H. Rushton and D. I. A. MacLeod. "The Equivalent Background of Bleaching," *Perception*, 15:689–703, 1986.

[112] A. Scheel, M. Stamminger, and H-P. Seidel. "Tone Reproduction for Interactive Walkthroughs." *Computer Graphics Forum*, 19(3):301–312, August 2000.

[113] C. Schlick. "Quantization Techniques for the Visualization of High Dynamic Range Pictures," in P. Shirley, G. Sakas, and S. Müller (eds.), *Photorealistic Rendering Techniques*, pp. 7–20. New York: Springer-Verlag, 1994.

[114] H. Seetzen, W. Heidrich, W. Stuerzlinger, G. Ward, L. Whitehead, M. Trentacoste, A. Ghosh, and A. Vorozcovs. "High Dynamic Range Display Systems," *ACM Transactions on Graphics*, 23(3), 2004.

[115] H. Seetzen, L. A. Whitehead, and G. Ward. "A High Dynamic Range Display Using Low and High Resolution Modulators," in *The Society for Information Display International Symposium*, Baltimore: SID, May 2003.

[116] P. Shirley. *Fundamentals of Computer Graphics*, Natick, MA: A. K. Peters, 2002.

[117] F. X. Sillion and C. Puech. *Radiosity and Global Illumination*. San Francisco: Morgan Kaufmann, 1994.

[118] S. M. Smith and J. M. Brady. "SUSAN: A New Approach to Low Level Image Processing," *International Journal of Computer Vision*, 23(1):45–78, 1997.

[119] B. Smits and G. Meyer. "Simulating Interference Phenomena in Realistic Image Synthesis," in *Proceedings of the First Eurographic Workshop on Rendering*, pp. 185–194, Rennes, France: Eurographics Association, 1990.

[120] L. Spillmann and J. S. Werner (eds.). *Visual Perception: The Neurological Foundations*. San Diego: Academic Press, 1990.

[121] J. C. Stevens and S. S. Stevens. "Brightness Function: Effects of Adaptation," *Journal of the Optical Society of America*, 53(3), 1963.

[122] W. S. Stiles and J. M. Burch. "NPL Colour-matching Investigation: Final Report," *Acta Optica*, 6:1–26, 1959.

[123] T. Stockham. "Image Processing in the Context of a Visual Model," *Proceedings of the IEEE*, 60(7):828–842, 1972.

[124] M. Stokes, M. Anderson, S. Chandrasekar, and R. Motta. "Standard Default Color Space for the Internet," 1996, *www.w3.org/Graphics/Color/sRGB.*

[125] M. C. Stone. *A Field Guide to Digital Color.* Natick, MA: A. K. Peters, 2003.

[126] S. Süsstrunk, J. Holm, and G. D. Finlayson. "Chromatic Adaptation Performance of Different RGB Sensors," in *Proceedings of IS&T/SPIE Electronic Imaging,* SPIE Vol. 4300, San Jose, January 2001.

[127] P. Thevenaz, U. E. Ruttimann, and M. Unser. "A Pyramid Approach to Subpixel Registration Based on Intensity," *IEEE Transactions on Image Processing,* 7(1), January 1998.

[128] C. Tomasi and R. Manduchi. "Bilateral Filtering for Gray and Color Images," in *Proceedings of the IEEE International Conference on Computer Vision,* pp. 836–846, 1998.

[129] J. Tumblin, J. K. Hodgins, and B. K. Guenter. "Two Methods for Display of High Contrast Images," *ACM Transactions on Graphics,* 18(1):56–94, 1999.

[130] J. Tumblin and H. Rushmeier. "Tone Reproduction for Realistic Computer Generated Images," Technical Report GIT-GVU-91-13, Graphics, Visualization, and Useability Center, Georgia Institute of Technology, 1991.

[131] J. Tumblin and H. Rushmeier. "Tone Reproduction for Computer Generated Images," *IEEE Computer Graphics and Applications,* 13(6):42–48, November 1993.

[132] J. Tumblin and G. Turk. "LCIS: A Boundary Hierarchy for Detail-preserving Contrast Reduction," in A. Rockwood (ed.), *Siggraph 1999, Computer Graphics Proceedings,* Annual Conference Series, pp. 83–90, Los Angeles: Addison-Wesley/Longman, 1999.

[133] J. M. Valenton and D. van Norren. "Light Adaptation of Primate Cones: An Analysis Based on Extracellular Data," *Vision Research*, 23:1539–1547, 1983.

[134] J. Walraven and J. M. Valeton. "Visual Adaptation and Response Saturation," in A. J. van Doorn, W. A. van de Grind, and J. J. Koenderink (eds.), *Limits of Perception*, Utrecht: VNU Press, 1984.

[135] B. A. Wandell. *Foundations of Vision*. Sinauer Associates, 1995.

[136] G. Ward and M. Simmons. "Subband Encoding of High Dynamic Range Imagery," in First *ACM Symposium on Applied Perception in Graphics and Visualization (APGV)*, pp. 83–90, New York: ACM, 2004.

[137] G. Ward. "Measuring and Modeling Anisotropic Reflection," *ACM Computer Graphics*, 26(2):265–272, July 1992.

[138] G. Ward. "Real Pixels," in J. Arvo (ed.), *Graphics Gems II*, pp. 80–83, San Diego: Academic Press, 1992.

[139] G. Ward. "A Contrast-based Scale Factor for Luminance Display," in P. Heckbert (ed.), *Graphics Gems IV*, pp. 415–421, Boston: Academic Press, 1994.

[140] G. Ward. "A Wide Field, High Dynamic Range, Stereographic Viewer," in *Proceedings of PICS 2002*, Portland: IS&T, April 2002.

[141] G. Ward. "Fast, Robust Image Registration for Compositing High Dynamic Range Photographs from Hand-held Exposures," *Journal of Graphics Tools*, 8(2):17–30, 2003.

[142] G. Ward, H. Rushmeier, and C. Piatko. "A Visibility Matching Tone Reproduction Operator for High Dynamic Range Scenes," *IEEE Transactions on Visualization and Computer Graphics*, 3(4), 1997.

[143] G. J. Ward. "The RADIANCE Lighting Simulation and Rendering System," in A. Glassner (ed.), *Proceedings of SIGGRAPH '94*, pp. 459–472, July 1994.

[144] G. Ward-Larson and R. A. Shakespeare. *Rendering with Radiance.* San Francisco: Morgan Kaufmann, 1998.

[145] C. Ware. *Information Visualization: Perception for Design.* San Francisco: Morgan Kaufmann, 2000.

[146] H. R. Wilson. "Psychophysical Models of Spatial Vision and Hyperacuity," in D. Regan (ed.), *Spatial Vision*, pp. 64–86, Boca Raton: CRC Press, 1991.

[147] H. R. Wilson and J. Kim. "Dynamics of a Divisive Gain Control in Human Vision," *Vision Research*, 38:2735–2741, 1998.

[148] A. P. Witkin. "Scale-space Filtering," in *Proceedings of the Eighth International Joint Conference on Artificial Intelligence*, 2, pp. 1019–1022, 1983.

[149] G. Wyszecki and W. S. Stiles. *Color Science: Concepts and Methods, Quantitative Data and Formulae* (2nd ed.), New York: John Wiley and Sons, 2000.

[150] H. Yee and S. N. Pattanaik. "Segmentation and Adaptive Assimilation for Detail-preserving Display of High-dynamic Range Images," *The Visual Computer*, 19(7–8), 2003.

[151] X. Zhang and B. A. Wandell. "A Spatial Extension of CIELAB for Digital Color Image Reproduction," *Society of Information Display Symposium Technical Digest*, 27:731–734, 1996.

[152] S. Agarwal, R. Ramamoorthi, S. Belongie, and H. W. Jensen. "Structured Importance Sampling of Environment Maps," *ACM Transactions on Graphics*, 22(3):605–612, July 2003.

[153] M. Ashikhmin and P. Shirley. "An Anisotropic Phong BRDF Model," *Journal of Graphics Tools*, 5(2):25–32, 2000.

[154] J. F. Blinn. "Texture and Reflection in Computer-Generated Images," *Communications of the ACM*, 19(10):542–547, October 1976.

[155] B. Cabral, N. Max, and R. Springmeyer. "Bidirectional Reflection Functions from Surface Bump Maps," in *Computer Graphics (Proceedings of SIGGRAPH 87)*, Vol. 21, pp. 273–281, July 1987.

[156] E. Chen. "QuickTime VR: An Image-based Approach to Virtual Environment Navigation," in *SIGGRAPH 95: Proceedings of the 2nd Annual Conference on Computer Graphics and Interactive Techniques*, pp. 29–38, ACM, 1995.

[157] J. M. Cohen. "Estimating Reflected Radiance Under Complex Distant Illumination," Technical Report RH-TR-2003-1, Rhythm and Hues Studios, 2003.

[158] J. M. Cohen and P. Debevec. "The LightGen HDRShop Plug-in," 2001, *www.hdrshop.com/main-pages/plugins.html*.

[159] F. C. Crow. "Summed-area Tables for Texture Mapping," in *Computer Graphics (Proceedings of SIGGRAPH 84)*, Vol. 18, pp. 207–212, July 1984.

[160] P. Debevec. "Light Probe Image Gallery," 1999, *http://www.debevec.org/Probes/*.

[161] P. Debevec. "Rendering Synthetic Objects into Real Scenes: Bridging Traditional and Image-based Graphics with Global Illumination and High Dynamic Range Photography," in *Proceedings of SIGGRAPH 98*, Computer Graphics Proceedings, Annual Conference Series, pp. 189–198, July 1998.

[162] P. Debevec, T. Hawkins, C. Tchou, H.-P. Duiker, W. Sarokin, and M. Sagar. "Acquiring the Reflectance Field of a Human Face," *Proceedings of SIGGRAPH 2000*, pp. 145–156, July 2000.

[163] P. Debevec, C. Tchou, A. Gardner, T. Hawkins, A. Wenger, J. Stumpfel, A. Jones, C. Poullis, N. Yun, P. Einarsson, T. Lundgren, P. Martinez, and

M. Fajardo. "Estimating Surface Reflectance Properties of a Complex Scene Under Captured Natural Illumination," *conditionally accepted to ACM Transactions on Graphics,* 2005.

[164] P. E. Debevec and J. Malik. "Recovering High Dynamic Range Radiance Maps from Photographs," in *Proceedings of SIGGRAPH 97,* Computer Graphics Proceedings, Annual Conference Series, pp. 369–378, August 1997.

[165] P. E. Debevec, C. J. Taylor, and J. Malik. "Modeling and Rendering Architecture from Photographs: A Hybrid Geometry- and Image-based Approach," in *Proceedings of SIGGRAPH 96,* Computer Graphics Proceedings, Annual Conference Series, pp. 11–20, August 1996.

[166] G. Downing. "Stitched HDRI," 2001, *www.gregdowning.com/HDRI/stitched/.*

[167] M. Fajardo. "Monte Carlo Ray Tracing in Action," in *State of the Art in Monte Carlo Ray Tracing for Realistic Image Synthesis,* SIGGRAPH 2001 Course 29, August, 2001.

[168] G. R. Fowles. *Introduction to Modern Optics* (2nd ed.), New York: Dover Publications, 1975.

[169] A. Gardner, C. Tchou, T. Hawkins, and P. Debevec. "Linear Light Source Reflectometry," in *Proceedings of SIGGRAPH 2003,* Computer Graphics Proceedings, Annual Conference Series, pp. 335–342, 2003.

[170] C. M. Goral, K. E. Torrance, D. P. Greenberg, and B. Battaile. "Modeling the Interaction of Light Between Diffuse Surfaces," in *SIGGRAPH 84,* pp. 213–222, 1984.

[171] N. Greene. "Environment Mapping and Other Application of World Projections," *IEEE Computer Graphics and Applications,* 6(11):21–29, November 1986.

[172] P. Haeberli. "Synthetic Lighting for Photography," January 1992, *www.sgi. com/grafica/synth/index.html*.

[173] P. Heckbert. "Color Image Quantization for Frame Buffer Display," in *SIGGRAPH'84: Proceedings of the 9th Annual Conference on Computer Graphics and Interactive Techniques*, pp. 297–307, ACM Press, July 1982.

[174] W. Heidrich and H.-P. Seidel. "Realistic, Hardware-accelerated Shading and Lighting," in *Proceedings of SIGGRAPH 99*, pp. 171–178, August 1999.

[175] J. T. Kajiya. "The Rendering Equation," in *Computer Graphics (Proceedings of SIGGRAPH 86)*, Vol. 20, pp. 143–150, 1986.

[176] M. Kawase. "Real-time High Dynamic Range Image-based Lighting," 2003, *www.daionet.gr.jp/~masa/rthdribl/*.

[177] T. Kollig and A. Keller. "Efficient Illumination by High Dynamic Range Images," in *Eurographics Symposium on Rendering: 14th Eurographics Workshop on Rendering*, pp. 45–51, 2003.

[178] E. P. F. Lafortune, S.-C. Foo, K. E. Torrance, and D. P. Greenberg. "Non-linear Approximation of Reflectance Functions," in *Proceedings of SIGGRAPH 97*, pp. 117–126, 1997.

[179] H. Landis. "Production-ready Global Illumination," *Course notes for SIGGRAPH 2002 Course 16, "RenderMan in Production,"* 2002.

[180] G. W. Larson, H. Rushmeier, and C. Piatko. "A Visibility Matching Tone Reproduction Operator for High Dynamic Range Scenes," *IEEE Transactions on Visualization and Computer Graphics*, 3(4):291–306, October–December 1997. ISSN 1077-2626.

[181] J. Lawrence, S. Rusinkiewicz, and R. Ramamoorthi. "Efficient BRDF Importance Sampling Using a Factored Representation," in *ACM Transactions on Graphics (SIGGRAPH 2004)*, August 2004.

[182] X. Liu, P.-P. Sloan, H.-Y. Shum, and J. Snyder. "All-frequency Precomputed Radiance Transfer for Glossy Objects," in *Rendering Techniques 2004: 15th Eurographics Workshop on Rendering*, pp. 337–344, June 2004.

[183] D. K. McAllister. "A Generalized Surface Appearance Representation for Computer Graphics," Ph.D. thesis, University of North Carolina at Chapel Hill, 2002.

[184] J. B. MacQueen. "Some Methods for Classification and Analysis of Multivariate Observations," in *Proceedings of 5th Berkeley Symposium on Mathematical Statistics and Probability*, Vol. 1, pp. 281–297, Berkeley: University of California Press, 1997.

[185] N. Metropolis, A. W. Rosenbluth, M. N. Rosenbluth, A. H. Teller, and E. Teller. "Equations of State Calculations by Fast Computing Machines," *Journal of Chemical Physics*, 21:1087–1091, 1953.

[186] G. S. Miller and C. R. Hoffman. "Illumination and Reflection Maps: Simulated Objects in Simulated and Real Environments," in *SIGGRAPH 84 Course Notes for Advanced Computer Graphics Animation*, July 1984.

[187] J. Mitchell, J. Isidoro, and A. Vlachos. "ATI Radeon 9700 Real-time Demo of Rendering with Natural Light," 2002, *www.ati.com/developer/demos/R9700.html*.

[188] S. K. Nayar. "Catadioptric Omnidirectional Camera," in *Proceedings of the IEEE Conference on Computer Vision and Pattern Recognition*, pp. 482–488, Puerto Rico, June 1997.

[189] R. Ng, R. Ramamoorthi, and P. Hanrahan. "All-frequency Shadows Using Non-linear Wavelet Lighting Approximation," *ACM Transactions on Graphics*, 22(3):376–381, July 2003.

[190] F. E. Nicodemus, J. C. Richmond, J. J. Hsia, I. W. Ginsberg, and T. Limperis. "Geometric Considerations and Nomenclature for Reflectance," *National Bureau of Standards Monograph 160*, October 1977.

[191] V. Ostromoukhov, C. Donohue, and P.-M. Jodoin. "Fast Hierarchical Importance Sampling with Blue Noise Properties," *ACM Transactions on Graphics*, 23(3):488–495, August 2004.

[192] M. Pharr and G. Humphreys. "Improved Infinite Area Light Source Sampling," 2004, *http://pbrt.org/plugins.php*.

[193] M. Pharr and G. Humphreys. *Physically Based Rendering: From Theory to Implementation*. San Francisco: Morgan Kaufmann, 2004.

[194] B. Phong. "Illumination for Computer Generated Pictures," *Communications of the ACM*, 18(6), September 1975.

[195] R. Ramamoorthi and P. Hanrahan. "Frequency Space Environment Map Rendering," *ACM Transactions on Graphics*, 21(3):517–526, July 2002.

[196] P.-P. Sloan, J. Kautz, and J. Snyder. "Precomputed Radiance Transfer for Real-time Rendering in Dynamic, Low-frequency Lighting Environments," *ACM Transactions on Graphics*, 21(3):527–536, July 2002.

[197] B. Smith and L. Rowe. "Compressed Domain Processing of JPEG-encoded Images," *Real-Time Imaging*, 2(2):3–17, 1996.

[198] G. Spencer, P. S. Shirley, K. Zimmerman, and D. P. Greenberg. "Physically-based Glare Effects for Digital Images," in *Proceedings of SIGGRAPH 95*, Computer Graphics Proceedings, Annual Conference Series, pp. 325–334, 1995.

[199] J. Stumpfel. "HDR Lighting Capture of the Sky and Sun," Master's thesis, California Institute of Technology, Pasadena, California, 2004.

[200] J. Stumpfel, A. Jones, A. Wenger, and P. Debevec. "Direct HDR Capture of the Sun and Sky," in *Proceedings of the 3^rd International Conference on Virtual Reality, Computer Graphics, Visualization and Interaction in Africa (AFRIGRAPH 2004)*, 2004.

[201] R. Szeliski and H.-Y. Shum. "Creating Full View Panoramic Mosaics and Environment Maps," in *Proceedings of SIGGRAPH 97*, Computer Graphics Proceedings, Annual Conference Series, pp. 251–258, August 1997.

[202] C. Tchou and P. Debevec. "HDR Shop," 2001, *www.debevec.org/HDRShop*.

[203] C. Tchou, D. Maas, T. Hawkins, and P. Debevec. "Facial Reflectance Field Demo," SIGGRAPH 2000 Creative Applications Laboratory, 2000, *www.debevec.org/FaceDemo/*.

[204] E. Veach and L. J. Guibas. "Metropolis Light Transport," in *Proceedings of SIGGRAPH 97*, Computer Graphics Proceedings, Annual Conference Series, pp. 65–76, 1997.

[205] G. J. Ward. "The RADIANCE Lighting Simulation and Rendering System," in *SIGGRAPH 94*, pp. 459–472, 1994.

[206] T. Whitted. "An Improved Illumination Model for Shaded Display," *Communications of the ACM*, 23(6):343–349, June 1980.

[207] L. Williams. "Pyramidal Parametrics," *Computer Graphics (Proceedings of SIGGRAPH 83)*, 17(3):1–11, Detroit, MI, July, 1983.

[208] G. Ward and E. Eydelberg-Vileshin. "Picture Perfect RGB Rendering Using Spectral Prefiltering and Sharp Color Primaries," in P. Debevec and S. Gibson (eds.), *Thirteenth Eurographics Workshop on Rendering (2002)*, June 2002.

Index

About the DVD-ROM

This book is accompanied by a DVD-ROM which contains over 4 GB of data. This DVD-ROM is readable under Windows, Linux, and Mac OS X operating systems.

This disk contains numerous high resolution images and renderings in different high dynamic range formats (HDR, OpenEXR, TIFF and JPEG-HDR), including a new set of images of the well-known Stanford Memorial Church (courtesy of Chris Cox and Sharon Henley of Adobe Systems Inc.).

For converting images between Radiance HDR and the recently developed JPEG-HDR format, this DVD-ROM includes executables as well as a set of libraries developed by Greg Ward for Sunnybrook Technologies. These are available for Windows, Linux, and Mac OS X. The license for this software is included below under "Sunnybrook High Dynamic Range Imaging Library." For Mac OS X this set of tools additionally includes executables to convert between additional HDR formats and to create HDRs from multiple LDR exposures.

Source code and executables for more than 20 tone reproduction operators, implemented by Erik Reinhard, are also included on this DVD-ROM. Executables are available for Windows, Linux, and Mac OS X.

Finally, this DVD-ROM contains Paul Debevec's tutorial on image-based lighting with the Radiance rendering system, as well as further information on various high dynamic range image encoding systems written by Greg Ward.

ELSEVIER DVD-ROM LICENSE AGREEMENT

acknowledge that you have read this agreement, that you understand it, and that you agree to be bound by the terms and conditions of this agreement. Elsevier inc. ("Elsevier") expressly does not agree to license this DVD-ROM product to you unless you assent to this agreement. If you do not agree with any of the following terms, you may, within thirty (30) days after your receipt of this DVD-ROM product return the unused DVD-ROM product, the book, and a copy of the sales receipt to the customer service department at Elsevier for a full refund.

LIMITED WARRANTY AND LIMITATION OF LIABILITY

NEITHER ELSEVIER NOR ITS LICENSORS REPRESENT OR WARRANT THAT THE DVD-ROM PRODUCT WILL MEET YOUR REQUIREMENTS OR THAT ITS OPERATION WILL BE UNINTERRUPTED OR ERROR-FREE. WE EXCLUDE AND EXPRESSLY DISCLAIM ALL EXPRESS AND IMPLIED WARRANTIES NOT STATED HEREIN, INCLUDING THE IMPLIED WARRANTIES OF MERCHANTABILITY AND FITNESS FOR A PARTICULAR PURPOSE. IN ADDITION, NEITHER ELSEVIER NOR ITS LICENSORS MAKE ANY REPRESENTATIONS OR WARRANTIES, EITHER EXPRESS OR IMPLIED, REGARDING THE PERFORMANCE OF YOUR NETWORK OR COMPUTER SYSTEM WHEN USED IN CONJUNCTION WITH THE DVD-ROM PRODUCT. WE SHALL NOT BE LIABLE FOR ANY DAMAGE OR LOSS OF ANY KIND ARISING OUT OF OR RESULTING FROM YOUR POSSESSION OR USE OF THE SOFTWARE PRODUCT CAUSED BY ERRORS OR OMISSIONS, DATA LOSS OR CORRUPTION, ERRORS OR OMISSIONS IN THE PROPRIETARY MATERIAL, REGARDLESS OF WHETHER SUCH LIABILITY IS BASED IN TORT, CONTRACT OR OTHERWISE AND INCLUDING, BUT NOT LIMITED TO, ACTUAL, SPECIAL, INDIRECT, INCIDENTAL OR CONSEQUENTIAL DAMAGES. IF THE FOREGOING LIMITATION IS HELD TO BE UNENFORCEABLE, OUR MAXIMUM LIABILITY TO YOU SHALL NOT EXCEED THE AMOUNT OF THE PURCHASE PRICE PAID BY YOU FOR THE SOFTWARE PRODUCT. THE REMEDIES AVAILABLE TO YOU AGAINST US AND THE LICENSORS OF MATERIALS INCLUDED IN THE SOFTWARE PRODUCT ARE EXCLUSIVE.

If this DVD-ROM product is defective, Elsevier will replace it at no charge if the defective DVD-ROM product is returned to Elsevier within sixty (60) days (or the greatest period allowable by applicable law) from the date of shipment.

YOU UNDERSTAND THAT, EXCEPT FOR THE 60-DAY LIMITED WARRANTY RE-CITED ABOVE, ELSEVIER, ITS AFFILIATES, LICENSORS, SUPPLIERS AND AGENTS, MAKE NO WARRANTIES, EXPRESSED OR IMPLIED, WITH RESPECT TO THE DVD-ROM PRODUCT, INCLUDING, WITHOUT LIMITATION THE PROPRIETARY MATE-RIAL, AND SPECIFICALLY DISCLAIM ANY WARRANTY OF MERCHANTABILITY OR FITNESS FOR A PARTICULAR PURPOSE.

IN NO EVENT WILL ELSEVIER, ITS AFFILIATES, LICENSORS, SUPPLIERS OR AGENTS, BE LIABLE TO YOU FOR ANY DAMAGES, INCLUDING, WITHOUT LIM-ITATION, ANY LOST PROFITS, LOST SAVINGS OR OTHER INCIDENTAL OR CON-SEQUENTIAL DAMAGES, ARISING OUT OF YOUR USE OR INABILITY TO USE THE DVD-ROM PRODUCT REGARDLESS OF WHETHER SUCH DAMAGES ARE FORE-SEEABLE OR WHETHER SUCH DAMAGES ARE DEEMED TO RESULT FROM THE FAILURE OR INADEQUACY OF ANY EXCLUSIVE OR OTHER REMEDY.

SUNNYBROOK HIGH DYNAMIC RANGE IMAGING LIBRARY NON-COMMERCIAL LICENSE

The Sunnybrook High Dynamic Range Imaging Library ("This Software") is based in part on the work of the Independent JPEG Group.

IF YOU (A PERSON RECEIVING A COPY OF THIS SOFTWARE) DO NOT AGREE TO THE FOLLOWING TERMS, YOU DO NOT HAVE PERMISSION TO USE THIS SOFTWARE:

1 Sunnybrook Technologies Inc. ("Sunnybrook") is the owner of all intellec-tual property rights in This Software, including worldwide copyright, any eventual patent rights in any country. You may not do anything inconsistent with such ownership, nor assist others in doing so.

2 Sunnybrook hereby grants You a non-exclusive, world-wide, royalty-free, non-sublicenseable license to use This Software for non-commercial pur-poses only. Under this License, *use* means to run, load into memory, trans-mit, call from another application, copy or distribute. You may NOT use this software for any commercial purposes, including without limitation:

* Incorporating any part of This Software into a commercial product;
* Distributing This Software together with any commercial product; or
* Using any part of This Software, or any work based on any part of This Software, in performance of a commercial service; or
* Otherwise attempting to profit from distributing or using This Software.

3 You may distribute copies of This Software, either alone or along with other applications which call portions of This Software, provided that:

(a) This License and the accompanying README file are distributed unaltered along with This Software; and

(b) Any application that calls This Software includes the message: "This software makes use of the High Dynamic Range Imaging Library from Sunnybrook Technologies Inc. ©Sunnybrook Inc. 2005" in the "About" menu item or some other appropriate location.

4 You may NOT modify, adapt, decompile, disassemble, decrypt, extract, or otherwise reverse engineer This Software.

5 This Software is provided under this License on an "AS IS" BASIS and WITHOUT ANY WARRANTIES OR CONDITIONS, either express or implied. Without limitation, all warranties of NON-INFRINGEMENT, MERCHANTABILITY or FITNESS FOR A PARTICULAR PURPOSE are expressly disclaimed. This Software is still in development and MAY INCLUDE BUGS. This Software has not been tested on all types of computers or in all operating environments. THE ENTIRE RISK AS TO THE QUALITY AND PERFORMANCE OF THIS SOFTWARE IS WITH YOU. This DISCLAIMER OF WARRANTY constitutes an essential part of this License. No license to This Software is granted hereunder except under this disclaimer.

6 Under no circumstances and under no legal theory, whether in tort (including negligence), contract, or otherwise, shall Sunnybrook or any of its employees, officers, shareholders or agents be liable to any person for any direct, indirect, special, incidental, or consequential damages of any character arising as a result of this License or the use of This Software including, without limitation, damages for loss of goodwill, work stoppage, computer failure or malfunction, or any and all other commercial damages or losses. This limitation of liability shall not apply to liability for death or personal